Changing States

Contemporary Art and Ideas
in an Era of Globalisation

Published in the United Kingdom by the
Institute of International Visual Arts (inIVA)

Institute of International Visual Arts
6-8 Standard Place, Rivington Street
London EC2A 3BE
www.iniva.org

ISBN 1-899846-40-9

A catalogue record of this book is available from the British Library.

Edited by Gilane Tawadros
Produced by Sarah Campbell
Designed by Untitled
Production co-ordinated by Uwe Kraus GmbH
Printed in Italy

On the cover: Simon Tegala, *Anabiosis*, 1998. A site-specific artwork
commissioned by inIVA. Concord Sylvania Building, London.
Photograph: Stephen White

Changing States

Contemporary Art and Ideas in an Era of Globalisation

Edited by Gilane Tawadros

Institute of International Visual Arts

Contents

Metropolis

Site

Nation

Performance

Global

Identity

Translation

Making

Archive

Modern

Preface
Stuart Hall

inIVA, the Institute of International Visual Arts, is a publicly supported, multi-channel, visual arts agency dedicated to exhibiting, championing and winning visibility for the work produced by artists from a variety of different cultural backgrounds. *Changing States,* a selection of artists' pages, texts and documents from a decade of work, celebrates inIVA's tenth anniversary and 'showcases' the work of the artists, from Britain and across the world, who have been associated with its project. It 'samples' inIVA's programmes in exhibitions, publishing, multimedia, performance, education, research, discussion and debate, offering a snapshot of the variety of projects and activities, themes and issues, which inIVA has promoted over the decade. The driving principle of selection has been to foreground the artwork, in its widest sense, as the *prism* through which is refracted the wide-ranging and diverse visual practices of these contemporary artists, the distinctive issues and experiences which animate their work, and the ideas and debates which provide its critical contexts. inIVA thus takes up and develops what Rasheed Araeen described, in the catalogue to his path-breaking 1989 Hayward Gallery show, *The Other Story,* as 'the unique story... of those men and women who defied their "otherness" and entered the modern space that was forbidden to them, not only to declare their historic claim on it but also to challenge the framework which defined and protected its boundaries'.

inIVA's project has been to create a site – a 'sense of place' – for artistic innovation and excellence and a receptive critical milieu for this kind of work. Its aim has been to bring the work in from the margins of invisibility, misunderstanding and neglect into the

'mainstream'; to create around the work an ethos of vigorous dialogue and debate; to provide, for the widest, most diverse publics, a 'window' into these alternative spaces and practices. In these ways, it seeks to challenge the narrow and culturally exclusive version of 'the national story' which sometimes appears seamlessly to unfold in exhibition programmes and institutional policies, in museums and galleries, as well as in the unexamined assumptions which underpin criticism and art history.

inIVA's project has been decisively shaped by artists who, sometimes by choice, more often by fate, force and circumstance, have come from a variety of different histories, traditions and cultural backgrounds across the globe to live and work in the UK. 'Conscripts of modernity', as David Scott felicitously calls them – but refusing either to lose themselves in a false universality or to be permanently immured in difference, these artists lay claim without apology to the languages of contemporary art, they 'travel' and translate between conflicting realities, and struggle through their practice to refashion themselves as modern subjects. inIVA's project was forged and tempered in the struggles by generations of such artists to resist racism, cultural stereotyping and marginalisation and, instead, to put themselves – their experiences and perspectives, their histories and their bodies – centrally 'within the frame' and to give them visual form. It has grown up with that deeply contradictory process of 'globalisation' which is transforming the world – and thus, inevitably, also, the artwork and the art world: making lateral connections, crossing frontiers, subverting boundaries, but also decentring individual lives, uprooting communities,

displacing peoples, destroying fragile ecologies – fundamentally redrawing relationships of power and culture, globally, between 'us' and 'them', the West and the Rest, North and South, margin and centre. These things – surprising visions, haunting shapes, disturbed fault lines – continue to be visible in 'the work', provided one knows where and how to look. inIVA insists, against the odds, on 'going on looking' in unexpected ways and unusual places.

Artists, curators, ideas, practices from across the globe, laterally, have therefore been, from its inception, intrinsic to inIVA's programmes. Its purpose and practice have become, irrevocably, 'global' in scope and reach. However, it also remains grounded in those persistent 'local' differences, discrepancies, conflicts and discordances of experience which continue to divide and bisect 'the global'; which continue to be reflected in the work; and about which the artist and the artwork often still provide the deepest clues and ask the most disturbing questions. As it enters a new decade of work with the construction of the new arts centre for the culturally diverse arts at Rivington Place – in the moment of a certain 'coming home' – inIVA rededicates itself to continuing to work at these awkward sites and to confronting this difficult but rewarding challenge.

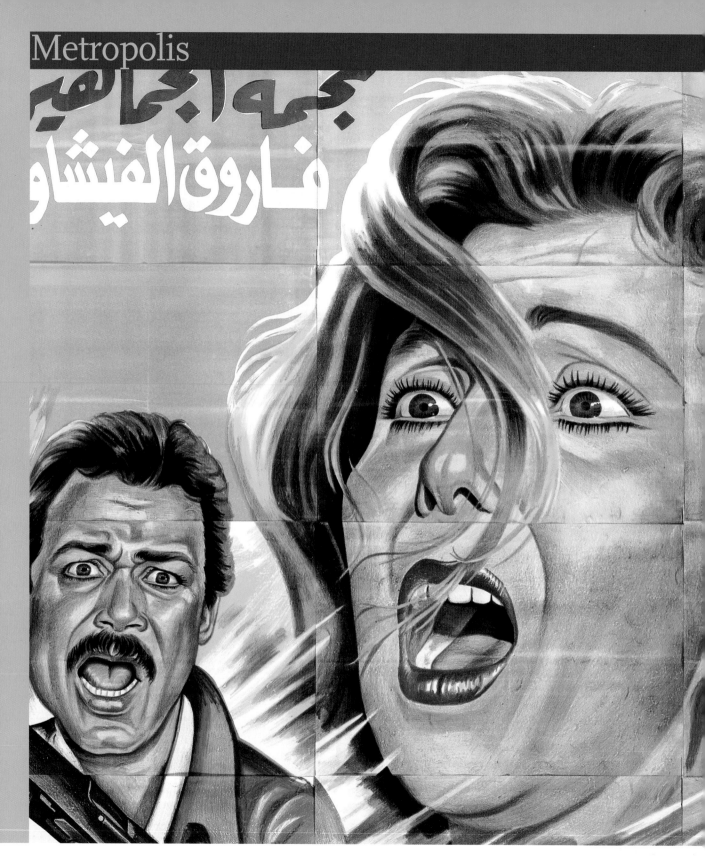

At a moment when national identities are being eroded and ethnic identities are being asserted violently within Europe's borders, the postcolonial cities of the world offer up the promise of a cosmopolitanism where cultures and ethnicities coexist and intermingle. In the urban hubs of cities like Birmingham, Cairo, London and Mumbai, no single group can lay claim to possess the city in its entirety. In London, a dynamic urban culture has been created by the continuous influx of migrants, from the Huguenots in the seventeenth century to the postwar migrations from the Caribbean and Indian sub-continent and the more recent arrivals from Eastern Europe. This influx means that the character of the metropolis from Paris to Bangalore to Johannesburg is undergoing constant transformation.

Parisien(ne)s

Hou Hanru

Parisien(ne)s is an exhibition that was curated by Hou Hanru and organised by inIVA in collaboration with Camden Arts Centre (Camden Arts Centre, London, 1997). All of the participating artists – Absalon, Chohreh Feyzdjou, Thomas Hirschhorn, Huang Yong Ping, Sarkis, Tiina Ketara, Tsuneko Taniuchi, Shen Yuan and Chen Zhen – had lived and worked in Paris, but had cultural roots outside France. Once the home of the some of the most celebrated modern artists, Paris has become, in recent years, the home of many itinerant artists, whose presence has infused the city with a cultural vitality and pluralism which have transformed established notions of location, identity and culture.

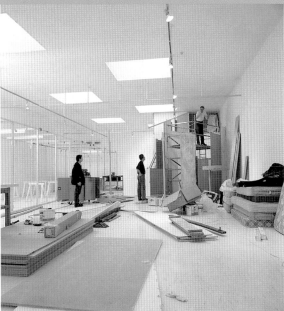

Installing *Parisien(ne)s*, Camden
Arts Centre, London, 1997. Courtesy
Camden Arts Centre

1. Reality

The Paris that exists in our minds is a city of artists and
the birthplace of modern art. Since the mid-nineteenth
century Paris has been associated with the expressions,
freedoms and vitality seen not only as the essence of the
modern metropolis but as central to the definition of
modernity itself. What cannot be overlooked, however,
as Raymond Williams[1] has emphasised, is that
immigration has played a fundamental role in the
formation of the image of the modern metropolis. Such
a conclusion is doubtlessly true in the Parisian context.
The presence and legacy of immigrant artists such
as Van Gogh, Picasso, Gris, Miró, Tzara, Chagall and
Brancusi helped create the idea we continue to hold,
that Paris is the epitome of the city of art.

Today, Paris is negotiating an important period
of transition and re-invention, or 'renovation' of its
identity. Like most Western cities, Paris is experiencing
fundamental mutations across a broad cultural front,
and its identity as a *modern* city is changing into a
pluralist, multicultural and constantly changing
postmodern city. These changes which can be traced
back to French colonial history, are tied to global
postcolonial influences and they can be seen now in
the unavoidable confrontations occurring between the
different cultures and opposing political and economic
interests that coexist in Paris. Tensions between the
local community and the wider society; centre and
periphery; globalisation and national interests;
representation and power; communication and
neo-colonialism; and others, are now defining Parisian
life. By foregrounding issues of exile and identity,
international migrations are proving to be the most

dynamic catalyst in this transformative process,
providing the foundation for a new, contemporary,
postmodern, 'Parisien(ne)' identity. But, like migration
itself, this new identity is constantly shifting.

Some of the tensions that these changes provoke
have been exposed in a number of recent events; for
example, in the polemics around the new immigration
laws,[2] in the recent event at the Eglise St Bernard[3] and
in the success of Mathieu Kassowitz's film *La Haine*.[4]
As well as revealing an emerging climate of conflict
between the new social order and established power
structures, the impact of this film highlights the need
for other artistic projects that recognise and respond
to the transformation of Paris....

2. Projects

Now, at the end of the twentieth century, established
visual codes are being constantly deconstructed and
reconstructed, reflecting changing social formations.
Metropolitan reality consists of both old and new
social orders, and the conflicts arising from cultural
difference contained within each, help drive social
change. This leads to the centrality of the question
of what is the identity of the 'Parisien(ne)'.

We cannot deny the decisive role of modernity
in the formation of global culture, including non-
Western culture. However, cultural differences should
not be understood in an entirely relativist manner,
not acknowledging modernism's imposition of a
supposedly progressive model, of a historical dynamic
over 'other' cultures, in order to recompose an *equal*
world map of different cultures. If we do so we risk
falling into a form of nostalgia for the exoticised 'other'

of the colonial era. As was seen with *Magiciens de la Terre*,[5] despite the intention to overcome in-built Eurocentrism, there is great difficulty in discarding a folklorised or exoticised reading of the colonial 'other'. The deconstruction of modernism and modernity should entail progress from, rather than denial of, the impact of modernity on international culture.

While a deconstruction of modernity occurs within the restructuring of global and local cultures, it cannot occur within a modernist ideology of 'cultural purism' which defines cultures and communities solely in terms of 'folklore' and 'tradition'. In contemporary Paris, a project intending to contribute to the city's cultural renovation should be conceived through a dialectical re-evaluation of the established modern and contemporary languages of representation. The process should be one of critique and reinvention, spawning new cultural practices that not only reflect but also generate the vibrant, constantly changing social condition emanating from Paris's new 'cultural hybridity'. A cultural project can only function effectively from what Homi Bhabha has termed a 'Third Space',[6] in which the coexistence of different cultures replaces the dominance of the 'mainstream', nationalist culture. This position implies that 'Parisien(ne)' identity, and identity in general, will continue to be a shifting process of identification, de-identification and re-identification.

Certainly immigrant artists play a vital role in the new formation of culture. They are not simply representatives of their own cultures but bring new perspectives to established codes and practices as they respond to the challenges of surviving and participating in an often alien world. And, they constantly confront the question of their own identity. For them, life as well as art is a process of confrontation, dialogue, negotiation and (re)invention. Their experiences as subjects of the often harsh legacy of the colonial past and the equally harsh reality of post- or neo-colonialism have helped form the immigrant artist's response. The immigrant artist does not remain within the confines of any politically correct formulation, but reaches beyond and responds with what Raymond Williams has referred to as the 'innovation in form'.[7]

For the first time, the destiny of immigration and exile is no longer that of marginality in the Western metropolis, although this remains a highly visible position. As immigrants are more central in society, society is increasingly defined by immigration. Along with increasing forms of globalisation, migration and travel, there are increasing displacements between and within 'First World' and 'Third World'. Immigration and globalisation are now embedded in the economic, political and social conditions of contemporary culture. A structural 'revolution' of metropolitan life is taking place in the flux of migration. The contemporary 'Parisien(ne)' is now one who travels between the city and the ends of the earth; the various displacements fill and simultaneously empty the city's spaces, while its boundaries are extended by their journeys and diverse trajectories. The 'Parisien(ne)' is being transformed from Walter Benjamin's '*flâneur*' into a '*voyageur*'.

3. *Strategies*

Immigrant artists are at the forefront of the new 'Parisien(ne)' identity; their strategies embody many

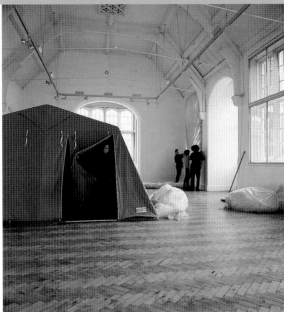

Installing *Parisien(ne)s*, Camden
Arts Centre, London, 1997. Courtesy
Camden Arts Centre

of the changes, tensions and re-evaluations which are shaping the city's new cultural agenda. The artists in this exhibition are among those who have made the most remarkable contributions to this process. The fact that these artists belong to diverse backgrounds (they are from seven countries) and generations (their ages range from thirty to sixty), and the fact that they maintain very different relations with the institutions and discourses of the art world, mean that together they constitute an entire history, reflecting the evolution of immigrant contributions to the artistic and cultural life of Paris. The works in *Parisien(ne)s* represent a range of distinct and original strategies; effective contributions to the artistic and cultural 'renovation' of Paris.

As 'Parisien(ne)s', these artists investigate the social reality of Paris from particular, personal viewpoints, each searching for answers to the increasing sense of social crisis in the city. In his work, *The Spasm of the Metro-Womb* (1997), Chen Zhen relates the metro to an image of the womb. By building a womb-like space with sponge/foam material that incorporates a video projection of metro images accompanied by recordings of metro noise, he reveals the 'spasm' of the Parisian metro as a symbol of the current social malaise. But, by inviting the viewer into this space, to 'return to the mother's womb', he also proposes a kind of social therapy.

If one can see travel as a metaphor for contemporary Parisian life in Chen Zhen's work, other artists in the exhibition have also explored this theme in both literal and more general ways. Considering his experience in Paris as a 'relais' of continuous displacement between memory and reality, Sarkis has developed his idea of the

'treasure of war' in the video installation, *9 Espaces Mimés* (1997). On nine video monitors covered with red and green satin, he recounts his life's journey as an artist-fighter through hand gestures that mime the 'potentials' of the nine studios, from Istanbul to Paris, in which he has made work since 1959. The nine studios are the satellite spaces of his life and work; at the same time the 'mimes' are an allusion to the mosaic of St Sophia in Istanbul which tells us: 'With the gesture, to bring everything to the scale of the hand.'

The relations between travel, displacement, memory and reality also play an important part in Tsuneko Taniuchi's work. Her project, *My Sentimental Journey* (1997), brings together images of an earthquake in the Japanese city where she grew up with others of marginalised and excluded people in Paris. The slide-projected images, along with sound recordings of conversations and music from different cultures and places, are shown in the intimate atmosphere of a tent, into which visitors are invited. Here, seated on mattresses, the viewer shares in the artist's experiences of travel, along with her inner struggle for identity while memory and reality, natural catastrophe and social disaster are confronting and overlapping each other.

Shen Yuan's work, *San Wu Cheng Qun – In Threes and Fours, Or In Knots* (1997), also focuses on the question of identity – in particular, the identity of an immigrant woman. Drawn to the architectural features of the exhibition space, its windows arranged along one wall like human faces looking outward, she uses hemp fibres to construct huge braids that are fixed to the windows with their ends laying interwoven across the

floor. The image of the braids has a special meaning for an artist from a Chinese background: it is a symbol of woman as well as a sign of 'old China'. And on a more profound level, the braids also represent life itself in traditional Chinese thought.

In a modern capital such as Paris the boundaries between private and public life are constantly changing as the two spheres merge and overlap. The work of Absalon, who until his death in 1993 was one of the most prolific artists working in 1990s Paris, derives from an intense investigation of this issue. His ideal, purified and uniformly white environments are spaces for his own survival in a world where private life and personal identity are continually under threat from the public domain. These architectural, sculptural works are an expression of his ambivalent struggle for a utopia of personal freedom and for social change. The installations in this exhibition, *Cellules* (1990) and *Prototypes* (1990), are among the most remarkable of his oeuvre....

This preoccupation with the relationship between private and public is also shared by Tiina Ketara. However, in contrast to Absalon's refined introspection, her work explores the processes of communication and contact between the individual and the communal. In her photo-installation, *Socks* (1997), she records people's reactions to a pair of socks knitted by her deceased grandmother, compiling a catalogue of absurd and humorous responses to the reality of ageing and death....

In *You and I* (1996), a robot-replica of the artist, she enquires into the relations between public and private, the communication between self and other, as a provocative challenge to the audience and herself. Lying on the floor and equipped with a sound device, the robot asks the audience to come closer and help 'her' stand up. She then speaks of the difficulty of survival and the illusion of reality. It is as if the viewer is presumed to be in direct contact with the artist's body and in direct communication with the artist.... Involved in this conversational process, it becomes clear that communication is unavoidably contradictory and challenging.

An essential concern of contemporary art has been to re-examine and challenge the dominant discourses of art and culture, especially those embedded within institutions. In the Parisian art world, institutional discourses and their influences represent a hegemonic power, and behind it lies an entire 'petit bourgeois' ideology. How to deconstruct such hegemonic power has become one of the most important, urgent tasks for those artists who would pursue genuine creative freedom. Thomas Hirschhorn has developed a whole strategy around resistance to and critique of institutionalised formalism and aestheticism. Underpinned by a wonderful sense of irreverent humour, his work is always provocative, forcing the spectator to face a chaotic, uncontrollable and constantly surprising world, while reflecting on the human condition and the affective power of art. His project for this exhibition, *Record-Jonas* (1997), is a form of 'laboratory', consisting of a long table on which an array of 'unidentified forms' are displayed. A greenhouse-like structure, made of transparent plastic curtains, encloses and defines the space, and details of the 'unidentified forms' are re-presented on video.

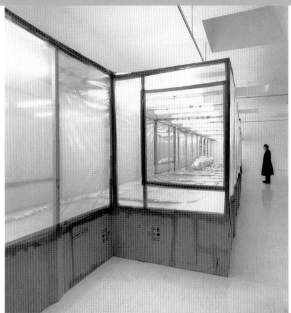

Thomas Hirschhorn, *Record-Jonas*, 1997. Courtesy Camden Arts Centre

As an Iranian Jewish woman in exile, Chohreh Feyzdjou (who died in February 1996 during the preparations for this exhibition) had devised another strategy with which to resist established institutional discourse. She 'recycled' her paintings and objects, transforming them into blackened 'relics', that signified her memories and the common destiny of those in exile. But also by 'naming' these relics 'products of Chohreh Feyzdjou' and selling them in her 'boutique', she symbolically rejected the common notions of 'work of art' and 'exhibition'....

If this exhibition did not directly address the postcolonial question, it would be missing an essential element, since this issue is not only a fundamental aspect of Parisian life but also plays a large part in artistic, cultural, political and economic conditions internationally. As a Chinese artist living in the West, Huang Yong Ping is acutely aware of these conditions and for him the context of London in 1997 is especially significant, bringing into sharp relief colonial history in Hong Kong and its postcolonial reality, as well as referring to the broader picture of British colonialism and its legacy. His new work, *Da Xian – The Doomsday* (1997), is a development in his ongoing critique and deconstruction of Western cultural-political hegemony (one of the most important directions in his extremely rich and powerful body of work). In his work enlarged replicas of porcelain bowls made in the eighteenth and nineteenth centuries by the British East India Company are installed at the gallery entrance and through its foyer. Images of Western concessions in Hong Kong are painted on the bowls and each contains many different kinds of food all labelled 'best before

July 1997' – the date Hong Kong reverts to Chinese rule. The work suggests the coming of the 'doomsday' for colonialism and its myth.

It is here that one can see the exhibition *Parisien(ne)s* not only as a specific project demonstrating a specific Parisian history, but also as an effort to open up a space in which more universal debates about our cultural renovation, which is and continues to be a necessity of life in these times of global migration, can be introduced.

Notes

1 Raymond Williams, *The Politics of Modernism: Against the New Conformists*, London/New York: Verso, 1989, p. 45.
2 The new immigration laws – Les Lois Pasqua – proposed by the French Interior Minister, Charles Pasqua, in 1993, rendered immigration into France more difficult than ever before and changed the notion of French nationality from '*les droits de la terre*' to '*les droits du sang*'.
3 On 18 March 1996, 300 Africans required regularisation of their status as refugees in France. While waiting for negotiations with the government, they were supported by human rights organisations and given shelter in the Eglise St Bernard for two months. The government subsequently refused all negotiations and ordered police to clear the church on 23 August. The event has provoked serious political discussions about 'Les Lois Pasqua' and the question of immigration in France.
4 *La Haine* was the winner of the Prix de la Mise en Scène, Cannes, 1995 and the César du Meilleur Film, 1996.
5 Exhibition held at the Centre Georges Pompidou and Grande Halle La Villette, Paris, France, 18 May –14 August 1989.
6 Homi Bhabha, *The Location of Culture*, London/New York: Routledge, 1994, p. 37.
7 Raymond Williams, op. cit., p. 45.

01

Parisien(ne)s

Parisien(ne)s is an exhibition that was curated by Hou Hanru and organised by inIVA in collaboration with Camden Arts Centre (Camden Arts Centre, London, 1997). Participating artists were Absalon, Chohreh Feyzdjou, Thomas Hirschhorn, Tiina Ketara, Huang Yong Ping, Sarkis, Tsuneko Taniuchi, Shen Yuan and Chen Zhen.

01–02 Shen Yuan, *San Wu Cheng Qun – In Threes and Fours or in Knots*, work in progress, 1997. Courtesy Camden Arts Centre

Overleaf
03 Chen Zhen, *The Spasm of the Metro-Womb*, 1997. Courtesy Camden Arts Centre/Galleria Continua
04 Chohreh Feyzdjou, *Boutique Products of Chohreh Feyzdjou*, 1995. Installed Camden Arts Centre, 1997. Photograph: Dennis Bouchard. All Rights Reserved
05 Huang Yong Ping, *Da Xian – The Doomsday*, 1997. Courtesy Camden Arts Centre
06 Absalon, *Cellules*, 1990. Courtesy Galerie Chantal Crousel, Paris
07 Absalon, *Prototypes*, 1990. Courtesy Galerie Chantal Crousel, Paris

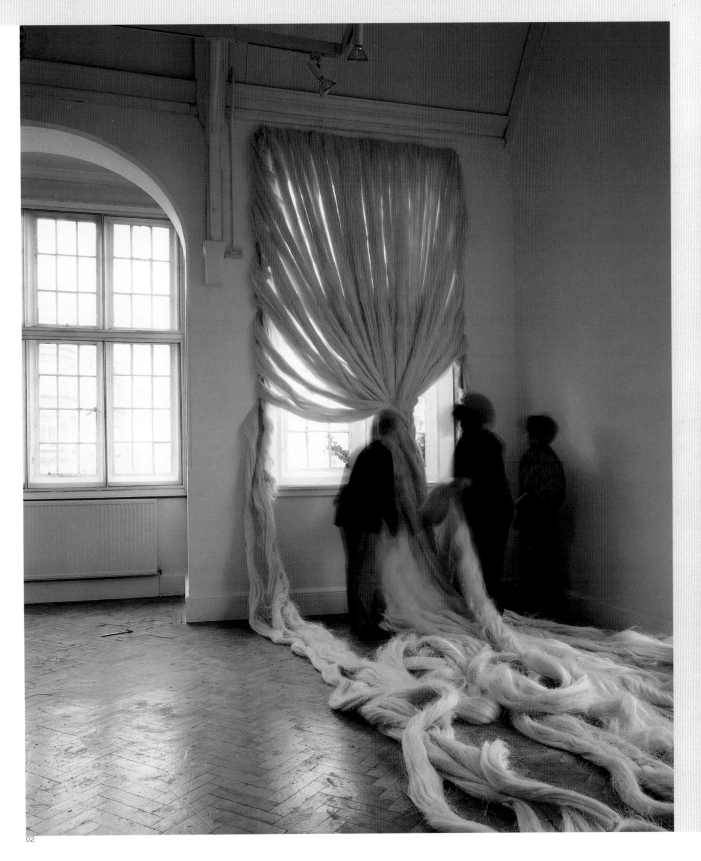

Parisien(ne)s

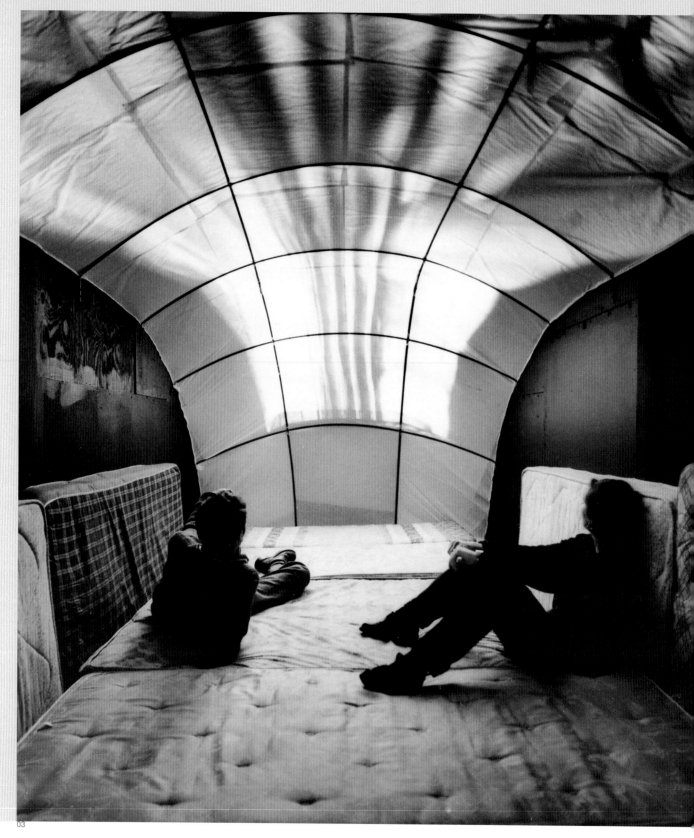

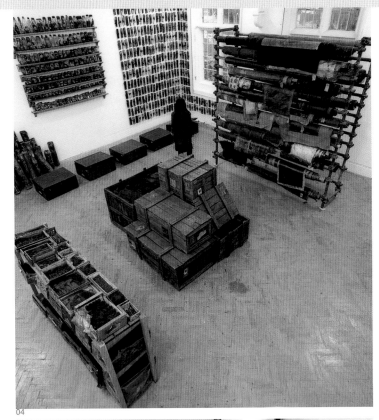

04

05

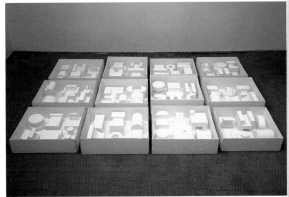

06

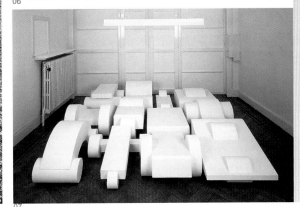

07

We've Also Been to Soweto

Prince Massingham

This short story was first published in *Fault Lines: Contemporary African Art and Shifting Landscapes* (London: inIVA, 2003), a catalogue to accompany an exhibition of the same name, curated by Gilane Tawadros, at the 50th Venice Biennale. The story accompanies the ink paintings of Clifford Charles, providing an insight into the contemporary reality of post-apartheid Johannesburg and the context in which Clifford Charles practises as an artist.

At exactly 9.30am on an oppressive sunny Saturday morning Morena, a *mpinchi* and reformed *gintsa* turned taxi driver whom I hijacked from the local taxi rank in my ghetto, brought the *skaftin* to a screeching halt next to the main entrance of the Witswatersrand University Medical School, Parktown, Johannesburg.

We waited for Rudolf – a Danny DeVito lookalike, Austrian medical student, who was part of a group I took on a tour the previous week – and his four colleagues to take them on a five-hour tour of Soweto with a local dish of chicken stew served with *morogo*, pumpkin, *maxonja*, *chakalaka* and beverages included. Like all tourists, they wanted a firsthand experience of the real *makoya, Msawawa*. In reality, it was an opportunity for Rudolf to collect *ivusa nduku* from Sophie, a local traditional healer, because the main ingredients hadn't been available the past Saturday. He complained to her that his 'main switch' was not functioning well. Shame.

After ten minutes of waiting, Morena spotted an open-air *chisa-nyama* on the pavement and nagged me to buy him a plate of *pap* and steak and a *collie* to wash it down. We both alighted and sauntered to the *chisa-nyama*, where we purchased his order and a 500ml bottled juice for me.

Whilst Morena gobbled his *pap* and steak voraciously, I reflected on the tongue lashing that *Bra* Zakes – a short, fifty-something visual artist and staunch patron of Aunt Lettie's *shebeen* – had given me the previous evening at the cabin. I was busy imbibing the waters of immortality all by myself in the corner, when he suddenly and without any provocation attacked me verbally.

'People like you, my *laaitie*, are a disgrace to the black masses', he said, pointing his index finger at me, 'you should be ashamed of yourself'.

'What have I done *Bra* Zakes?' I asked perplexed.

'You are a sell-out, a black Judas Iscariot.'

'That is a serious allegation, *Bra* Zakes. *Hoe meen jy* I'm a sell-out?' I enquired, still confused.

'You bring these *larnies* to look at our poverty, squalor and *mkhukhus*. Sies! *Uyangi dina*! Tell me! What are your *ngamlas* going to change? *Fokkol*, absolutely nothing. The reason why they come to *Msawawa* is because of sheer curiosity to see how darkies can survive under severe conditions. It is like a visit to a zoo for them and a reassurance that they are better off.'

Suddenly I registered Rudolf tumbling and bouncing towards the *skaftin* like a *diski*, with his colleagues in hot pursuit. *Abo shwee* were sporting different coloured shorts, t-shirts, designer sneakers and eyewear, equipped to the teeth with top of the range digital Minolta and Pentax cameras. Morena, who gallops after everything wearing bloomers, like a chihuahua on heat, was smitten by the ladies.

'*Bheka lo slenda ufana no Julia Roberts*', he said amusingly as we hasten to the *skaftin*.

'*Ja, ufana naye*', I confirmed.

'*Eish, uyangi shaya ding dong*', he said looking at her amorously and rubbing his palms against each other.

'*Hayibo unga zophupa la, si sem sebenzini*', I said.

'Hey *wena* dreams do come true and it is *pashasha* to mix business with pleasure. Just imagine me, Morena, married to a *ngamla*', he bragged.

'Good morning master Prince', Rudolf greeted me folding his hands Buddha-style.

'Good day everybody', I responded. The others mumbled their greetings.

'I brought you tourists. I must become your partner', he said with a broad smile endowing his round face.

'Thanks Dolf', I said opening the sliding door.

Morena and myself exchanged pleasantries with his colleagues. Zwaam. The doors closed and we were on our way to *Msawawa*.

'My name is Prince as you all know and my pilot's name, nodding in Morena's direction, is Morena. It is a Sotho word meaning "king". You should feel very honoured to be chauffeured by royalty.'

'*Kua! Kua! Kua!*' they laughed.

Ah, got them. They at least laughed at my stale joke. Ice broken, I consoled myself.

Our first stop was the old Forte Prison in Braamfontein. 'Guys, this was a former prison called the Forte Prison. It was notorious for its ill-treatment of black prisoners until its closure in the late 1970s. It is now a heritage site. It hosted Nelson Mandela, Mahathma Gandhi and a number of other political prisoners', I explained. While I was explaining to them, my mind went on a fantasy flight to nowhere. I imagined Mandela and Gandhi doing the *tauza* jive to the delight of the warders who were a law unto themselves back then. Just imagine *buntu* two great people jumping up and down *kaalbezozie*.

'Prince, was Gandhi held here?" Barbara asked giving me dagger looks.

'Yes', I answered.

'What was he doing in South Africa?' she continued with her interrogation.

'Gandhi practised as a lawyer in South Africa in the early 1900s, after studying in England, and staged numerous passive resistance marches against the discriminatory laws before he returned to India in 1914. He had his first taste of racism, when he was ordered off a whites-only train coach', I answered.

'Yes! Yes! I saw it in the film *Gandhi*', Rose, the squeaky-voiced Julia Roberts lookalike British woman chipped in.

'Yes you're right', I confirmed.

'I didn't know that he once lived in South Africa', said Barbara startled.

She then conversed in her native *scamto* to Rudolf and her compatriot Johanna, a tall slim, hourglass-figured, oval-faced brunette with big shifty eyes, who did her internship at Baragwanath/Chris Hani Hospital, Soweto, a former military base. Baragwanath is the biggest hospital in Africa. Some argue that it is the biggest in the world. It was at Bara, as the locals affectionately call it, where the greatest number of youths with bullet wounds were arrested by the system during the Soweto uprising.

As we drove through Hillbrow, the place was, as usual, busy like India during rush hour. Taxis and cars were zigzagging through the congested traffic defying road rules. Morena was making full use of the opportunity to impress the *mlungus* with his *kasie* driving skills. *Magoshas*, whose curves were bulging out of their xxx-small miniskirts, and street vendors were enticing potential customers with their wares. Two glue-sniffing urchins standing next to Nandos, a chicken outlet, blew kisses and made indecent movements to the ladies. *Batung!*

'This is Hillbrow, popular for its nightlife, vice and influx of African immigrants. This place is busy twenty-four hours a day. It also housed immigrants from Europe from the early 1900s until the abolishment of the Group Areas Act. White people started moving out when blacks moved in.'

'Is this place safe?' enquired Rose, starry-eyed.

'It is very dangerous if you don't know the place well. There are what we call "no-go areas", which are where a lot of muggings take place.'

'My colleagues who are based at the General Hospital said they get more than four gunshot victims from this place on weekends', she said.

Rudolf also mentioned that they learn to treat gunshot wounds in *Umzansi* because in their countries they seldom treat gunshot victims. Shoo! That means we are a violent country *mos*. I also told them about the pass laws and how black people had to carry and produce that dreadful document at every corner, when confronted by cops. It is the very same document that Mandela and his comrades burnt during the Defiance Campaign in 1960, which resulted in sixty-nine people being shot in Sharpville on the 21 March 1960. I didn't forget to mention the 10pm to 10am curfew. If you were found in town after ten, you had to produce a night pass signed by your employer. Musicians who used to perform at speakeasies for liberal *mlungu* audiences were the main victims of this law. The white cops would make them perform the whole evening at roadblocks.

Jy ken, the hourglass-figured one seemed to be in a state of total paralysis. *Ke a o jwetsa. Mahlo a hae ane ale maholo jwale ka kgomo*. She resembled someone who has seen a *tokoloshe*.

On the M1 south, I showed them mine dunes owned by white mining houses and explained to them that *Mjondolo* was built as a result of the discovery of gold, hence the names *Igoli* and *Gauteng* both meaning 'the city of gold'.

'The sand is being removed to extract gold from it.'

'Prince, can we go and steal the gold', asked Rudolf.

'Yes, you can, but do you have the equipment to extract the gold?' I responded.

'WELCOME TO SOWETO' screamed a board as we approached Baragwanath Hospital. Then we passed the Diepkloof Military Base.

'This is a military base which served as a buffer zone between Soweto. The previously white suburbs and those long grey buildings on your right are the single men's hostels.'

'Are there white people living in Soweto?' asked Barbara.

'No, I don't think any white person would even dream of living or setting foot here. They are still privileged and Soweto is just a big ghetto.'

Morena emitted a loud guffaw, when Barbara asked, 'Is that a nuclear plant?' pointing at the Orlando Power Station.

'That is a former power station. It has existed since the late 1940s and yet Soweto only got electricity in 1982', I explained.

'Who then was it supplying?' asked Johanna.

'The white people', I said.

The *skaftin* became silent like a horror movie. The only sound came from the clicking and clacking of their digital toys, as they were snapping away at the locals who looked at them mysteriously.

Montecasino, Johannesburg.
Photographs: Clifford Charles
and Ramidan Suliman

'Those are four-roomed council houses built by the previous government. The locals call them matchbox houses. The new government is building houses even smaller than those', I said.

'What is the population of Soweto?' asked Barbara.

'It is estimated at five and a half million people.'

'You know', said Johanna, 'I always thought that Soweto was a shanty town. Do you know what a shanty town is, Prince?' she asked. I nodded. 'I'm surprised that people live in nice houses and drive nice cars. Look at that one', she added pointing at a BMW 325i.

'We call that a *Gusheshe*. It means "fast" in the lingua franca of the youth. In Soweto most brand cars have their own township names. For instance a BMW 535 is called *isandla SEM fene*, meaning monkey paw, because its gear lever looks like a monkey's paw. BMW 520is and 518is are called dolphins because of their shapes. The 518i and 520i 1990s models are called g-string due to the shape of their boot and any cabriolet is called *sihlahlamatende*, meaning "throwing the tent backwards".'

We descended on Kliptown, Morena parked and we alighted for a walk through the marketplace. The girls zapped out their cameras and took *kiekies*. The marketplace, which attracts people from Soweto, was an *inqubevange* of activities. The pavements on Union Street were packed with traders selling everything from fresh fruit and vegetables, shoes, live chickens, tripe, trotters and *muti*. Pedestrians and motorists were competing for space on the road.

'This is oldest township in Johannesburg. It was proclaimed in 1904 and the Freedom Charter of the African Nationalist Congress was launched here in 1955.' I was still explaining when a tall petrol attendant with a light complexion called Chopper (in acknowledgment of his egg-shaped head) approached us. Nobody dares call him by his nickname within hearing distance, although he knows it. He asked Barbara, 'Madam could I please take a photo with you?'

'Why not?' she replied.

'I want international photo', he said, winking at me. I volunteered to take the international photo.

'*Uyabon*', he bragged to people passing. '*Ngi posa nabo tegen ase States. Hayi nabo darkie.*'

Gene, a freckled-face coloured man and curator of the photo exhibition at the Kliptown Community Centre *wietied* the group as they browsed through the exhibition viewing photos taken during the launch of the Freedom Charter. The Centre was a disused council building that was renovated and extended to attract tourists during the Earth Summit in 2002. It ceased to attract tourists after the summit. Next to it is a big squatter camp called Angola, where people live in abject poverty with a high rate of both unemployment and HIV/Aids. Storks deliver daily babies infected with *Z3*. Instead of improving the plight of the community, money is spent on attracting tourists. We need to address the issue of *Z3* because some ignorant people believe you can cure yourself by sleeping with a virgin.

We alighted from the *skaftin* in front of Mandela's old house – now turned into a museum – where Winnie Mandela used to sell soil to tourists for twenty dollars. I saw a snot-nosed *laaitie*, who was in goal for a street *diski* game, abandon it when he saw the *mlungus* and bolted like lightning towards us. '*Ngi cela ugu culela*

abelungu?' he asked. He bursts into an impromptu rendition of our trilingual national anthem and spiced it with a Madiba shuffle when the crew started zapping him. He was also well rewarded for amusing them. This is a new phenomenon in Soweto. At tourist sites, groups of children often galvanise into diluted and adulterated African dances, hoping to receive coins.

Our last stop was the Hector Peterson Memorial, where a tour guide totally distorted the history of June 1976, telling the tourists that the students' action was spontaneous. *Ek was in die moer in* and I'm sure Steve Biko and all those who died on that day were turning in their graves. He totally marginalised an organisation that created a consciousness during that period and became an *imbongi* of the popular movement in our country. *HAI SUKA.*

Glossary

abo shwee (slang): the ladies
batung (Sotho): people
bheka lo slenda ufana a ufana no Julia Roberts (Zulu): look at the slender one, she looks just like Julia Roberts
Bra: Brother (abbreviation)
buntu (Zulu): people
chakalaka (slang): hot chilli salad
chisa-nyama (Zulu): place where they sell meat or a plate of porridge and meat
diski (slang): ball
collie (slang): cold drink
eish, uyangi shaya ding dong (slang): she makes me crazy
Ek was in die moer in (Afrikaans): I was very angry
fokkol (Afrikaans, slang): nothing
Gauteng (Sotho): the city of gold
gintsa (slang): car thief
Gusheshe (slang): fast
hai suka (Zulu): go away
hayibo unga zophupa la, si sem sebenzini (Zulu): hey, don't dream, we are at work
hoe meen jy? (Afrikaans): what do mean?
Igoli (Zulu): the city of gold
imbongi (Zulu): praise singer
inquebevange (Xhosa): pot pourri
isandla SEM fene (Zulu): monkey's paw
ivusa nduku (Zulu): aphrodisiac (literally, stiffen the stick)
ja, ufana naye (Zulu): she looks like her
jy ken (Afrikaans): You know
kaalbezozie (slang): naked
kasie (slang): township
ke a o jwetsa (Tswana): I'm telling you
kiekies (Afrikaans): photos
kua, kua, kua: mimicking laughter
laaitie (slang): boy

larnies (slang): white people
magosha (slang): sex worker
mahlo a hae ane ale maholo jwale ka kgomo (Sotho): her eyes were as big as those of a cow
makoya (slang): genuine
maxonja (Tsonga): mopani worm
Mjondolo (slang): Johannesburg
mkhukhus (Zulu): makeshift dwelling
mlungus (Zulu): white people
morogo (Zulu): wild spinach
mos (Afrikaans): affirmation
mpinchi (slang): friend
Msawawa (slang): Soweto
muti (Zulu): herbs
ngamlas (slang): white people
ngi posa nabo tegen ase States. Hayi nabo darkie (Zulu): I'm posing with ladies from the United States of America. Not with darkies
ngi cela ugu culela abelungu? (Zulu): could I please sing for the whites?
pap (Afrikaans): porridge
pashasha (slang): good
Sies (Afrikaaans): Sis
skaftin (slang): Mitsubishi 2000 minibus; lunch box
scamto (slang): talk
shebeen (Scottish): illegal pub
sihlhlamatende (Zulu): throwing the tent backwards
tauza (slang): prisoners had to jump up and down naked to show that they were not hiding anything
tokoloshe: evil spirit
Umzansi (Zulu): South Africa
uyangi dina (Zulu): you irritate me
wietie (slang): talk
wena (Zulu): your
uyabon (Zulu): You see
Z3 (slang): HIV/AIDS.

As part of the Celluloid Cities season, inIVA presented a series of Egyptian cinema posters, curated by Rana Salam, on massive billboards throughout London in June 1999. By re-presenting posters that had been produced using traditional techniques over the preceding two decades, the iconography of Cairo, one of the world's oldest and most dynamic cities, collided with one of Europe's largest and most culturally diverse cities.

Egyptian Cinema Posters

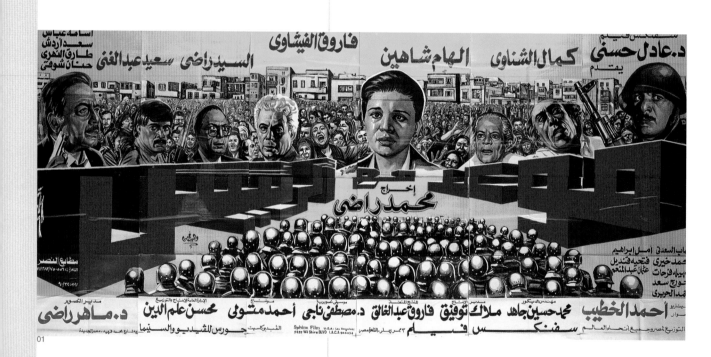

01

01 *Maweed Maa El Ra-ees*
(Appointment with the President), 1988
02 *El-Irhas* (Fear), 1992
03 '*El Maktoufah* (The Kidnapped
Lady), 1985

Overleaf
Wohoush El-Minaa
(The Beast of the Port), 1986

02

03

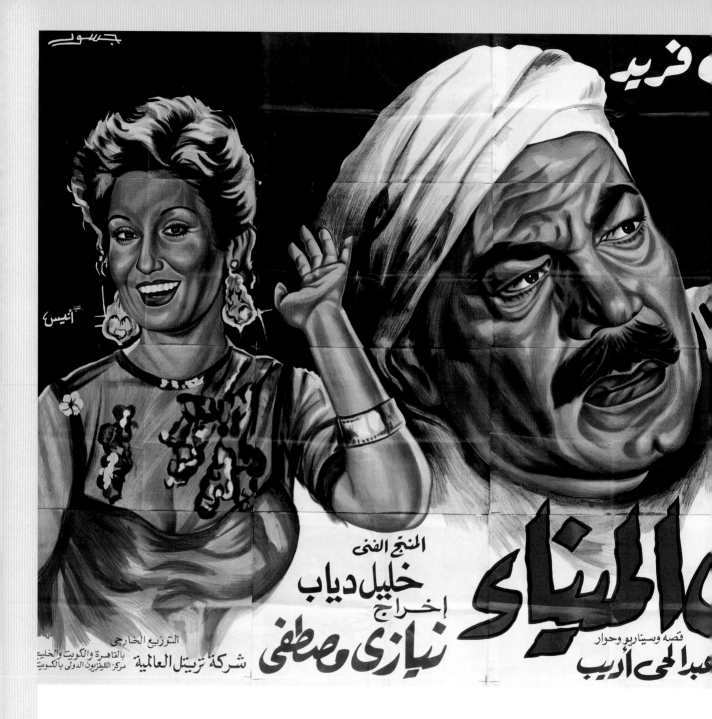

Bangalore

Suman Gopinath

This text was first published by inIVA in the inaugural *Magnet* magazine in 2001, which focused on the theme of 'non-place'. The magazine was compiled by a group of artists and curators from different parts of the world, who established themselves as Magnet; the aim of the group is to produce a field of exchange on a global basis where local differences, can be discussed, confronted and problematised. For the group, 'local' is a word whose meaning changes from place to place and from context to context. Suman Gopinath's contribution to the magazine looks at the particularities of the city of Bangalore and how they affect artistic practice there.

It was the summer of 2001, in London, that the idea for a research project on Bangalore was first talked about. The *Century City* show at the Tate Modern had just opened. Grant Watson, a curator I work with, and I had been to a seminar which accompanied the show. We were asked if we would like to research an exhibition on Bangalore.

'Not as a requiem for a dead city', we were told, 'but instead as an investigation of one of the liveliest and fastest growing cities in Asia.' I was excited, as this would give me a chance to regard critically the city that I have always lived in, but, like all things familiar, never thought much about. The two of us spent time meeting artists, designers, architects and academics – we talked to them about our research and came up with the idea of commissioning a broad range of people to respond to the city in relation to their particular field.

It was about the same time that our group – Magnet – decided to address the notion of non-place as the theme for our journal. In my attempt to define this concept I saw the new Bangalore as a location for both place and non-place. Material from our research on the city could perhaps provide an entry into a whole new area – that of non-place.

Bangalore is roughly four centuries old. Kempagowda, the founding father, put up four towers in the cardinal directions to show what he thought would be its limits. I, like other Bangaloreans, had read this story as a child. Although there was a distinct divide between the local town and the British cantonment set up for the troops in the nineteenth century, the two were administratively united in 1949.

Up until the 1970s, Bangalore was quiet, middle-class, laid back in character, remarkable for its moderate climate, trees and gardens. The most common descriptions I seem to remember were either 'Pensioners' Paradise' or 'Garden City'. All this changed dramatically in the late 1990s with economic liberalisation. Large multinationals and Infotech industries brought an inflow of global money into the city. The result: unbelievably high salaries, inflationary prices and high levels of consumption.

At the turn of the century, the population of the city stands at over 5.5 million while the urban area covered has grown from 66 square kilometres to about 450 square kilometres, leaving Kempagowda's towers somewhere in the centre! Bangalore flourishes today as a service industry and will continue to do so as long as it proves cost effective for the global players. However, the shift to the fast track has changed the urban fabric of the city entirely. The *Lonely Planet* guide describes Bangalore as:

> The capital of Karnataka State... a thriving modern business centre, dubbed the Silicon Valley of India whose gracious garrison features are being remodelled in the image of India's mall-loving middle class.... Its stark contrast with the rest of the state is evident in the MG Road area where fast food joints, yuppie theme bars and glitzy malls are all the rage.

The city has begun to reinvent itself but in the process has created an environment that is divorced from its people and context.

In search of signs of the Silicon Valley, Grant and I visited the Singapore-like IT park in Whitefield, Bangalore. A mammoth cylindrical structure of concrete and glass, cloned from Singapore's sanitised architectural patterns, it jostles with its semi-urban surroundings. It was hard to get permission to enter this place, which is essentially a no-go area for the general public. Once inside, we walked through its air-conditioned corridors, its malls and food courts that emulate those other non-places – five star hotels. We visited an office where the receptionist was sitting against wallpaper depicting a New England autumn, as Mozart played in the background. This surreal feeling of placelessness was broken by something that connected us back to more familiar sights – a group of chauffeurs taking a nap on the well-manicured grass and gardens of the park after lunch!

The language and nomenclature of the city is morphing. A roll call of the names of the growing suburbs reflects the changing consciousness of the people. Earlier, areas were known by the names of national heroes, religious icons or the public sector industries that promoted them: Indiranagar, ITI Colony, Basavanagudi. Today, swank developments go by the names of 'Dollar Colony' and 'High Income Group Layout' – leaving nothing to the imagination nor a need for recall. Flyovers and roads have appeared all over the place to connect the ever-growing communities of people who make huge demands on the availability of land.

And yet for all its rapid urbanisation, Bangalore's development as a city has remained piecemeal. Unplanned growth has led to the city engulfing villages;

though absorbed by the city, many of them continue their self-contained existence relatively independent of the commercial centre. This proximity of the rural to the urban doesn't always make for a tension-free existence but it does provide the space for two completely different lifestyles to continue side by side.

But how does this scene which I have been describing impact on artistic practice. Sheela Gowda addresses some of these issues in her work *Private Gallery*, made in 1998–99 for a group show called *Tales of 6 Cities*. This work reflects Gowda's perceptions as an artist living in Bangalore City and working on the periphery, where the borders between the urban and the rural are blurred. *Private Gallery* is a room (1.5 x 1.5 m) made of a synthetic wooden veneer that looks like a large sculptural piece from the outside. On the inside, it is made up of two panels fixed perpendicular to each other (2 x 1 m), dotted with cowdung pats and paintings.

The first response to the work is sensory, an overwhelming awareness of the smell of cowdung, coupled with the discomfort of feeling hemmed-in. Gowda uses the three genres of painting – still life, landscape and portraiture – to allude to different aspects of the city. The images of Bangalore that she evokes through these are Bangalore as the 'Garden City', the fast growing metropolis and as a space where the urban and rural coexist. The last is suggested in the rough portraits of some of the people she knows from this milieu.

On a formal level, the work situates itself somewhere between painting, installation and performance, while in a very literal sense, in her choice of materials – the artificial veneer and cowdung – the work can be read as the coexistence of the pseudo-modern city with the

Bangalore, 2001.
Photographs: Grant Watson

village. Gowda doesn't see this as derogatory but rather as a positive sign of resistance.

Historian Janaki Nair who is currently writing a book on Bangalore, sees these signs as hope for the city. The metropolis, she says, is not just a place where people live but a space founded on contests, pain, loss, dispossession, negotiation and violence. She suggests that for every attempt to render 'place' into 'space' there lies a struggle, which we in our context may call the operation of democracy.

Through this investigation of Bangalore City I found that for me the word 'place' is suffused with meaning; it is linked with collective and individual history, memory, experience. Alternately, the word non-place is not denuded of meaning but suggests 'a sense of place'. A place that has been transformed into a space with no familiar associations, that is not linked to tradition, context, local resources or people. When translated into physical terms, in terms of the city, it suggests a place where vernacular traditions of architecture are fast giving way to the demands of the realm of the urban non-place.

It remains a matter of speculation if Bangalore can withstand the onslaught of urbanisation or if it will succumb and be transformed into a global, homogenised non-place.

The New Frontier
A WELCOME BENEATH THE SILICON SUN FOR YOU & YOUR FAMILY

Keith Piper

Since the early 1980s, when black British artists were declaring a radical voice in Britain, Keith Piper's work has sought to interpret powerfully the iniquities and struggles of black diaspora experience. In 1997, inIVA produced a multimedia exhibition of Piper's work, together with a monograph and CD-ROM entitled *Relocating the Remains*, as well as a website. The exhibition opened at the Royal College of Art in London in July 1997 before touring to the Ikon Gallery, Birmingham, and the New Museum of Contemporary Art, New York. This was the first integrated multimedia project of its kind in the contemporary visual arts in Britain.

01–05 Stills from *Relocating the Remains* CD-ROM, 1997

YOU ARE
TRESPASSING
IN CYBERSPACE

WE EXPECT YOU TO STEP THE FUCK B

02

ENTER

BEWARE OF LOW
FLYING JARGON
& INSIDERSPEAK

03

Keith Piper

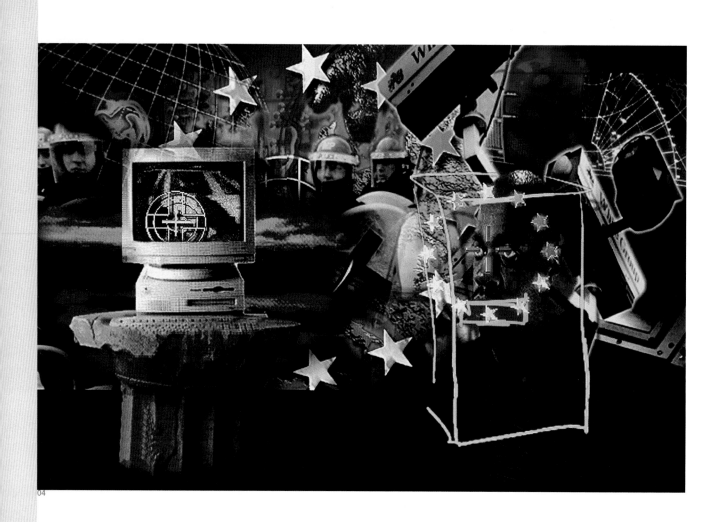

04

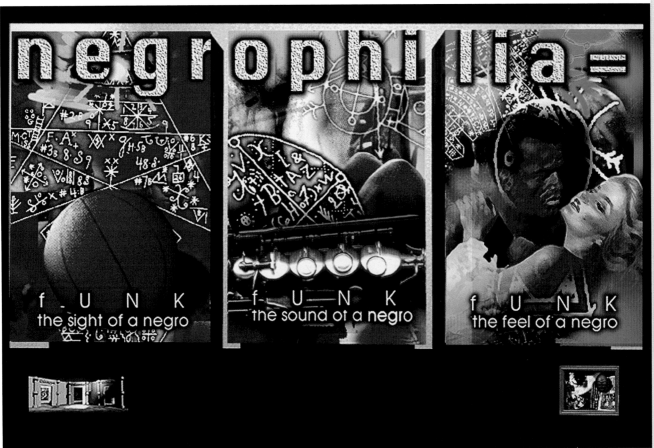

Keith Piper

A Nigger in Cyberspace

Keith Piper

One of the themes that Keith Piper's work addresses is the impact of new technologies on surveillance and policing, particularly in relation to notions of community, nation and difference. In this essay, first written in 1993 and published on the CD-ROM *Relocating the Remains*, Piper compares the physical and social landscape of the city with the parallel landscape of Cyberspace.

I was struggling to envisage a Rodney King computer game.

Initially, one would be confronted with an interface asking you to choose one of two options, to be a Controller or to be a Transgressor. However, in response to your privileged position as custodian of the system, the role of Controller is set as a default, whilst Transgressor is ghosted and inactive.

As the game opens on the first level you are alerted to the fact that your system has been infiltrated by a rouge 'virus', which you perceive to be crammed with transgressive algorithms. The 'virus' is moving at high speed along a communications bus, and you fear for the security of the cherished resources and privileged information stored in discrete locations elsewhere in the system. In response to this perceived threat you dispatch a series of devices programmed to 'protect and serve' and this level of the game develops into a scenario of cat and mouse. The object of the game at this point is to apprehend the 'virus' and return it to the part of the system which has been labelled the 'trashcan', a location within which all redundant, inconvenient, unsightly and transgressive elements are deposited, out of sight and out of mind. Once the 'virus' has been apprehended, this stage of the game is complete, and you are at liberty to move on to the second level.

The second level of the game borrows elements from 'Street Fighter II'. However, as the Controller you have up to eight agents at your disposal, arrayed against the single Transgressor. The object of the game is to determine an adequate response to transgressive gestures on the part of the 'virus'. If, for instance, the virus raises itself to an angle of twenty degrees or greater, you are presented with a choice of options ranging from administering a swift blow to the side of its head with a long handled baton, shocking it with a electrified prod, or placing your heel on to the back of its neck. This stage of the game is over when the 'virus' either assumes a position of absolute passivity, or lapses into unconsciousness.

On the third level of the game, you are confronted by the uncomfortable knowledge that the tactics employed on level two have been scrupulously logged in the system's memory and you are called upon to defend your choice of responses as measured against the perceived threat to the system posed by the transgressive 'virus'. If you succeed on this level, if you are able to create an argument which sufficiently demonises the transgressive 'virus' and amplifies the danger which it potentially posed to the continued smooth running of the system, then you are at liberty to play another game.

The first time the game was played, however, the logic broke down and transgressive viruses flooded out of the trashcan crashing the entire system.

Half a decade on, a Rodney King computer game may represent a marketing flight of fancy, but it does provide us with a convenient metaphorical entry point into a wider set of debates. It provides us with a recognition that we are currently entering a scenario in which we are coming to occupy two parallel landscapes, separate but inextricably linked. Both are sites across which a range of contests of territory are being played out in earnest and, within these contests, we have all become both players and the played.

The first of these landscapes is the physical and social landscape of the city, both as an conglomeration of disparate neighbourhoods, and as key locus in a complex web of regional, national and international networks. The second is the parallel landscape which has come to be known as 'Cyberspace', the intricate and inextricably expanding universe of digital data; the 'virtual' spaces which it occupies and the channels through which it is disseminated.

Both of these landscapes historically came to be identified in modernist discourses as sites across which the optimism and opportunity afforded by the inextricable forward march of technology would inevitably bear their finest fruit. The city would become an arena replete with the technologies of economic, material and social enablement and recreation, and within this scenario of a brave new world, computer-based technologies would play a key role. The new citizen of the high-tech metropolis (the Technotropolis) would be at liberty to delve into Cyberspace at will, tapping into information networks and structuring lifestyles around the logical interaction between commerce, productive labour and entertainment.

The historical events surrounding the beating of black motorist Rodney King, the acquittal of the police officers who had been caught on video tape administering the beating and the subsequent rioting which gripped Los Angeles provide a symbolic point of dislocation, a key indicator marking the final and inextricable abandonment of any previously held scenarios of optimism.

Instead, what emerges is the notion of the 'dislocated city'. What emerges is a vision of the contemporary 'city' as a dislocated jigsaw of isolated and antagonistic communities entrenched within balkanised neighbourhoods. Disintegrating communications systems along with the entrenchment of privilege and disenfranchisement have not only created a dangerously volatile underclass, but also a disjuncture between the language systems with which these dislocated communities conceptualise the world around them. It is this chaos of language, this inextricable fragmenting of a 'common sense' which led the Simi Valley jury in the Rodney King beating trial of 1992, to accept the logic which framed excessive force on the part of the police officers as a justifiable protective measure. After all, these were individuals who had enlisted to guard the boundaries of those neighbourhoods of plenty, of good order and accumulated privilege from incursion by outsiders. The 'outsiders' being individuals from those other neighbourhoods: neighbourhoods of poverty, chaos and bedlam; neighbourhoods of the racial 'other'. These were their front line troops in the contest of territory between white wealth and the numerical expansion of black and other 'Third World' peoples. Here was a key point of struggle in the battle against the inextricable 'Africanisation' of the city. This language and the logic which underpinned it were lost on those black and 'Third World' folks and for three days the city burned.

The metaphor touched upon within the scenario of the Rodney King computer game which identifies the black as a rouge virus, as a conglomeration of transgressive algorithms whose presence must inextricably disrupt the smooth running of any

system which it infiltrates, is useful only to the extent to which it parodies white racist discourses which frame the black as the cause rather than victim of urban depravation and decay.

The wider issues, however, around the particular in-roads and struggles for the visibility of a black theoretical and aesthetic presence within Cyberspace, and the sense to which it parallels the various struggles around black visibility and presence across the landscape of the postmodern city is of particular interest to us here. This is very much a contest of territory, a struggle around the colonisation of Cyberspace by various constituencies, and within this colonisation, a series of eclectic and expansionist 'Africanised' enclaves are emerging. These 'Africanised' presences are transgressive to the extent that the 'founding fathers' of Cyberspace very much replicated the social and economic interests of the enfranchised white status quo, and within their 'brave new world', as in the landscape of the affluent city, the black presence would always be a trespassing one. It is however the extent to which the black presence in Cyberspace uses its transgressive and trespassing nature as a tool of tactical engagement and struggle which I shall go on to explore in this text.

Transgressive behaviour has been a feature of Cyberspace since close after its inception. The so-called computer 'hacker', a technically literate data burglar, ensured an early entry into the lexicon of digital demonology, presenting himself as the swashbuckling scourges of the banker and the information manager. The image of the 'hacker' seemed to hover in the space between the rouge and disgruntled digital professional – using his insider knowledge of systems' architecture to roam Cyberspace at will – and the adolescent digital prodigy launching raids from a computer rig cobbled together amidst the clutter of an untidy and unventilated bedroom. Such an individual was conjured into celluloid life in the John Badham film *War Games* (1983) which sees a teenage boy hack his way into a military mainframe computer in order to play a game of 'thermonuclear war'. What becomes interesting about such characterisations is that the hacker is firmly located against a backdrop of middle-class white America. Whilst this may in fact be an accurate reflection of the background of progressive generations of digital technocrats and while the path from teenage hacker to corporate new technology yuppie may indeed be a well-trodden one, it has the net effect of recreating Cyberspace as a domain peopled exclusively by clever white males.

Moral panic around the dangers of allowing young people to immerse themselves into a Cyberspace universe as threatening as any inner city no-go area, replete with violent games and corrupting pornography has now become another favoured *cause célèbre* of the British tabloid press.... It is interesting therefore to begin to examine how various aspects of black visibility, so often characterised as an almost essential cipher in the recasting of a space into a site of dangerous and transgressive activities have impacted upon the universe of Cyberspace.

With a few notable exceptions, the world of new technology has succeeded in projecting an image which either sees the black as placed outside of its domain, as being literally 'other', or frames the black as the

'subject' of the high-tech gaze. The so-called 'Third World' for instance, the world of underdevelopment and poverty, is seen very much as a pre-technological space. Its dark skinned peoples are characterised within the Western gaze as being unconscious to any notion of a digital realm of logic, development and privileged knowledge....

Their other potential interaction with Cyberspace would come only if they ever attempted to trespass into the so-called 'First World'. The perceived threat of the migration of peoples from the poor South into the industrialised centres of Europe and North America have resulted in an unprecedented escalation in investment in new technology as a means of monitoring and controlling their movements. At every port of entry, Cyberspace forms an invisible but all pervading barrier, scrutinising potential migrants and adding high-tech refortification to the fortresses of economic privilege which are now Europe and North America.

It is within the boundaries of the so-called 'First World', however, that the perception of the black as being either outside technology or passive subject of the technological gaze comes under its severest strain. Although often celebrated as the occupant of a more intuitive, physically reflexive space, a space in touch with the body, as opposed to the cerebral, coldly logical and physically detached space of new technology, the black presence has marked out a whole set of terrains in Cyberspace as sites of contest with the enfranchised status quo. Principal amongst these sites has been the terrain of new technology and music. In the track 'Caught, Can I Get a Witness!' rap group Public Enemy explore the legal minefield opening up around copyright ownership and the re-appropriation of black creativity through the use of the digital sampler as an act of political defiance.

> I found this mineral that I call a beat
> I paid zero
> I packed my load 'cause it's better than gold
> People don't ask the price, but it's sold...

The power which new technology gave to plunder the previously sacrosanct world of copyright ownership (the copyright of much popular music being in the hands of the record company as opposed to the artist) represented a major transgressive threat to the music recording establishment, initiating a form of digital looting. The realisation that the technology also allowed production capabilities, which were formally the exclusive domain of the enfranchised, to become available to individuals to use in their bedrooms redoubled its transgressive potential. The fact that the resultant musical movements of rap, house and acid house were all the products of the democratisation of Cyberspace and represented a significant creative entry into that technological domain by young black people is noteworthy. The recognition that around all of these movements has gathered a smokescreen of media demonology and hysteria – from panic around the violent, political and sexual lyrical content of rap to the spectre of British riot police storming 'illegal' acid house 'raves' – is testimony to the transgressive potential afforded by the colonisation of these spaces by black and black-derived cultural activities.

The key issue here is one of control. The contest has always been between those agencies which need to preserve Cyberspace as a tightly structured domain where information can be organised and accessed by the privileged and by so doing reinforce their control over the physical landscape of the city and the nation state, and those who find themselves the subject of that control.

In this sense I would argue that the enthusiasm on the part of Cyberspace insiders for so-called 'interactivity' has to be placed in perspective. True 'interactivity' – in the sense for example that African cultural forms have always displayed interactivity, allowing an unpredictable and intuitive interaction between presenter and spectator – would represent an anarchic nightmare to the enfranchised controllers of Cyberspace. The listeners' intervention into the griot's account, the traditions of 'call and response' in black cultural events and, more recently, the 'scratch, cut and paste' of some contemporary black music where the DJ is able to intervene with the received pre-recorded disc, creating a new 'interactive' collage of sound are all at odds with the artist and audience scenario of Western 'high culture'. Within this scenario one is presented with the work of the gifted 'maestro' as fixed and eternal. As the audience you are asked to spectate passively and applaud at the end, using a fixed set of expressive gestures....

Despite the fascinating progress towards user definable interactive tools as seen within the work of organisations such as 'AntiRom', it remains clear that many of the digital products presented as 'interactive' remain in many cases, by necessity, tightly structured matrixes through which one is allowed to navigate only along preordained pathways to a set of fixed destinations. In the case of many 'issue-based' or educational products, it must be acknowledged that a set range of destinations logically remains the very point of the exercise. However, in a broader sense it could be argued that many 'interactive' products become models (or at best parodies) of the orderly city of which the power structure has dreamed but failed to realise. As a pedestrian in this orderly city, one can only proceed along predetermined roadways, turning left, right or straight ahead at set junctions.

Within the truly interactive city on the other hand, the unruly pedestrian could jay-walk and trespass, cutting across wasteland and leaving graffiti on hallowed walls. Worse (or better) still, such a pedestrian could force a path through or over those walls and help him or herself to the treasured resources beyond. This becomes the interactive domain as riot zone with the user not as orderly citizen but as digital looter, disorderly and anarchic. Within this zone, treasured and privileged resources are redistributed and exclusive spaces are democratised. It is within this nightmare scenario for the controllers of Cyberspace that the digital equivalent of the disorderly black of urban chaos and transgressive behaviour steps into full visibility. It is at this symbolic point that Cyberspace changes from a sterile zone at the service of the establishment into a free domain within which everyone becomes at liberty to seize a portion of terrain and reshape it to their individual needs.

How are artworks shaped by the place in which they are made? How can architecture embody the lived experiences of the people who will occupy it? How can art reflect the ways that we travel between different geographical spaces, both physically and emotionally? These are the kinds of questions that have preoccupied many contemporary artists, architects and thinkers. In their work, they explore the notion of site as a physical location – the marker of a specific place – but also site as origin and identity – the space that helps define who you are. The built environment reflects our dreams of the future as well as our nostalgia for the past. The places where we live and the spaces that we travel between embody both our nightmares and our desires.

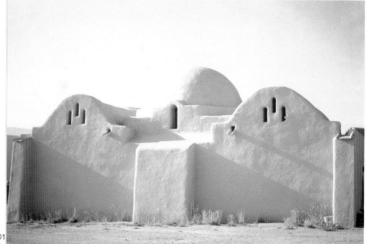

01

Hassan Fathy

The most renowned Egyptian architect of the twentieth century, Hassan Fathy combined his passionate engagement with local building traditions with a global mission to improve living conditions for the poor. His tireless engagement with vernacular architecture and his lyrical interpretation of Egyptian architectural traditions won him international acclaim. His work was shown at *Fault Lines: Contemporary African Art and Changing Landscapes*, an exhibition curated by Gilane Tawadros at the 2003 Venice Biennale.

01 Hassan Fathy, Dar al-Islam
Village, Abiquiu, USA, 1980s.
© Aga Khan Trust for Culture
02–03 Hassan Fathy, New Baris
Village, Kharga, Egypt, 1967.
© Aga Khan Trust for Culture

Overleaf
04–05 Hassan Fathy, Stoppelaere
House, Luxor, Egypt, 1950.
© Aga Khan Trust for Culture
06–08 Hassan Fathy, Development on
the northern shore at Sidi Krier, Egypt,
1971. © Aga Khan Trust for Culture

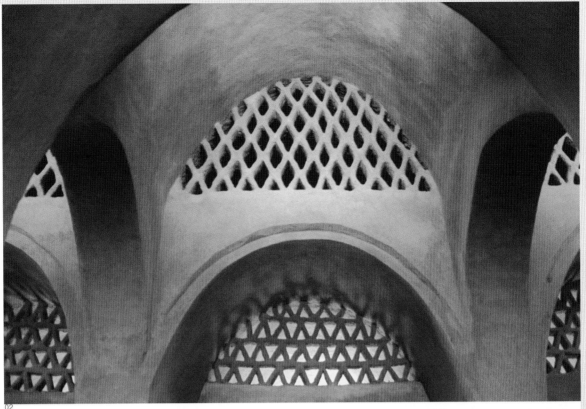

02

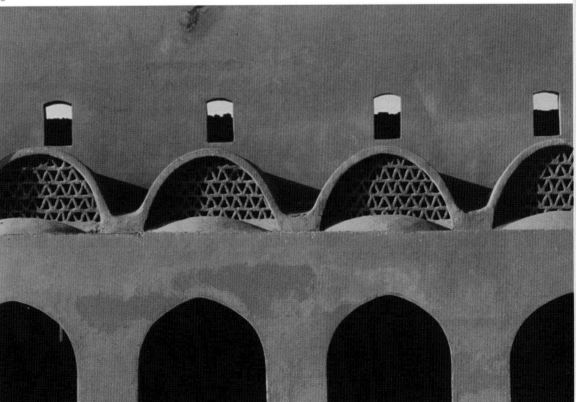

03

Hassan Fathy

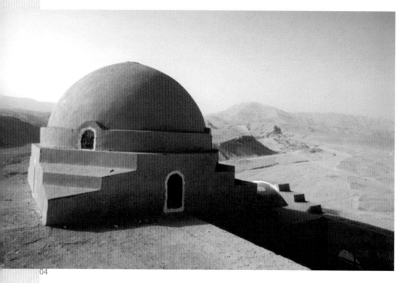

04

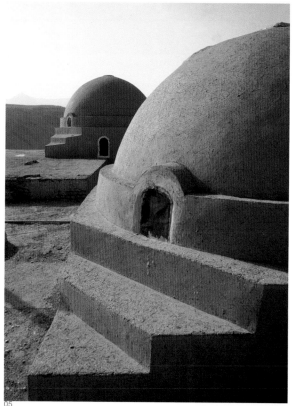

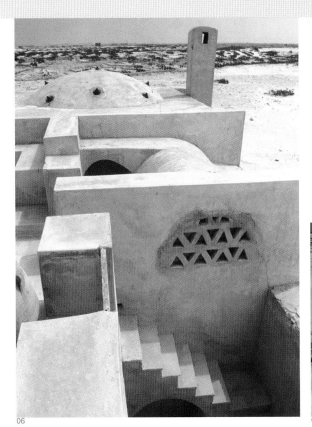

06

07

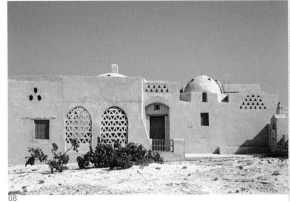

08

Hassan Fathy

Architecture for the Poor:
An Experiment in Rural Egypt

Hassan Fathy

Extracts from Hassan Fathy's *Architecture for the Poor* (Chicago: University of Chicago Press, 1973, pp. 1–26) were reprinted in *Fault Lines: Contemporary African Art and Changing Landscapes*, the catalogue to an exhibition of the same name at the 2003 Venice Biennale. The text describes how the architect redeployed traditional Nubian building techniques to solve the problem of inadequate housing for the poor in modern Egypt.

Paradise Lost: The Countryside

The country, the place where the fellaheen lived, I had seen from the windows of the train as we went from Cairo to Alexandria for the summer holidays, but this fleeting experience was supplemented by two contrasting pictures, which I had got respectively from my father and my mother....

These two pictures combined in my imagination to produce a picture of the country as a paradise, but a paradise darkened from above by clouds of flies, and whose streams flowing underfoot had become muddy and infested with bilharzia and dysentery. This image haunted me and made me feel that something should be done to restore to the Egyptian countryside the felicity of paradise. If the problem appeared simple to me at that time, it was because I was young and inexperienced, but it was and is a question that has occupied the greater part of my thoughts and energies ever since, a problem whose unfolding complexity through the years has only reinforced my conviction that something should be done to solve it....

After I graduated I went one day to supervise the building of a school at Talkha.... The town haunted me; I could think of nothing but the hopeless resignation of these peasants to their condition, their cramped and stunted view of life, their abject acceptance of the whole horrible situation in which they were forced to put up with a lifetime's scrabbling for money amid the wretched buildings of Talkha. The revelation of their apathy seized me by the throat; my own helplessness before such a spectacle tormented me. Surely something could be done?

Yet what? The peasants were too sunk in their misery to initiate a change. They needed decent houses, but houses are expensive. In large towns capitalists are attracted by the return from investment in housing, and public bodies – ministries, town councils, etc. – frequently provide extensive accommodation for the citizens, but neither capitalists nor the state seem willing to undertake the provision of peasant houses, which return no rent to the capitalists and too little glory to the politicians; both parties wash their hands of the matter and the peasants continue to live in squalor.... Their state is shared by millions in Egypt, while over the whole of the earth there are, according to the UN, 800,000,000 peasants – one third of the population of the earth – now doomed to premature death because of their inadequate housing....

Mud Brick – Sole Hope for Rural Reconstruction

Surely it was an odd situation that every peasant in Egypt with so much as an acre of land to his name had a house, while landowners with a hundred acres or more could not afford one. But the peasant built his house out of mud, or mud bricks, which he dug out of the ground and dried in the sun. And here, in every hovel and tumbledown hut in Egypt, was the answer to my problem. Here, for years, for centuries, the peasant had been wisely and quietly exploiting the obvious building material, while we, with our modern school-learned ideas, never dreamed of using such a ludicrous substance as mud for so serious a creation as a house. But why not? Certainly, the peasant's houses might be cramped, dark, dirty and inconvenient, but this was not the fault of the mud brick. There was nothing that could

not be put right by good design and a broom. Why not use this heaven-sent material for our country houses? And why not, indeed, make the peasants' own houses better? Why should there be any difference between a peasant's house and a landowner's? Build both of mud brick, design both well, and both could afford their owners beauty and comfort....

Nubia – Survival of an Ancient Technique of Vaulting
It was a new world for me, a whole village of spacious, lovely, clean and harmonious houses, each more beautiful than the next. There was nothing else like it in Egypt; a village from some dream country, perhaps from a Hoggar hidden in the heart of the Great Sahara – whose architecture had been preserved for centuries uncontaminated by foreign influences, from Atlantis itself it could have been. Not a trace of the miserly huddle of the usual Egyptian village, but house after house, tall, easy, roofed cleanly with a brick vault, each house decorated individually and exquisitely around the doorway with claustrawork – mouldings and tracery in mud. I realised that I was looking at the living survivor of traditional Egyptian architecture, at a way of building that was a natural growth in the landscape, as much a part of it as the dom-palm tree of the district. It was like a vision of architecture before the Fall: before money, industry, greed and snobbery had severed architecture from its true roots in nature....

I was getting more and more confirmation of my suspicions that the traditional materials and methods of the Egyptian peasant were more than fit for use by modern architects, and that the solution to Egypt's housing problem lay in Egypt's history....

A Tomb Robbery Begets a Pilot Housing Project
The village of Gourna is built on the site of these Tombs of the Nobles. Here there are very many graves, some known, cleared, and cleaned, and some still unknown to the department and consequently full of objects of great archaeological interest.

There are seven thousand peasants living in Gourna crowded into five clusters of houses, built over and around these tombs. Seven thousand people living quite literally upon the past. They – or their fathers – had been attracted to Gourna some fifty years before by the rich graves of their ancestors, and the whole community had ever since lived by mining these tombs....

This robbery caused such a stir that the Department of Antiquities had to take some positive action over the problem of Gourna. There was already a royal decree expropriating the land on which the Gournis' houses were built and annexing the whole area of the necropolis to the government as public utility land. This decree gave the Gournis the right to continue using the existing houses, but prohibited any further additions or extensions. So now another ministerial decree had to be issued expropriating the houses too, with the intention of clearing the whole antiquities zone of its undesirable squatters....

The only solution was to rehouse them, but hitherto this had been far too expensive a proposition. One million pounds was the estimate for an exactly similar village which was being built for the workers at Imbaba, just outside Cairo. It was then that my buildings came to the notice of the Department of Antiquities....

They had seen my two examples of mud brick building, the houses for the Royal Society of Agriculture

Hassan Fathy, *Gourna, Plan and Elevation with Hathor*, 1948. Photograph: Philippe Maillard. American University of Cairo Collection, Rare Books and Special Collection Library. Courtesy Aga Khan Trust for Culture

and the house for the Red Crescent, and had been impressed alike by the potentialities of the material and the low cost of using it. Accordingly Drioton came to see these buildings and approved the suggestion, with the result that I was granted leave of absence from the School of Fine Arts for three years to build a village. So I was going to fulfil my childhood wish – I hoped somewhat more cheaply than for L.E.1,000,000....

Birth of New Gourna – The Site

However attractive may have been the project of at last building a whole village, it was also somewhat daunting to be presented with fifty acres of virgin land and seven thousand Gournis who would have to create a new life for themselves there. All these people, related in a complex web of blood and marriage ties, with their habits and prejudices, their friendships and their feuds – a delicately balanced social organism intimately integrated with the topography, with the very bricks and timber of the village – this whole society had, as it were, to be dismantled and put together again in another setting....

Architectural Character

Every people that has produced architecture has evolved its own favourite forms, as peculiar to that people as its language, its dress or its folklore. Until the collapse of cultural frontiers in the last century, there were all over the world distinctive local shapes and details in architecture, and the buildings of any locality were the beautiful children of a happy marriage between the imagination of the people and the demands of their countryside.... It follows, too, that no one can look with complacency upon buildings transplanted to an alien environment.

Yet in modern Egypt there is no indigenous style. The signature is missing; the houses of rich and poor alike are without character, without an Egyptian accent...

Tradition's Role

Architecture is still one of the most traditional arts. A work of architecture is meant to be used, its form is largely determined by precedent, and it is set before the public where they must look at it every day. The architect should respect the work of his predecessors and the public sensibility by not using his architecture as a medium of personal advertisement. Indeed, no architect can avoid using the work of earlier architects; however hard he strains after originality, by far the larger part of his work will be in some tradition or other. Why then should he despise the tradition of his own country or district, why should he drag alien traditions into an artificial and uncomfortable synthesis, why should he be so rude to earlier architects as to distort and misapply their ideas? This happens when an architectural element, evolved over many years to a perfect size, shape and function, is used upside down or enlarged beyond recognition till it no longer even works properly, simply to gratify the architect's own selfish appetite for fame....

When an architect is presented with a clear tradition to work in, as in a village built by peasants, then he has no right to break this tradition with his own personal whims. What may go in a cosmopolitan city like Paris, London or Cairo, will kill a village.

01

Avtarjeet Dhanjal

In summer 1997, inIVA published a monograph on the artist Avtarjeet Dhanjal to coincide with a solo exhibition of his work at Pitshanger Manor and Gallery in London. Dhanjal's work draws heavily on his experience of Indian aesthetic traditions, blending them with the influence of European, and specifically British, modernist sculpture. In his sculptures, Dhanjal makes brilliant use of man-made materials, seeking out their relationship to natural materials, such as weathered rocks and soil.

01 Avtarjeet Dhanjal, *Open Circle*,
1984–85. Photograph: Jerry Hardman-
Jones
02–04 Avtarjeet Dhanjal, *Aluminium
Series*, 1974
05–06 Avtarjeet Dhanjal, *Stone
and Aluminium Series*, c. 1981–82.
Photographs: Jerry Hardman-Jones

Overleaf
07 Avtarjeet Dhanjal, *Slate Series*,
1996–97. Photograph: Jerry Hardman-
Jones
08 Avtarjeet Dhanjal, *Upper Level 1*,
1984–85. Photograph: Jerry Hardman-
Jones

02

03

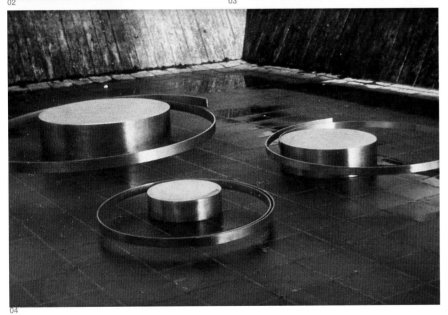

04

05

06

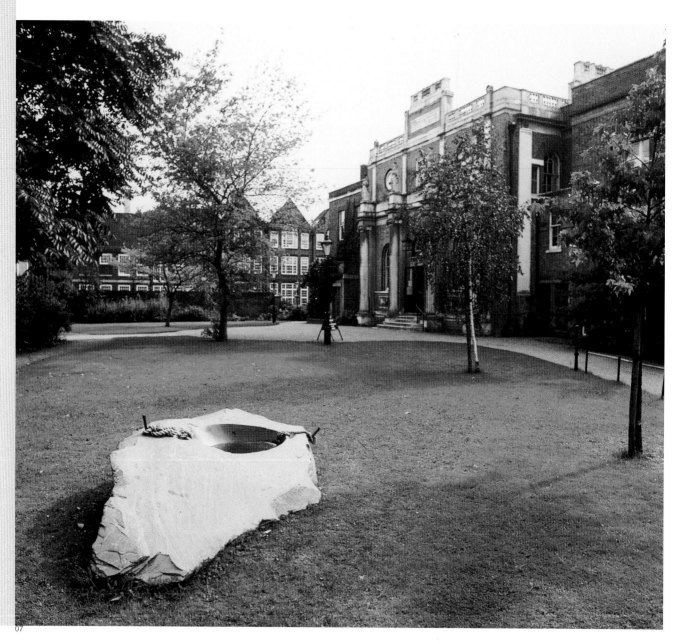

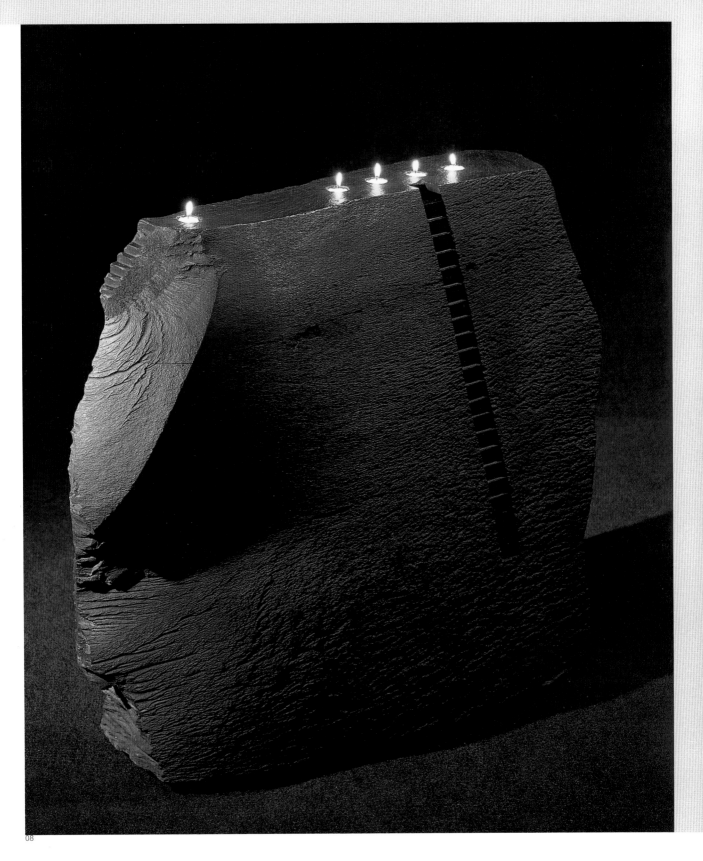

Avtarjeet Dhanjal

Wanderlust

This text was written for the *Exotic Excursions* catalogue which accompanied an exhibition of the same name, curated by Clare Cumberlidge and Virginia Nimarkoh and produced by inIVA (28 Fouberts Place, London, 1995, touring to Oldham Art Gallery). Bringing together the work of five artists – Michael Curran, Clair Joy, Tatsuo Majima, Fernando Palma Rodriguez and Kate Smith – the exhibition and catalogue reflect on the luxury of travel in the modern age and focus on the individual as the site of cultural exchange and mart.

Clare Cumberlidge and Virginia Nimarkoh

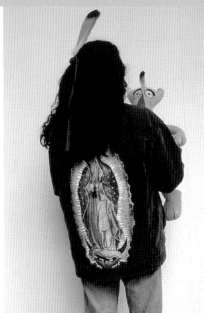

Exotic Excursions is a collection of images and ideas, at once introspective and panoramic, which investigate our relationship to travel.

The endemic wanderlust: the need to be somewhere else. Exotic Excursions taps into a mood, a pervasive feeling within modern culture; the need to move; to not be tied down to one place, time or sense of self. Essentially the need to be in control of our own destiny.

To leave, to depart, to arrive, to return. There is always the hope, the anticipation that somehow our lives will have been transformed and enriched by our sojourn.

To travel. To go in search of the familiar and the different. To come home. How can we convey our memories? The translation of experience from actual to verbal; one step removed. Something is missing, impoverished, diminished.

Tatsuo Majima's *Dinner Party*: the scene is a welcome home party for a returning traveller, the table is spread with exotic foods, four friends are gathered together, drinking saki and relaying their travellers' tales. As the conversation unfolds the apparent subject becomes displaced, the series of anecdotes reveal the individuals themselves, rather than the cultures of which they speak. *Dinner Party* occupies a hermetic space, the home of the 'sensitive traveller', which is inhabited/pervaded by an uneasy awareness of the cultural distance between people and places.

Did you have
guidebooks,
maps, timetables,
stout shoes?[1]

To travel is as much a necessity as a luxury. A means by which desires (for change) maybe at least, potentially quenched. To travel is to find ourselves; to lose ourselves. To decontextualise our lives and allow a new perspective.

Kate Smith and Clair Joy's photographs originated from shared wanderings through New York and London. To wander. To seek the pleasure of unexpected discovery, to risk the particular anxiety of being lost. How do we grasp location? Our recognition of place is filtered through the glimpses they allow. Experience of place becomes a process of layering ourselves against detail; architecture, building, passer-by. The images skim the surface of the particular and the general. We permeate the surface only to the level of familiarity. We recognise the cityscape but not the city. The fragments remain dislocated.

Say to yourself fifty times a day:
I am not a connoisseur
I am not a romantic wanderer,
I am not a pilgrim.[2]

Projection. Reflection. With the privilege of travel comes the glimpse of cultures different from our own. We travel. We take a break. We get a sense of distance on life; we can compare and contrast our lives against those of others. Against the difference and the similarity.

You send postcards on which
you write 'Bliss'. Remember?
You sent one to me.[3]

Wanderlust. Where is the location of our desires? The desire for escape. Michael Curran's *Les Souffrance du Dubbing* attempts the tortuous translation of sex, location and time. The assemblage of facades collapse and slip against each other, denying penetration. Sentences fracture, disintegrate; references collide and splinter. Anguish at the impossibility of translation.

(How) do we negotiate the interface of cultures? The question is whether it is possible to travel beyond our expectations and penetrate the surface.

To negotiate the interface (between cultures). How do we negotiate that which is not fixed but fluid; constantly evolving, metamorphosing? In *All My Friends Jackets*, Fernando Palma Rodriguez takes the icon, the 'travelling signifier' as his vehicle. *The Virgin of Guadalupe* represents a syncretic layering of indigenous and Catholic culture within Latin American society. Painted directly on to the jackets of friends, the icon has the potential to be carried through random and unforeseeable routes. Acting in the mode of a computer virus, infiltrating, 'contaminating', modifying the environment it occupies. The individual becomes the host, the carrier; the site of cultural exchange.

The afterimage of travel. Postcard, souvenir, snapshot. The traveller on return recollects the journey, now safely in the past; the traveller en route looks back to home. Reflection, nostalgia, fantasy. I'm ready to go.

Notes
1–3 Susan Sontag, 'Unguided Tour', 1983.

Left Clair Joy and Kate Smith,
postcard stand, detail of installation,
Exotic Excursions, 1995
Below Clair Joy and Kate Smith,
two pages from a postcard booklet
New York/London published for
Exotic Excursions, 1995. Courtesy
the artists and Matt's Gallery

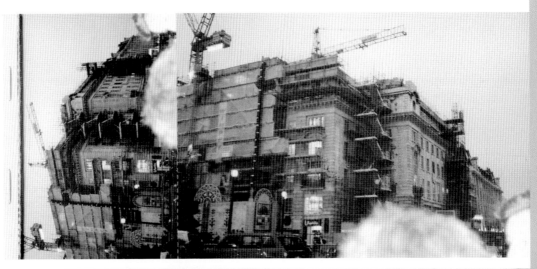

01 OFILI 9/04/93/GOOD FRIDAY.

Chris Ofili

As part of inIVA's *Maps Elsewhere* exhibition (Beaconsfield, London, 1996), Chris Ofili exhibited a series of copper plate etchings entitled *The Visit*. The exhibition stepped beyond the fact of maps as single, two-dimensional representations of geographical space to explore the conceptual basis of maps and their impact on our personal and cultural identities. Ofili's etchings 'document' a series of journeys between London and Berlin.

01–05 Chris Ofili, *The Visit*, 1993

OFILI 11·4·93 EASTER SUNDAY

Chris Ofili

03

04

05

Interview between Cedric Price and Hans Ulrich Obrist

Since the visionary British architect Cedric Price set up his practice in 1960, his time-based interventions have earned him legendary status among artists and architects alike. A capsule exhibition of his drawings, selected by Hans Ulrich Obrist, opened at TheSpace@inIVA in January 2001 and included a retrospective presentation of *Magnet City*. These drawings of short-life structures – situated in walkways, elevators, arcades and piers – were developed throughout the 1990s to stimulate new patterns of movement between existing sites in the city.

Hans Ulrich Obrist
In the context of *Cities on the Move* (Hayward Gallery, 1999), I think one of the reasons your work has been so important to many architects in Asia has a lot to do with the notion of time and the ephemeral, something which is understood better in Asia than in Europe.

Cedric Price
A short lifespan for a building is not seen as anything very strange in Asia. Angkor Wat in Cambodia is so vast and yet it lasted for less than three hundred years. I liked your dependence on change in the *Cities on the Move* exhibition and I particularly liked the Bangkok exhibition where time was the key element. I see time as the fourth dimension, alongside height, breadth and length. The actual consuming of ideas and images exists in time, so the value of doing the show betrayed an immediacy, an awareness of time that does not exist in somewhere like London or indeed Manhattan. A city that does not change and reinvent itself is a dead city. But I do not know if we should use the word 'city' any more; I think it is a questionable term.

*HUO*_What could replace it?

*CP*_Perhaps a word associated with the human awareness of time, turned into a noun, which relates to space.

*HUO*_The paradox is that the city changes all the time, so it would have to be a word in permanent mutation; it could not be a frozen term. But let's return to the idea of dead cities, tell me more about why they die.

*CP*_Cities exist for citizens, and if they do not work for citizens, they die.

*HUO*_Which is interesting because you also talk about the fact that buildings can die.

*CP*_Yes, the *Fun Palace* (1961) was not planned to last more than ten years. The short life expectancy of the project had an effect on the costs, but not in a limiting, adverse way. No-one, including the designers, wanted to spend more money to make it last for fifty years and we had to persuade the generators and operators to be economic in terms of both time and money. The advantage, however, was that the owners, the producers and the operators, through necessity, began to think along the same lines, as the project created the same set of priorities for everyone. That should be one of architecture's aims; it must create new appetites, rather than solve problems. Architecture is too slow to solve problems....

*HUO*_Let's return to the *Cities on the Move* show in Bangkok. Due to the open structure and the lack of a contemporary art museum in Bangkok, the city entered the museum and the contents of the show were carried into the city. The museum opened to the world.

*CP*_That's it – museum world, world museum. The exhibition in Bangkok was all about dialogue; it acted as a key for the people who experienced the show, only to realise that they were experiencing it all the time. It was the same with the *Fun Palace*; it was never intended as a Mecca – a lovely alternative to the horror of living in

London – but instead it served as a launch pad to help people realise how marvellous life is. After visiting the *Fun Palace*, they went home thankful that their wife looked as she did and that their children were noisy; the 'key' had opened the door for them. The *Fun Palace* was a launch pad to reality, mixed with a large portion of delight....

HUO_Alexander Dorner, the great hero of museums of change who ran the Hanover museum in the early twentieth century, wrote that institutions should be like dynamic power plants. Could you tell me about your museum-related projects, which address the concept of the portable or ephemeral museum?

CP_When the Queen Mary was up for sale, I suggested a museum in the ship, so that you could travel like a millionaire while the ship stayed in the bay in Liverpool; it was at sea but only a short boat ride away. The Atlantic crossing which used to take four or five days was concentrated into eight hours, the time you could take to go around the ship. You could see the machine rooms, the kitchens, the lavatories, the tennis courts and all the paraphernalia of the ship, but primarily the luxury of it. The ship was on hydraulic jacks and a range of seasonal crossings, relating to the weather you would have experienced in the Atlantic, were on offer. You would then realise why, in rough weather for example, the tables were made with edges on them to prevent the plates from slipping off.

I also did a scheme for the Tate, which they did not select. It turned the power station into an object. I proposed building a glass box over the whole thing, so that the business of producing exhibitions would have become secondary to the main exhibit, which was in a box with a single door. In bad weather, it would have been like one of those snowstorms, with Jesus being the one to shake up the snow! I was assuming that it could last at least a year or so, and then they could decide what kind of object they would put in the Tate....

HUO_There is an interesting and productive paradox between, on the one hand, your projects for temporary buildings and dynamic institutions, which would eventually auto-dissolve, and, on the other, your interest in old museums.

CP_I think that the notion of the classic museum still has – limited – viability. At three o'clock every afternoon, I get very tired. I am no use in the office so I go to this wonderful distorter of time and place called the British Museum. It distorts the climate because the building has a roof over it; it distorts my laziness, because I do not have to go to Egypt to see the pyramids; and it distorts time, because I can see someone wearing an Elizabethan dress. The distortion of time and place, along with convenience and delight, opens up a dialogue that reminds people how much freedom they have for the second half of their life.

This automatic distortion, whether of time or of place, when you visit a museum is a good thing. If you visit the same museum on two consecutive wet Thursdays, it will be different on both occasions. You will have distorted the contents of the museum through familiarity, which only occurs through going twice, rather than once. The distortion then becomes two-fold.

Cedric Price, *Cities on the Move*, 4 October 1999. © Estate of Cedric Price, 2004

○ FINITE LOCATION (at any ONE TIME)

⊙ 'mobile' OR INFINITE locale(s)

1. → 2. → 3.,4.,++ TIME SEQUENCE

There is the compaction of old bits of history into a convenient time and place for the consumer and then there is the added distortion of going there today with you, which was quite different from going there alone.

*HUO_*We both looked at it differently than we would have done, had we been on our own.

*CP_*Yes, but the distortion was also that we were both in London, which is not our home. It is about the enrichment and enlivenment of a new time dimension, or a new pace of events, which differs from the normal passing of time.

Museums, far more than art galleries, have to distort time, otherwise the element of coincidence in the collection does not occur – the distortion of time between when the objects were created and when they are shown. There is a quality to museums which is more relevant to the present time and to seeing the objects in the museum than to the date of their creation...

*HUO_*How do you feel about the omnipresent ideology of the white cube?

*CP_*Obviously it is nonsense. A museum or gallery cannot be a neutral space, because the degree of distortion ensures that it never will be. Why would all the objects be together? This so-called neutral space that people want cannot exist, because of all the coincidences caused by the personal objects.

*HUO_*Could you talk a bit about your time-based project in Glasgow and how that opened up a dialogue between the city and its citizens.

*CP_*The city hall is in the centre of Glasgow. They are very proud of it and people are not allowed in very often, unless they have got a complaint against the city. We decided to improve the lift to the top of the tower – putting a carpet in, installing lovely mirrors, spraying it with perfume – and invited the public in. We did not tell them why; all we said is that they could go to the top of the tower and for free. In the lift was a tape announcing 'Tonight, all the areas which we think should be saved without question will be floodlit red.' Only parts of the city were lit up, so their attention was focused. You heard comments like: 'Well of course that church should be saved' and 'Why keep that slum?' The next night, different areas of the city were floodlit green, indicating districts they decided should be improved. On the last day, the floodlights were white. The public was invited to tell the city what they should do with the spaces lit in white. There were no 'superiors' involved, no architects with patches on their tweed jackets around for miles. The city was saying, 'We've thought about it for years and still don't know what to do with the white areas. You tell us. But don't tell us next year, tell us within a month, because after that it's too late. As you go down, pick up a free postcard and mail us your response.'

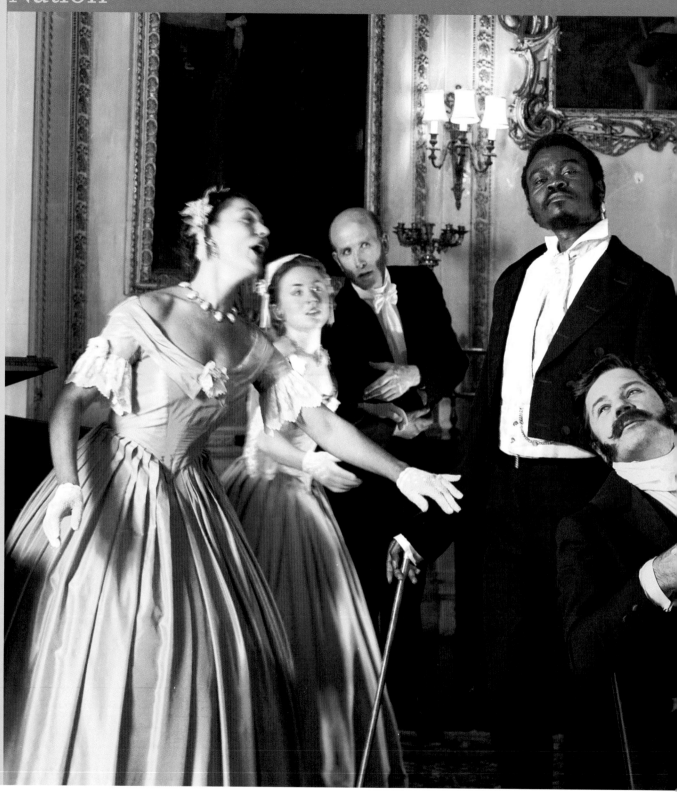

It is over two hundred years since the nation state and nationalism took root as organising principles for modern society and culture. Yet, in spite of globalisation and the rise of the multinational company, the idea of nation continues to grip our collective imagination, equally in the art gallery as on the football pitch. Nationality remains an important vehicle for expressing a shared identity, whether real or imagined. But national identity also continues to be a source of conflict and tension, as the boundaries of the nation state (and what it includes or excludes) expand or contract over time. Artists like Yinka Shonibare and Andrew Lewis, amongst others, have playfully challenged our assumptions about the nation, its borders and those who are excluded from the national story.

An Essential Guide to British Painting: Hogarth

John Styles

This short presentation on Hogarth was delivered by John Styles as part of the 'Essential Guide to British Painting' series of debates, organised by inIVA, which brought together artists and critics from different backgrounds and critical perspectives to look at major British painters and question fixed definitions of cultural and artistic identities. Chaired by Roy Porter, the discussion took place at Tate Gallery on 14 February 1995 and the speakers were Nick Dear, Partha Mitter and John Styles.

We've heard about Hogarth the entrepreneur, the self-made man, a man on the make in a very specific context, the London of the early eighteenth century. We've heard about Hogarth the pluralist, a man of broad sympathies in his thinking about beauty, and particularly a man hostile to many of the cosmopolitan aesthetic assumptions of the early eighteenth-century aristocracy. I want to pull some of these ideas together by considering Hogarth in the context of attitudes to the foreign and the different, in early eighteenth-century England and early eighteenth-century Europe.

We think about the eighteenth-century in Europe as the great age of cosmopolitanism. It's a cosmopolitanism that flourishes in the aftermath of a hundred and fifty years of bitter religious animosity between Protestant and Catholic, the consequence of the Reformation, which generated deep, deep divisions and bloody conflicts. And it's a cosmopolitanism that disintegrates when challenged by the nationalisms which erupted throughout Europe in the aftermath of the French Revolution at the end of the eighteenth century.

The eighteenth century is a kind of cosmopolitan interlude, a period when, at least for the middle and upper classes, there was something of a shared culture throughout the Continent of participation in art – in the form of visual art, painting, sculpture, music, even the theatre, and broader intellectual enquiry – that was universal. It was a world in which *savants* – and the use of the French word is deliberate and significant here – corresponded with each other about all sorts of aspects of culture and of what we today would call science. For the upper classes – and of course, it was the upper

classes who tended to buy the sorts of engravings and paintings that Hogarth produced, even if they were not always the subject of those engravings and paintings – there is some truth in this notion of a surprisingly cosmopolitan era.

Now, why should Europe have been so cosmopolitan? There are a number of reasons. I think, first of all, one can see in the eighteenth century the extraordinary power and strength of an international language, perhaps for the first time since the Middle Ages, when Latin dominated in elite circles. An international language seizes the upper classes of the Continent, and it's of course French. If you were a European of some wealth and status in the early eighteenth century, you could go to courts or aristocratic houses in many parts, not only of France and the French-speaking world but parts of Germany, Scandinavia, Italy and the like, and you would find that if you spoke French, you had an immediate way of communicating, an entrée into those circles. Indeed you would be astonished by the degree to which people in those circles did not use their own language but rather used French in all sorts of everyday discourse. So there's a universal language in which these people share.

There is also something of a universal set of cultural forms which are common to the educated and the wealthy throughout western and northern Europe. It's a culture, especially in the first half of the eighteenth century, which is reverential towards the classical world, the world of Greek and Roman antiquity. Indeed, reading the words that French and English and German noblemen sometimes wrote,

one wonders whether they actually saw themselves literally as Roman senators, as Roman aristocrats. But for all the often lukewarm way that religion is expressed among elite circles in the eighteenth century, there is nevertheless a profoundly shared Christian culture too. There is a constant looking back to the Bible, to the classics, to a shared past, which all western and northern Europeans of some education and wealth can participate in.

But this was a cosmopolitanism which was confined to the elites. Only they spoke the foreign languages, particularly French, of which this cosmopolitanism was made. But often it was also only the elites that spoke the standardised form of their own language, in Italy, in Germany, and indeed in France itself. Among the poor, among the peripheral, there were a host of local dialects, local cultural forms. It was only the elites who in any sense spoke the standardised form of the national language as well as speaking the cosmopolitan international language of French.

Now England was in a number of respects the odd man out in this Europe of cosmopolitan elites. Although elite English men and women often learned French, they rarely spoke it or wrote in it when communicating with their fellow English men and women. In contrast to educated circles in the rest of Europe, the vast majority of printed works in eighteenth-century England were published in English, and the second most important printed language was Latin, not French.

In other respects, too, England was unusual. The Church of England was a strange creation by Continental European standards. It was not Roman Catholic and of course much of Europe was Roman Catholic. But on the other hand, it wasn't like any other Protestant church in northern Europe either. Other Protestant denominations, like Lutheranism and Calvinism, were international, indeed cosmopolitan in a sense and they regarded the Church of England as a rather curious and deeply idiosyncratic creation. So, in religious terms, England again was odd. And England's own religious innovations of the period, like Methodism, although influenced by European Protestantism, were never taken up in Europe.

And finally, in politics, England was extremely peculiar by European standards. The English were, in the early eighteenth century, profoundly conscious of being on an entirely different path to other European countries. Virtually all educated, wealthy, polite Englishmen felt that England was in some way or another exceptional politically. They may often have felt that the arrangements that the seventeenth century had bequeathed to the eighteenth century, particularly the arrangements that were put in place after the Glorious Revolution of 1688, had been corrupted. Hogarth was one of those who earlier in his career clearly felt they had been perverted. Nevertheless those arrangements were seen as being utterly different from what went on in the rest of Europe. And this wasn't simply true of political arrangements in the sense of parliament and its relationship with the king, but it was also a matter of English society more broadly. The English legal system was very different from most European legal systems and of course there were aspects of English social structure which were distinctive.

So in Hogarth's time, there is a very powerful English myth of English exceptionalism, of which Hogarth of course is a great – but certainly not the only – exponent. This belief was shared among broad sections of the English elite and had its parallels in an intense xenophobia amongst many of the English labouring classes. From top to bottom of society, the English believed that England was better. Sometimes England was considered to be better because it was exceptional, sometimes it was considered to be exceptional because it was better, but either way England was generally regarded as a different place and a superior place.

But of course, at the same time, the English elite weren't immune to foreign influences. They wore French fashion, they watched Italian opera, they ate French food, and so on. I think one can draw from this the conclusion that England, certainly in the first half of the eighteenth century, is a somewhat schizophrenic society. It is a society with a powerful notion of its own identity, but it's an identity that always seems to some extent under threat, that seems problematic, that's always trying to judge itself and measure itself against other people's standards, ideas and models. And so England, like 1920s America, or like Japan in the 1970s and 1980s, is an enormous consumer, an eater-up of foreign culture, whether it be paintings, chairs, or ideas. This is a society that is anxious to take on board foreign ideas, and yet in some ways to repel them, to reject them, or at the very least to anglicise them.

Much of this unease about the foreign attachment to English exceptionalism is expressed in English views about France. France is the other great European power militarily and economically and is, of course, the great European power culturally. Voltaire, in the 1730s, describes France as 'the whipped cream of Europe'. France dominated the production and consumption of luxury goods and the setting of style and taste throughout Europe. This was something that English people resented deeply.

We've seen that Hogarth was concerned with his own Englishness, and with the Englishness of English art. In a very profound sense he was a patriot, but he was not alone in this. One can see many of the aesthetic, artistic, and architectural interventions made by a variety of English people in the first half of the century as attempts to define what Englishness should be in painting, in building, in design and the like. But there was no common agreement on how to do it.

Hogarth is perhaps unique among English artists of his generation in the intensity of his dislike for the way that the rich often buy French goods, buy Italian paintings, kowtow to Italian standards in culture, and to classical standards. He, by contrast, relies to a great extent, in his thinking about what constitutes beauty and what should constitute good painting and good art, on a notion of naturalness that will in and of itself be English. But at the same time, he doesn't entirely reject the classics: he had his collection which goes on to be used after his death in artistic education.

He is also uneasy about England's successes and commercial expansion and some of his treatment of blacks, David Dabydeen has suggested, indicates a sympathy for the plight of slaves on English sugar plantations in the West Indies, on English ships in the Middle Passage between West Africa and Barbados.

But at the same time, he is also something of a jingo and a xenophobe, a celebrator of English successes in war, in commerce and the like.

A great deal of this can be explained by seeing Hogarth as one of a number of cultural entrepreneurs who are trying in this period to construct a self-confident, distinctly English set of cultural forms and aesthetic standards – ways of painting, building and designing. But he's not the only one, so he had to differentiate his own product. Hogarth is a splenetic, awkward, troublesome man who resents and dislikes all those who are playing, in the broadest sense, the same game.

Take, for example, the third Earl of Burlington, the man who built Chiswick House, the father of English Palladianism, perhaps the most successful aesthetic form that carries the label 'English'. Burlington establishes neo-Palladianism as a distinctively English sort of architecture. He differentiates what goes on in England from what goes on in France, particularly from the French Baroque, and from what goes on in other parts of Continental Europe. Yet at the same time Burlington justifies it, by reference to the classical past, claiming that his new architecture is more truly antique, more truly Roman in this case, than the sort of classical architecture that is practised in other European countries. Hogarth is not a fan of Burlington, at least for large proportions of his life. Hogarth attacks Burlington's pedantic view of how the classics should be defined and incorporated into the modern world. But in a sense what Hogarth is attacking is simply another cultural entrepreneur, another man trying to play the English card in the world of the arts and design.

Hogarth's own views are best understood as those of someone who is very much a Londoner. His programme for defining Englishness in painting and in the other arts is not the programme of an enormously wealthy aristocrat like Burlington. Rather it is the programme of the sort of people he knew and consorted with in the West End, in Covent Garden, around St Martin's Lane, where he had his academy. St Martin's Lane is a world of skilled artisans – goldsmiths, coach-makers, furniture-makers and the like – who are highly influenced by foreign models. There are often Huguenots, German immigrants and other foreigners in their midst. It is a vibrant and visually extremely sophisticated culture of artisanal production. It is the world of Hogarth the engraver, as opposed to Hogarth the painter.

Perhaps we should interpret Hogarth's attitude to foreigners, to Britishness, and indeed his accommodating stance towards black people as an extension or an interpretation of his experience in this milieu of the aesthetically skilled artisan. Perhaps when we think about Hogarth and Englishness, we should be thinking about Hogarth the craftsman, as opposed to Hogarth the artist. In defining himself against the Burlingtons, against the cosmopolitan aristocratic elite whom he so reviled, what we are seeing is a man drawing on his own family roots in the city and on his own immediate context in the West End to construct a different sort of Englishness. It's an Englishness that is more plural, that's less concerned with classical models, that's less cosmopolitan, and as I think we've seen today, it can still speak to us in all sorts of ways.

William Hogarth, *Marriage à la Mode: The Countess's Morning Levée*, c. 1743. © National Gallery, London

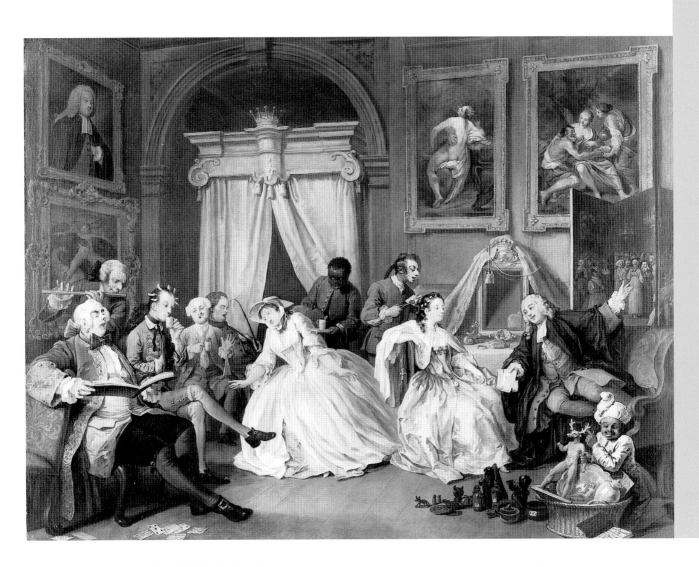

Commissioned by inIVA, Yinka Shonibare's *Diary of a Victorian Dandy* was exhibited initially throughout poster sites on the London Underground in October 1998 and subsequently as a touring gallery exhibition (to Castle Museum and Gallery, Nottingham, and Laing Art Gallery, Newcastle). The series of photographs reflects the nation's popular taste for period costume dramas and a nostalgia for a utopian past at the heart of little England. Shonibare plays the central role of the dandy, resulting in these staged photographs which mimic the style of Victorian theatre at the height of colonialism.

Yinka Shonibare

01 Yinka Shonibare, *Diary of a Victorian Dandy, 03.00 Hours*, 1998
02 Yinka Shonibare, *Diary of a Victorian Dandy, 11.00 Hours*, 1998
03 Yinka Shonibare, *Diary of a Victorian Dandy, 14.00 Hours*, 1998

Overleaf
04 Yinka Shonibare, *Diary of a Victorian Dandy, 17.00 Hours*, 1998
05 Yinka Shonibare, *Diary of a Victorian Dandy, 21.00 Hours*, 1998
All images courtesy Stephen Friedman Gallery

01

02

03

Yinka Shonibare

04

Yinka Shonibare

Reframing the Black Subject:
Ideology and Fantasy in
Contemporary South African
Representation

Okwui Enwezor

This text was pubished in Okwui
Enwezor and Olu Oguibe (eds), *Reading
the Contemporary: African Art from Theory
to the Market Place*, London: inIVA, 1999,
having first been published in an exhibition
catalogue entitled *Contemporary Art
from South Africa* (Oslo: Riksutstillinger,
1997). These extracts examine the
representation of the African body in
relation to concepts of nationhood in
post-apartheid South Africa.

I

In the house next door to mine in a suburb of Johannesburg, my Afrikaner neighbour makes it a duty every weekend and on public holidays to hoist on his flagpole the blue, white and orange colours of the old South African nation. Like all symbols of a nationalistic identification, this flag raises extreme emotions – either of mortification or nostalgia. It has become rare to find a South African of any race who is not either a staunch supporter of the African National Congress or an anti-apartheid activist, and my new neighbours have made it very clear on which side of the ideological plane their allegiances lie. It seems nothing has changed for these people and thousands of others like them, who still persistently dream of the return of the old nation. Nostalgia, cleansed of poisonous memories, endures, and is thus justified in its almost fatalistic clinging to a relic of racism. In many ways, this defiant use of an old nationalist symbol, with its undisguised, terrifying history, is nothing new or unique. It has companions in the recent Fascist revivalism that has engulfed Europe in the aftermath of the Cold War, with the return of swastikas and Nazi symbolism, and in the more enduring history of the Confederacy flag in the southern United States.

Reading this image in the uneasy light that illuminates South Africa's return to the ranks of the modern nations, the flag display reveals, and at the same time masks, certain anxieties around the transition from apartheid to a representative, tolerant, liberal democracy. As I write this, I am listening to the wind snap the stiff cloth and colours of the fading flag. I am fascinated by that sound, by the rituality of my South African companion's forlorn hope. The flag is an ideological prop of longing, the lost dream of a fallen nation whose haunted past is very much part of the present, a sentinel that echoes the ambivalence and the desires of both the new South African nation, and the fantasy of a time fading fast with the bleached tricolour of the old flag. However optimistic one may sound in articulating the new South Africa, we must constantly remind ourselves that while nations may disappear, the ideologies that feed and sustain them, and which form the foundational basis of their creation, are more difficult to eradicate. For they are imaginatively reconstituted through the use of the surplus resources of their enduring myths as banners to rally adherents.

Thus in late 1996, two years after the legal fall of apartheid, it is hardly revealing to observe that racism and racial suspicion endure as rampant realities of the new South African state. We can hear it in the resplendent, undisguised accent of those anxious voices who still await the return of the owl of Minerva, bearing the news that the experiment was a failure: the 'natives' are simply ill-prepared to run a functioning, well-oiled state. In pointing out the above, I am less interested in the fraught political context out of which these issues arise than I am in using the questions they raise to examine issues of representation in a culture that has lived for generations with racist stereotypes as a prevailing attitude. To sketch out the image fully, I want to begin with two analogous depictions that run synchronously through the histories of both the United States of America and of South Africa: *baas* and *massa*; *kaffir* and *nigger*; the Hottentot and the auction block; Jim Crow and apartheid.

The uncanny resemblance of these characterisations is not an accident. For they are both founded on blackness as anathema to the discourse of whiteness; whiteness as a resource out of which the trope of nationality and citizenship is constructed, and everything else that is prior is negated, defaced, marginalised, colonised. By thinking analogously of the two systems of whiteness as official policy, and as a mechanism of bureaucratic normality, I want to extrapolate from the cultural text of the United States a commentary on the fascinating usage in post-apartheid representation of the African body as subject and prop in both the political and cultural expressions of the 'New South Africa'.

This retrieval of the black figure from the debased image-bank of the former apartheid state is not surprising. Nor is it necessarily new; it is parcelled in the experience of a 'nation' emerging from one of the most traumatic events of the twentieth century: the long, terrible, insomniac night of apartheid. Dialectically, what one encounters within this scripted and representational presence is a nation seeking a new identity, and thus new images, new geographies, boundaries with which to ballast its strategic and mythological unity as what has come to be known as the 'Rainbow Nation', a term coined by Desmond Tutu to describe the multicultural population of South Africa. To put it bluntly, such a search is clearly related to how whiteness and its privileges are presently conceived, interpreted, translated and used to access the code of a disturbed sense of South African nationality. Thus to examine the charged descriptive detail of what strikes at the mortal heart of the 'New South Africa' –

multilingual and, hopefully, multivocal – is to keen one's ears to the new uses and revindication of whiteness (in subdued and barely registered forms) as an idiom of cultural identity, that is, as a renewed and authoritative presence in the country's iconographic text....

II

Until recently in South Africa, as with Germany's *jus sanguinis* ethnic policy, citizenship (nationality) was a special animus that carried the Calvinist symbol of whiteness. For it not only declaimed belonging from the position of exclusion, it effectively rendered millions of the indigenous population *personae non gratae*. Under such definition, to challenge the sanctity of whiteness, to represent it adversely, either in writing or image-making, to question the Calvinist ethic of racial purity on which it is founded, is to court terrible reprisals (brutal beatings, ban orders, jail, solitary confinement, exile, death) or to be cast out of the inner sanctum of the *broederbond*. And nowhere is the ideology of this racial fundamentalism in the shaping of national identity more potently manifested than in the arena of sports and visual arts. These are modes of culture that, according to Edward Said, occupy the realm of pleasure and leisure, coarsened by brutal exclusion and primitive racial determinism.[1]

For years, because they were neither citizens nor persons with a national affiliation, black South Africans were not offered the opportunity to participate in the corporate body of national sports, let alone to represent such a body or speak on its behalf. Sports had simply become a purified zone, the hallowed ground upon

which white supremacist impulse traded its currency. In art, the museums of South Africa, in their attempt to redress the imbalances of the past, are paying the price for their past neglect of work by African artists, excluded from their collections. Because of this neglect, a process of gobbling up any work of art made by 'black' artists has intensified within both public and private institutions in the last ten years. But since the pragmatic value of everything that defines the old South Africa was derived from the interregnum of white nationalism and black resistance – in terms of popular iconography, art, literature, language and religion – it goes without saying that the birthright of utterances that spoke authentically about the nation, rendered the exactitude of its character, probed its borders and alleviated its insecurity, drew it into the light through all kinds of signifying devices (which included speaking on behalf of the 'native'), ultimately belonged to the white interlocutor....

III
In the post-apartheid moment of national reconciliation, reconstruction and unification, we have heard much of the militant black subject who wants to change everything and remake the nation in the illusory image of black identity. Conversely, another enduring popular image has emerged of the sulking white subject who harbours fantasies of an ethnic white *volkstaat*, and failing that, either emigrates to Australia or stays behind to complain bitterly about how things have changed. These images represent the polar axes around which the terms of transition are being negotiated. But they are both founded on the basis

that notions of whiteness have constituted the terms of national identity and citizenship, and must now either be amended or attenuated and deconstructed in order to reconstitute the new image of the nation as something neither white nor black, but 'a rainbow of multiple reflections'. Hence, to speak through the territory of both the old and new South African nation and the intersection of black and white subjectivity within their iconographic lexicon, might it be possible to begin with the question of the abject, so as to delineate what binds the subject of the nation to both its object of desire, its internal unity, its frame of stability, and to that which disturbs it, calls it into question, sets it adrift?

As part of the experience of apartheid, the primal symptom of whiteness was always in relation to that broad category in which large groups of people were reproduced in the image of the abject, defined by Julia Kristeva as that which 'disturbs identity, system, order... does not respect borders, positions, rules'.[2] Frantz Fanon relates this to that moment when a white child shrinks in horror and terror into her mother's arms, pointing to a black man in a public space as some kind of defilement, a mark of excess, an abscess sprung fresh in the temporal imagination. 'Look, a Negro', screamed the child.[3] Here, the Negro becomes an object of fetishistic fascination and disturbance to both the spatial and temporal order. There is a demand both for the repression of his presence and for his objectification, so as to mark out the divide that separates his polluting presence from the stable environment of whiteness: the enclosed suburbia in which he is forever a stranger, a visitor. Within South

Africa, the Pass Laws, Separate Amenities Act, Bantu Education Act, Group Areas Act and so forth, were the mechanisms employed to cleanse territories, coveted by whites, of the scourge of blackness. This schematic trace of the abject as a transgressor of borders and rules is especially disturbing because the abject seems so wholly reproduced in the image of the criminal, the fugitive, the trespasser. This point was necessary in the construction of South African identity, regimented as it was in a colour-coded system of appreciation, value and worth, of which the ideological fantasy of whiteness becomes the marker against which everything is measured, whether as resistance or aspiration....

It appears that the struggle for the meaning of identity in post-apartheid South Africa hinges on who controls the representational intentionality of the body politic, especially its archive of images, both symbolic and literal....

IV

Two years after the official demise of apartheid, Nelson Mandela and the majority of South Africans – black and white – have tried to achieve nothing less than the reinvention of their once-divided country, a new South African identity attempting to shed the wool of its racist past. The drive is for the emergence of a new nation, from one that lived in isolation and mutual suspicion, in competition and as adversaries, to one today described as the last miracle of the century. Part of the formidable repertoire of images with which the nation has attempted to heal itself is framed in the iconographic technicolour of the 'Rainbow Nation'. One's understanding of the 'Rainbow Nation' has less

to do with its mythic dimensions, the uneasy air of ambivalence that visits its every invocation, than with the pragmatic politics of reconstruction that it seeks to articulate: a reborn nationalism. But no one in full honesty believes the 'Rainbow Nation' to be a long-term project. Rather, it is a project of accommodation, or armistice, in the absence of which competition between the various members could again erupt into civil strife. Along this thinking, Rob Nixon has noted that 'much the strongest current of nationalism in South Africa – that represented by the ANC – is inclusive, nonracial, and premised on a conciliatory unity, not an enforced ethnic homogeneity'.[4] But the critics of the 'Rainbow Nation' easily ignore this fact.[5] In this regard, one casts an uneasy glance in the direction of KwaZulu Natal, where the cauldron of Zulu nationalism bubbles.

On this note, I want to suggest that nationalism – whether framed in the sectional rhetoric of Zulu nationalism, in the *volkstaat* of Afrikaner nationalism, in the settler colony belief in generic whiteness as an essential way of being, or in blackness as a revolutionary discourse of decolonisation – has always been an inextricable reality that frames South African identity. There is no better way to acknowledge this sense of factionalism than in the different responses to the concept of the 'Rainbow Nation', particularly that of a white community that suddenly finds itself a minority and, potentially, the underling of its former African vassals. And nowhere has this recent resistance been more fierce than in a representational terrain still dominated by highly literate, but nonetheless unreflexive white cultural practitioners, unblinkingly intent on representing black subjectivity at the margins

of cultural and aesthetic discourse. Unmoored from what they have always known – that is, the unquestioned privilege of whiteness from which everything is refracted – the Rainbow now seems a motley reflection of images alien to the old sensibility. Very simply, the Rainbow either opposes or seems antagonistic to whiteness. The Rainbow as what 'disturbs identity, system, order… does not respect borders, positions, rules' has made artistic practice a volatile and transgressive act of realpolitik, for it has suddenly made South Africans clearly aware of how different, culturally, ethnically and linguistically they are as a 'nation'. No longer tenable is that hardened position of binaries – black/white, settler/native, coloniser/colonised.

Notes
1 Edward Said, *Culture and Imperialism*, London: Vintage, 1994.
2 Julia Kristeva, *Powers of Horror: An Essay on Abjection*, trans. Leon S. Roudiez, New York: Columbia University Press, 1982, p. 4.
3 Frantz Fanon, *Black Skin, White Masks*, trans. Charles Markmann, New York: Grove Press, 1967, p. 112.
4 Rob Nixon, 'Of Balkans and Bantustans', *Transition*, no. 60, New York: Oxford University Press, 1993, p. 25.
5 While on the surface, the challenges to the 'Rainbow Nation' as a unitary polity might seem like a defence of pluralism, difference and heterogeneity, in reality they seem to recast a neo-conservative stance that echoes the divisive Bantustan policy of separate development of the apartheid regime. For what the critics fear and have failed to admit, at least explicitly, are the prospects for whiteness in an overwhelmingly 'black' South African country. Hence, the maintenance of ethnic, racial and linguistic faultlines seem the best check against an encroaching Africanisation of South Africa. In fact, the extreme right wing have seized on such arguments and fears of Africanisation to demand an outright white Bantustan (homeland) for Afrikaners, and the Inkatha Freedom Party has adopted the neo-biologism of Zulu ethnicity to make an appeal for what its leader Mangosuthu Buthelezi has dubbed the 'Yugoslav option' or KwaZulu. See Rob Nixon's brilliant essay (ibid.) for a more in-depth study of these contestations.

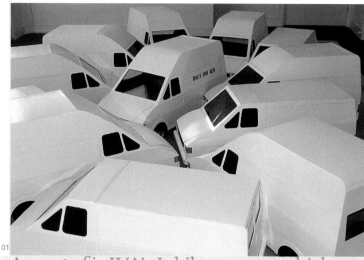

01

Andrew Lewis

As part of inIVA's Jubilee season, which coincided with the fiftieth anniversary of Queen Elizabeth II's coronation, to present an alternative view of contemporary Britain, Andrew Lewis's exhibition *Systems* opened at TheSpace@inIVA in April 2002. Works such as *Southern Hospitality* address questions of national identity perceived through a chocolate-box view of the English landscape.

01–03 Andrew Lewis, *White Van Men*, 2002. Stedelijk Museum Collection

Overleaf
04–05 Andrew Lewis, *Race-ism*, 2002
06–08 Andrew Lewis, *Southern Hospitality*, 2002

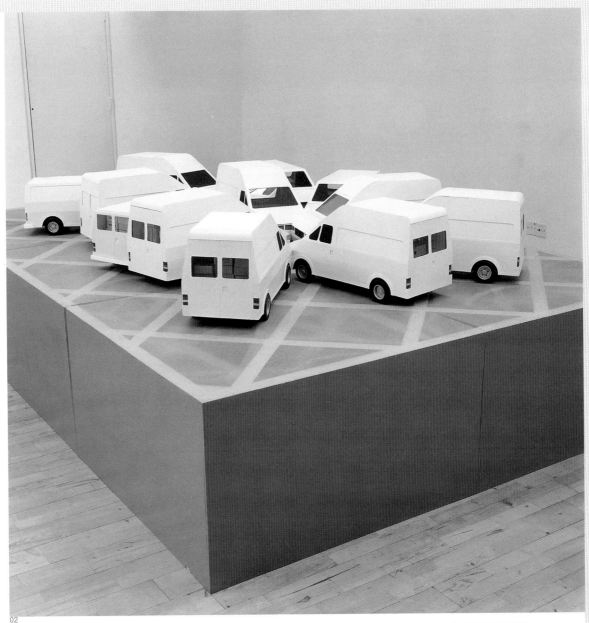

02

03

Andrew Lewis

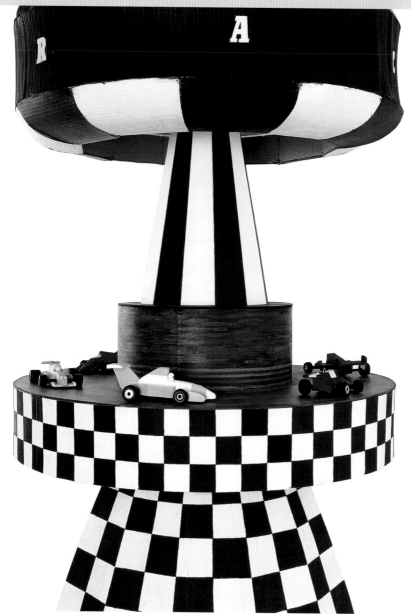

04

05

06

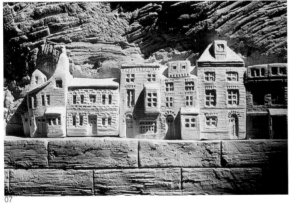

07

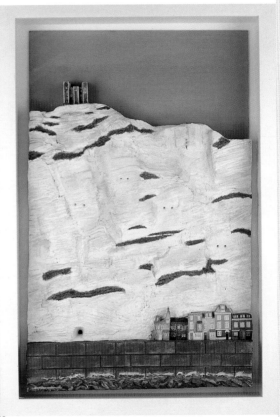

08

Andrew Lewis

Vindaloo and Chips
What's in a Dome?

Remi Abbas

These two Chat Room events were part of inIVA's Thoroughly Modern Britain season in 1998. At the first, guests – who included a number of young British artists – were served curry and chips while being invited to mull over the question of what it means to be an artist, young and British. At the second, the Millennium Dome was the starting point for a discussion about British culture 'on the street'. Poet and writer Remi Abbas was commissioned to write reflections on both of these events for inIVA's website.

Vindaloo and Chips

Just before arriving at inIVA I pass Professor Stuart Hall on the street. Feeling deep pangs of fandom, I decide not to stop him and speak. I have to admit I'm a possessor of a humiliating intellectual *faux pas* where Stuart Hall is concerned, no matter how hard I focus or meditate, the glitch remains huge and overbearing. Everytime I hear his name, I think about the TV programme *It's a Knockout* synchronously with the debates around culture. Only for a few seconds mind, but that's enough. Shame torments me with an extended process of self-flagellation where my brains are pummelled *It's a Knockout*-style into a squidgy pulp by the ghostly figures of Raymond Williams, Frantz Fanon and Antonio Gramsci.

As a child born in the 1970s I knew of the entertainer before I knew the scholar. But both have informed my idea of Britishness. Bearing this in mind, I enter inIVA to find out what it means to be a young British artist in this whisper away from the millennium.

Titled 'Vindaloo and Chips', the first event in the Chat Room series offered guest artists, those involved with the arts and members of the public the opportunity to discuss what it means to exist in this milieu. Decorated to resemble a restaurant, with five, large circular tables, inIVA's conference room became a site of declaration. What broke the illusion of a private dinner was the ubiquitous video recorders, loads of them littered strategically to be utilised by those present. Staged though the dinner may have been, the chance to create a Scorsese-type documentary must

have crossed the patrons' minds. Who could resist playing with this equipment and not think about the potential for a fly-on-the-wall documentary. Like the Kurt and Courtney exposé, video cameras have enabled us to record our own dramas and are recoding British behaviour. We are encouraged to tape ourselves, reveal our gaffes. From *Beadle's About, Food and Drink* to *Video Nation*, the public is being invited to document parts of their lives and send them in for all of us to view. Other than our national trait of repression eroding, we all get a chance at stardom albeit miniature.

Dinner comprises snacky foods. Bhajis, chicken curry, samosas, salad and chips. Not rice, *chips*. Alistair Raphael reminds us that 'vindaloo', as with 'Balti', does not exist elsewhere; they are solely British words. These neologisms are more to do with exoticising India than with Indian culture. Superficially symbolic of India, these words represent a facade but also an element of syncretism. Obtuse though it may seem, this meal is quintessentially British; with the appearance of beer I knew we were partaking in Lad culture. The curry, the chips, the pints. And we tuck in, all of us from various different ethnicities, class milieux, we all converge to talk about what being an artist, young and British means to us. Most artists I've met tend to be multi-national. Identifying with a one-world aesthetic, they become receptors absorbing stimuli to satisfy the autotelic worlds of their art. Eschewing nationality, they inhabit an unfettered zone to create their own *Weltanschauung*.[1] So why ask them what it means to be British? What do they know? Or care? They are omni-earthlings, global citizens whose notions of belonging transcend any specific national codes.

Perched between artist Simon Callery and programmer Keith Shiri, I get conflicting answers to the question.

'I always believe that the artist's responsibility is to be outside the parameters of government. To always be critical and in sync with the realities of their environment. And it's a responsibility', says Keith Shiri. Simon Callery interjects, 'I remember being young and the whole idea of an artist to me was so inspirational... it lifted me out of the fact that I would have to go and do some awful job for life.'

Devoid of social responsibility?

'As an artist you can assume as much moral obligation as you want. You can be somebody who wants to completely reverse everything and find some sort of success by being as bad as you can. Or you can follow with your own sense making what you think is a good thing to be making today. The artist is someone who self-generates.'

Shiri's example of Shona artists[2] operating with a social conscience conflicts with Callery's far more individualistic British artist. Maybe that's our answer, to be a British artist is to be self-indulgent, beyond guidelines, to support collectivism or seek stardom.

A whisper before the millennium, stardom beats collectivism hands down. The individual is god. Following this leitmotif, most British artists want to be popular, primarily for their work. To be a young British artist is to grapple with the perennial integrity versus commerce question. Do you dumb down your work in order to become popular?

'If you think of the people who become art stars or really well established, it's often about their own personalities.' Audiences aren't really involved in understanding the ideas. 'They're just attaching themselves to another famous person. What the hell has that got to do with art?', Callery asserts.

Invariably, on every table Chris Ofili's name pops up. Art stars cannot be discussed without Britain's current art fave appearing. Everybody knows him. Everybody loves him. Everyone defends him. For what Chris cultivates is a precarious balance between artistic integrity, populism and commerce. Hence his art stardom. Table Four has a questionnaire, you have to match the artist with their quote: Sarah Lucas, Gavin Turk, Steve McQueen and Chris Ofili. Two black British artists, two white British artists, all British. However, when the quotes are matched up you notice that both black artists avoided any political sentiments. Apoliticising themselves, their quotes neutered the volatile subject matter of their work. I imagine Ofili and McQueen sweating as they answer from the trenches of the art world. A little voice inside them mumbling, 'Avoid didacticism if you want to survive. Keep your politics to yourself, keep the conversation light. Just put your work out and keep ducking.'

These differing answers state more about the racial tripwires still alive in wider British society, than they do about the cultural values shared by young British artists. The truth is you may define yourself as whatever you choose, but when it comes to popularity, minorities still need to abide by the rules of a silent apartheid.

To be a young British artist is to be hip to individualism, media savvy and cynical. It's the struggle of two Stuart Halls. Popularism versus intellect. Young British artists grew up living the life Professor Hall

theorised about whilst watching the hugely popular banality of *It's a Knockout*. It is to be disillusioned with collectivism, wary of individualism, yet maintain artistic integrity and popularity. You have to define your own formula to address the criteria. Nobody swallows the artist-as-subversive line anymore. To be a young British artist a whisper before the millennium is to live under the shadow cast by art stars and to yearn for their success on your terms. As Yinka Shonibare states: 'If you had the chance to be on page three of *The Sun* with 500,000 readers or in an art gallery with four people, where would you rather be?' A young British artist's dilemma.

Notes
1 German word meaning a particular philosophy, a particular way of viewing the world.
2 Shiri is describing a recent visual and sculpture art movement emerging from Zimbabwe and Mozambique.

What's in a Dome

Often the best and most offensive conversation comes from cab drivers. If you order a cab in certain areas it's best to relax the sensitive antennae and grin and bear the bullshit. This was one of those journeys. I'm stuck in a cab travelling for an hour through a mild summer afternoon into the heave of a frustrated congested metropolis chauffeured by a bigot cab driver who insists on chattering constantly. As we stop off at a petrol station, he declares the following: 'I'm gonna get some jungle.' Baffled I turn around to stare at an equally baffled moving assistant. It took us a few seconds to work out that jungle is short for Jungle Juice.

London not only has different worlds coexisting, it has different eras thriving (this driver's mindset was firmly entrenched in the 1950s). Searching for an affinity with me the cab driver chats about reggae music because I'm black. He chats about a crack addict he picked up last week because I'm black. He drives aggressively, threatening other drivers, also because I'm black. And he slows down when he sees the Millennium Dome because I'm... British and black.

The Millennium Dome was born a symbol of ridicule. Passed from a destroyed Conservative government into the hands of jubilant New Labour, the Dome has been doomed from conception. Nobody can save it: the TV show *Big Breakfast* spent most of 1998 poking fun at its design and incomplete state; the print media have dissected it and found much to laugh at; and everybody has a more worthy cause to spend the £500 million pounds construction costs on. Yet the idea

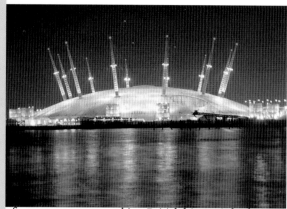

of one monument marking British history is both a heroic and foolish gesture. Heroic because it poses questions about this nation; if London and Britain are a place of coexisting realities, how can one monument represent this? Why is it in London? Actually, why is it in Greenwich? I know the yarn about the Dome being situated on the Meridian Line but there has to be a better reason than this.

inIVA's final Chat Room entitled 'What's in a Dome?' was a critique focusing on the Dome and all the surrounding issues. Chaired by eminent theorist Professor Stuart Hall, the panel was to consist of *The Guardian's* architecture critic Jonathan Glancey, film-maker Sonali Fernando and Eliza Fielding from muf architecture/art. Proceedings began without Jonathan Glancey's presence – and continued without his presence.

'The Dome is a phenomenon in its own right, if not a symptom of our times. And it's important to understand what this symptom is about symbolically. It's an old idea that from time to time the nation should try to represent itself in some way. But whenever that happens one has to ask oneself which nation is it that is being represented? Who has a say in how the nation is represented? Who doesn't? How can people have a say these days in shaping or having an influence on a project? How to get in and get a handle on it? We are interested in the process by which the Dome has come to be what it is,' prefaces Stuart Hall.

Seguing perfectly into Sonali Fernando's short film *Ufo Woman*, tonight's topic centres on the exclusion of voices from the construction of a monument representing Britishness. Fernando's

film articulates minority exclusion through the work of performance poet Patience Agbabi. Ufo woman is a cultural *double entendre*; in Britain she is alien, as in UFO (Unidentified Flown-in Object), whilst in Nigeria she is deemed alien (UFO) for not being born or having lived in Nigeria. In both countries Ufo woman is excluded; in conclusion her rejection becomes a zone of comfort. Rejection becomes home from which something new develops. 'This film and my standpoint are that I haven't yet come across a monument that encapsulates [Britain's future]. Apart from some of the proposals for the Fourth Plinth [in London's Trafalgar Square], here I feel we actually had the most public discussions on what monuments are about', states Sonali Fernando early on. Paraphrasing Peter Mandelson's rhetoric on the fragmentation of British society, Fernando illustrates how the Labour party is portraying this alienation as a plight to be cured by the Millennium Dome's unificatory aims. Obviously sceptical of this premise Fernando later hints at how the Dome could be turned into a successful symbol of Britain's diverse past and present.

Eliza Fielding's stance repudiated Fernando's idealism. As one of the companies present at the initial stages of the Dome's development, her take on the exclusion of minority voices prised the discourse away from laying blame with the Dome committee into a slapstick overview of the monument's construction. In Eliza Fielding's view nobody is to blame for the lack of minority presence; it was purely coincidental. Combinations of financial and time constrictions and public accessibility were for her the primary factors shaping the Dome.

Although entertaining, her talk was worrying. Emblematic of our current disillusionment, her talk held nobody responsible. But surely somebody must be accountable. Even though the bodies involved in the construction of the Dome were and still are disparate entities, there are people making decisions relating to the Dome's make-up and those involved have an opinion formed by their particular perspective. At the end of the talk, resolution seemed far. It seems easy, due to government requests for outside bodies to get involved, for anyone to become part of the Dome project. However it increasingly seems like a huge monolith representing a clichéd reality. As a British citizen observing the Dome's construction, I ask myself the same questions I do when I'm purchasing an item. Does it co-ordinate? Why do I need this? Stuart Hall left another question to ponder: 'Why do we have to have one building representing our nation?' Maybe next year the answers to these questions will transpire. Whatever's happening within the Dome is still a mystery and constantly subject to change.

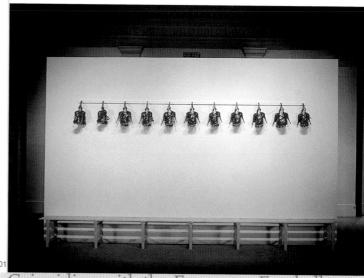

01

Offside! Contemporary Artists and Football

Coinciding with the European Football Championship in June 1996, the exhibition *Offside! Contemporary Artists and Football*, curated by John Gill, opened at Manchester City Art Galleries, before beginning a UK tour to Northern Gallery of Contemporary Art, Sunderland, and Firstsite, Colchester. It comprised newly commissioned and recent works from thirteen artists from Argentina, Britain, Colombia and Mexico. The exhibition identified the football stadium as an arena for the public display of national aspirations and anxieties and the players as the focus of individual and national fantasy.

01–02 Freddy Contreras, *Stud*, 1996

Overleaf
03 Rosana Fuertes, *Pasión de Multitudes*, 1992–93. Installed at Havana Biennale, 1994
04–06 Lucy Gunning, *The Footballers*, 1994. Courtesy the artist and Matt's Gallery
07 Roderick Buchanan, *Work in Progress*, 1993–94
08–09 Mark Wallinger, *vs.*, 1996.
Photographs: Peter White, FXP

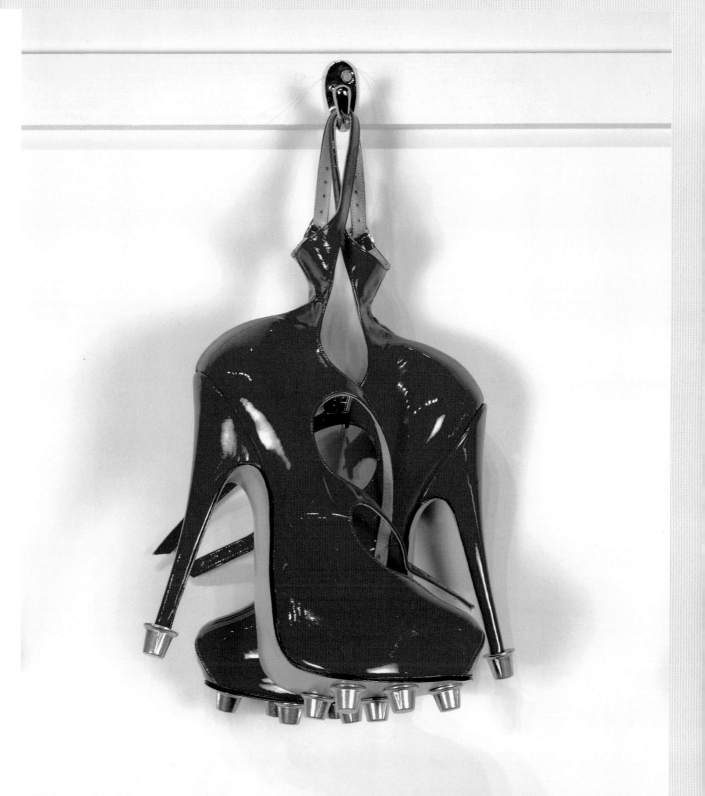

Offside!
Contemporary Artists and Football

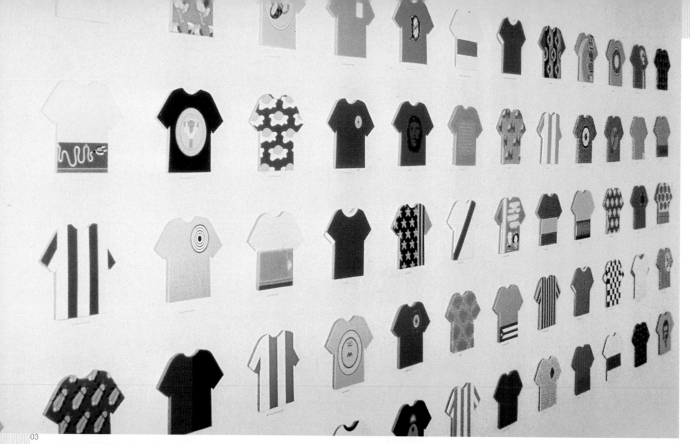

03

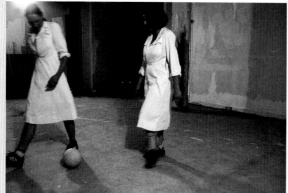

04

05

06

07

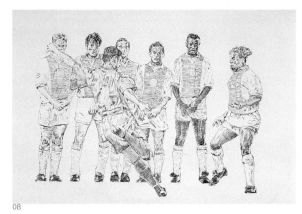

08

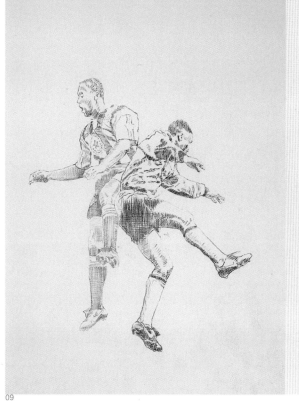

09

Offside!
Contemporary Artists and Football

What's New in Indian Art: Canons, Commodification, Artists on the Edge

Geeta Kapur

In collaboration with the Royal College of Art, inIVA presented a lecture series entitled 'International Curator Lectures'. Geeta Kapur was one of the invited speakers and her presentation, given on 8 April 1997, traces recent developments in the Indian artworld – in terms of the challenge to established art historical canons and the growth in the art market – in the context of the nationalist paradigm. An earlier version of this text was published in Pratapaditya Pal (ed.), *2000: Reflections on the Arts in India*, Mumbai: Marg Publications, vol. 52, no. 2, 2000.

The turn of the century produces an axial dynamic in the understanding of world phenomena. One amongst these is the influence of the ideology and aesthetic of modernism. Reviewing art practice at this moment involves fresh interpretations of the modernist principle. Indian views on such questions are triggered by momentous changes in the last decade: the liberalisation of the Indian economy; the emergence of the hidden agendas of nationalism; the cultural continuities and final ruptures in the narrative of identity. These three contrary pulls in the business of self-representation complicate the status of modernity in India and make it once again polemical. What is new in Indian art is that its certified locus is under siege from all sides and its older canons do not hold.

The cluster of canons dominant in India during the century has had to do with Indian nationalism and its agenda of cultural reconstitution during the period of decolonisation. The Indian national State, when it comes into existence in 1947, serves to realise the aspiration for a secular democracy with a replete sense of sovereignty. At this historical point, the first canon under consideration is the artist's symbolic sovereignty now delivered to the context of an independent nation. This is subsumed and reinvested into a responsible task of representation. Here is an art that moves back and forth between indigenism (classical and folk forms derived from the multiple traditions, by now eclectically assimilated); an adapted realism; and a modernism that is continuous with this realism and foregrounds dominant motifs of ethnicity, class and gender.

The second canon is an exact counterpoint to this. The logic is reversed when the artist climbs to the apex of 'his' sovereignty cutting clean beyond the civilisation/national/communitarian pyramid. He simply flags the achievement of collective cultural creativity and goes on to convert this deducible identity into singular, authorial terms. What is peculiar in this self-designation is that the romantic version of the artist, cast in anarchist models of self, draws at the same time on indigenous, mystical models. It shades into a style that is compatible with but not identical to the lyric aspects of modernism.

These two norms give us the ideological context of the arts in India up to the post-independence decades. The artist community, replicating in a sense the national community, develops a peculiar notion of allegiance. Positions are plotted in a familial, filial style and some form of collective destiny is thrown up which exhorts artists not to exceed or supersede the national communitarian cause. Even the avantgarde initiatives have to respect a kind of group psychology which goes in the name of solidarity to the cause which is India.

If in the Indian cultural situation all negotiations with the world require something like a community sanction, it is not surprising that this should take on a more formidable form when they acquire State sanction and support. So that in fact what is communitarian can become bondage to national norms and Statist regimes. By the cumulative effect of national responsibility followed by State hierarchies, a peculiarly restraining moral aesthetic of a new middle class comes into play. This is easily transferred to a consumer scale when the art market, in tune with the overall move into marketism, develops from the national to the global level. At this juncture, a contained

universe of symbolic imagery is the more amenable to commodification. I am suggesting that social conformism leads to market pragmatism in the late phase of a national culture.

In the wake of India's economic liberalisation policies beginning in the 1980s and fully publicised by the early 1990s, there has come into view an enormous, two-hundred-million-strong Indian middle class. As part of its self-legitimising process, as part of its multinational corporate identity and, finally, as a result of its investment interests, there is now a fairly flourishing art market in India. In addition to the middle class, the globalising Indian bourgeoisie and the NRIs (non-resident Indians) have come into the picture and now constitute the largest section (ninety per cent) of the international buyers. All these categories of buyers need the national/Indian slogan to shore up their self-image, their consumer status, and cultural confidence. In this moment of transition from a mixed to a market economy, in the complicit relationship of the State and the market, the national is set up as a culturalist charade. Problems of identity, ethnicity, and religious (in)tolerance amalgamate into an ideology that compensates for an economy dismantled at the behest of global capital.

The ruling taste at the beginning of the commodification of Indian art is still emphatically national and indigenous: peoples' traditions and their icons continue to be valorised. Imagist and discernibly sensuous painting is privileged above all. Iconographic repertoires of mythology and easy forms of mystical sublimation are exploited to make the image accessible. At this point, when the opening up of the Indian market is catching world headlines, there is a judicious stepping in of international auction houses: Christie's holds its first auction of contemporary Indian art in 1987; Sotheby's in 1989. While international auction houses signal the growing buying power of the NRIs, the auctions have been the most important single factor in raising the market value of Indian artworks at home as well. A new breed of galleries and collectors make a coup in this period. There were around ten private and commercial galleries in the whole of India in 1990, there are around two hundred today.

Private galleries are interested to be seen to have a varied menu under the rubric of national art. As the doors of Delhi's National Gallery of Modern Art open to private collaboration, there is a similarity between the State and the market on aesthetic preferences. To disrupt this converging purpose, there is pressure from the younger artists on the private galleries to diversify.

There is now a defined field of art production sporting a full four generations of artists; there is an institutionalisation of art activity and a commercial viability layered on top of national sentiments; there is, in contrast, the introduction of cultural reflexivity based on social disjuncture. Art comes under scrutiny precisely when its wholeness and goodness and desirability come to be a successful proposition in the market and the media. This produces the occasion for a cultural retake on the meaning of the artwork, introducing a deliberate form of irony. Conceptual moves, where the practice of art is seen as one among other reflexive acts in a precise cultural/political context, come to be staged.

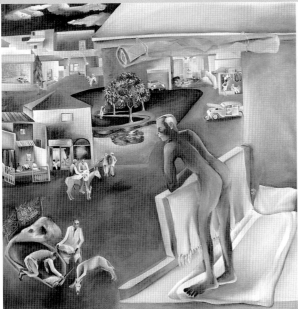

Certain aspects of contemporary art, and certain artists, can be seen to be at the cutting edge in the 1990s. Indian artists still undertake, in a far from exhausted way, representational subversions through direct iconoclasm and textual allegories. We have only to see K.G. Subramanyan's painterly idiom as it continues to tackle a great haul of figural motifs to recognise how the iconographic repertoire (with specific mythic features) of a contemporary artist can be rendered so remarkably volatile. We can then pick up an active history of quite provocative issues around representation with the amazing career of the painter Bhupen Khakar (died August 2003). Slowly pushing his art to the brink on questions of taste, he developed a unique form of intransigence through sexual motifs, homoerotic and transvestite imagery flowering into an understanding about gender in the spiritual protocols of Indian culture. Finding a visual language through and beyond indigenism, he built an iconography which broadens the debate on contemporary figuration and suggests that there are representational conundrums still on hand. There must be an actual privileging of marginal lives as there is a quizzing of the heroic self-stance of male/modernist art.

Younger artists like Atul Dodiya and Surendran Nair can be counted as heirs to Khakhar. They give the high-modern vocabulary of images a layer of irony associated with postmodernism, but remain committed to the meaning within the postmodernist genre of the picture-puzzle. Both Dodiya and Nair work consciously to recast iconographies of mythic and historical figures in the Indian cultural context. Thus it is as Indian artists that they make a particular contribution to the relation between the icon and narration and between the mythic and secular allegories coded to signal contemporary political encounters.

Dhruva Mistry and G. Ravinder Reddy, then K.P. Krishnakumar and N.N. Rimzon make a dramatic entry into the art scene in the 1980s. Breaking open the conventional use of modernist materials and forms, they establish the domain of figural, iconic (iconoclastic) sculpture in a manifestly theatric, at times provocative, setting. In the 1998 sculptural ensemble, *Speaking Stones*, Rimzon stages private mourning in the public domain: a crouching figure sits barricaded by a circle of rocks pressing down news of ethnic violence. Rimzon's profound concern with the archetypal subject advances the idea that the Indian artist's grasp of his self is haloed by the spiritual sense of community.

In the last two decades, the representational question has been tackled by women artists who take the bull by its horns and present a slew of alternatives. Indeed, Indian art has been characterised by women artists taking over the female body as their marked domain and handling its erotics to counter the carnal devourment and straitened forms of visual pleasure in male representations. Overlapping the beloved and the mother with the goddess image – so powerful in the Indian psyche to this day – artists like Arpita Singh and Nilima Sheikh have pulled it away from the false deification in the male imaginary. The discourse on female representations now includes allegorical accounts of the female body, the performance of the feminine as masquerade, anthropological definitions of identity and self-mocking aplomb. The photo-narratives of Pushpamala N. push the question of

representation to ironical ends. In *Phantom Lady or Kismet* (1996–98), she enacts a fantasy of the 'masked woman' and, with a collaborating photographer, constructs a suite of black and white photographs with an elaborate *mise-en-scène* in the style of *film noir*. In *Sunehre Sapne* (1998), Pushpamala, dressed up to become a middle-class heroine dreaming her existence through the medium of clichés and stock scenarios, arrives at a set of hand-tinted photographs that are perfect kitsch.

We have already, in these references, arrived at the changing status of the object (of art) in relation to material practices and forms of installation. Alongside we have seen that there is a substitution of full-bodied cultural metaphors with disembodied signs. There is a starting anew – sometime with debris – to reverse the norms of visual culture and to question the basis of art production. Artists like Navjot Altaf and Sheela Gowda resignify the importance of social production in a community context and simulate a ritual reconstruction of everyday life-processes.

Navjot Altaf has (intermittently since 1997) lived and worked with tribal artisans and ritual image-makers in the interior of the Bastar region. Her installations with discreetly/jointly made figures and objects, hug the earth, clutter the surface and shoot up like totems declaring their material and magical intent. Sheela Gowda, in her installation *Tell Him of My Pain* (1998), passes through the eye of the needle hundreds of feet of thread, then adds blood-red pigment and glues together these threads to make a thick cord. Great coils of disembowelled innards – umbilical cord, intestines, veins, nerve fibres, arteries – festoon a large room. This particular visceral route takes Sheela Gowda's concern with the ethics of (female) labour into an act of doing, nurturing, being. The woman's body is erotically signified through its absence, the work entangles you through the enticement of her labour that is also a narcissistic self-designation as artist.

I spoke above of the fetish. This form of coded desire deflects both the alibi of objective representation and the myth about material well-being. With the women artists mentioned above, there emerges a definite stand against high culture and high purpose. Together with male artists like Sudarshan Shetty and Subodh Gupta, developing their seductive and critical forms of commodity-fetishism, what comes into focus is the subversive, quasi-surrealist relationships with the Real introduced into the vocabulary of contemporary Indian art under the sign of postmodernism.

What is significant is that at the same time political intervention by artists takes on more elaborate strategies. I have already mentioned how a part of the cultural discourse turns on the problem of subjectivity positioned by women in the public domain. When this takes a reflexive turn, feminism itself can come to stand in for the larger question of the politics of representation. In the last decade, Nalini Malani has elaborated her engagement with the identity of the female as victim/as subaltern/as principal mourner in the theatre of tragedies. She invokes the psychic horrors worked out through mythology in her 1993 theatre installation for Heiner Mueller's *Medea* staged in Mumbai; and in the traumatised images titled *Mutants* (1994–97), she obsessively figures the environmental degradation of human biology. The threat of global

destruction finds its culmination in her 1998 video installation titled *Remembering Toba Tek Singh* after Saadat Hasan Manto's famous Partition story. This is Malani's end-of-the-century contribution to contemporary art featuring twelve video monitors relaying scenes of religious terror/ethnic conflict.

Continuing with the question of feminism and the politics of representation, Rummana Hussain (who died in July 1999) attempted successive modes of historical self-inscription: in her installations, *Home/Nation* (1996) and *The Tomb of Begum Hazrat Mahal* (1997), she chose forms of masquerade about the fictional/historical, real-life Muslim woman. Constructing an overlap of the female body (subject to affliction, intrusion, aggression) and historical sites (Ayodhya, and Bombay, recently violated), she laid out part-for-whole narratives about a woman's subjectivity/her Muslim identity in India. In her 1998 performance piece, *Is it What You Think?* she asked, as if from the crucible of Islam, questions that arrived at a redoubled state of doubt about *identity* too glibly theorised in postcolonial discourse.

Through the 1990s Vivan Sundaram has developed a succession of installation sites as (dis)placements of the historical motif. In his ambitious public project titled *Structures of Memory* (1998), a site-specific installation in the white marble monstrosity that is Calcutta's Victoria Memorial, Sundaram disembowels the imperium by inserting contradictory trajectories from floor to dome – as for example a twenty-four-metre narrow-gauge railway track that cuts through the middle of the Darbar Hall and turns the space of imperial encounters into a railway platform. Prefigured in the very design of this complex installation about Indian modernity, is a normative designation of the citizen who aspires to reconstitute the institutions of modern knowledge (archive, museum), into sites of labour, of social production.

There is, as we have seen, the appearance of an ironical aesthetic that drives a wedge between the artists and art market, between art market and the State institutions. Heterodox alternatives – secular, non-canonical, restlessly poised, and interventionist artworks have multiplied to offer a conceptual shaping of social energies in their transformative intent. There are what might be referred to as postmodern enactments of tradition through the means of quotation, allegory, and spectacle – as there is an increased theatricality in the making and presentation of art. While there is some ambitious and passionately committed painting being done in India, there is now process-based and situational art practice, often in the form of installations, where the artist, using familiar objects, overlays different modes of cognition to offer what I have elsewhere called a poetics of displaced objects. Further, as against this very foregrounding of material, there is a determined resort to conceptual distancing. We know that it is in the moment of disjuncture that an avant-garde names itself and recodes the forces of dissent into the vocabulary of art.

It is interesting that all of these are further subjected to a relayed critique that questions the tenets of postmodernism itself. Indeed, the testing and critique of the postmodern by the critically positioned postcolonial artist has become the occasion of furthering discourse in contemporary art history.

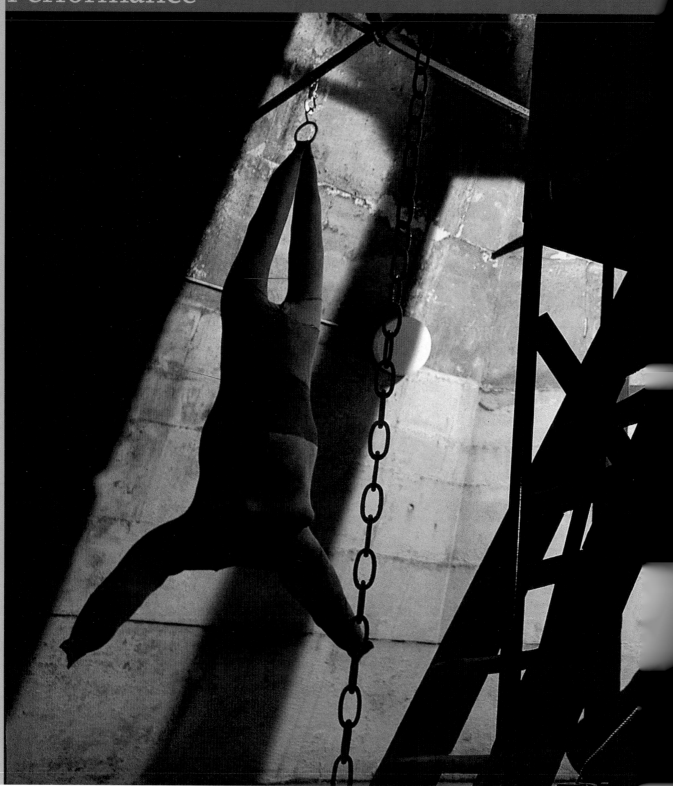

How is the body represented in contemporary art and culture? How are different bodies – inflected by race, age, gender and sexuality – mirrored in the wider culture? Performance plays a part in every aspect of our existence, from the different roles that we play in our daily lives through to the relationship that we have with our bodies. Artists from all over the world have used performance-based work to explore how the individual negotiates the external world. Artists use their own bodies, experiences and interactions to create artworks in which the viewer is rarely passive, but often an active participant. Through these artworks, the dividing line between artist and artwork, artist and viewer becomes increasingly blurred – and so too does the line between private individual and public body.

Janine Antoni: Artist's Talk

Organised by inIVA and hosted by Whitechapel Art Gallery, this talk took place on 29 November 2003. Janine Antoni talks us through a selection of her distinctive performative artworks which challenge our understanding of the body and of sexual and cultural difference.

I wanted to start with the first work I did out of graduate school, which mapped out a certain territory for me; from that point on, all my work has followed. It is a series of negative imprints in the wall: the first is my breast; the second is my nipple; then there are three latex baby bottle tops; and the last is the packaging of those latex nipples. When you go to the drug store, everything you buy has a kind of clear vacuum form of packaging with a cardboard backing. Well, those three nipples stack and fit into that packaging form. The piece is called *Wean* (1989–90) and, with a title like that, you probably understand that I'm interested in stages of separation from the mother. I was trying to figure out how I could do a piece about absence with having a sculpture present in the room, so I decided to take the existing architecture and scoop these forms out of it, so you could feel that something was missing. The moment between the real nipple and the latex nipple is very important to me. All the objects that I deal with are like the latex nipple: they're objects that mediate our intimate interaction with our body, they're objects that replace the body and define the body within culture. More than separation from the mother, I'm interested in the separation that we go through with our own bodies as we are weaned into culture.

Gnaw (1992) is a piece that begins with two 600 pound cubes – one of chocolate and one of lard that I slowly chew away at. About a week into the exhibition, the cube of lard collapsed on to the ground. I realised my lard was getting fatter and fatter. What was I going to do? Should I mix it with wax or put a cooling unit in it? And I decided that this aspect of the work was about materiality; if that's what 600 pounds of lard does, then

I should let it happen and it seemed somehow conceptually in keeping with the work. We all know how difficult it is to control fat in your own body, so it seemed quite appropriate that my fat was falling straight off the pedestal on to the ground. I then made objects from the material that I spat out while chewing the two cubes. The chocolate that I spat out, I melted down and made into heart-shaped packaging for chocolate candy. And the lard that I spat out I mixed with pigment and beeswax and made into about 150 lipsticks.

It was my first big show after graduate school and I was trying to take everything I had learned about art history and get it into this piece. The first inspiration was to do the most traditional thing I could do as a sculptor and that was to carve. I was also interested in the tradition of figurative sculpture, but I wasn't so interested in describing the body; I wanted to talk about the body by the residue it left on the object. And I put these two ideas together, so rather than use a hammer and chisel, I decided to use my mouth. Then I thought: 'If I'm going to sculpt with my mouth, what would be an appropriate material to sculpt with?' And it seemed like chocolate was a natural choice: it embodies desire for the viewer. I was interested in seducing you with thinking of chewing on 600 pounds of chocolate, then completely grossing you out by thinking about chewing on lard and then turning around and taking that lard and making it into lipstick. We wear lipstick to make ourselves attractive so that somebody will give us a heart-shaped box of chocolate. So I was amusing myself with this little story. But the most obvious reference in this piece is the minimalist cube,

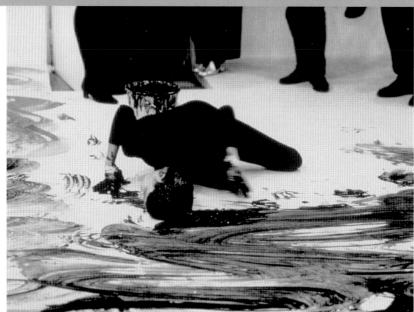

Janine Antoni, *Loving Care*, 1993.
Photograph: Prudence Cumming
Associates, London. Courtesy Luhring
Augustine, New York

which I chewed on, intending it as humorous. The dominant talk around this piece at the time was that this was an angry critique of patriarchal art history.

I'm a child of the 1980s in the sense that it was the decade when I was in graduate school, so I was thinking about some of the ideas of the 1980s when I was making this piece. The work entered a dialogue that critiqued consumerism and also engaged feminism. But I harked back to the language of the 1970s, a language that was more visceral and direct. It spoke more to my heart and so I tried to take some of my knowledge of the 1980s back to that language of the 1970s.

When I begin *Loving Care* (1993), a performance piece, the room is filled with people. Then, slowly, as I mop the floor with my hair, I mop the people out of the room. I used a similar logic to *Gnaw*. If I was thinking about how to use my body as a tool for making, it seemed like my hair would be a pretty good paintbrush. And then I thought: 'If I'm going to paint with my hair, what is the appropriate material to paint with?' It seemed like Loving Care hair dye, Natural Black, would work well.

I was also thinking about comparing painting to an everyday activity. The idea of mopping people out of the room is important because, on my hands and knees, I was very vulnerable, but claiming the space at the museum (or the gallery) was very empowering. When I was young, my mother would say: 'Janine, you have to go and play outside because I've just mopped the kitchen floor.' For that time, the kitchen became her space. How could I do the same thing with the gallery or the museum?

There are some obvious references here as well. I was thinking of those dramatic photographs of Pollock doing his dance around the canvas, but most specifically I was thinking about Yves Klein. I'm thinking about the women he painted blue and stamped the canvas with. Rather than paint the model, he wanted to paint with the model. My response in *Loving Care* is about the conflict of wanting to be the model and the master at the same time.

I'm interested in aesthetics that have been passed down to us through art history, but simultaneously I'm interested in working with the issues of woman and beauty. My hope is that if I work with both issues in a parallel way, I'll be able to call both of them into question.

To make *Eureka* (1993), I was suspended above a tub that was filled to the top with lard and was lowered into it. I thought that I was going to sink magically into the lard, but I had to get my friends to help bury me. When I was completely underneath, we removed the amount of fat that my body displaced and flattened out the top of the tub again. Then I was pulled out very dramatically. We took the bucket of fat that we had removed and we mixed it with lye and water and made a big cube of soap. I bathed with it for about two weeks, sculpting it by repeated washing. *Eureka*, was inspired by the story of Archimedes, who was asked by the king how much gold was in his crown. He's killing himself wondering how he can measure volume. And then, lying in the bathtub, he suddenly realises that his body's volume is displacing the water in the tub. He's very excited to have figured how to answer the question, jumps out, screams 'Eureka!' and runs through the streets naked.

It seems to me that Archimedes' body was a tool for the experiment, just as my body is a tool for making. But more important is this idea of body knowledge, the fact that he came to this idea through the experience of his body. This is pretty much why I do these extreme things with my own body.

I believe that because you, the viewer, have a body too, you might be able to imagine what it's like to chew on 600 pounds of chocolate or be dumped in a tub of lard, and I suspect that you don't have a neutral relationship to any of those experiences. I'm really interested in whether I can put the viewer in a position of empathy with my process. To me, this is a different approach to what we usually bring to a conceptual work of art. We normally stay very objective and go through a process of decoding information and putting it together to make meaning, which always keeps us away from what is unique about the object. I'm interested in a more subjective relationship to the object, and then if you want to analyse your response, that's up to you.

For me, *Eureka* is the next big breakthrough after *Wean*. *Wean* took you from the body and traced its way into culture. Now, with *Eureka*, by washing with the soap, I've told you a story that begins and ends with the body.

I'm interested in the fact that soap is made out of lard. If you think of lard as the material of the body, we've taken the body and made this object to wash the body, so we're cleaning the body with the body. Using my body capacity in fat to make the soap, I have metaphorically entered the cube. I'm washing myself with myself. That idea brings me to *Lick and Lather* (1993). This time I tried to tighten that circle a little

more, using my own image. Now, I'm literally feeding myself and washing myself with myself. I made a classical self-portrait bust. I used a product called alginate, that minty-tasting stuff they put in your mouth at the dentist, which makes this incredible mould. The alginate picks up every minute detail. I submerged my whole head in the stuff because I wanted to start with an exact replica of my body. Then I cast myself seven times in chocolate and seven times in soap. I reshaped my image by licking the chocolate and washing with the soap. The process of making the work was really different from *Gnaw*. With *Gnaw* I felt that the bite was aggressive; I was thinking of babies and how they put everything in their mouth in order to know it and half the time destroy it in the process. With *Lick and Lather*, the acts of licking and washing were very loving acts. Having the soap head in the tub with me was like having a little baby in there. Through this loving process, I'm slowly erasing myself, so it addresses, for me, this love-hate relationship we have with our physical appearance.

With *Slumber*, another work from 1993, I built a loom the size of a room, at the centre of which I placed a bed. I slept in the bed and hooked the electrodes of a polysomnograph up to my temples and recorded one night of my rapid eye movement (REM). I got about 1,500 pages of information in a night and was taught how to recognise which sections were my dreams. So I used the dream graphs as a pattern to weave an endless blanket. Every night I would sleep in the bed, and when I would wake, I would take my nightgown and rip it into strips and use that as the material to draw my REM patterns into the blanket.

Then I'd get in bed and sleep with my dreams again, transformed into the blanket.

I started by wanting to make a piece about sleep, as it's another everyday activity, like eating and bathing. At a certain point I thought: 'Dreams are the material of sleep. But how am I going to work with dreams? They're immaterial.' So I turned to psychoanalysis and surrealism and in my research I opened a book about the physiological approach to sleep; I found the polysomnograph and instantly fell in love with it. It seems to be doing what my work was trying so hard to do – science had made a machine for the body to make a drawing. If we think that art comes from the unconscious, this drawing was coming straight from the unconscious mind on to the page without an intercession of the conscious mind, a kind of automatic drawing.

With *Mom and Dad* (1994), I had this cool idea to turn my mom into my dad and my dad into my mom! They weren't so excited about it. My work being mostly about identity, and specifically gender identity, my parents were perfect because they were my role models in terms of how I came to understand my own sexual and gender identity. I got a make-up artist to teach me how to sculpt them into one another. The make-up artist could have done a much better job than me, but I thought it was interesting to turn the tables. They had made me and now I was going to turn around and remake them.

I started the piece with the obvious questions. What happens after forty years of marriage? Do you start to take on the qualities of your mate? I was thinking about gender roles and how we need them to communicate,

whether we work with them or against them. After forty years, I was observing that those gender roles seem to fall by the wayside and my parents were becoming a unit. I became less interested in making them into one another, and more interested in this half-mom, half-dad creature, a caricature or composite of the two. I have come to think of this work as a self-portrait, because that's what I am, a biological composite of the two.

For *and*, which I made between 1996 and 1999, I placed two 800-pound boulders on top of each other. There's a pole coming up through the centre, holding one on top of the other. There's another pole coming out horizontally from the top rock. I pushed the top rock around in a circle for about five hours a day, trying to grind these two forms into one another. The idea came to me in Delphi, where I saw these incredible walls; the stones were honeycomb-shaped and fitted perfectly together, with no mortar at all. I turned to my friend and asked, 'How's that possible?' And she replied, 'Oh, they took the two stones and rubbed them together until they were airtight.' It was so beautiful to think of two forms sculpting each other simultaneously, so I set out to create that perfect relationship. Parts of my stones were harder than others since they were made of different mineral deposits. In one very hard part, I started to carve an upside-down bowl in the top rung, and on the other side they touched ever so softly. Similarly to with *Mom and Dad*, I started to be interested in the resistance as much as the coming together. I started to think of a relationship as this space that we sculpt between us, so I called the piece *and*, in a way to try to name that space between.

Mortar and Pestle (1999) is also about how two objects come together and resist one another. It is a photograph that is 1.2 x 1.2 m and is shot on an 8 x 10 camera, so it has incredible detail. The inspiration for this piece is a desire I had to know the taste of my husband's vision. The work is a close-up of my tongue licking my husband's eye. You may be noticing that I have an obsession with trying to get on the outside of myself in order to see myself. I don't know if anyone else has had that experience of just looking into your lover's eye and wondering, 'What are they seeing?' The piece is also about trust as the eye is the most vulnerable part of the body, so for him to let me lick his eye is an act of trust.

I have this fascination with cows because I grew up on an island where there was only one cow and, as a little kid, we would get in a car and drive half an hour to get a look at this cow, as though it were a monument. I had the opportunity to show in a place in Sweden that was connected to a working dairy farm, so immediately I said, 'Can I go and see the cows?' Having not grown up around farms, I didn't know that they used bathtubs as troughs. I was thinking, 'What is this cow doing, drinking out of a tub for humans? Hmm, if I take a bath, do you think the cow will continue to drink?' So I got in the tub and the whole herd of them came and I got a little bit nervous. We took hundreds of photographs and this cow was just so incredible because she came and drank right close up, as if she was nursing from me.

I was interested in our relationship to the cow, in how we are weaned off our mother and on to the cow. She's like a wet nurse or a surrogate mother to us, but we don't know her intimately for having drunk from her. And so I wanted to do a piece that brought that relationship closer. The piece which I made in 2000 is called *2038*, which was the number on the cow's ear. I thought that number epitomises our relationship to the cow; she's not like an animal to us anymore, just some biological machine. The impersonality of the number contrasts with the tender moment I was trying to reference of a mother nursing her child.

One of my most recent works is the video *Touch* from 2002. I went home to the Bahamas and I set up a tightrope on the beach in front of my house. I walked back and forth on that rope, and when the wire actually bows, it lines up with the horizon. Some moments it looks like I am standing on the horizon. This horizon is probably the view I've seen most in my life. I remember my mother saying, 'Janine, go and see the world, because this place that we come from is behind God's back.' So the horizon for me represented the world out there. What I realise is that the horizon is not a real place, because the closer you try to get to it, the more it recedes. This video is about my desire to walk in this place – to walk in the place of my imagination.

01

The Visible and the Invisible: Re-presenting the Body in Contemporary Art and Society

The Visible and the Invisible: Re-presenting the Body in Contemporary Art and Society was a large-scale contemporary art project comprising a series of satellite exhibitions, installations and events occurring simultaneously in sites across Euston in central London. It combined new commissions and work, not previously seen in the UK, by fourteen international artists. The project was curated by Zoë Shearman and Thomas Trevor and artists included: Sutapa Biswas, Louise Bourgeois, Tania Bruguera, Nancy Burson and David Kramlich, Maureen Connor, Brian Jenkins, Bruce Nauman, Virginia Nimarkoh, Yoko Ono, Jayne Parker, Donald Rodney, Doris Salcedo and Louise K. Wilson.

01 Tania Bruguera, *Anima* from the *Homage to Ana Mendieta* series, 1996. Photograph: Edward Woodman
02 Doris Salcedo, *Atrabiliarios*, 1992. Courtesy Alexander & Bonin/White Cube, London
03–04 Jayne Parker, *Flood*, details, 1996. Photographs: Edward Woodman

Overleaf
Louise Bourgeois, *Single I*, 1996. Photographs: Edward Woodman. Courtesy Cheim and Read, New York

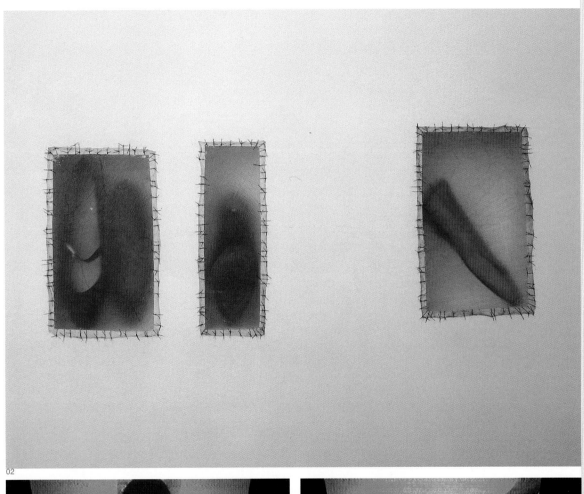

02

03

04

The Visible and the Invisible
Re-presenting the Body in Contemporary Art and Society

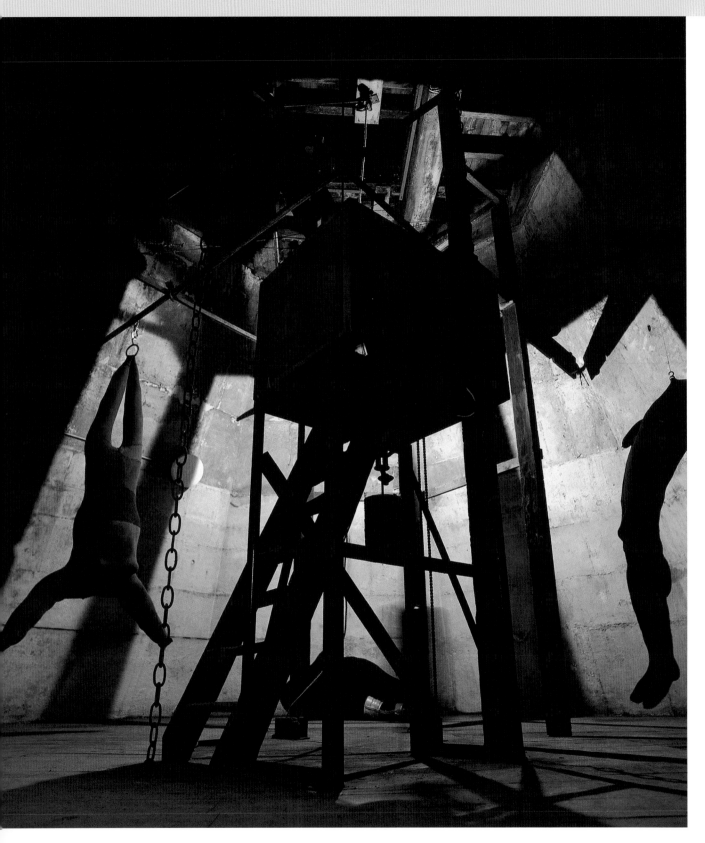

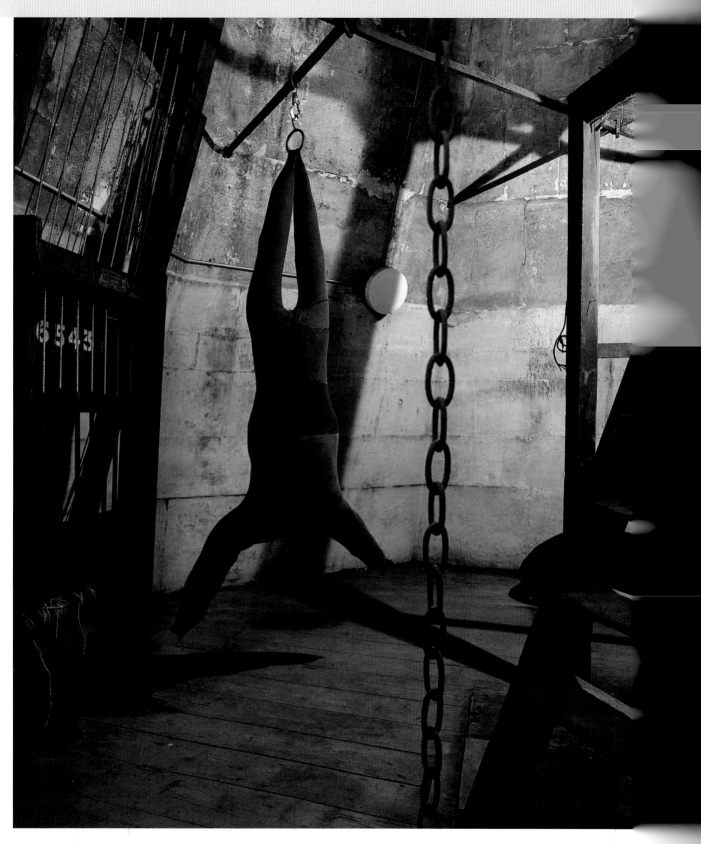

The Visible and the Invisible
Re-presenting the Body in Contemporary Art and Society

David Medalla in Conversation with Gavin Jantjes

This interview with Gavin Jantjes was published by inIVA in *A Fruitful Incoherence: Dialogues with Artists on Internationalism* (London: inIVA, 1998). In the extracts reproduced here, Medalla discusses some of his most memorable works, explaining the difference between his two types of performance pieces: 'ephemerals' and 'impromptus'.

Gavin Jantjes

Transformation through mobility is so much part of
what you do and what you expect the audience or
participants to do. In other words there is something
you expect of us....

David Medalla

I expect a simple dialogue. The reason why it seems that
my work has so many references to Western culture is
because those things that I did in the West are the ones
that have been documented. But I did a lot of things
during my three visits to Africa. I also lived in India,
Nepal, Thailand, Sri Lanka, Pakistan and Malaysia. In
those places the work that I did was totally ephemeral
except for one or two things that were photographed by
chance. But they were just as valuable to me as for the
people I encountered there, because they related to
what I saw there. To give you an example of this,
recently I was in Texas. Now that's not Asia but it's just
as exotic as any place for me, and the one thing that I
enjoyed doing there was meeting and working with the
Filipinos who lived there and the Tejanos and Tejanas –
the Mexicans who ruled Texas before US colonisation.
I was involved in doing performances with people who
were either in jails or people who were in jails which
have become museums. Being a country full of
banditry their jails are about their greatest monuments.
They have the most beautiful structures and I did these
wonderful events in them, so there was an inter-
relationship. I did a performance with masks, which I
have done everywhere, including Rotterdam and Paris,
but in Texas I did it in a Texan way with on-line dancing.
During my performance I distributed pages of the
Austin American Statesman and I invited people to
make paper masks which they wore as they danced
to live music played by young Texas musicians....

GJ_You have, of course, played quite a substantial
role here in England directing us towards a notion
of an international art which is not hierarchical and
institutionalised, but actually does look at practice
in a broader way....

DM_Before May 1968, I made one of my most
beautiful conceptual works. I used to go back and forth
between Paris and London.... But one summertime I
arrived and the [student] restaurants were closed and
I went to the Sorbonne and met some people there
who said they do still run a restaurant somewhere in
the Sorbonne but for delegates who were having a
conference. These were presidents of universities and
colleges from around the world. So I said 'How do I
enrol?' and they said 'Well you have to be a president
of a college or university. In France they make these
cartes de visite, so I got one made which said 'Président
Universitaire de Failure'. They thought this must be
a new university in the Pacific Islands, the 'Isles du
Failure', so they enrolled me. Then they said,
'What is your school, where is it?' and I said, 'Well
at the moment we're having problems in the Pacific.'
This was when there had been atomic tests in that area,
so I said, 'I'm moving it to England as a correspondence
school.' They were very serious and wanted my address.
Months later, back in England, I started receiving
correspondence from people saying, 'Can you please
tell us what your university is?' and I said, 'Well, we just

guarantee that we'll fail you in anything.' People would write to me and say things like, 'I'm just newly married and my husband likes me to make a special type of omelette but I always seem to make a failure of it, and I'm getting worried he might be turned off by me.' So I wrote to her and I said, 'Don't worry I'm sending you a certificate and tell your husband that I guarantee you will fail every omelette that you make.' So I had a lot of these people who were afraid of failing in something: their driving test, reaching an orgasm etc., and I was running a correspondence school all over the world because of this wonderful university. Finally somebody from the Ministry of Education here visited me. He said, 'Are you David Medalla?', and I said, 'Yes'. 'You know that it is illegal to conduct any correspondence courses in England unless you have a permit from the Ministry of Education?' I was horrified so I said, 'Oh I didn't know that'. I was terrified of being deported so I had to write to all my students saying sorry I failed in this one too. This was to be my most beautiful work. I call them cosmic propulsions.....

GJ_I want to talk about the torn paper mask pieces you made. A mask both conceals and reveals. It raises all those questions about cultural, personal and sexual identity. And because your masks are paper, they bring to mind another mask, that of the 'paper tiger' which Mao Zedong used as a metaphor for the frightful enemy who is just a paper effigy.

DM_I've always done masks in performances, but the mask I made in Venice really worked well. I did my piece in the Academy, it was called Voyages and

Somersaults of the Pilgrim Monkey. I always believe that where you are you should try to relate yourself to the environment. Venice is the one city in Europe that for a long time was the meeting place of East and West, so I came across a poem about Alexander the Great going to Persia and conquering Darius.... I decided to play [the] role of the monkey by reconstructing the story from the poem. After conquering Darius, Alexander the Great went to the desert to this big temple with a perfect dome which Darius had built. The dome's interior was undecorated, so Alexander asked his ambassadors to look for the most brilliant artist they could find in all his kingdoms. One set of ambassadors found a young Greek artist in Alexandria, and brought him all the way to the desert, while another found an old Chinese artist with a monkey who had been decorating the caves of Duhuang. Alexander divided the inside of the dome into two parts with a huge, thick curtain and he gave each of the two artists a part of the dome to decorate with the theme 'the beauty and unity of the cosmos'.... So they worked on this thing for a period of a month and when Alexander came back he saw the work by the young Greek as he entered. It was beautiful and perfect like everything in Greek art at that time, a pantheon of creatures of creation. When Alexander went to the other half of the dome which was in a kind of darkness, he looked up and there was nothing on the ceiling.... And the Chinese man said, 'If you remove the curtain you'll see what I've done.' So they removed the curtain, and all of this time the Chinese man, with the help of his monkey, had polished his half of the dome so it became a mirror, and it became the unity of the cosmos. So you have these two visions. In doing this

performance I had to make masks and because I had very little time I made them out of things I found while working in Venice. One of them was a pizza box. I started to make it into a paper mask. People laughed and they said 'Oh my God it looks like an ancient Greek mask.' That was the beginning of these paper masks..... In Rotterdam, for the start of the De Kooning show, the paper masks were made in such a way that we cut out the lips and pasted on our smiling lips for a work called *Smiles for Willem*, for De Kooning....

GJ_You also say that your art is dialogical, meaning that there has to be a common language for discourse. There's something you expect the audience to be, you expect them to be prepared to engage in a conversation. But are these dialogues predominantly about culture or do they step outside of culture? In other words what is the role of the participants in your pieces?...

DM_I'll give one example, *A Stitch in Time* which is very dialogic.... *A Stitch in Time* started in 1968. I had two lovers who by chance arrived in London at the same time. One was going back to California and the other was going to India, and in those days you had even longer waits in airports. I had to see both of them at the same place and I had nothing to give them. I had two handkerchiefs, which is how it started, and I had some needles and thread. I'm very bad at stitching things by the way, I couldn't even stitch a button, so I said, 'Hey listen, just in case you get bored along the way why don't you just stitch things', because I understand that if you do some needlework it's very therapeutic and waiting for aeroplane flights becomes less boring.

I gave each a handkerchief and at first I sort of embroidered my name and the date and love and all that, and I didn't see them again, neither the lovers nor the handkerchiefs, for many, many years. Then one day I was at Schipol airport in Amsterdam and there was a young, very handsome, tanned Australian who was lugging something which looked like a very crazy sort of totem and it looked very interesting. He said 'Somebody gave this to me in Bali and you can stitch anything on it'; it had become a column of my *Stitch in Time*. I looked at the bottom of it, and it was my original handkerchief.... After that I started to make different versions of *A Stitch in Time* in different places....

In Paris where I installed it at the Musée d'Art Moderne, many of the young people would go to the toilet and take polaroids of themselves naked and stitch them on, and then I think somebody kept taking them off because they were terrified that the museum might be closed for pornographic reasons. In Texas, some people would stitch a marijuana joint, and then another would stitch a hundred dollar bill and pick up the marijuana joint. Recently I put up another version of *A Stitch in Time* in Cornwall at the *A Quality of Light* exhibition at the Tate, St Ives. In the first few days, because St Ives is very Methodist, many people were stitching prayers on it, quotations from the Bible and things like that. One lady put a beautiful fish and then an explanation that this was the symbol for Christ. That was the first week, but by the second week the tourists started coming in and now they put nothing but tourist things that they'd picked up everywhere: hotel brochures, restaurant menus, railway and bus tickets. So you see there is a dialogue, but it begins to be more

and more like a choral symphony because you can look at what people have stitched, and begin to realise that in one sense it refers to a specific time and place, a specific person, then you see the densities and the diversities of people. In many cases they just take things out of their pockets, and the things they take out are fascinating because there are two kinds. On the one hand something they want to get rid of, like an old ID card, and on the other hand something that they treasure, like a small photo of their lover or friend or of themselves. One guy stitched a quotation from Gandhi which he had found in Bangalore and kept in his pocket for years. This little text from Gandhi was something he treasured. I remember from the 1960s and 1970s some totally insensitive people who would light cigarettes and burn little holes with cigarette butts, but actually it became quite an artwork because somebody would start with just one little hole and then somebody else would add to it and then before you knew it you had a Fontana or an Yves Klein in miniature.

GJ_You have a lot of works which you call 'impromptus', but you initially called them 'ephemerals'.

DM_There's a difference actually. The 'ephemeral' is a physical thing that I used to do. There were artists like Lygia Clark and Hélio Oiticica who were my friends in the 1960s, who were such pioneers in participation art. Lygia Clark made a work with a stone on a plastic bag. You blew into the bag and your breath sustained the stone. You could feel its weight. It's a beautiful work, a masterpiece in fact of modern art. Hélio did things where he would have containers full of bright pigment and you plunged your hands into them so that you felt the colour inside.

I did pieces that were very simple things like games with a line and cone for picking up raindrops. Or in some cases I did things with leaves where you darkened one part with saliva or with tea stains and then measured sunlight with it. Just standing there measuring sunlight, very ephemeral. But the impromptus were different because they came from performances. There was one impromptu that I did with Kai Hilgemann, when we used to walk in cities at night in front of all these windows selling men's clothing. I've always admired Casanova, to the horror of my feminist friends, for his writings, and I did a piece called *Mr Casanova International*.... One thing I would do at night with my friend Kai, because we couldn't afford expensive clothes, was to look in the windows of men's stores. This was the time when artists were beginning to dress in Armani suits and Versace shirts, it was the new style. I enjoyed performing in front of these windows. I would talk to people and I would say, 'Heh, do you want to get rid of your shirt?', and they would say, 'Yeah, do you want it?'. So I started to make them into actual instant installations on street pavements by using a very simple spectrum concept, using the rainbow, putting the darkly coloured shirts on to one side of the pavement and the lightly coloured ones on to the other side. Then I would put the different shirts into different formations on the pavements of cities at night. People walking by, who are used to beggars and homeless just thought I was one of them, but then I started to perform in front of these things.

I would go to cities where I didn't know the language, I couldn't speak Catalan in Barcelona or German in Germany. I would get some of these magazines that advertise sexual things.... So I would read these out and I would pretend to be one of these dummies, so I'd say '*Isch veen ein...*' It was a good way of learning the language, and people passing by would ask what I was saying and doing? I would say 'This is Mr Casanova International', it's all about the desire for love, the desire for partnership.

So there is an impromptu, it was of the moment, but there is an actual structure to all of them.... My impromptus are carefully constructed and very subtly done. Once I coerced Guy Brett[1] to come with me, on a walk from Brixton to Westminster.... When we arrived at Westminster Bridge, I put a bust of Mozart and Beethoven on each hand, pretending they were boxing gloves and I put on a mask, one of my paper masks, which is actually the cover of a book entitled *Psychic Self-Defence*. I had a little tape recorder at my back playing Mozart or Beethoven. Then I start confronting people with Mozart and Beethoven. Occasionally I punched, ever so lightly, a passer-by. Other passers-by said 'Oh my God what's he doing'. It was an act of 'psychic self-defence', protecting myself with effigies of two great composers.

I spent a year in Rotterdam and often I just walked down the street where there's the flea market: the Blaak. I did impromptus called *Celebration of World Mythologies*. Rotterdam is a big port and people come from all over the world with all sorts of things. There you have every single kitsch you can imagine, from Greece, Kenya, Taiwan, Uruguay, etc., and I gave myself

the challenge that if I found anything I had to dance with it, I had to do a specific dance. People asked, 'How do you manage to do this? It's so wonderful.' It's because it's all contained in my knowing this plethora of cultures.... I make these connections all the time by the way, because I think it's a way of not becoming alienated.

GJ_Being conscious of how the world is actually structured.

DM_It's a performance, and sometimes it gets recorded, and the interesting thing is that the photographs that are taken look so beautiful. And people say to me, 'Why are they so beautiful?' and actually it's because they are from a pictorial mind. I actually started as a painter, so I'm very conscious of the painterly, even though it doesn't look like that at first.... I did a piece in Texas where I was trying to be like a crazy cowboy and I had all this ice because it's very hot. I just went to the refrigerator and coloured the ice with different colours. Americans love all this lemonade and blackberry. I had cast all these little cowboy toys in ice and when they started melting they became limping cowboys. It was beautiful, it was an impromptu, but it was done thinking pictorially using what was available.

Note
1 Guy Brett is a writer and critic and long standing friend of David Medalla. He is the author of *Exploding Galaxies: the Art of David Medalla*, London: Kala Press, 1995.

David Medalla is a pioneer of conceptual, kinetic, performance, time-based and live art. He has worked with inIVA on a number of occasions over the past ten years, including his exhibition, *The Secret History of the Mondrian Fan Club II: Mondrian in London* (1994); the 1995 reprinting of a boxed facsimile edition of *Signals*, the magazine which Medalla edited in the 1960s; and his participation in the exhibition *A Quality of Light* (Tate St Ives, Cornwall, 1997).

David Medalla

01 David Medalla, *A Stitch in Time*,
1972. Arts Council Collection
02 David Medalla, *A Stitch in Time*,
Tate St Ives, 1997. Photograph:
Richard Okon

Overleaf
David Medalla, *Cloud Gates*, 1994.

01

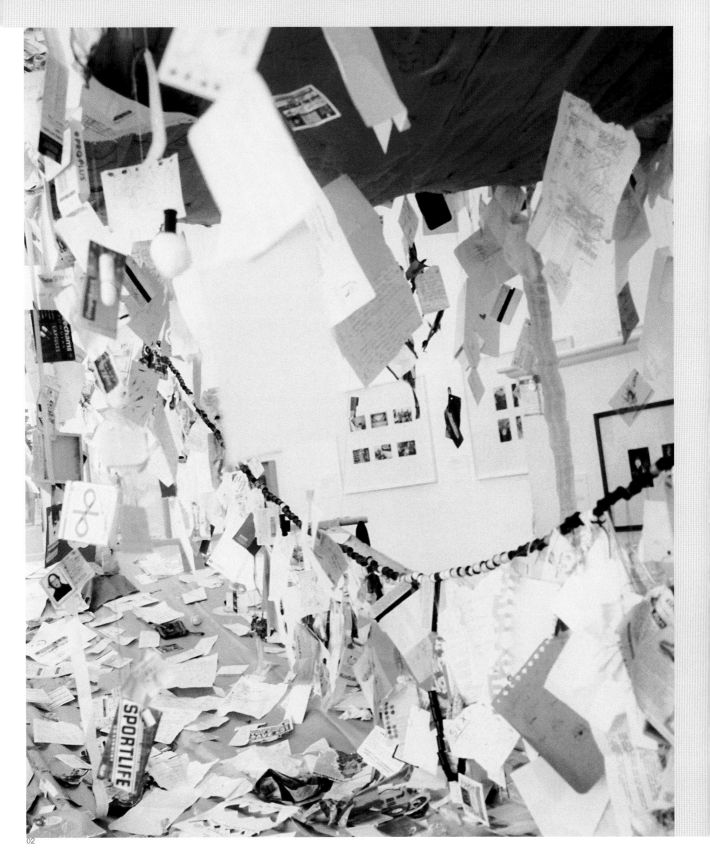

David Medalla

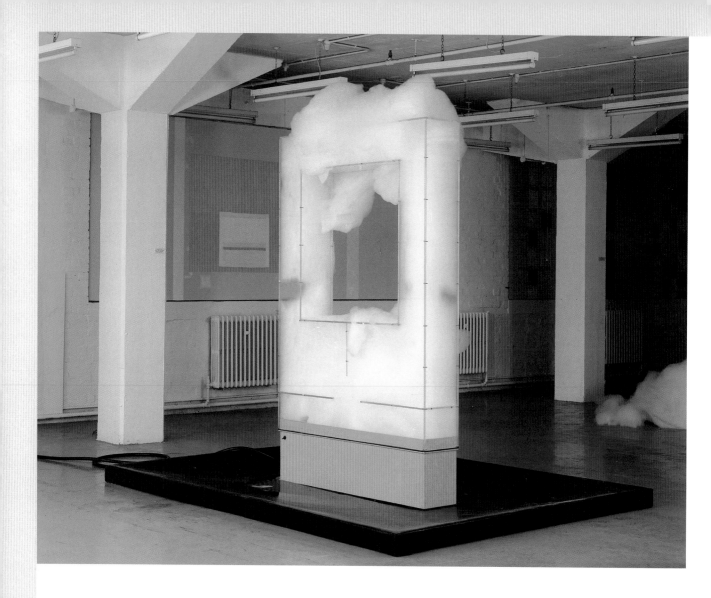

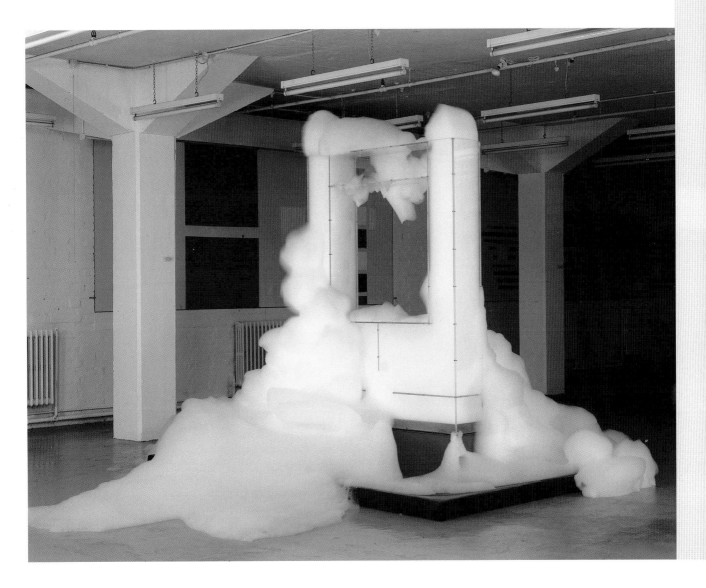

David Medalla

Over the past decade, the world has literally gone global. Not only do commodities and investments flow across the globe but so do artists and artworks. In recent years, biennials and triennials have sprung up in new locations across the world from Johannesburg to Havana, from Cairo to Kwangju, from Sydney to Berlin. Significantly, these newly inaugurated events have rejected the national, competitive model established by the Venice Biennale with its national pavilions and prizes in favour of cross-national thematic exhibitions which bring together artists of different national and ethnic identities under the same roof. But has the recent globalisation of the art world brought us any closer to understanding the particular and varied experiences of people in different parts of the world?

Changing States:
In the Shadow of Empire

Stuart Hall and Michael Hardt

On 12 December 2002 at Tate Britain, inIVA held the last in its year-long programme of 'Changing States' debates that considered the shifts in the cultural landscape in the light of globalisation. Michael Hardt is co-author with Antonio Negri of *Empire* (Cambridge, MA: Harvard, 2000), in which they argue that Empire is alive and well in the form of the new political order of globalisation, with new forms of racism, identity, difference, communication and control. This discussion with Stuart Hall was chaired by Niru Ratnam.

Michael Hardt

I'd like to start thinking about the relationship between political representation and cultural or aesthetic representation, which clearly are different concepts but none the less have some relationship. I've been thinking a lot recently about the crises of democracy that have been provoked by processes of globalisation, due in many ways to the failures of political representation. Throughout the modern era, representation on a national scale, in its various forms – electoral systems, citizens' groups, trade unions – have been criticised, and rightly so. In the processes of globalisation, however, much more dramatic failures of political representation on a global scale are provoked. For instance, there are many ways in which, today, everyone in the world is represented by the US president and the US military. There are ways in which everyone in the world is represented by the major multinational corporations. There are ways in which, also, everyone in the world is represented by the major supernational economic institutions: the IMF (International Monetary Fund), the World Bank, the WTO (World Trade Organisation). I would call it a patriarchal representation, in the way a feudal lord represented the peasants, or the way a slaveholder might have represented the slaves that he owned. It's obviously a very weak form of representation and the way that many in the world are represented by such institutions should provoke us to think about the failures of political representation and the crisis of democracy on the global scale that it entails.

I feel like we're thrown back, in thinking about democracy, to early modern periods, primarily to the eighteenth century, when there was a similar question of scale in relation to democracy. For instance, you could imagine eighteenth-century sceptics saying, 'In the Athenian city state, in the confines of the *polis*, democracy was possible, but in the nation state, it's absolutely unthinkable.' Today, those who advocate democracy in a global domain are met by the legacies of those sceptics, 'Yes, of course, in the limits of the nation state, democracy was possible. But now, on a global scale, it doesn't make any sense.' We can learn from this analogy that the crisis of democracy, the crisis of representation, has to do with a question of scale, which was at least one element of the early modern dilemma in North America and Europe.

This failure of representation in a political sense also relates to the concept of representation, in both cultural and aesthetic terms, which has certainly undergone several crises in recent times. I want to ask you how political and cultural representations are related and how each, perhaps differently, is related to the problem and the possibilities of democracy?

Stuart Hall

Let me just say first that I agree with much of what you have said so far. I do think the crisis of representation politically has to do with what is happening to the nation state. I think the nation state, the national economy, and to some extent national culture, together, were the principal framework in which, over the last two hundred years, we've come to think of political representation, and there is certainly a major crisis and rupture in that. This takes different forms in different nation states, but it now seems to me that there is this

general *caesura* between the forms, the means of representation and where the people are.

A second thing which has led to the crisis of democratic forms of representation is more local and has to do with the way in which notions of liberal democracy have been massively colonised by a structure of power. The two key elements that come together in Francis Fukuyama's thesis about the end of ideology and the end of history are the massive revalorisation of the market and the ideology of liberal democracy as the only coherent expression of freedom left. Precisely because it so unites and condenses the market and representation, that particular notion of liberal democracy has weakened and eroded notions of democracy.

The commonsense wisdom is a blanket notion that globalisation has subverted the nation state, but that is not my own position. National politics and a national economy can no longer function within the borders of the nation state, because they are overridden by global economic, political, geopolitical and military questions, but nevertheless I think there is still a kind of 'displaced place' for the nation state and national politics. They survive, but in a weakened, more subordinate state. And the US remains an exception to all this.

But back to your question. Although there is no neat parallelism between crises of representation in the political sphere and in the cultural sphere, I can't help thinking that, *à la longue durée*, they are not unrelated. If you think of politics as always underpinned by the framework and dissemination of cultural meanings, culture seems to me to have always been the integument within which politics is obliged to operate.

This is not to reduce politics to culture, but there does seem to me to be a connection between the two. You can't get a major crisis in cultural representation which persists for any period of time, which doesn't in the end also undermine, or have a bearing on, the way in which political forces are represented.

One of the immediate effects of globalisation has been the so-called internationalisation of the circuits and circulations of cultural and artistic production. This is an extremely tricky phenomenon, because it's now ideologically represented to us as if there is a frictionless cultural universe in which anybody can get on the tramline anywhere, any work of art will be seen anywhere. This reductive model presents globalisation as a circuit without power, which is very mysterious. In reality, the moment you look closely at those circuits, you see massive disparities of access, of visibility, huge yawning gaps between who can and can't be represented in any effective way. I think this is because we haven't effectively grasped the singularity of globalisation as a concept. Instead, we have transferred some of the old humanist feelings we had about internationalisation to it. But globalisation is not internationalisation at all. It doesn't have anything to do with *inter*-nations.

MH_I want to emphasise two things that Stuart said, which seem to me to be absolutely right. Such discussions often 'go off track' when one person says, 'There is globalisation, therefore, the nation state no longer matters', and the other person says, 'The nation state is still important. Therefore there is no globalisation.' Both and neither are true. Within these

extensive global networks of power, nation states still play extremely important roles. For instance, the global economy must also function through the decision-making of national capital, but in a way that at the same time looks at the interests of global capital. National interests and global interests coexist, in ways that are sometimes complementary and sometimes conflictual.

The other thing that I wanted to emphasise is that I do recognise that systems of power have become globalised, that resistance movements have become globalised, but that doesn't mean that there aren't hierarchies. Globalisation is not about a general equalisation, nor about a creation of a smooth world; instead it's about the creation of proliferating hierarchies that exist in each geographical location, among geographical locations.

SH_The fact that globalisation excludes certain people, it exploits certain people, it drives certain people into poverty, into the margins, into migration would suggest that the resistance to globalisation comes from those it excludes. However, that is not your position in *Empire*.

Let me take it back to questions of representation. One of the most transformatory things in the last two decades has been the way in which the thematics of visual representation have been massively rewritten from the margins, from the excluded; and this is precisely the contest being played out within that global circuit of cultural production. It's not just that folks are being kept out of the mainstream, but their historical experiences, their trajectories, are what people are trying to write back into the centre. This year's Documenta got ambiguous press because it did not show the best that has been thought and said and written in Western Europe, which is what you expect from a big international modern art show now. You walk through all these halls and you see massively excluded discourses, images, including forms of representation, using the media, using multimedia, using the modern forms of technology in order to voice the marginalised, the migrant, the endlessly mobile, the homeless. These works are tremendously important, so I'm not sure why you argue that this is not where the key resistance to a global system of power is going to come from.

MH_*Empire* is formulated on two slogans: that empire, or global power, has no centre and that there is no more outside. When saying that there is no more centre to power, we're trying to argue that the forms of cultural and political practices that were assumed to be liberatory are not necessarily liberatory and sometimes coincide with forms of power. Global power is not centred in the White House or in the Pentagon or in Wall Street, but is instead a distributed network of powers – including the major nation states, military powers, the major corporations, a variety of non-governmental organisations – that has no centre. That proliferation of powers, or of nodes, isn't necessarily itself liberatory, and can be a more frustrating form of domination.

SH_But for whom?

MH_For us. It can inspire a kind of nostalgia for previous political frameworks: if only there were a

Winter Palace to storm; if only we knew there was a centre of power, we could storm the Winter Palace and it'd be done. But if one accepts this notion that there isn't a central headquarters of power, but a more dispersed network of systems instead, then how can one direct one's attack against it?

From my point of view, it's not that we have too much globalisation: we have not enough. Certain forms of globalisation – globalising relationships, free movement of peoples, for example – have been introduced but are limited by the present form of globalisation. What we really want is a more thorough-going globalisation. With that kind of logic, I would argue that the present systems of domination contain within themselves the possibility of a kind of liberation.

SH_I accept that we need to think of both globalisation and anti-globalisation as networks and nodes rather than concentrated opposition, focal points, agreed agendas, etc. As I understand it, you're saying that the current globalisation is a hangover of the older system and that in an ideal fully globalised system, there wouldn't be a centre. But I'm not sure that you're right to read globalisation at its most ideal form. What we have now – the United States as an extremely powerful nation state in a global system – is not going to disappear, but is the messy reality that exists. You can't omit the centring effect of the existence of the temporary localisation of power in the United States. 'The mess' is actually what we're in: neither the old nation state, nor no nation state, but some funny configuration of the national and the global. It's not about no centre and it's not about the old centre, nor

the US as an old style of imperial power. Instead, in this new configuration, there is a difference between the role which very powerful nation states can play in orchestrating the global distribution of power; it has centring effects that count politically.

MH_It seems to me that in the last year and a half or so, there has been the formation of a US imperialism that is in fact based on older models of global extension of the control of a nation state. The current US administration is imagining itself as a centre of the global system; they want to transform the global networks or channels in a variety of domains so that they're centred on the United States, to create a network where everything passes through the United States. Economic flows, cultural flows, certainly military or security flows pass through the US. Rather than a decentred, distributed network like the internet, they create a network resembling a wheel with spokes, which all lead to a common centre. It seems that the global elites today have two alternatives: either US imperialism or what we describe in *Empire* as a decentred system.

I would argue that US imperialism is actually acting against the interests of the global elites today, even the US global elites. It's against their interests in economic terms that the great profits of capitalist globalisation are facilitated by the lowering of boundaries and the proliferating channels of exchange across the globe. By transforming this network US imperialism is in fact raising boundaries; it's obstructing the possibilities for profits for global capital itself. In security or military terms, US imperialism exacerbates the conflicts that

are recognised in the present forms of global hierarchies we have and it organises those conflicts. It paints a big bull's eye on the US that says: 'If you're not pleased with the present world order, this is who you blame'. In contrast, a system like Empire, in which there is a real decentring of forms of power deflects antagonisms born from hierarchies in the globe.

SH_As far as capital and the communicative systems which are central to it are concerned, a cultural homogenisation would be most appropriate to a fully globalised world. In the course of the expansion of the cultural industries – which are no longer in some super-domain of culture out there, but absolutely integral to the operation of capital, as global capital could not function without the communicative systems and that has transformed the nature of forms of labour – cultural homogenisation has encountered a resistance which takes the form of localism, particularism. It says, 'Not *ER* every night; let's have a Pakistani soap opera every other night.' It is I suppose the same thing as one found in the economic sphere. During the Asian crisis, Malaysia said, 'We are going to adopt the nation state solution, and within our borders we will simply suspend financial transactions.' Of course it has to come back into globalisation, but it did use this 'backward' form of the nation state and the national economy as a kind of temporary barrier to insulate some folks from the full sweep of the Asian crisis. I wonder whether, in looking for the points of friction in the global system, one isn't obliged to go to exactly those points where there are particularisms which interrupt the smooth flow of the global.

A lot of modern labour is flexible and mobile, but migration is that kind of joker in the globalisation pack. The ideal form of globalisation must, if it is to take competitive advantage of different markets, want labour to stand still. Capital flows, investment flows, money flows, commodities flow, goods, messages flow, meanings flow, but labour cannot be as mobile because there's no point at all in Pakistan being in Los Angeles. Whether driven by civil war or by disease, or just because they see it on the television, people pick themselves up and start to move. The unplanned, largely illegal, flow of peoples is an incredible phenomenon of our time. Some move for the most desperate reasons, some are not necessarily desperate, and some still come in search of better economic opportunities. They go through the most desperate circumstances, they ride on the bottom of trains, they attach themselves to the wheels of aircraft, to move, to move, to move. This is a location of resistance within the system, and it keeps being not fully within the control of global power and of global capital. It is the undefined story, the un-modernist story, the un-museum story, which keeps getting spoken in cultural production; it's produced not outside, but not completely inside either, not completely managed, or manageable by the circuits of global capital.

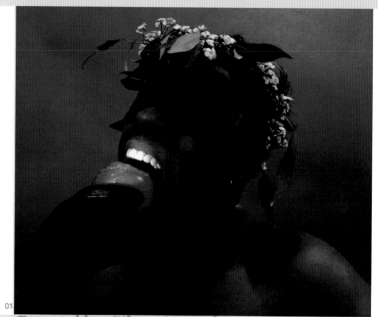
01

Fault Lines: Contemporary African Art and Shifting Landscapes

Curated by Gilane Tawadros as part of the Venice Biennale 2003, *Fault Lines: Contemporary African Art and Shifting Landscapes* brought together contemporary artists from the African diaspora whose works trace the outlines of fault lines that are shaping contemporary experience locally and globally. These fault lines have been etched into the physical fabric of our world through the effects of colonialism and postcolonialism, of migration and globalisation.

01 Rotimi Fani-Kayode, *Untitled* from *Communion* series, 1995. © the artist's estate. Courtesy Autograph: Association of Black Photographers, London
02 Laylah Ali, *Untitled*, 2001. Courtesy 303 Gallery, New York

Overleaf
03 Sabah Naim, *Untitled*, 2003. Photograph: Muhammad Saif
04 Clifford Charles, *Rhythm and Blues*, 2001
05 Frank Bowling, *Who's Afraid of Barney Newman?*, 1968. Private Collection

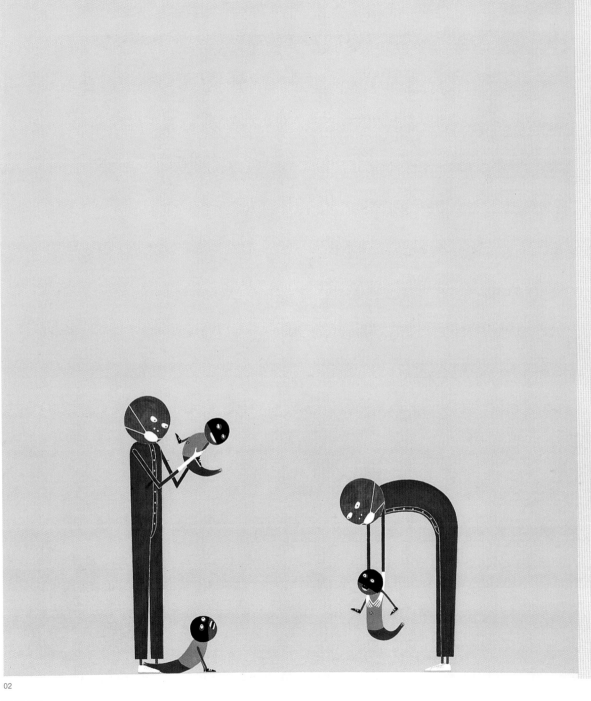

Fault Lines
Contemporary African Art and Shifting Landscapes

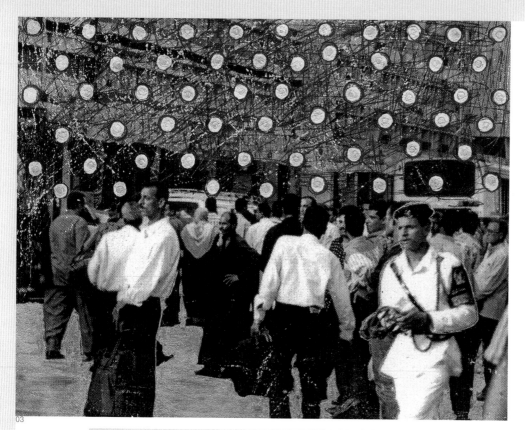

03

04

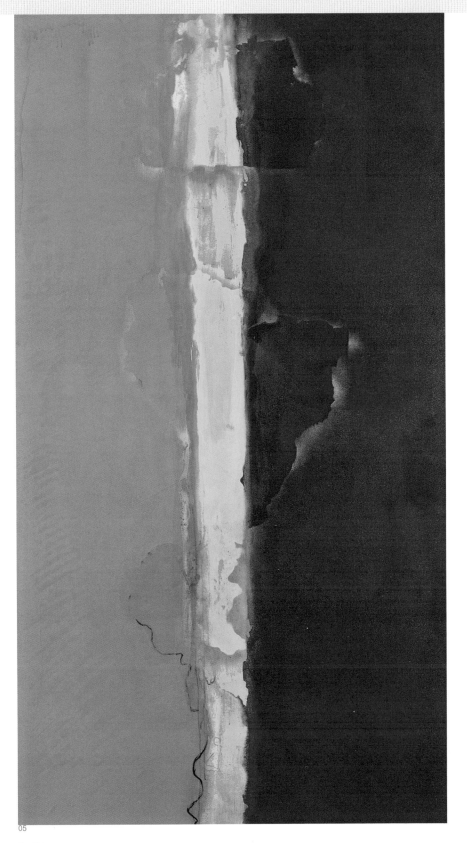

Fault Lines
Contemporary African Art and Shifting Landscapes

Simon Tegala
Downloads his Heart

Deborah Levy

To accompany statistical information and data about Simon Tegala's heart rate that was collated as part of his *Anabiosis* project in February 1998, writer Deborah Levy was commissioned to write a fictional text for the *Anabiosis* website (www.iniva.org/anabiosis). The resulting diary entries are presented as an antidote to the analytical heart rate information that was transmitted twenty-four hours a day to a large electronic display in central London for a period of two weeks.

14 Feb 1998: Simon Tegala has lost his heart
He leaned his back against the wall of the embassy and held her against him. It was an electrical event. Small voltages spread through their limbs. She fluttered her blue mascaraed atomic eyelashes against his cheek. She said, honey, that was a test burn. She heard his heart sounds: lub dup lub dup lub dup. She noted they were fifth in the queue for visas. Naomi was the Newton of atomic kissing; erotic radioactivity buzzed through her blackberry lips. They had to produce proof of identity in triplicate. Driving licence, passport and a household bill. He knew that her lips were a state of mind, a site-specific performance. He knew they were never going to make it to America. Immigration officials had to turn a hose pipe on the couple.

15 Feb 1998: Simon Tegala is smoking to his heart's content
Simon Tegala bought three packs of cigarettes made from blond tobaccos and a bottle of vodka. While Naomi went off to buy chicken at a meat market, Simon Tegala threw the I Ching. He opened the book of Knowledge. It said: This hexagram is made up of veins and tissues (symbolising X). This hexagram is made up of fats and oils (symbolising Y). Naomi walked into his apartment carrying the meat wrapped in wax paper. They salted the chicken and cooked it in its own sweet juices. The Cuban guy from next door shared the meal with them. He wore a cool cotton shirt and said he sold guns in the Miami flea market. Simon Tegala smoked the whole pack of blond cigarettes. He inhaled and exhaled and inhaled and exhaled.

16 Feb 1998: Simon Tegala wears his heart on his sleeve
Naomi said to Simon Tegala, I want you to touch my body in the following order: 1 My head; 2 My foot; 3 My ear; 4 My hand; 5 My belly; 6 My thigh; 7 My eye; 8 My mouth. She said, you can touch my inner thigh at dawn, my armpits at noon, my neck at midnight, my ribs mid-morning, my breasts at twilight. She said, when there are thunderstorms I am aroused, when it rains I am anxious. Simon Tegala's heart is a biomachine beating hard and fast. It is dawn.

17 Feb 1998: Simon Tegala's heart is in the right place
Mr Tegala is sitting in a caff eating a fry up. Eggs bacon mushrooms tomato bubble two slices and a mug of tea. Simon Tegala is trying to predict what will happen with him and Naomi. Images of projected futures whirr like a slide show behind his eyes. His heart is creating a science fiction.

18 Feb 1998: Simon Tegala's heart is full of fear and anxiety

19 Feb 1998: Simon Tegala's heart is in his mouth
Naomi said, what do you mean you feel strange lying in my arms? Of course we are strangers that's the bloody point of kissing. I sometimes feel a stranger in my own country, in my own home, clasped to the bosom of the mother who birthed me. I am distant and reserved in my own street which is as familiar as the back of my hand; the corner shop, the bit of the pavement that is loose, the house where the mad woman lives, the house where the man with the white dog lives, the tree with berries growing on it through the winter and which birds nibble, the house with the cats who watch the

birds from the front window, the house where Dipo lives with his two young children, the block of flats where the masseur who's going to visit the Inca sites lives. We are strangers that's the point of kissing. You're a problem boyfriend you should go back to boyfriend university and get some qualifications. Whatever, I can't hang out with a guy who has no car to run his girl around.

20 Feb 1998: Simon Tegala has set his heart on a Cadillac
While he negotiated with the car salesman – a dude with a brummie accent who dated a model called Wendy – it occurred to Simon Tegala that this man was full of blood. The salesman (who wore a thick gold wedding ring on his finger) had a substantial volume of blood pumping through a system of arteries to all the organs of his body. In fact this man in the suit pointing at the lonely chrome Cadillac of Simon Tegala's dreams, was a biological highway of organs venules and veins. Head, neck, forelimbs, lungs, heart, liver, gut, kidneys, gonads, hind limbs. Mr Tegala the customer had suddenly become butcher. He saw the salesman merely as a sum of parts with blood flowing between through and around them. The salesman, unaware that he was perceived merely in terms of circulation of the blood and lymph, smiled and said he'd make a friendly price for Mr Tegala. They walked over to his office to complete the deal. The salesman twisted the band of gold round and round his knuckle.

21 Feb 1998: Simon Tegala's heart is a desert island
Simon Tegala's heart is a miniature world waiting to be discovered by explorers. Is Naomi the Columbus who discovered his heart, colonised it and left her teethmarks embedded within it? Is his heart just an anthropological location to be visited and departed from, having gathered its most precious minerals? A place where Naomi the conqueror loots his soul's attitudes and then sails back across the ocean with her booty? Naomi told Simon Tegala she hated his poncey Cadillac and wouldn't be seen dead in it. Mr Tegala searched for his car keys and drove to a late night movie on his own.

22 Feb 1998: Simon Tegala has no heart
The usherette shone her torch on a red velvet seat and sat Simon Tegala next to a woman eating an apple. Half way through the movie, the woman told Simon Tegala that her name was Caroline Joseph. At that same moment the plot took a twist. Simon Tegala had missed a crucial clue and the film made no sense from then on. On the screen a man swam in a pool of salt water. A woman in a bikini waved to him from a rock.

Simon Tegala sneaked a look at Caroline. Her eyes were like spark plugs shining in the dark. She was all sharp edges, lathed and polished. So very different from Naomi. The film had a happy ending. Caroline put on her red coat with its fake ermine trimmed hood. Simon Tegala found himself saying 'I've just bought a new Cadillac and my girlfriend hates it. Do you want a ride home?' Caroline was so perfect she looked like she'd just stepped off the production line at a factory in Norway. He unlocked the gleaming Cadillac and she glided in, admiring the white leather seats and the way he gripped the steering wheel. She told him she lived in Hammersmith with her dog, a terrier called Baby. Would he like to meet Baby? Simon Tegala nodded

enthusiastically. When he woke up next to Caroline he told her he was in love. With Naomi.

23 Feb 1998: Simon Tegala's heart is torn in two

24 Feb 1998: Today, Simon Tegala has a broken heart
Naomi said to Simon Tegala: 'It's over between us.' Cut, close window, empty wastebasket, shut down, eject. Mr Tegala muttered something about how on that particular night with Caroline Joseph he had a desire to experience more desire, it was something to do with brain chemistry and he couldn't help himself. Naomi said, well if you want sex magic I am the only love drug on the market. Simon Tegala said he had to post a letter and then hoover his flat. Could they talk later? Naomi walked out before he could tell her that his heart was pierced with the swords of seven sorrows. He woke up to a reminder call and forgot what it was he wanted to be reminded of. He thought about going down to his local surgery to have a free vaccination to pass the time. Measles mumps rubella. Naomi's strappy gold sandals lay under his bed. He missed the tension of dialling her tel no. Naomi was a series of digits. Naomi was 0171, an inner London zone. Loss burned through his ligaments. His pillows smelt of her. He went for a swim at the local leisure centre. Crawl, breaststroke and butterfly. Simon Tegala's heart has two chambers – the upper and the lower. Blood flows between these chambers. Simon Tegala's heart is the size of his fist.

25 Feb 1998: Simon Tegala has no heart for small talk
Mr Tegala's heartbeat is his internal graffiti. This is his fifth day without Naomi.

26 Feb 1998: Simon Tegala's heart is an inner voice
As Mr Tegala rides his bicycle to the pub, his heart is just DNA and high tech muzac. This is his sixth day without Naomi.

27 Feb 1998: Simon Tegala wears his heart on his computer
Simon said to Naomi: Let's restart, by icon, by name, by size, by kind, by label, by date, copy, paste, clear, select all, show clipboard, open, find, find again, print. While he spoke he grated fresh limes – the rind for a Thai green curry, the juice for a margarita. They noticed that the fur on the cat was standing on end. 'He's seen something', Naomi whispered. They looked around. So tell me about yr father yr mother yr brothers and sisters. Yeah she said, but knowing who my folk are does not tell you who I am. I don't care about the past. It's a place I have left I want to arrive somewhere else. Simon Tegala squeezed the lime into a silver cocktail shaker. Naomi the Futurist tasted the margarita and gave him 7/10. What if I told you my great grandfather was a travelling fragrance merchant who knew no frontiers in the search for plants and flowers with mysterious powers? Tegala rolled his eyes. She continued. 'I don't want to be a magic box for you to open and open and open again until you see the real me drenched in light. Any way we are just bodies absorbing the waves of politics and radiation. The only thing left for us to do is to explode into fame. Mr Tegala smiled. I should chuck you out of my heartspace, he murmured. But I won't. My heart is a hallucination, it's sewn together with electronic fibres. Plug yourself in. I am a flesh and blood species but I am also a creature of bits and bytes. Access the codes of my heart.

Simon Tegala

01

For a period of two weeks in February 1998, Simon Tegala's heart rate was monitored and transmitted to a large electronic display in the window of the then Concord Sylvania Building in Holborn in London. Changes to his heart rate were updated on the display every second, raising questions about what had caused the change in his heartbeat. The project provoked wider considerations of mortality and our changing relationships to digital technology and communication.

01–03 Simon Tegala, *Anabiosis*, 1998.
Photographs: Stephen White

Simon Tegala

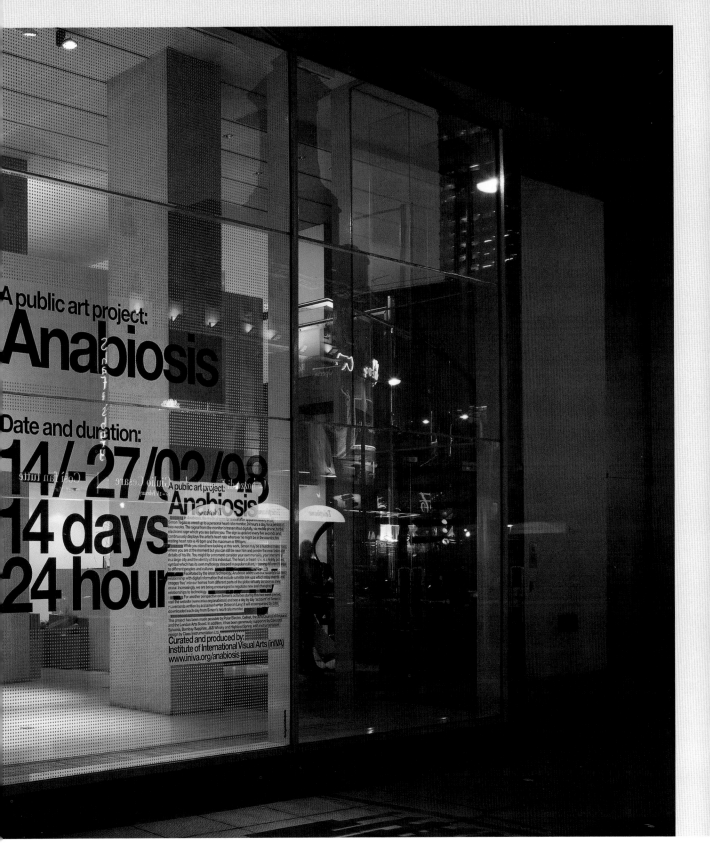

Simon Tegala

Electronic Disturbance

Coco Fusco and Ricardo Dominguez

This is an edited version of a conversation, organised and broadcast by inIVA on 25 November 1999. As a member of the Electronic Disturbance Theatre, Ricardo Dominguez talks to artist and writer Coco Fusco about how the internet is used not only as a communication tool, but also as a means of direct action and electronic civil disobedience on a global scale.

Ricardo Dominguez

Hola. Bienvenidos, hermanos y hermanas. Welcome sisters and brothers, I'm going to tell you a little story, *una pequeña historia*: Pedrito (a Tojolabal, two and a half years old, born during the first Intergalactic) is playing with a little car with no wheels or body. In fact, it appears to me that what Pedrito is playing with is a piece of that wood they call 'cork', but he has told me very decisively that it is a little car and that it is going to Margaritas to pick up passengers.... We are passing through this village which is today electing the delegates (one man and one woman) who will be sent to the March meeting. The village is in assembly when a Commander-type plane, blue and yellow, from the Army Rainbow Task Force and a pinto helicopter from the Mexican Air Force, begin a series of low flights over the community. The assembly does not stop; instead those who are speaking merely raise their voices. Pedrito is fed up with having the artillery aircraft above him and he goes, fiercely, in search of a stick inside his hut. Pedrito comes out of his house with a piece of wood and he angrily declares that 'I'm going to hit the airplane because it's bothering me a lot.' I smile to myself at the child's ingenuousness. The plane makes a pass over Pedrito's hut and he raises the stick and waves it furiously at the war plane. The plane then changes its course and leaves in the direction of its base.... The Sea and I look at each other in silence. We slowly move towards the stick which Pedrito left behind, and we pick it up carefully. We analyse it in great detail.... Without saying anything else, we take it with us. We run into Tacho as we're leaving. 'And that?' he asks, pointing to Pedrito's stick which we had taken. 'Mayan technology',

the Sea responds. Trying to remember what Pedrito did I swing at the air with the stick. Suddenly the helicopter turned into a useless tin vulture, and the sky became golden and the clouds floated by like marzipan. *Muchas gracias,* I hope you enjoyed the story.

This Mayan technology, this stick is a metaphor for what Electronic Disturbance Theatre (EDT) has created as its performative matrix. The stick represents a third, or a fourth, or fifth alternative to the apocalyptic or utopian sense of the internet. Those of us working in the virtual domain are constantly told to obey the utopian dream of the wired world where there will be no class, sex and no issues of identity. But, the Zapatistas, using this Mayan technology, advocate another type of gesture which I would say is related to magical realism....

The Zapatistas use the politics of a magical realism that allows them to create these spaces of invention, intervention, and to allow the world wide networks to witness the struggle they face daily. It was the acceptance of digital space by the Zapatistas in twelve days that created the very heart of this magical realism as information war. It was this extraordinary understanding of electronic culture which allowed the Zapatistas on 1 January 1994 – one minute after midnight just as NAFTA (a Free Trade Agreement between Canada, USA and Mexico) went into effect – to jump into the electronic fabric, so to speak, faster than the speed of light. Within minutes people around the world had received emails from the first declaration from the Lacandona Jungle. The next day the autonomous Zapatista zones appeared all over the internet. It was considered the first postmodern

revolution by the *New York Times*. The American intelligence community called it the first act of social net war. Remember, that this social net war was based on the simple use of email and nothing more. Like Pedrito's 'stick', gestures can be very simple and yet create deep changes in the structures of the command and control societies that neo-liberalism agendas, like NAFTA, represent....

EDT has created a counter-distribution network of information with about three hundred or more autonomous nodes of support. This has enabled the EZLN (Zapatista National Liberation Army) to speak to the world without having to pass through any dominant media filters. The Zapatistas' use of communication on the internet, email and webpages created an electronic force field around these communities in resistance which literally stopped a massive force of men and the latest Drug War technologies from annihilating the EZLN in a few days.... When the communiqués were distributed globally through the Net, they began to flow between pre-existing anti-NAFTA and other newly formed activist listservs, newsgroups, and personal cc lists, etc. By the summer of 1994 we began to hear the Zapatistas use the terms 'intercontinental networks of struggle' and 'intercontinental networks of resistance'.

This movement of information through these various Zapatistas networks of resistance can be said to have occurred via a strange chaos moving horizontally, non-linearly, and over many sub-networks. Rather than operating through a central command structure in which information filters down from the top in a vertical and linear manner – the model of radio and television broadcasting – information about the Zapatistas on the internet has moved laterally from node to node.

The primary use of the internet by the global pro-Zapatista movement has been as a communication tool. However particularly since the Acteal massacre in Chiapas at the end of 1997 in which forty-five indigenous people were killed, the internet has increasingly been used not only as site or a channel for communication, but also as a site for direct action and electronic civil disobedience. Beta actions of electronic civil disobedience occurred early in 1998. Information about the Acteal massacre and announcements of Mexican consulate and embassy protests were transmitted rapidly over the net. The largest response was a street protest, drawing crowds of between five and ten thousand in places such as Spain and Italy. But there were also calls for action in online communities. On the low end of digital activism people sent large amounts of email protest to selected email targets of the Mexican government.

The Anonymous Digital Coalition, a group based in Italy, issued a plan for virtual sit-ins on five websites of Mexico City financial corporations, instructing people to use their internet browsers to repeatedly reload the websites of these institutions. The idea was that repeated reloading of the websites would block those websites from so-called legitimate use. FloodNet was created by EDT, a group composed of myself, net artists Carmin Karasic and Brett Stalbaum, and Stefan Wray, an activist and media scholar....

*CF_*Can you explain a little bit about how you conceive of EDT work as performance?

RD_Augusto Boal, who theorised and performed what he calls 'invisible theatre' once argued that middle-class theatre was able to produce complete images of the world because it existed within a totalised social mirror of production. Other sectors of society that wanted to create a different kind of reflection could only produce incomplete performances that pointed towards something beyond what already exists. There is a history in the theatre of this type of critical social performance: the theatre of Erwin Piscator, Bertolt Brecht's Epic Theatre, the Living Theatre, and Teatro Campesino working with Julio Cesar Chavez, etc.... These agit-prop groups pointed to the possibility of new forms of the performative matrix that could be translated on to the digital stage, to the possibility of using techniques to create social or civil drama in this new space....

This is a history of performance that EDT continues. What I am interested in are practices that break with traditional performance art or traditional theatre, and more importantly, that reflect a form of critique and discontent by a community. Activists, direct action performers, or more traditional forms of agit-prop theatre can choose to use the spectacle of visible collective street action, or they can choose to use the invisible performances of digital gestures, such as uploading the names of the victims of the Acteal massacre into Mexican government or Pentagon servers.

CF_I'd like to consider your work with EDT in relationship to a specifically Latin American genealogy. There are several examples of performance art from the 1970s and 1980s that were designed to take place in the street to reappropriate public space during political periods of extreme repression. I am thinking here of the emergence of the Chilean *avanzada* during the Pinochet dictatorship and the street actions carried out by several collectives; the *Grupos* in Mexico during the same period that involved performances in public places and that formed a delayed response to the massacre of Tlatelolco; and work by The Border Art Workshop/ *El Taller de Arte Fronterizo*. In a sense, the objective of that work was to point to the absence of civic life, to engender a dialogue about how public life had been eviscerated by political power. Can you talk about how you transposed that dynamic into the domain of the virtual with EDT?

RD_The public space of electronic culture as it exists now is through browsers, such as Netscape or Internet Explorer. EDT sees the browser as the public base of the virtual community. It is the space where communities gather either to chat, to exchange information or to put up representations of their cares or concerns, or, in the case of e-commerce, representations of what they're trying to sell you. What EDT has done is to create an Applet. Brett Stalbaum, one of the members, took this public function of the 'reload' button on browsers and just added another element. Instead of the user hitting the reload button, the system automatically turns and refreshes itself as more people come to the site. The more people enter the Zapatista Floodnet, the faster that refresh or reload button calls on the information that resides on the government servers where the sit-in is taking place....

Through a virtual sit-in, EDT creates a mass representation of the community of resistance. As FloodNet performs automatic reloads of the site, it is slowing or halting access to the targeted server. This representation constitutes a disturbance on the site, a symbolic gesture that is non-violent. The more hits there are to President Zedillo's website, the more our presence is felt, and the less functional the government site becomes, until it is eventually overwhelmed by the public. This disturbance points to the nature of what public space means and who is allowed to be present in the public space of the internet. FloodNet does not impact upon the targeted websites directly, as much as it disrupts the traffic going to the targeted website.... The disturbance doesn't necessarily bring down a server, since many, such as that of the Pentagon, are quite robust and expect millions of hits. But the disturbance creates a sense of solidarity, what I would call 'community of drama' or a community joined by the magic stick....

CF_What are some of the responses that EDT has received from the US military and also from the Mexican government?

RD_These confrontations began in Linz at Ars Electronica when EDT undertook its *Swarm* performance, the largest virtual sit-in that we had done until then on Mexican President Zedillo's website, the Pentagon and the Frankfurt Stock Exchange. The Department of Defence initiated a counter-measure or a hostile Javascript Applet against the Zapatista Floodnet. From that point on we have been in dialogue with the military, which is very strange for us. The military invited us to do what we call 'The National Security Agency Performance' on 9 September 1999 for some three hundred generals and military men and also National Security Agency people as well as congressmen. We approached it as theatre. They interrogated us. Of course they wanted to know who was in charge? How extreme could we possibly get? What was the future like? What do we expect from the growth of this new term 'hacktivism' which had emerged as a response to the drama?...

One of the things about us is that, unlike hackers, EDT is very transparent. We use our names, people know who we are and what we do and this really disturbs the military. They are modernist at heart; they want secrets, they want encryption, they want cyber-terrorists, and they want cyber-crime. What we give them is net art performance that allows everyone to see who the real cyber-terrorists are.

CF_How does *Swarm* work? I'm particularly interested in how internet gestures end up on screen as a kind of abstract performance language.

RD_The real drama and the real space of performance come before and after the action and follow the structure of a three-act play. In the first act you announce what is going to happen. The middle act is the actual action itself. The last act is a gathering of dialogue about what happened, a social drama among different communities – net activists, net artists and net hackers. The dot.coms and government sites also play their parts in this social drama.

The FloodNet gesture allows the social flow of command and control to be seen directly – the communities themselves can see the flow of power in a highly transparent manner. During the last act, we see the endless flow of words come, not only from EDT members, but from people around the world: a woman from South Korea, an Aborigine from Australia. We create a network for a social drama because they're interested in what is going on, how they can help, etc. A virtual plaza, a digital situation, is thus generated in which we all gather and have an encounter – an *encuentro*, as the Zapatistas would say – about the nature of neo-liberalism in the real world and in cyberspace.

CF_Can you explain the meaning of the visual signs that appear on screen during a Floodnet action?

RD_FloodNet encourages individual interaction on the part of protesters. Net surfers may voice their political concerns on a targeted server via the 'personal message' form which sends the surfer's own statement to the server error log. While Floodnet action goes on, we not only recall President Zedillo's web page, but we also call internal searches. For example, we will ask for the names of the dead, or about the question of human rights in Mexico. We ask the server the question, 'Do human rights exist on President Zedillo's website?' And then a 404 file emerges backstage; the 404 'not found' reply is a report of a mistake or gap of information in the server. This use of 404 files is a well-known gesture among the net art communities. EDT just refocused the 404 function towards a political

gesture. For instance, we ask President Zedillo's server or the Pentagon's web server 'Where are human rights in your server?' The server then responds 'Human rights not found on this server.'...

CF_What you are doing makes me think of Rachel Whiteread's casting negative spaces. In a sense you are operating within a virtual domain, and are pointing to the absence of information, which amounts to an absence of concern for ethical issues and lives.

RD_Yes, we bear witness to this with a gesture that retraces a Latin American performance tradition. We are bearing witness to the gap or to the invisibility that has been caused by the engines of destruction....

CF_EDT also distributes the codes freely to others, right?

RD_Yes, on 1 January 1999, one minute after midnight, in celebration of the 5th Declaration of the Lacandona, and the 5th year of the Zapatistas, we started distributing 'The Disturbance Developer Kit' or DDK, which is free to anyone if they come to our site. During our actions, many groups who wanted to do virtual sit-ins contacted us, so in response we developed a kit that's quick and easy to put up. It has been used by a wide variety of groups such as Queer Nation, the international animal liberation groups, anti-arms trading groups, anti-WTO groups, and 'The Electro Hippies'. So our performance continues through a new act of distributing the software, as the power to disturb the Virtual Republic is extended to new communities.

In the 1980s and 1990s, questions of race
and identity came to the fore in the work
of many contemporary artists, writers
and critics. As Kobena Mercer writes,
identity became a shorthand for talking
about the politics of difference. Initially
seen as uniquely the preoccupation of artists
and thinkers from culturally diverse
backgrounds, it subsequently became clear
that race and identity had come to define
the way in which culture and society was
understood and experienced on a global
basis. Far from dispensing with the
categories of race and ethnicity as defining
identity within the public and private realms,
the most recent phase in the process of
globalisation adds another layer to the
intricate construction and experience of
individual identity.

01

Mirage: Enigmas of Race, Difference and Desire

inIVA collaborated with the Institute of Contemporary Arts in London on their season curated by David A. Bailey entitled *Mirage: Enigmas of Race, Difference and Desire* in 1995, which focused on the work of writer and theorist Frantz Fanon. The exhibition presented work in a range of media by nine artists: Sonia Boyce, Eddie George/Trevor Mathison, Renée Green, Lyle Ashton Harris, Isaac Julien, Marc Latamie, Glenn Ligon and Steve McQueen.

01 Lyle Ashton Harris, *The Empress,
The Emperor and his Divine Staff*, 1994
02 Marc Latamie, *The Factory*,
1992–95

Overleaf
03 Steve McQueen, *Five Easy Pieces*,
1995. Courtesy Thomas Dane, London,
and Marian Goodman Gallery, New
York/Paris
04 Eddie George and Trevor Mathison,
The Black Room, 1995

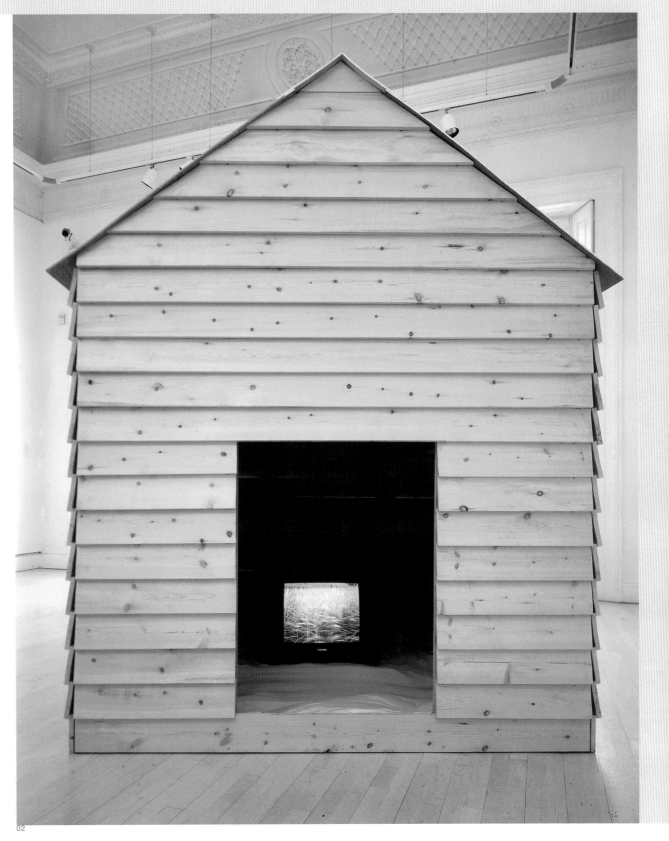

Mirage
Enigmas of Race, Difference and Desire

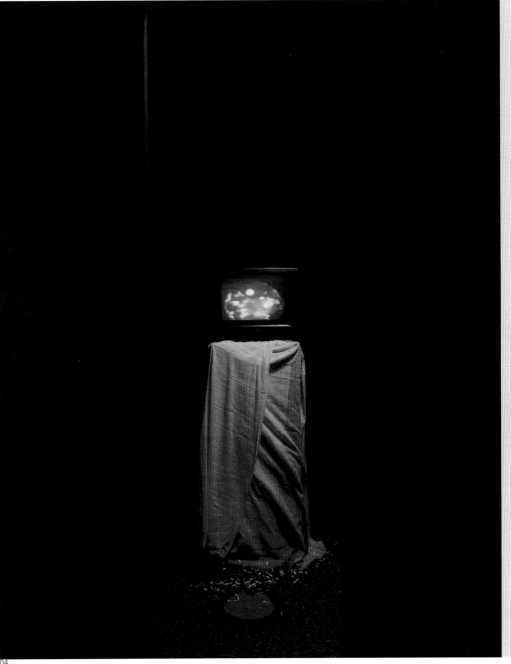

Mirage
Enigmas of Race, Difference and Desire

Busy in the Ruins of Wretched Phantasia

Kobena Mercer

On the occasion of the *Mirage* season, inIVA collaborated with the Institute of Contemporary Art in London to publish *Mirage: Enigmas of Race, Difference and Desire* in 1995, with essays by David A. Bailey, Kobena Mercer and Catherine Ugwu. In the context of Fanon's writing, Kobena Mercer's essay traces representations of race and identity from the early nineteenth century to the work of many contemporary artists.

Identity has come to function as a sort of shorthand for the recognition of the politics of difference. However, as a static noun the term suggests a fixed category whereas the key shifts accentuated by diaspora artists over the past 'critical decade'[1] have been moving in the other direction, recognising that the assertion of identity always depends on dynamics of differentiation, that the resulting forms of individual and collective identification are always relational and interdependent, and that the production of a differential is the mainstay of language and politics alike. While often apprehended as a shift from essentialist to constructionist conceptions of subject-formation, politically accentuated as a debate between cultural nationalisms and a post-nationalist emphasis on hybridity, it is crucial to note that postcolonial artists have turned to psychoanalytically inflected notions precisely because the recognition that identities are constructed in language and representation then raises the more vexed question of how to account for the historical persistence of oppressive relations in which one's identity is continually positioned as Other in relation to someone else's construction of Self....

It is from this viewpoint that black artists have wielded Fanon's insight that 'the real Other for the white man is and will continue to be the black man' in order to deconstruct the way in which ideologies seek to fix and eternalise differences into absolute, categorical, binary oppositions; the logic by which 'the legends, stories, histories and anecdotes of a colonial culture offer the subject a primordial Either/Or.'[2] Hence, if the task is to unfix and loosen up dichotomous codifications of difference, the terrain within which black artists intervene can no longer be adequately met by an aesthetics of realism or protest which seeks to counteract 'mis-representation', but requires an acknowledgment of the emotional reality of fantasy as the domain of psychic life that is also subject to the demands of the unconscious....

To glimpse the pivotal importance of vision and visuality in the historical sedimentation of racialising representations, consider Charles Cordier's *Aimez-vous les uns les autres* (also known as *Fraternité*) of 1867, a sculpture conceived within the era when European nations disavowed their dependence on slavery by putting forward a self-image that defined them instead as the liberators of the enslaved. The stark visual contrast between the two cherubs about to embrace in a kiss serves to connote both formal equality and either/or difference. While it enacts the sentimental trope repeated today in the exhortation that 'ebony and ivory get together in perfect harmony', the very banality of its binary model of identity and difference serves to conceal the subtle disposition whereby it is the black cherub who actively moves towards the slightly superior, upright posture of the white one, thus positioned as the universal human from which the other is differentiated. Paraphrasing Ralph Ellison, one might say that if the West had not 'discovered' the Negro, then the Negro would have to be invented, for the invisibility of whiteness is thoroughly dependent on the visible difference which the black subject is made to embody as the other needed by the self for its own differentiation, yet at the same time constantly threatening the coherence of that self on account of its unassimilable otherness.[3]

This structural interdependence is the locus of the ambivalence called forth in the fantasmatics of cultural difference, and two interrelated but distinct issues are at stake. First, it entails, on the part of the dominant culture, a fantasy based on the epistemological privilege of vision in the West. What is common to the representational forms of the three distinct modes of 'othering' that often get simplified as racism, sexism and homophobia, is that in each instance the historical construction of differences of race, gender and sexuality is reduced to the perception of *visible differences* whose social meaning is taken to be obvious, immediate and intelligible to the naked eye....

Contemporary artists have created an archaeological space in which to re-view the fantasies of absolute difference at play in a work such as Cordier's. Drawing on the conventions of museum display, artists such as Fred Wilson, Danny Tisdale, Zarina Bhimji and Renée Green have sought to enter the space of the archives, and in doing so have engaged in a dialogic partnership with cultural historians such as Sander Gilman who, between them, have unearthed the fossilised coils of myth and stereotype that continue to haunt the collective imagination. The contemporary rediscovery of Sartje Bartmann, a twenty-five-year-old African woman brought to Europe in 1815 to be displayed and exhibited as the Hottentot Venus, an object of scientific curiosity and circus-like entertainment until she died in 1824, provides a powerful instance of how black bodies were forcibly objectified under Europe's gaze to provide that foil against which discourses of physiognomy, medicine and anthropology combined to construct the visible 'truth' of absolute otherness. Summarising the views of Cuvier and Buffon, Sander Gilman demonstrates the underlying 'definition by antithesis' at work in science and art alike:

> The antithesis of European sexual mores and beauty is the black, and the essential black, the lowest exemplum of mankind on the great chain of being, is the Hottentot. It is indeed in the physical appearance of the Hottentot that the central icon for sexual difference between the European and the black was found.[4]

In this context, the practice of re-vision that discloses the centrality of racialised differences to modernist representations of identity – rendered, for example, by Laure, the black female maid proffering the bouquet to Manet's *Olympia* (1865) – has opened up new ways of re-entering the past. Renée Green's installation, *Bequest* (1991), foregrounds citations from Melville and Poe to make visible the hidden centrality of chromatic codifications of 'otherness' in US national and cultural identity: 'It was the whiteness of the whale that above all things appalled me/ The raven by its blackness represents the prince of darkness,' in a way that remarkably complements Toni Morrison's compelling interpretation of the 'Africanist' presence in American literature, in, for example, Mark Twain's Huckleberry Finn, who would have no identity as such if it were not for the antithetical presence of Nigger Jim.[5]...

African-American art history shows the many contradictory strategies undertaken to find lines of flight out of the dilemma of how one can posit a full

and sufficient black self in a culture where blackness serves as the sign of absence, negativity and lack.[6] In the black British context, this problematic has been taken on by Sonia Boyce, in a series of self-portraits including *From Someone Else's Fear Fantasy* to *Metamorphosis* (1987) which features visual quotations from comic book cartoons as well as from *King Kong*, a film whose 'sex-race' unconscious was brilliantly brought to light by James Snead, just as Lola Young has investigated the way in which black women are constructed as exotic others mirroring (white) male fears and fantasies in films such as Neil Jordan's *Mona Lisa* (1986).[7]

Whereas the realist refutation of racist stereotypes often ended up with an idealised view of a black identity untouched by degrading images of otherness, one strand in the postmodern repertoire of hybrid appropriation and parodic repetition among black visual artists has been to suggest that such stereotypes, however disavowed, may nevertheless act as 'internal foreign objects' around which self-perception is always 'alienated' by the way in which one is perceived by others as *the* Other. This dilemma is at the heart of Fanon's analysis of racialising interpellation: being objectified under the imperial gaze – 'Look, a Negro!' – to the point where the black self's own body is fragmented, dismembered and thrown back as 'an object in the midst of other objects'. Unlike the infant in front of the mirror for whom the specular reflection returns as the basis of the body-image, when blacks are made to bear the repressed fantasies of the imperial master, they are denied entry into the alterity which Lacan sees as grounding the necessary fiction of the unified self. For Fanon, this is because 'the white man is not only The Other but also the master.' The implications of Fanon's conclusion, that the colonised is 'forever in combat with his own image' have been explored by black visual artists for whom self-portraiture in its received sense is a structurally impossible genre for the black artist to occupy.

Carrie Mae Weems' *Mirror, Mirror* (1986–87) signifies on the (de)formative experience of the black subject's mirror phrase by captioning the non-reflective surface of the specular other with a parody of the nursery rhyme, 'Looking into the mirror, the black woman asked, "Mirror, mirror on the wall, who's the finest of them all?" The mirror says, "Snow White, you black bitch, and don't you forget it!!!"'[8] Relatedly, in key works by Adrian Piper, from pictorial collages such as *I Embody* (1975) and *Vanilla Nightmares #8* (1986), to her performance pieces in the character of 'Mythic Being' who appears in whiteface, the use of mimicry and masquerade subverts the cultural narcissism inherent in white supremacy's arrogation of otherness to itself alone (thereby condemning the black to stand in for, and re-present, the mirror image which the white ego props itself upon). Piper thus problematises the issue of self-representation to enact a practice of non-self-representation, which makes whiteness visible as a historically constructed identity dependent upon antinomies of white/not-white, male/not-male, I/not-I....

While the recognition of multiple identities has helped skewer the double-binds of minority/majority discourse, thereby unpacking the black artist's burden of having to be a representative – a process which has brought to light the sheer diversity of black identities

previously repressed in cultural nationalisms – the flip-side to the new pluralism has been a kind of identitarian closure. Indeed, the term identity often pre-empts understanding of subjectivity as constituted by alterity, often resulting in new modes of policing access to self-representation, as Sonia Boyce has pointed out:

> Whatever we black people do, it is said to be about identity, first and foremost. It becomes a blanket term for everything we do, regardless of what we're doing.... I don't say it should be abandoned (but) am I only able to talk about who I am? Of course, who I am changes as I get older: it can be a life-long enquiry. But why should I only be allowed to talk about race, gender, sexuality, class? Are we only able to say who we are, and not able to say anything else? If I speak, I speak 'as a' black woman artist or 'as a' black woman or 'as a' black person. I always have to name who I am: I'm constantly being put in that position, required to talk in that place... never allowed to speak because I speak.[9]...

In the work of artists such as Lyle Ashton Harris, Marlon Riggs, Rotimi Fani-Kayode and Isaac Julien, unprecedented insights into Fanon's premise that Self and Other are always mutually implicated in ties of identification and desire have arisen precisely at the intersections of diverse artistic traditions. Rather than the reflection of a 'black gay aesthetic' as such, the key feature of black lesbian and gay cultural production of the past decade has been its emphasis on the constitutive hybridity of the postcolonial subject, which dislodges the authoritarian demand for authenticity and purity. Querying the way in which exclusionary notions of belonging have been replicated in the legacy of the post-war 'liberation' movements, black lesbian, gay and bisexual interventions have contributed creatively to a post-nationalist politics of difference which seeks to bring new forms of 'imagined community' into being.

This post-essentialist conception of black selfhood has nowhere been more graphically displayed than in Lyle Harris's photographs – including Constructs (1989), Americas (1988–89), and Secret Life of a Snow Queen (1990) – in which the artist theatrically stages a self whose authentic identity gives way to the artifice of the mask, an iconic element of diaspora aesthetics. Making literal Fanon's metaphor of black skin/white masks, Harris performs a version of black masculinity that signifies upon the grotesque pathos of the minstrel mask in white popular culture (sambo as sign of entertainment and enjoyment), and does so in such a way as to simultaneously evoke the masquerade of femininity as spectacle. Something vital differentiates the subversive ambiguity of Harris's critically parodic literalisation from the mere illustration of the Fanonian metaphor, to be found, for instance, on the cover of Chinweizu's book Decolonising the African Mind (Lagos: Pero Press, 1987).

I think it is because the Snow Queen snaps pointedly, signifying on the worst fears and fantasies of a model of black masculinity, in which the racial and sexual ambivalence of the mask provokes the mortal anguish of inauthenticity that remains unsaid and unspeakable in the discourse of black nationalism. Am I not a man and an other?

After the innocence, modernist movements came to grief at the crossroads of difference. In traffic management, crashes are most likely to occur at junctions or intersections, which is one way of looking at how the race, class, gender contingent got caught up in the mimetic loop whereby the very binary structures of Self and Other underpinning the hubris of the Western fantasy of sovereign identity were ceaselessly repeated in narratives which sought to deliver the wretched and unloved into the utopian spaces of 'total' liberation, but which got stuck instead on the road to nowhere: or is it the road to hell? When Isaac Julien states, 'I want to raise ambivalent questions about the sexual and racial violence that stems from the repressed desires of the other within ourselves,'[10] he indicates the ruined scene that Fanon ghosts today, the incomplete project of decolonisation pervaded by what Mathison and George call 'the smell of disappointment.'

Notes

1 See *Critical Decade*, *Ten 8*, vol. 2, no. 3, Birmingham, 1992.

2 Homi Bhabha, *The Location of Culture*, New York: Routledge, p. 61.

3 The sculpture is discussed in Hugh Honour, *The Image of the Black in Western Art*, Cambridge: Menil Foundation/Harvard University Press, 1989, vol. 4, part 1, p. 251. See also Ralph Ellison, *Invisible Man*. Harmondsworth: Penguin, 1952, and Ralph Ellison, *Shadow and Act*, New York: Vintage, 1964.

4 Sander Gilman, *Difference and Pathology: Stereotypes of Sexuality, Race and Madness*, Ithaca and London: Cornell University Press, 1986, p. 83. See also Sander Gilman, 'The Figure of the Black in German Aesthetic Theory', *Eighteenth Century Studies*, vol. 8, no. 4, 1975.

5 See Renée Green, *World Tour*, Los Angeles Museum of Contemporary Art, 1993, and Toni Morrison, *Playing in the Dark: Whiteness and the Literary Imagination*, Cambridge, MA: Harvard University Press, 1992.

6 The key statement of this problematic in African-American art history is Michele Wallace, 'Modernism, Postmodernism and the Problem of the Visual in Afro-American Culture' in Russell Ferguson et al (eds), *Out There: Marginalisation and Contemporary Culture*, Cambridge, MA: MIT Press, 1990. See also Henry Louis Gates, 'The Trope of a New Negro and the Reconstruction of the Image of the Black' in *Representations* 24, Berkeley: University of California, 1988, and Guy McElroy, *Facing History*, Brooklyn Museum of Art, 1989. See also Gavin Yearwood, 'Expressive Traditions in Afro-American Visual Arts' in Gay and Barber (eds), *Expressively Black*, Indiana University Press, 1987, and Richard Powell, *The Blues Aesthetic: Black Culture and Modernism*, Washington Project for the Arts, 1989.

7 James Snead, 'Spectatorship and Capture in King Kong: the Guilty Look' in *White Screens/Black Images*, London and New York, Routledge, 1994, and Lola Young, 'A Nasty Piece of Work: A Psychoanalytic Reading of Difference in Mona Lisa' in Jonathan Rutherford (ed.), *Identity*, London: Lawrence and Wishart, 1990.

8 In African-American vernacular speech, 'to signify' upon the utterance of another is to express (often with caustic wit) an unremitting critique of the referential effects of racial discourse in standard English by means of using performative moves drawn from the rhetorical, lexical and semantic resources of the dominant code (or master-language) itself. According to Henry Louis Gates, signifyin(g) is an intrinsically paradoxical 'relationship of difference inscribed within a relation of identity', and it is this ambivalence and doubling (encompassing irony, parody and mimicry) that makes it, in his view, the trope of tropes revealing the specificity of African-American language practices, from folk tales and joking, to jazz improvisation and black modernist literature. See *The Signifying Monkey: A Theory of African-American Literary Criticism*, New York and Oxford: Oxford University Press, 1988, p. 45.

9 Sonia Boyce in Manthia Diawara, 'The Art of Identity', *Transition*, New York: Oxford University Press, 1992, no. 55, pp. 194–95.

10 Isaac Julien, 'Black Is... Black Ain't: Notes on De-Essentialising Black Identities' in Michele Wallace (ed.), *Black Popular Culture*, Seattle: Bay Press, 1992, p. 260.

01

Johannes Phokela

inIVA curated a solo exhibition of the work of Johannes Phokela at Cafe Gallery Projects, Southwark Park, London in May 2002. Phokela's beautifully painted takes on iconic images by Rubens, Jacob de Gheyn and others weave a personal history into the historical canon of Dutch and Flemish old master painting. The gender and race of key protagonists are often altered from their Northern European origins to result in unsettling images that challenge nationalist and ethnic narratives around contemporary and historical art.

01 Johannes Phokela, *Pantomime Act Trilogy*, 2001. Collection of Robert Loder
02 Johannes Phokela, *Fall of the Damned*, detail of part II, 2000

Overleaf
Johannes Phokela, *Mortal Diptych Surmounted by Cameo Emblems*, 1997

Johannes Phokela

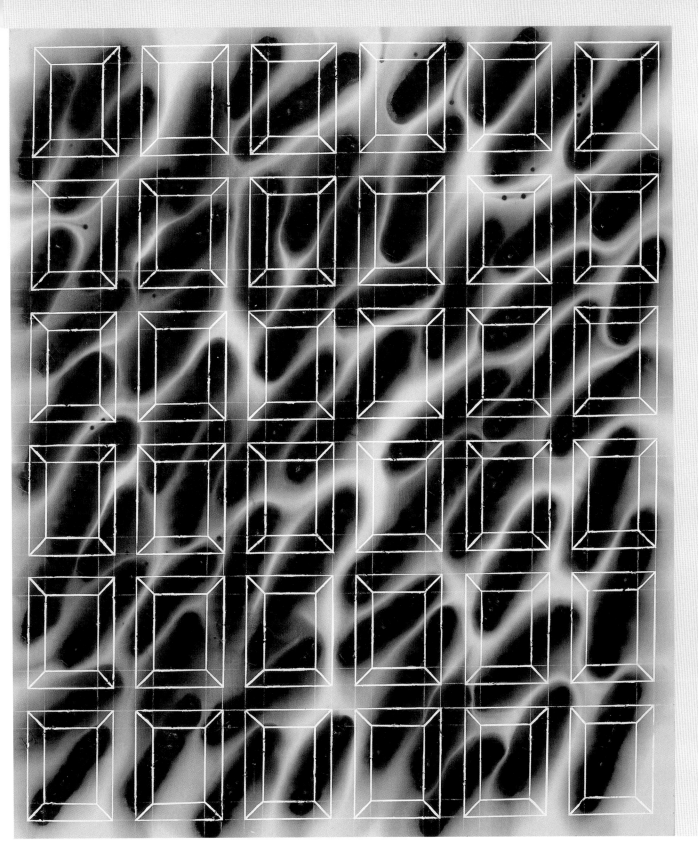

Johannes Phokela

Mainstream Capers:
Black Artists White Institutions
Whitewash

Eddie Chambers

Both published by inIVA in 1999 in the fifth volume of the *Annotations* series, *Run Through the Jungle: Selected Writings by Eddie Chambers*, 'Mainstream Capers: Black Artists White Institutions' was first published by *Artrage* (Autumn 1986) and 'Whitewash' by *Art Monthly* (April 1997). The first text challenges the belief that large-scale black artists' shows equate to black artists finally being taken seriously by the art establishment, while the second questions the absence of black people from jobs in the visual arts in relation to equal opportunities policies.

Mainstream Capers: Black Artists White Institutions

The Whitechapel Art Gallery recently opened its doors to Black[1] artists with the quaintly titled *From Two Worlds* exhibition. Eight months earlier, the ICA was the venue for *The Thin Black Line*, another exhibition by Black artists. So, two of London's (and indeed, the country's) most prestigious galleries finally played host (reluctantly or otherwise) to work by Black artists. Five years ago, these exhibitions would not have happened. Black artists couldn't even hope to command this sort of ostensible attention. Clearly, Black artists seem to be increasing their profile.

Unfortunately, however, one sobering factor prevents my jubilation at this apparently improved situation for our artists. This factor is my belief that both of the above-mentioned exhibitions, along with a score of others, have been organised and mounted on terms which are clearly not our own. By this I mean that the initiatives for these exhibitions invariably come from the white art administrators, whose publicly stated motives are best described as being unconvincing. The real motives for such exhibitions lie somewhere between political expediency and liberal posturing. (Thus ensuring that exhibitions like *From Two Worlds* are organised and perceived as being concessionary acts of white charity and liberalism, rather than assertive acts of Black consciousness.) Clearly, any exhibition by Black artists that comes about merely as a response to white gestures can never really be on our terms.

But this in itself is an incomplete picture. It is not simply a case of Black artists being manipulated by white administrators. Administrators realise, all too correctly, that it would be unacceptable for they themselves to select Black artists directly. Instead, they select the selectors, who proceed to choose or reject artists as they see fit.

Thus we see the emergence of a three-tier system, which has the white administrators where they most like to be – at the top and in control. Similarly, the Black artists themselves remain where they are accustomed to being – at the bottom, manipulated and ignored, alternately. One of the most amusing factors in this situation is that white art administrators often accord Black selectors a minimal, derisory amount of respect.

Both the ICA and the Whitechapel shows were 'selected' by practising Black artists, as have practically all group exhibitions by Black artists in recent years. It is my view that no persons (least of all Black artists) have the right to determine what Black artists (other than themselves) are represented in white galleries. These acts of selection imply and expose a definite hierarchy. Apart from the selectors (who have a particularly distasteful habit of including themselves in their own exhibitions), the potentially selected artists have no choice but to be passive; their only hope being that they too are 'chosen'....

So yet again, Black artists are unable to be taken seriously. Exhibitions such as *From Two Worlds* should be milestone events. Occasions when we see bastions of white art supremacy challenged, tackled, and dealt severe blows. Instead, we have constant repetitions of a situation which borders on the farcical: one or two or three selectors deciding which artists will (or equally as important, will not) have the privilege of being represented in the white chapels of art.

Black selectors seem to be labouring under the naïve assumption that gallery administrators are genuinely concerned with the interests of Black artists, and are quite prepared to act accordingly. The current situation that Black artists find themselves in plainly indicates that such a belief is not only misguided, but clearly unsustainable. Take for example the ICA's performance with, and since, *The Thin Black Line*. For a start, the ICA got eleven Black artists on the cheap. The thinking here must have been something along the lines of 'Why exhibit one Black artist, or why give them the whole gallery space, if you can do a job-lot and get away with exhibiting eleven of them – all in the same space, and all at the same time?' The corridor space where the work was shown was cramped, dull, pokey, and altogether unsuitable. To this can be added the final insult – in the adjoining gallery (a well-lit, spacious area) was an exhibition by one solitary white artist, whose work could very reasonably be described as crap.

But the negative and ultimately racist nature of such exhibitions can only become apparent in the long term. Most publicly funded galleries have policies of not showing work by the same artists between gaps of less than two, three, four, or even five years. In the case of *The Thin Black Line*, what this ultimately means is that none of the eleven artists will be represented in the ICA for quite some time, if ever again. If these artists had all been given major one- or two-person shows, there could be no reasonable cause for complaint. But the reality is that each of the artists was (through a chronic shortage of space) criminally under-represented. Furthermore, the 'job-lot' mentality of the ICA effectively rules out the possibility of main-space

shows by any of these artists for the foreseeable future.... In the light of eleven artists being herded into one small space, the Whitechapel must at least be given credit for allowing Black artists access to the entire gallery. (Though even here, one of our finest painters, Tam Joseph, is ridiculously under-represented, with a paltry two paintings. And even these have been described as 'the least probing of those in his collection'.) Another conclusion that I'm forced to draw is that all persons involved with the exhibition are apparently lacking in political principles – presumably having no qualms and seeing no inconsistency in being associated with sponsorship from Marks and Spencer, a company that sells South African produce as quickly as it can import such products of apartheid. Furthermore, the list of Foundations and Trusts, Sponsors, Corporate Patrons and Corporate Associates from which the Whitechapel has received financial assistance reads like a roll-call of Masonic Grand Masters. It's not surprising that one observer felt compelled to mention the very conspicuous decision by the selectors to 'bypass works with more dynamic content'.

In an article written some time ago, I quoted Marcus Garvey as follows: 'The great stumbling block in the way of progress in the race has invariably come from within the race itself.' I would, if I may, like to offer another quote, which both contrasts and complements the one above. 'Action, self-reliance, the vision of self and the future have been the only means by which the oppressed have seen and realised the light of their own freedom.' Or, for the purposes of this article, 'positive, assertive action, a defiant reliance on our own community and resources,

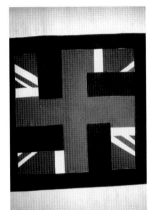

plus an active awareness of the necessary political role of Black art, are the only ways that Black artists, as an integral part of the Black community, can expect to make real progress.'

It is by no means conclusive that white art galleries are the most suitable venues for Black artists' work. However, if we must engage with white galleries, this engagement must be, and be seen to be, on our terms. This effectively rules out hierarchical 'survey' shows. There is an often-quoted view that such exhibitions are 'a foot in the door', and that if a gallery shows the work of a Black artist, or any given number of Black artists, subsequent Black artists will somehow find it easier to gain access to the same space.

Close scrutiny of this laughable theory will show that in actual fact, the reverse is more likely to be the case.... One of the most effective ways that Black artists can challenge white galleries is by collectively taking the initiative and demanding exhibition space. A response in the affirmative would obviously be the most welcome reply. However, a response in the negative, which is much more likely, will afford Black artists the opportunity to engage in a focused struggle against their exclusion from specific galleries, at specific times. This cannot effectively be done by one or even two people. The process of challenging white art establishment racism must be the priority task of organised, homogenised groups of Black artists. Apart from disorganisation, the principal enemy of Black artists is the racism of the art world. Survey-type shows do nothing to challenge this racism, and are in fact a product of a gallery system unable to accept Black people as equals in this society....

If all our energies are directed at creating inroads into the white art world, then clearly our energies are being misdirected. The focus of our art should be the Black community, and no white gallery can seriously be considered as a bridge between the Black artist and the Black community. The cornerstone of Black creativity should always be the Black community. Yet it seems as though the people to whom we owe our very existence are not even a minor determining factor in the production and exhibition of our work. If we unwittingly turn our backs on the Black community, we are heading for certain failure, or, as is more likely, a hollow, empty success.

The current feeling of self-satisfaction among our artists is not totally dissimilar to the position of prospective Black parliamentary candidates who believe that significant gains for Black people can be made through the election of Black MPs. But a handful of Black MPs (assuming them all to be of the same political party) can in no way significantly improve our position in this society. Likewise, one or two exhibitions in 'major' galleries will ultimately do nothing for Black artists or Black people. The only course of action guaranteed to improve the position of Black artists is a collective, unwavering commitment to the principles of Black art. That is, art specifically for the Black community, in the Black community. Because if we aren't talking to ourselves, we aren't talking to anybody.

Whitewash

I wonder if you have ever been into the offices of National Touring Exhibitions, above the Royal Festival Hall? If you have, I'm sure that you can't have failed to notice that all of the staff are white. I wonder also, if you have had a coffee or a bite to eat in the café/restaurant area of the Royal Festival Hall? If you have, I'm sure that you can't fail to have noticed the high proportion of the catering/service staff who are Black. Of course, the café/restaurant within the Royal Festival Hall represents a private franchise operating within a space otherwise largely funded by public subsidy. But even so, nothing vividly demonstrates the limitations and failures of *equal opportunities* so much as the racialised upstairs/downstairsness of the people who work at the Royal Festival Hall.

I have no interest in *personalising* this issue. I do not doubt for a moment that each of the National Touring Exhibitions/Hayward Gallery/Foyer Gallery staff was chosen fairly on his or her merit and suitability. But surely the same cannot be said about those whose work consists of serving coffee and selling sandwiches? By and large, those white people who work *upstairs* do so because they want to, and because they have chosen to develop careers within curating, gallery education, or visual arts administration. Meanwhile, many of those Black people who work downstairs – sometimes juggling several catering and cleaning jobs – do so because these jobs are the only ones they can get. But white people are not the only ones who can curate exhibitions, organise talks or type letters, any more than Black people are the only ones who can make frothy cappuccinos or cut sandwiches. But if we accept this, how can we then account for the continued conspicuous exclusion/absence of Black people from jobs in the visual arts?...

The wholesale absence of Black people from art galleries, and their proliferation in jobs as cooks and cleaners has, over a period of years, created the formidable impression that the only jobs Black people can get are the only jobs Black people are good for, or the only jobs they are capable of doing.

Though Black artists struggle now as much as they ever did, the art establishment has come to accept that not all artists are white and that a bit of colour (imported or home-grown) in a gallery's programme, every once in while is now *de rigueur*. Unless or until the Arts Council determines otherwise, this sullen, reluctant 'acknowledgment' is all we are likely to get. But when will galleries realise or accept that the issue of 'representation' extends beyond what goes on the walls of the gallery, to who gets to make, or contribute, to those curatorial decisions? In other words, in the same way that a gallery's programme cannot, with any credibility, remain all-white, a gallery's staffing structure similarly cannot, with any credibility, remain all-white.

Equal opportunities policies were supposed to put a stop to all this Persil™ nonsense. Or at least, give Black people a fair shot at getting a job that did not consist of, or involve, washing dishes from dawn to dusk. But equal opportunities policies have, without exception, failed miserably. Week after week we see pages and pages of job adverts, peppered with sheepish, self-conscious references to equal opportunities. This

gallery 'aims to be an equal opportunities employer'. That gallery 'is striving to be an equal opportunities employer'. Or this gallery 'is developing an equal opportunities policy' or that gallery 'actively encourages applications from Black people'. Some of these adverts go on to say things like 'Black people are currently under-represented in our work force' as if, like a leaking tap or a flat tyre, the problem has only just come about and with a bit of luck, will soon be fixed....

With some opportunities clearly being more equal than others, it is, I believe, time for an equal opportunities rethink. We cannot possibly accept that equal opportunities policies are a good thing, because to do so is to accept that Black people are, when it comes to careers in the visual arts, inherently inferior and unsuitable. Consider the implications of the current application of equal opportunities: jobs go to those considered to have the most relevant experience and who can otherwise demonstrate their suitability for the post. Black people consistently fail to get jobs in the visual arts. Therefore, according to the current culture of equal opportunities, Black people, despite being given sympathetic consideration by potential employers, simply do not have what it takes to work in the visual arts. The introduction of equal opportunities has had the effect of solidifying Black exclusion from visual arts jobs, whilst simultaneously giving the impression that everything is as it should be....

Equal opportunities should not mean just giving job recruitment a semblance of fairness. Instead it must surely mean that an ever wider range of people get to share the resources that the country of their birth and residence has to offer. And these resources must

include jobs. Black visual arts traineeships, such as those occasionally offered by the Arts Council, appear to be of little or no use. There seems little or no point (not to mention a waste of resources) in 'training' someone, only to deny them the opportunity to put that training to proper and substantial use. Similarly, Black graduates of the country's postgraduate curating, museums and arts administration courses still find that they can get no further than the wrong side of the desks in gallery offices.

I'm tempted not to make mention of the Catch 22 analysis, because I am not entirely convinced that it has merit. Nevertheless it may perhaps be worth reminding galleries that it is no use protesting that Black people can't get the jobs because they don't have the experience, because more Black people won't have gallery experience until more Black people are offered jobs.

Additionally, it is no use gallery directors shrugging their shoulders or wringing their hands. Claiming that a Black candidate 'just wasn't right' or 'didn't come across well at interview', or 'didn't look like they'd fit in', or 'wasn't quite what we were looking for' or any other pathetic excuse is, quite imply, not good enough. Nor is the excuse 'We'd love to have one, but they just don't apply.' All sorts of people like art. All sorts of people make art. And all sorts of people want to be involved in the process by which art interfaces with the public. When will galleries realise this, accept this and above all, do something about it?

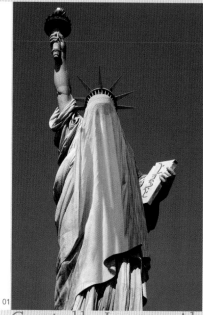

01

Veil

Curated by Jananne Al-Ani, David A. Bailey, Zineb Sedira and Gilane Tawadros, *Veil* opened at the New Art Gallery Walsall in February 2003 and toured to Bluecoat and Open Eye Galleries, Liverpool; Modern Art Oxford; and Kulturhuset, Stockholm. The exhibition brought together the work of twenty international artists and film-makers whose work explores the symbolic significance of the veil and veiling in contemporary culture. Addressing the veil in all its complexities and ambiguities, the exhibition sought to challenge any single or fixed cultural interpretation of one of the most powerful symbols in contemporary society.

01 AES art group, *New Freedom 2006, AES – The Witnesses of the Future*, 1996
02 Marc Garanger, *Femme Algérienne (Algerian Woman)*, 1960

Overleaf
03–04 Kourush Adim, *Le Voile (The Veil)*, 1999–2000
05–06 Emily Jacir, *From Paris to Riyadh (Drawings for my Mother)*, 1998–2001

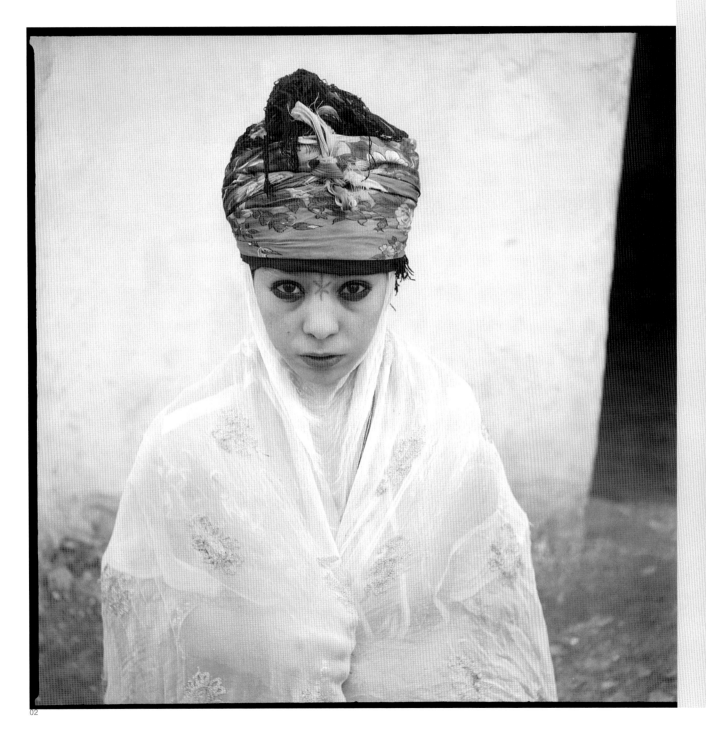

Veil

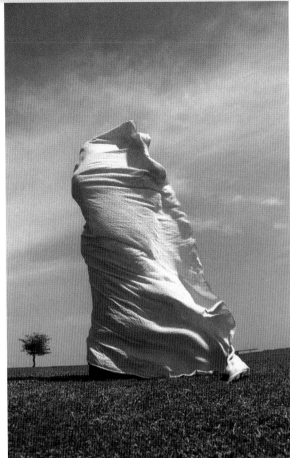

04

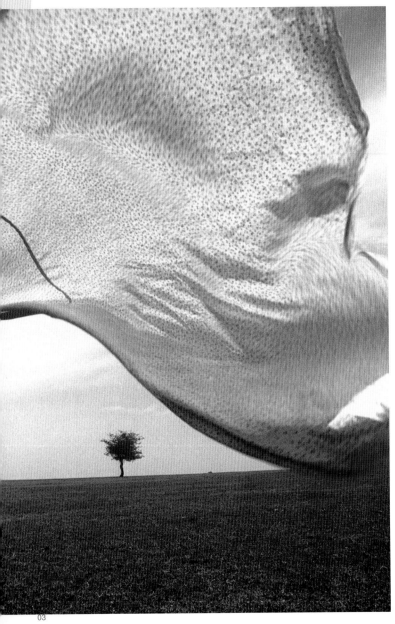

03

05

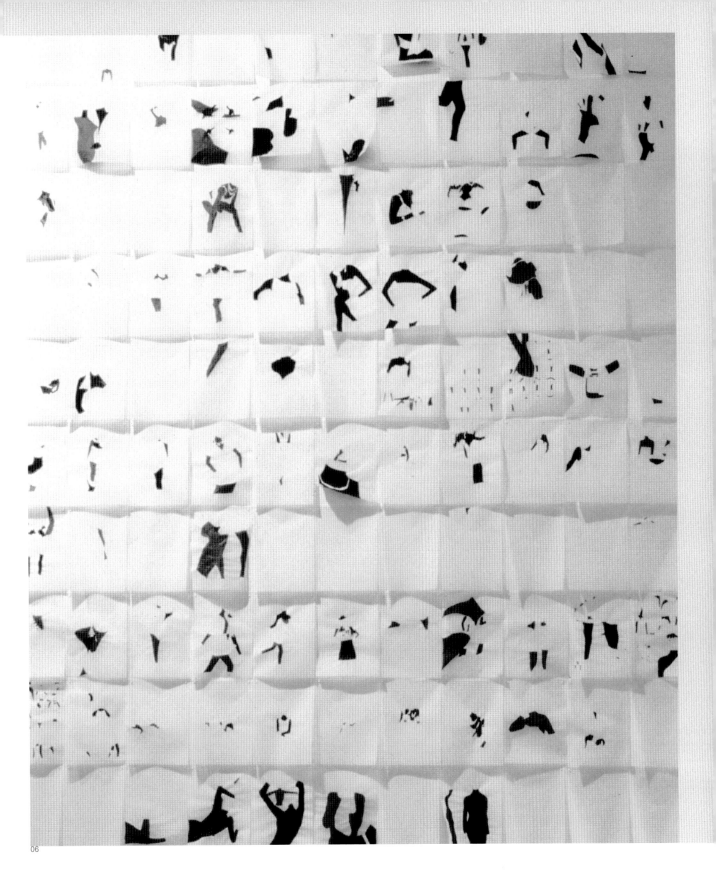

Veil

Mapping the Illusive

In collaboration with Modern Art Oxford, inIVA published *Veil: Veiling, Representation and Contemporary Art*, edited by David A. Bailey and Gilane Tawadros in 2003 to coincide with the exhibition *Veil*. Combining newly commissioned essays with historical texts, the anthology serves as a starting point to reflect on the veil in the context of contemporary visual culture. Zineb Sedira's text draws on her own multiple identities – as an Algerian-born French artist practising in London – to address issues of veiling and representation.

Zineb Sedira

How do you represent the unrepresentable, unrepresentable due to over exposure or lack of exposure? How do you represent that which has been drained of meaning, misrepresented to the point of over saturation, yet under appreciated and neglected to the point of absurdity? Is it even futile to attempt such an endeavour... maybe, it is advisable, perhaps not.[1]

The dilemma of how to represent the unrepresentable – in this instance, the veil – has been in the forefront of my mind for many years. To this day, it raises numerous questions, often without answers. For me, the veil has never been a simple sign, but one which always elicited a multitude of readings, both visible and invisible. As an artist I have spent years exploring the physical and the mental veil, negotiating the social and cultural boundaries and contexts that inform such an investigation, and asking whether it is feasible to write and communicate productively about the subject.

At first sight, my artistic practice refers to the veil as a visual motif. But the veil is never purely a physical code, delineated and present; it is also a transparent and subtle mental code. My postcolonial geography has marked my practice and I tend to draw upon the veil worn by Algerian women, because of my own personal history and experience. Each Muslim state is culturally, politically, economically and socially different. Colonial histories and subjugation have varied according to the particular country, which has had a profound effect on the way Muslim subjects differ from one another in how they are positioned in terms of gender, class, language and other forms of cultural and political identity.

As the autobiographical – particularly my matrilineal personal history – is a central aspect of my work and research, it is important to recognise the (dis)continuities of my own experience and to understand the multiple readings that I present as an artist. My identity has been formed by at least two seemingly contrasting and sometimes conflicting traditions. On the one hand, I grew up in the Paris of the 1960s and 1970s, partly educated by and socialising in the dominant secular and Catholic tradition of France. Yet, simultaneously, my family and immediate community were Arab Muslims. In addition, London has further shaped my identity and, for the last seventeen years, I have lived away from the North African community. The differences between England and France, particularly their contrasting attitudes to cultural difference, have also contributed significantly to my rethinking representation and identity.[2]

Whilst I never wore the veil, my work returns frequently both to the veil as a motif and to the less visible effects of veiling which I describe as 'veiling-the-mind', a concept which addresses the shifting worlds of external censorship and its internalised counterpart – self-censorship. We believe we understand the external culture which surrounds us. But do we? What influences the way we view the Other? In the West, do we recognise how and when self-censorship comes into play? How often do we choose not to notice – or not to read – our surroundings, because doing so would make us feel uncomfortable? What veils do we hide

behind everyday? What differences are there between the physical veil in Muslim culture and the mental veil in Western culture? It soon becomes apparent that the mental veil is not about a forced Muslim enclosure but rather about an awareness of the cultural paradigms, that inform our ideas around sexuality, gender and emotional space. Veiling-the-mind has become a metaphor of mine for the (mis)reading of cultural signs; to counteract the Western view of veiling, I try not to resort to the literal veil in my artistic practice. Instead I refer to veiling-the-mind in order to explore the multiple forms of veiling in both Western and Muslim cultures. I find myself asking how to 'represent the unrepresentable' and my artistic interventions reveal my desire to open up the paradoxes, ambiguities and symbolism of the veil.

The idea of presenting a collection of writings and readings about the veil arose as I gathered together research, experience and observations around this complex symbol. The writings about – and readings of – the veil seemed, at first, to be confined to Western postcolonial or Orientalist debate. The apparent absence of the Muslim voice or experience created an unbalanced dialogue, a conversation with only one speaker. My subsequent research revealed what I had suspected – that a more complex and layered discourse around the veil was taking place amongst artists, writers and academics of Muslim origin – and this project evolved from the necessity to bring these thoughts, works and studies into the Western frame. The gathering of dialogues evolved into a collaboration with other curators and artists and the work presented in the resulting exhibition is part of a continuing discussion on representation. The aim of the show was never to present a single reading of the veil, but to encourage concerns, questions and explorations to emerge.

How successfully an exhibition and publication can move that dialogue forward is a question that resonates throughout this essay. After all, how can I discuss the veil in Algeria without feeling the tensions of writing about constructed identities – such as 'Algeria' or the 'West' – which are socially produced and then used for political ends? How do I write about the subject of the veil in the West without worrying that my writing reinforces Orientalist fetishes, commodifying experience? Gayatri Spivak has expressed her reservations about postcolonial intellectuals who turn 'Third World' literature and experiences into 'commodities' to be consumed by the West. What space does this leave visual artists when exploring the veil as the object of representation? Can the artist escape the burden or cultural responsibility of representation? Is the artist, or indeed the curator, responsible for reinforcing the stereotypes of an audience? Mapping out an environment is not enough; instead, we must, as bell hooks suggests, transform the image – providing new strategies and readings – if we are to move the debate forward.

[It] is not just a question of critiquing the status quo. It is also about transforming the image, creating alternatives, asking ourselves questions about what type of images subvert, pose critical alternatives, and transform our worldviews and move us away from dualistic thinking about good and bad. Making

a space for the transgressive image, the outlaw rebel vision, is essential to any effort to create a context for transformation.[3]

The visual art in *Veil* has many readings, but I wish to foreground that of transgression. All the artists in this project communicate the personal and the collective, with photography, video, words, installations and sound as their media of expression and inscription. My ambition for such a dialogue was, and still remains, the need for a critique that enables a renewed lexicon with which to articulate the complexities and subtleties – the ambiguities and contradictions, the generalities and specificities, the similarities and differences – of veiling. Working creatively, sensitively and provocatively, such a lexicon could then speak to and about the paradoxes of the veil.

I am conscious about carrying the weight of translating cultural difference and, as a cross-cultural artist working in the West, I accept I can do little to disrupt this ever-present global cultural dominance. Do the interpretations and writings about artists' work instead serve to reinforce the limiting assumptions we are trying to subvert? I have encountered critics and commentaries on the work of others and myself, where the reading of the work is limited and its richness and complexity lost. Carly Butler has raised this issue in reviewing Shirin Neshat's work. She notes that some interpretations of her work fit too comfortably with the existing ways we allow the Islamic world into our own, giving the viewer a sense of knowing control: 'The ambiguity disturbs us, yet through our transparent stereotypes we believe we must see bigger, less threatening issues such as global diaspora and displacement...'[4]

This inclination to read and communicate an understanding of the work without any cultural instruction is a study in itself, and would open up a series of very fruitful debates, since whenever we delve deeper, we find the deceptive simplicity unravels to reveal layers of visibility and invisibility.

Let us not pass too quickly over the tenacity of the veil. For the Western gaze, the veil and the Orient are so closely entwined. In his book *Orientalism*, Edward Said clearly states that for the West, the Orient 'was one of its deepest and most reoccurring images of the other'.[5] He argues that one needs to examine Orientalism as a discourse in order to grasp that 'because of Orientalism the Orient was not (and is not) a free subject of thought or action'. In our visually dominated culture, particular images of the veil have been deployed and replayed again and again to the point that it now seems almost impossible to represent the East, the Orient, or Islam without recourse to the veil. Repeatedly it has become a sign of the supposedly repressive Muslim world and implicit in that assumption is the superiority of the West in relation to that world. So transparent is this item of clothing to the Western gaze, that the veil has become an effective visual shorthand to signify an extreme state of being – either repression or resistance. With such a long-established static visual language, how can I or any other visual artist bypass such representation?

The Muslim woman's body is central to Orientalist imagery as a voyeuristic site of otherness and

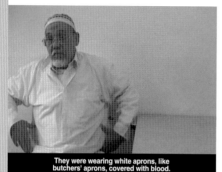

They were wearing white aprons, like
butchers' aprons, covered with blood.

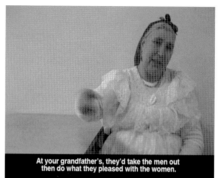

At your grandfather's, they'd take the men out
then do what they pleased with the women.

difference. The veil functions as a personal, cultural,
religious and political emblem – an ideological object
shrouded in fantasy and mystery. It has come to
symbolise class, culture and the related conflict
between colonised and coloniser – a site of
contestation. The unveiled woman is seen as an
individual and civilised subject, a far cry from the over-
represented and culturally constructed veiled woman,
who is considered anonymous, passive and exotic.
The construction of gender in the Islamic world has
already been mapped by the Western mind.

It is not the question of the body being under the
veil, but that the identity and the body of the Arab
Woman is made in the surface of her clothing, an
interweaving of her skin and cloth; 'If the veil is part
of her body, part of her being in the world, then it
defers from a simple cover that has an inside and
outside.'... In the ambiguous position it occupies,
the veil is not outside the woman's body. Nor is she
the interior that needs to be protected or penetrated.
Her body is not simply inside of the veil: it is of it;
she is constituted in and by the fabrication of
the veil.[6]

The physical veil has indeed become a spectacle.
Not simply an item of clothing, it marks a cultural
and emotional territory. Inscribed to the body, the
distinction between the wearer and the cloth is made
invisible; the Muslim woman's body – the medium
through which power operates and functions – is
defined by the surface of her clothing. This is a subtle
but potent commentary on cultural experiences and
codes, revealing the complexity of the gaze upon the
Muslim woman.

The veil... has come to be one of the most visible
and... debated external signs of difference, social
positioning, gender, desire and exclusion/inclusion.
The veil is a complex symbol that carries a
multiplicity of frequently shifting and often
contradictory meanings in differing postcolonial
geographies.[7]

There are, of course, no ready answers – nor
should there be – to the questions and dilemmas
that are part and parcel of the work in *Veil*. More
important, however, is to continue asking questions –
interrogating, deconstructing, reworking ideas about
the veil – and to create a greater space to explore and
understand veiling in all its multilayered, complex
guises. The visual interventions within the exhibition
attempt on a number of levels to disrupt this
supposedly unequivocal symbol. I am also concerned
that *Veil* should not be seen as just another exhibition
addressing postcolonial and diasporic issues, as the
complexity and richness of the work is eclipsed by such
a simplistic and limited reading. As Fadwa El Guindi
asks, 'Veiling was and is a practice that is differentiated
and variable, with each variant deeply embedded in the
cultural system. Perhaps the whole issue should be
reframed. Is it the same "veil" that is being documented
throughout the millennia?'[8]

I would like to think that a reframing might
include the investigation of the veil's role within
contemporary Muslim society and the sacred meaning

of the veil that connects it to cultural notions of sanctity and privacy. At this stage, however, I am not sure of the implication for contemporary artists, curators and writers of such a reframing. It merits further consideration.

Despite my questions and reservations, I have continued to want to work with themes relating to the veil and veiling. It is a real part of my history – personal and social, private and public. At a material level, veiling itself is a heterogeneous practice and the differences in veiling are reflected in the variety of work found in this exhibition. Visual artists, writers and curators need to continue to challenge the recurrent reductionism and work towards a critical, polyvocal dialogue. And *Veil*, I hope, will play a small part towards achieving this.

Images we have of each other are part of the baggage we bring to dialogue. Sometimes we are at the mercy of our image; sometimes we hide behind it; sometimes we act as though neither of us had an image of the other.... It is the degree to which image is present in dialogue that affects the ways in which identity is articulated.[9]

Notes

1 Jayce Salloum, *Intangible Cartographies: New Arab Video*, exhibition catalogue, Worldwide Video Festival, 2001.
2 Zineb Sedira and Jawad Al-Nawab, 'On Becoming an Artist: Algerian, African, Arab, Muslim, French *and* Black British', in *Shades of Black. Assembling Black Arts in 1980s Britain*, Durham: Duke University Press and inIVA, 2005.
3 bell hooks, *Black Looks: Race and Representation*, Boston: South End Press, 1992.
4 Carly Butler, 'Ambivalence and Iranian Identity: The Work of Shirin Neshat', in *Eastern Art Report*, no. 47, 2001–2, p. 46.
5 Edward Said, *Orientalism*. New York: Pantheon Books, 1978.
6 Meyda Yegenoglu, *Colonial Fantasies: Towards a Feminist Reading of Orientalism*, Cambridge: Cambridge University Press, 1998, pp. 118–19.
7 Fran Lloyd, 'Arab Women Artists: Issues of Representation and Gender in Contemporary British Visual Culture' in *Journal of Visual Culture in Britain*, vol. 2, no. 2, 2001, pp. 1–15.
8 Fadwa El Guindi, *Veil: Modesty, Privacy and Resistance*, New York and Oxford: Berg, 1999.
9 Miriam Cooke, 'The Weight of the Veil', in *Women Claim ISLAM – Creating Islamic Feminism through Literature*, New York: Routledge, 2001, p. 130.

How can you translate experience from one culture to another? Is it possible or even desirable? There is always something that gets left out. For artists like Hamad Butt and Shen Yuan, art provides a space to picture what has been left out. And, as Sarat Maharaj says, it is what gets left over from the translation – the untranslatable – that is the most productive and creative space for dialogue. In an artistic sense, the untranslatable is what cannot be put into words. In a political sense, the untranslatable can suggest the element that resists translation, in other words that which refuses the state's ability to translate and slot a person into a set category of difference. The untranslatable space then comes to suggest a space of resistance – an elusive and fluid zone.

Preceding pages
Shen Yuan, *Feel Just Like a Fish
in Water*, work in progress, 2001.
Photograph: Lee Funnell

Modernity and Difference

Stuart Hall and Sarat Maharaj

This conversation took place at an event, organised by inIVA, at the Lux Centre, Hoxton, London, on 25 October 2000 and was subsequently published in Stuart Hall and Sarat Maharaj, *Annotations 6: Modernity and Difference* (London: inIVA, 2001). The speakers discuss issues of translation in reference to notions of modernity and difference, mapping out the space of the 'untranslatable' as a means of thinking about difference.

Stuart Hall

As I think is true of all important terms in this kind of debate, it is best to deconstruct a term before you use it, or at least explain what you do not intend it to mean. There is one sense of the term 'translation' that I do not want to awaken, which is the notion that there is an original text and that all translations are then necessarily partial renderings of that original. They stand in relation to the original text as copies to origin. However, I'm really not interested in the notion of origin in that sense, because my position is that most original texts, when looked at closely, turn out to be translations themselves.

I regard translation as an unending process, a process without a beginning. Except in myth, there is no moment when cultures and identities emerge from nowhere, whole within themselves, perfectly self-sufficient, unrelated to anything outside of themselves and with boundaries which secure their space from outside intrusion. I do not think that either historically or conceptually we should think of cultures or identities or indeed texts in that way. Every text has a 'before-text', every identity has its pre-identities. I am not interested in the notion of translation in terms of rendering what has already been authentically and authoritatively fixed; what I want to do instead is to think of cultural practices as always involved in the process of translating.

Cultural processes do not have a pure beginning; they always begin with some irritant, some dirty or 'worldly' starting point, if I can call it that. When I say 'dirty', I mean that there is no pure moment of beginning; they are always already in flow and translation, therefore, is always from one idiom, language or ideolect into another. All languages have their own internal character, their own kind of ethos, their own space, and so it is therefore impossible to think of a perfect translation; no such thing exists. One has always to think of cultural production of any kind as a reworking, as inadequate to its foundations, as always lacking something. There is always something which is left out. There is always mistranslation because a translation can never be a perfect rendering from one space or one language to another. It is bound to be somewhat misunderstood, as we are all always misunderstood in every dialogue we undertake. There is no moment of dialogic relationship with an other which is perfectly understood by them in exactly the way intended by us, because translation is a mediation between two already constituting worlds. There is no perfect transparency.

So the notion of a perfect translation does not help us at all. What we usually think of as polarised between copying or mimicking on the one hand and the moment of pure creativity on the other are really two moments that are mutually constituting – they do not exist in a pure form. Pure creativity draws on something which is already there; it moves from one space to another and the creative act is that movement. It is not that I have thought of something or said something or produced something which has never been produced before – it is not the romantic notion of a pure start. Nor is it the notion of a pure finish, because every translation generates another. No-one reads a translation without thinking, 'I bet that's what the original really means. I bet I could express it better.'

One has to think of meaning as constituted by an infinite, incomplete series of translations. I think cultures are like that too, and so are identities. I think cultural production is like that and I am sure that texts are like that. In fact, the notion of 'cultural translation' is absolutely central to an understanding of this whole field. There are many people who have contributed to this particular notion of translation which I am trying to invoke, but I shall mention just three names as a way of orienting my argument: Walter Benjamin, Jacques Derrida and Mikhail Bakhtin.

Sarat Maharaj
Stuart had put the ideas across clearly with regard to cultural translation – I feel there is little more I could add, except simply to expand on what he has said and refer back to my essay on the untranslatable, since for me the search for translatability involves constantly bumping into and tussling with what is untranslatable. The names that Stuart concluded with – Benjamin, Derrida and Bakhtin – are crucial from the point of view of a theoretical understanding of translation and of analysing what happens in the process: translation of identities, translation of cultures, translation of ethnicities. Whatever might be the case in hand, the point is that we are always in the process of translation – translation is not so much an exceptional moment in our lives but a condition of being and becoming.

Against the three discursive and analytical commentators who have helped us so powerfully to comprehend the mechanisms of translations in the twentieth century, I would like to say that my own involvement begins in a much less grand, less

theoretical way. It started quite simply through living in the apartheid state which assumed to translate one and all 'ethnic and native' groups in the way it saw fit for modernity. We would be translated – our primordial archaic features ironed out. We would be cleaned up, dusted down and given a voice in such a way that the apartheid state could then speak to us and make us intelligible to itself. Growing up in such an environment irked all of us, needless to say, and the issue of translation was immediately both a violating political act and a political process of resistance.

Later on, during years of more solitary reflection on this question, I found two other thinkers helped me to delve deeper into the mechanisms of translation. They were James Joyce and Marcel Duchamp. They remain the figures with whom I have worked and tried to relate what I have understood about translation through that massive, sprawling, unreadable, untranslatable work, *Finnegans Wake,* and through the great untranslatables of Duchamp's notes and jottings for the *Large Glass – The Bride Stripped Bare by Her Bachelors, Even* (1911–23). Richard Hamilton translated one batch of notes in 1960 as *The Green Box* and another bundle in 2000 as *The White Box.* These works served as instruments through which I tried to think about the difficulties of translation. While the analytical contributors to this question have largely focused on what can and can not be translated, I felt the practitioners Duchamp and Joyce also looked at and probed zones of the untranslatable. How do we live it? What does it mean to be in the experience of the untranslatable? Is it nonsense to talk of the untranslatable in these terms? But what kind of non-sense? Counter-signification, anti-meaning, what?

These reflections through Joyce and Duchamp strengthened the idea that although certain things can be translated in the domain of the linguistic, culture is far more than simply language and words. This produced in me a deep sense of the limits of words and language as the exclusive model through which we might think about cultural life and the translation of our everyday experience. With Joyce and Duchamp, there emerged, it seemed to me, a notion of translation which activates both the visual and the sonic. Beyond the *sense* of the word and image are sounds which cannot be entirely drawn into the net of signification and cannot entirely be decoded and deciphered as meaning this, that or the other. These larger sonic pools – the penumbra of the untranslatable that shadow and smudge language and for which we have to venture beyond language – became an increasingly important area of interest in my thinking about cultural translation.

*SH_*There are a number of points that I would like to pick up on and develop from what Sarat has just said. One is about the notion of the untranslatable, that which escapes representation, or what is always left behind as a kind of resistant remainder. I, of course, accept the notion that everything cannot be translated. I think of the nature of the remainder in a slightly different way, which perhaps remains too confined within the linguistic domain and for that reason is, I think, somewhat limited. It has to do with how we understand meaning; whatever the medium in which it finds itself expressed, the notion of meaning always depends, in part, on what is not said, and on what is not

represented, as part of meaning's constitutive outside. This is the notion, derived essentially from Ferdinand de Saussure, that one cannot know what it is that one means unless one also implicitly affirms or states what one does *not* mean – that every marked term or signifier implicates its unmarked 'other'....

We are defined as much by what we are not as by what we are. The 'truth' of the Lacanian insight is that the subject is constructed across a 'lack', the self by its 'others'. This for me is an absolutely fundamental point, because it implies that, within ourselves, within the terms of a meaning, we are always inadequate. We cannot complete ourselves. We are always open to that which is other or different from ourselves, which we cannot encapsulate into ourselves, draw into our field of meaning or representation. This notion of a lack has psychoanalytic Lacanian echoes, but I do not want to get into that today. However, I do not think that you could talk about an identity without talking about what an identity lacks – difference. This is very important because it is the point at which one recognises that one can only be constituted through the other, through what is different. Difference, therefore, is not something that is opposed to identity; instead it is absolutely essential to it. You cannot talk about the identity of a set of terms without talking about how they are different from what that set of terms does not include. So the question of difference then does, for me, emerge from what Sarat said about the untranslatable.

If I want to say something, I have to form a statement of some kind, which is true of whatever medium I am using. There is always a kind of closure to that, because I have not finished saying anything

until I stop. In language, that stop or closure is both necessary and arbitrary. It is necessary because the thought cannot be completed until you frame it, but the frame is completely arbitrary because the moment somebody else responds to that statement, the frame is reopened – your previous statement (totalisation) is completely detotalised. My perfectly finished thought stops and somebody else, by taking up the thread and elaborating it in a new direction, implicitly says, 'Of course that's not quite so.' So we move from arbitrary closure to movement to other closures, which is how dialogue – the dialogic – works. I think of any text, sentence or work as a moment of arbitrary closure in what I call the infinite flow of meaning – the infinite semiosis of language. Thus, as Bakhtin argues, no speech is wholly my own, but is sustained in the passage of meaning between speakers (the metaphor here is linguistic but applies also to the visual field).

Any statement which has a meaning for another human being is therefore grounded in more than what it says – its excess – but is also less than what you want it to say; it is the result of arbitrary closure. It is not a completely full, self-present statement of everything, because if it was, history and meaning would end; it would give up the ghost. It would say, in effect, 'OK, that's the sentence we've all been trying to say since the year dot and, now you've said it, there's nowhere else to go.' The supposedly finished statement is instantly overridden by that which it cannot say, that which it has not said, that which it cannot bring into representation. Meaning – not cognitive meaning only, but anything that somebody else will get something out of – is therefore always constituted in the interplay between

excess and lack. And that is another way of thinking about what is *not* and can never be inside representation – the untranslatable.

I am interested in asking Sarat whether what he means by the untranslatable, which in a sense gives power to the images and the language he is talking about, is the same as, or different from, or close to what I have just said about what has to be left out of representation. I am strongly aware that my argument is grounded in a conception of language and is using the linguistic as a kind of master model of meaning, which is something that I do not mean to impose.

SM_I think that Stuart has, as usual, lucidly presented how one would think of the untranslatable if one were to proceed with the linguistic model as a master model. Language has served in most of our thinking about cultural translation and I suppose that translation itself seems to be so tied up with words, translating from one language to the other. Those of us who come from areas that also involve image and sound have therefore had to really sit up and think about second-round translation – the translation of image to image, image to sound, or image to word – which is not entirely served by the linguistic model.

I feel what Stuart has presented is absolutely central to an understanding of identity and difference, difference that cannot be stopped and difference that continuously writes itself in the way that Duchamp speaks of writing 'in the infinitive'. Imagine something that could never be written in 'stationary verbs' that give a standstiff account of where one is, but is instead written 'in the infinitive', forever suggesting potential

movement out of itself into a future that is, as yet, not described, nor defined, nor in any way pictured. Even within linguistic terms, if I think of translation as being an act in the infinitive mood, then I get close to Stuart's notion of perpetual translation in which no sooner you feel you have fixed an identity, you have to translate it again and again and again.

This sometimes produces the effect of saying that identity is a series of negations, of saying this is not what it is, this is not what I mean, this is not how I see it. In fact, there has a been a line of thinking, particularly in twentieth-century music and visual arts, which can be traced back to the famous words uttered by the Buddha. Asked to describe what is the essence of things, what is identity, he simply answered with three words which have reverberated throughout the twentieth-century avant-garde. He replied in Sanskrit, '*Neti, neti, neti*', meaning, 'Not this, not that, not this.' Having heard these words, some felt that this was extreme mystification and were exasperated by this kind of answering. Later, commentators, particularly in the Indian school of philosophy called the Nyaya-Vaisesika, went on to elaborate thinking in terms of such negatives. They stopped trying to define what we are, as though one could hold one's identity, one's sense of self, in the palm of one's hand. When they did try to, they did so in a very knowing way, conscious that what they said would be translated, rephrased, recast again. So those would be my notations to Stuart's clear account of the linguistic model.

I have tried to struggle with the notion of the untranslatable as that area that is simply the leftover – Stuart mentioned the term remainder – the 'leftover-dross' in the act of translation. When one language, one experience, one visual or retinal regime gets translated into another, it has to be re-jigged to fit into the system of thinking of the other and something is 'left out'. This remainder – at least this is what logically appears when you analyse translation – inhabits the space of the untranslatable, a fog that persists no matter how much in everyday life we feel we overcome the untranslatable and manage to thrash out a ground of crystal-clear communication for ourselves. In some instances, artists have gone on to say that translation – even from one set of words to another – demands picturing or somehow seeing what is left. The remainder which cannot be put into words might be something you can visualise or something that can be suggested through sonic stuff, through the 'sounding of that difference' as a kind of turbulence, as a cloud of disturbance around clear-cut linguistic meaning.

In the more political sense, I understand the untranslatable to mean that which resists translation – in the sense that it refuses the state's ability to translate and slot a person into a set category of difference. When a government attempts to fix a person into a difference-box and then treat him or her according to a policy or programme of diversity, I call this pigeon-holing *multicultural managerialism*. In the light of my concern about that managerialism and fixing of difference, I have tried to explore beyond the linguistic model to understand the untranslatable not simply as a place of resistance or turbulence or perturbation, but as one of elusive liquidity – in Duchamp's and Bergson's lingo, as a matter of 'passages' rather than 'stoppages'.

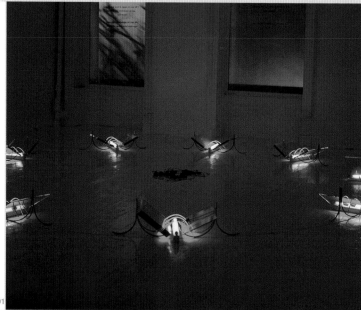

01

Hamad Butt

Hamad Butt was a brilliant young artist who graduated from Goldsmiths College in London in 1990 and died four years later. He had begun devising a publication about his work during his life time and two years after his death, in collaboration with the John Hansard Gallery in Southampton, inIVA published a posthumous artist's book. Hamad Butt distilled different kinds of knowledge drawn from science, popular culture and religion, translating them into visually exquisite (and sometimes dangerous) artworks.

01–02 Hamad Butt, *Transmission*,
1990. Courtesy Ahmad Butt
03 Hamad Butt, *Cradle*, 1994. Courtesy
Ahmad Butt
04 Hamad Butt, *Substance
Sublimation Units*, 1994. Courtesy
Ahmad Butt

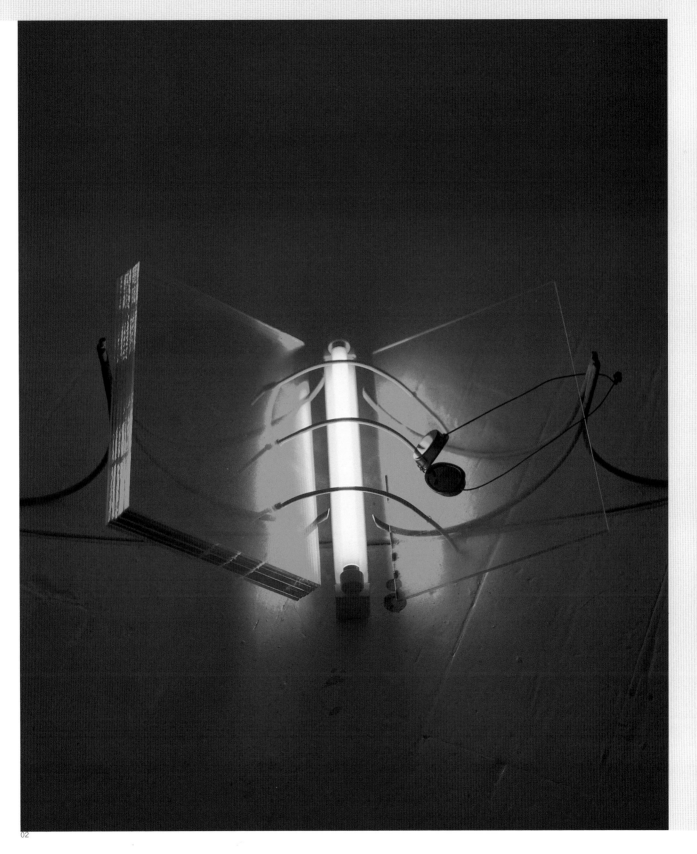

Hamad Butt

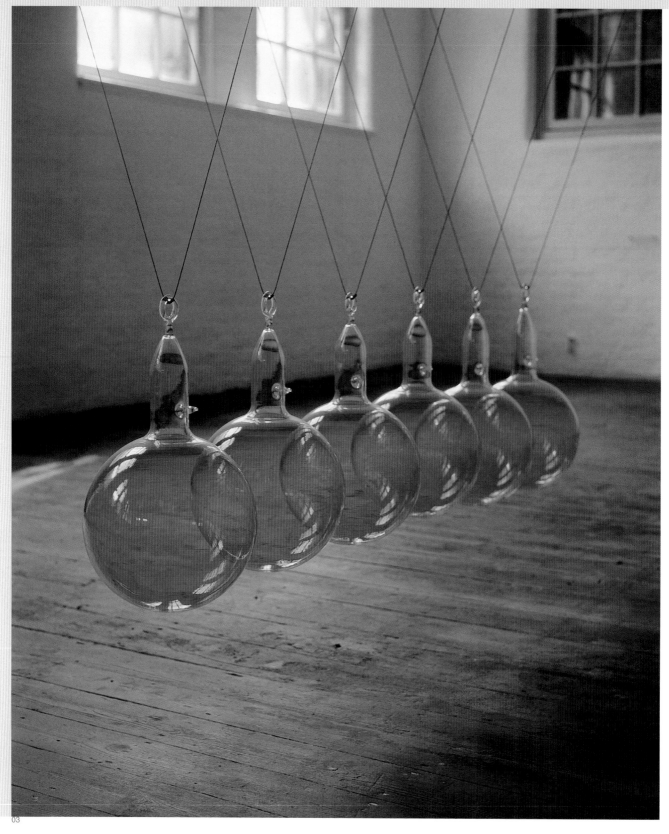

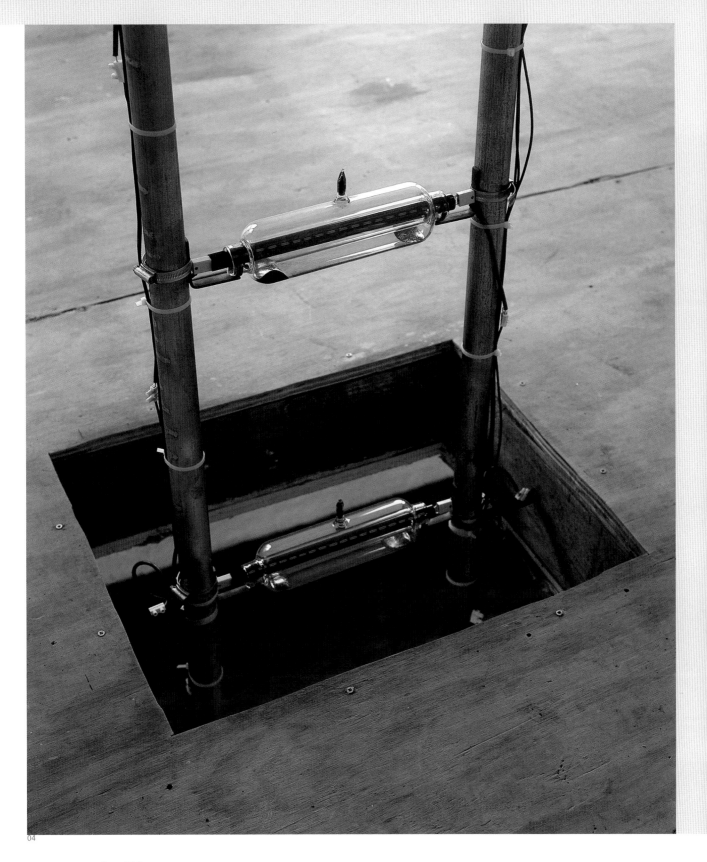

Hamad Butt

The Leftovers of Translation:
The Works of Shen Yuan

Gilane Tawadros

This text was published in full in the monograph *Shen Yuan* (London: inIVA, 2001). As part of her practice, Shen Yuan takes everyday objects and materials, investing them with new lives and meanings, translating them from the mundane into the extraordinary. By introducing readers to a number of her works, the text explains how her work addresses the inadequacy of translations from one language or culture into another.

A frozen, wine-coloured tongue carved from ice hangs down over a metal spittoon. The tongue is suspended, like a sheet of glass, frost-bound and hard. As warm currents of air circle around it, the frigid organ softens and yields. Drop by drop, the melting ice drips into the waiting spittoon until the glint of metal, reflecting through the water, hits your eye. In time, the frosty tongue thaws to reveal the blade of a kitchen knife, sharp and pointed. *Perdre sa salive* or *Wasting One's Spittle* (1994), an installation piece composed of frozen tongues, kitchen knives and metal spittoons is concerned, like many of Shen Yuan's works, with the transformation of images and objects from one state to another. Like the Chinese expression of 'finding reincarnation in another's corpse', Shen Yuan takes everyday objects and materials and invests them with new lives and meanings, translating the mundane into the extraordinary.

In *Wasting One's Spittle*, objects and materials are transformed into something other than themselves but, like the spittoons that gather the melted ice, the residue of the original material remains. Here the role of the artist is not that of a magician conjuring new forms from old, nor that of an alchemist transforming base metal into gold. Rather, the artist acts as translator, reinterpreting elements of the physical world into new visual metaphors that often refer back both to the previous condition of these materials and to spoken language, in particular, to colloquial proverbs and sayings. 'To lose one's spittle' in Chinese is to be excessively modest or submissive, but here the unassuming image of drooling tongues dissolves itself into the spectacle of sharpened knives. In a

subtle inversion of the original meaning, Shen Yuan's icy tongues 'lose their spittle' only to acquire the trappings of imminent violence.

But *Wasting One's Spittle* is also concerned with the limits of language: the cul-de-sac of clichéd proverbial sayings; the inability of words to approximate to the visual image; and the inadequacy of translations from one language or culture to another. At one moment, these tongues are as solid as ice; at another moment, they have melted and metamorphosed into another state. Perhaps, they might be seen as the 'leftovers of translation', all the things that are left unsaid or all the nuances of language that inevitably remain untranslated. Invoking the untranslatable should not be seen as a melancholy exercise but, on the contrary, it offers the possibility of a dynamic exchange between artwork and viewer that leaves the work open to continuous interpretation and re-interpretation. Shen Yuan's works articulate what Sarat Maharaj calls the 'leftover inexpressibles of translation', demonstrating 'an attentiveness that opens on to an erotics and ethics of the other beyond its untranslatability'.

> How... to recode translation taking on board ideas about its limits and dead-ends, its impossibility, the notion of the untranslatable, what we might call 'the untranslatability of the term other'?... The idea is to ask if the hybrid might not also be seen as the product of translation's failure, as something that falls short of the dream-ideal of translation as a 'transparent' passage from one idiom to another, from self to other.... To recode it in more circumspect key involves defining it as a

concept that unceasingly plumbs the depths of the untranslatable and that is continually being shaped by that process. It is to reinscribe it with a double-movement that cuts across 'optimism and pessimism, the opaque and the crystal-clear' – to activate it as a play-off between the poles. It amounts to reindexing hybridity as an unfinished, self-unthreading force, even as a concept against itself. At any rate, as an open-ended one that is shot through with memories and intimations of the untranslatable.[1]

The French title of the work, *Perdre sa salive*, introduces another colloquial meaning to the work – wasting one's breath – that becomes knitted into the increasingly complex fabric of the piece and its multiple meanings, translations and interpretations. The artist herself talks about the work in terms of the excess of language, of when words spill over to such an extent that they become meaningless and language loses its ability to communicate. In this respect, *Wasting One's Spittle* and other works by Shen Yuan reflect on the relationship between the visual and the linguistic, elegantly and succinctly problematised by René Magritte's painting of a painted pipe, accompanied by the words '*Ceci n'est pas un pipe*' (This is not a pipe). Created in what Walter Benjamin christened as 'the age of mechanical reproduction' and in the face of the challenge presented to painting by the photographic image, Magritte's painting underlines the gap between the 'real' world and its representation by the artist. Shen Yuan's work, made in an age of increasingly rapid communication technologies and the mass migration of peoples across the globe, points to the limits of language to describe and translate lived experience in a new global economy.

Shen Yuan's preoccupation with spoken language and its limited ability to articulate contemporary experience is undoubtedly informed by her own migration from China to Paris and the consequently painful negotiation of an alien culture and language, familiar to many migrants. Uprooted from a familiar environment to an utterly different cultural space, language which once acted as an anchor rooting you in a particular place and culture, is abruptly weighed, leaving you adrift and lost. Linguistic and communication skills honed over decades become defunct overnight, crudely underlining the fallibility of language.... Her eloquent description of how a sixteen-hour flight changed everything echoes the temporal transformation that her installations frequently undergo, becoming, over time, altogether different. 'Becoming' rather than 'being' is the condition to which Shen Yuan's works approximate – constantly changing and transforming from one state to another.

Paris, the first foreign city after leaving the country where I was born.
A sixteen-hour flight and at last I arrive in the paradise I had imagined the West to be.
My first walk, with my husband and a friend, is up the hill to Montmartre.
We pass by some enormous dustbins on which is written 'The property of Paris'.
Following in Duchamp's artistic tradition and in the name of the readymade, they suddenly leap inside.

Sixteen hours later, my mother tongue becomes useless. Language is nothing more than noise. My brain enters into a sponge-like state.
It is like having a mouth, but not knowing how to open it; having ears, but they do no hear anything.
The first thing I have to do is to buy a little notebook and write down the telephone numbers of my friends and their addresses. But in front of these blank pages, what should I do?
Sixteen hours. It is not a long time, but all the rules have changed.
My first reflection: how does one start one's life again, aged thirty-one?[2]

In 1999, Shen Yuan made another work involving tongues. *Diverged Tongue* (made originally for the CCA Kitakyushu, Japan) consists of a huge, inflatable, forked tongue, reminiscent of a children's toy whistle, which is suspended from the wall and blows itself up at three to four minute intervals along the gallery floor. The work takes as its reference point a Chinese saying, in this case, one that defines an extended and forked tongue as the mark of a person with a distinctive (regional) accent, a person from another place who attempts (and fails) to speak two languages with one tongue. *Diverged Tongue* reflects on the failure of language to straddle, at one time, two distinct linguistic systems and, by extension, two different, cultural spaces. Extravagant claims are made for this twenty-first-century globalised world in which we can bridge vast geographical distances in a matter of hours, communicate in a matter of seconds, and yet, Shen Yuan implies, we trip up at the first hurdle of linguistic difference.

The 'forked tongue' also denotes a different register, accent or idiom. Variously termed as broken English, lingua franca, patois, creole, this new 'tongue' unfurls, creating something new, something other than its constituent parts from the residues of half-remembered speech and almost-forgotten expressions. Deflated and curled up in the corner of the gallery space, Shen Yuan's *Diverged Tongue* is an absent presence, barely registered by the visitor entering the space. As it inflates and expands across the gallery floor, however, *Diverged Tongue* takes on an altogether different persona as a deafening and overwhelming presence in the space that is impossible to overlook. In the context of the European Continent which has been transformed and continues to be transformed by the influx of migrants from all parts of the world, *Diverged Tongue* could be seen as a metaphor for the ambivalent status of Europe's migrant communities. Deracinated and transposed to the Continent's urban spaces, they are perceived as a latent threat – at one moment barely visible or acknowledged and, at another moment, caricatured as hordes on the brink of 'swamping' Europe's indigenous cultures. A fluctuating tide of xenophobia and racial violence ebbs and flows across Europe and intermittently surges like a tidal wave over the neo-liberal defences of the Continent's democracies. At times such as this, it is the polite and liberal patina of civilised societies that threatens to melt like the ice concealing Shen Yuan's steely knives, transforming a domestic implement into a deadly weapon.

Shen Yuan cites the literary and linguistic as significant references in her work over and above the

sociological or philosophical – hence her repeated use of colloquial proverbs and sayings as a starting point for the making of works. Her visual and linguistic punning owes much to Marcel Duchamp's readymades, not least in her fascination with the transformation of images, the possibility of plural meanings and the migration of the readymade object into the gallery space. But unlike Duchamp's readymades that, by their movement from the world outside into the space of the gallery, are bestowed with the status of art objects, Shen Yuan's objects and materials are continually in the process of transformation, continually becoming something else that cannot easily be fixed or held. They are, to all intents and purposes, migrating objects moving from one space to another and being transformed in the process. In this respect, Shen Yuan's 'readymades' are deeply personal and intimate reflections on the experience of identity as a continuously shifting and allusive entity. In *Fingerprint* (1999), a slice of raw ham, laid out on a plate like a slice of human skin, is delicately embroidered with minute gold thread to create the configuration of the artist's fingerprint, the body's unique identification system, in such a way as to reinforce its fragility and impermanence rather than to fix identity once and for all....

In a later installation piece – *Un Matin du monde* (2000) – the explicit references to the human body have disappeared, remaining now only as an implicit physical presence in the work. Recreating the rooftop of a traditional Chinese house, the installation gives you the illusion of standing on a rooftop in China, which has been peppered with the sounds of everyday life and the smell of spices and prepared duck that has been put

out to dry. The viewer's physical presence 'activates' the work by introducing a human scale to the installation and by bringing the viewer's imaginary and sensory responses into play. Smell and sound are added here to the trilogy of senses (taste, sight, touch) invoked in Shen Yuan's earlier installations. This piece, perhaps more than any other, accentuates the sensuality of her works that stretch out to engage you physically with all your senses and emotions.... *Un Matin du monde* mines the latent characteristics of her materials and at the same time stimulates our latent senses and emotions, transforming us in the process from spectators into participants. 'Art for me', writes Shen Yuan, 'is a way of finding "reincarnation in another's corpse". To reveal the latent language of the material, to breathe life into inanimate things, make useless things useful and make useful things useless, that is what I wish to do.'[3]

It is this poetic and often disturbing transformation of objects from their literal meaning and function in the world into something different that lies at the heart of Shen Yuan's practice as an artist. In this respect, her work challenges the literal nature of some contemporary artworks where 'real' things are preserved or moulded and re-exhibited in the gallery space as figurative metaphors for the human condition. Perched on Shen Yuan's reconstructed rooftop, your view is restricted to what lies on the roof and above it. In visual terms, you have a bird's eye view restricted to the skyline without the benefit of seeing what lies beneath or around you. You are in a 'real space' but at the same time removed from reality. *Un Matin du monde* transposes you to a space of limitless

imagination but also to the realm of flawed and incomplete memories.

The Dinosaur's Egg (2001) provides a different kind of bird's eye view. A map of China and its neighbouring countries covers the gallery floor. A large fibreglass egg has hatched and given birth to an army of fibreglass figures, caricatures of 'traditional' Chinese characters that are reminiscent of children's toys. Half a metre in height, over fifty of these fibreglass characters are dotted across the map to resemble a gigantic children's chess game. Like *Diverged Tongue*, this work is inspired by children's toys....

The Dinosaur's Egg figures are also translations or mistranslations of Chinese culture. They represent the failed attempt to translate another culture, giving birth to these bizarre, over-sized caricatures whose somewhat sinister presence populates the entire gallery space. The work speaks to the contradictions of globalisation where the movement of people, criss-crossing the world, has not been mirrored by a parallel movement of ideas. The speed and exchange of worldwide communication has not resulted in an equally fast exchange of cultural understanding. Shen Yuan's most witty and playful installation is also the most pessimistic appraisal of the failure of cross-cultural translation and, more specifically, of one culture's failure to engage in any depth with cultures and ideas that are different from it. Over the past decade, we have seen the increasing 'globalisation' of the art world in parallel to many other sectors of the economy. And yet the more visible presence of artists from Africa, Asia, South America and the Caribbean on the international art world stage has not shifted the enduring hierarchies. Nor has it challenged the prevalence of cultural and racial stereotypes that insist on mediating 'difference' according to their own terms of cultural engagement. The new economy of 'multicultural managerialism', as Sarat Maharaj has characterised it, demands a fresh response that, like Shen Yuan's installations, is seductive and playful, but at the same time, armed with a razor-sharp critique of the dead-end that 'multicultural managerialism' encourages....

Shen Yuan's artistic practice is perhaps best characterised as one that uses the gallery (and its exterior) as a performative space into which she brings materials and props in order to stage works that address the conditions of modernity in the twenty-first century. Invariably, the viewer is implicated in some way in this elaborate staging for which the individual and their negotiation of the world is key. Inherent to the materials she employs and the artworks she fabricates out of those materials are the transformation of images and objects; the limits of language and the translatability of cultures; the sense of possibility of connection with the rest of the world and, at the same time, the imminence of disconnection; and, above all, the continuous and cyclical movement and migration of things.

Notes
1 Sarat Maharaj, 'Perfidious Fidelity: The Untranslatability of the Other' in Jean Fisher (ed.), *Global Visions: Towards a New Internationalism*, London: Kala Press/inIVA, 1994, pp. 28–30.
2 First published in *Paris pour escale*, exh. cat., Paris: Musée d'Art Moderne de la Ville de Paris, 2000.
3 Shen Yuan, unpublished writings about her work.

01

Shen Yuan

Living and working in Paris since 1990, Shen Yuan belongs to a generation of artists who left China to pursue their artistic practice. *Shen Yuan* was a touring show curated and produced by inIVA and Arnolfini in collaboration with Chisenhale Gallery that showed simultaneously at Arnolfini in Bristol and Chisenhale in London in 2001 before touring to Bluecoat Gallery, Liverpool. In collaboration with Arnolfini, inIVA published a monograph on the artist on the occasion of this exhibition.

01 Shen Yuan, *Feel Just Like
a Fish in Water*, work in progress,
2001. Photograph: Lee Funnell
02 Shen Yuan, *Feel Just Like
a Fish in Water*, 2001

Overleaf
03 Shen Yuan, *Diverged Tongue*, 1999
04 Shen Yuan, *Perdre sa Salive*
(Wasting One's Spittle), 1994

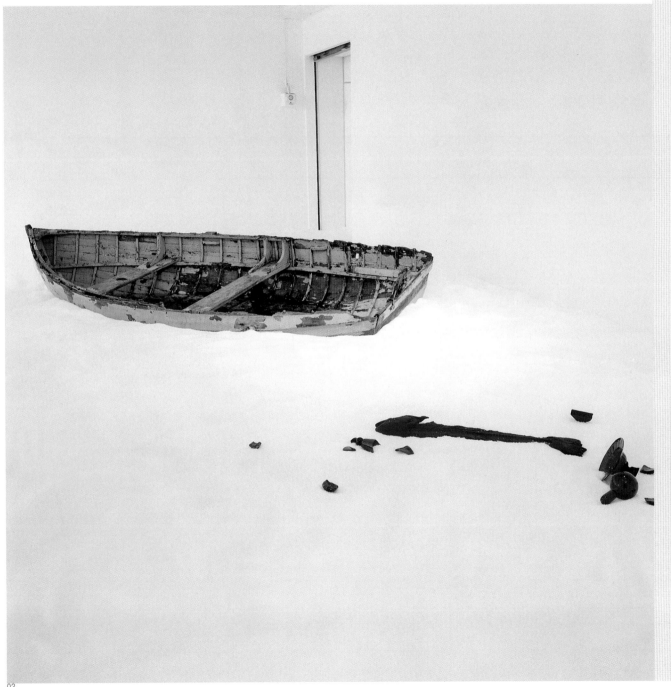

Shen Yuan

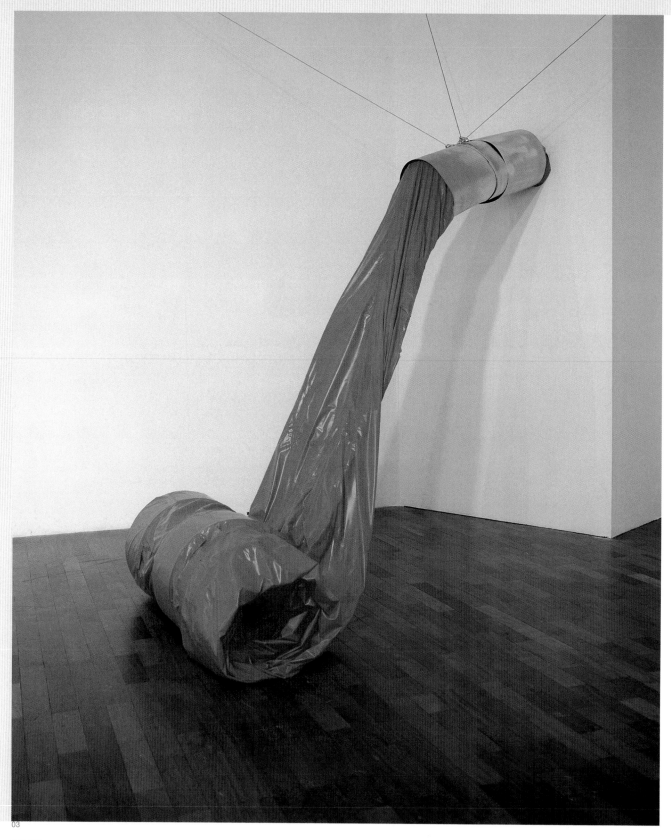

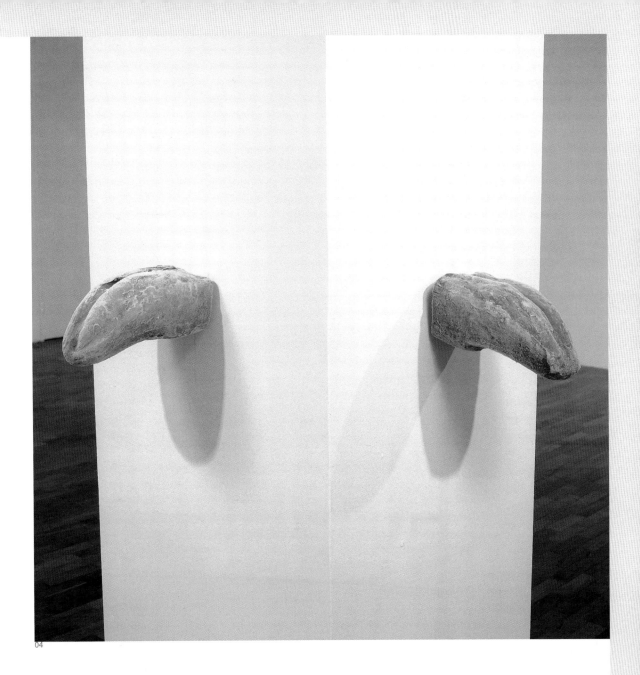

Shen Yuan

Economics, Postcolonialism and New Technologies

Françoise Vergès

This paper formed part of a seminar entitled 'Translating Technologies', organised by inIVA in 1996. It was the first in a series of seminars entitled 'Frequencies', which, as inIVA launched its first website, set out to cast a net across the numerous debates that were concerned with the use, understanding and problems of technology in relation to contemporary art. It was subsequently published in *Annotations 3: Frequencies. Investigations into Culture, History and Technology* (London: inIVA, 1998).

210_211
Translation

New technology's politics of language and cultural difference can be viewed from different perspectives: from the position of postcolonialism and how the political subject is constituted in today's world to the question of multi-lingualism. I believe that technologies do not exist in themselves as such; a computer is a computer is a computer, to paraphrase the famous saying: 'a pipe is a pipe is a pipe'. They do not exist without a mode of production, without the image of a young woman building little chips in Taiwan and subsequent knowledge of the computer being used by a businessman in Taiwan trying to make more money. It is necessary to examine how computers are built, how they are used, who uses them, who has access to them and what kind of discourse is built around them – such as the discourse that says new technologies will facilitate communication and, as a result, a new world is being built.

We are told that the internet will facilitate communication throughout the world. Certainly speed has facilitated communication, but is it only about speed? To communicate there must be at least two people, so the question of talking to the Other, of translation, of understanding and of what is constantly missing or lacking in communication, of what is left and cannot be totally 'communicated', is not resolved by speed. We are also told that we will better understand each other because people will discover other cultures and other languages. Again, why is this expansion of knowledge so imperative? What do we remember and what do we learn? Can we say, after Freud, that we can remember only because we can forget? There is a possibility of remembering because we can forget; if we were constantly remembering, there would be an overload – to use a technological term.

There are two facts that I recently read in a newspaper which are relevant to the theme of translating technologies. The first one referred to the number of telephones in the whole African continent which represent only a quarter of the number of the telephones in the entire city of Tokyo, although twelve percent of the world's population lives in Africa – out of the whole number of telephones in the world, two percent of them are in Africa. In nine African sub-Saharan countries, the number of telephones has decreased since 1994. Even though sub-Saharan Africa has so few phones, Africa as a continent has the highest number of international calls per year and per inhabitant in the world, because of migration. One consequence of this 'underdevelopment' in communication is the high number of mobile phones that are owned. Whereas in Kinshasa, the capital of Zaire (now the Republic of Congo), there are only 4000 phone lines for the entire population, there are 8000 people with mobile phones. The phone companies in the United States, France and Britain as well as an African consortium have decided to remedy the situation. The American project is to bring the internet to twenty African countries; in 1999 AT&T plan to start a project that they call 'Africa One', by laying 39,000 kilometres of cable that will connect the cities along the African coast. The other fact reported in the newspaper was about how the internet has been offering, since August 1996, a programme of child adoption in four languages: Portuguese, Spanish,

Far left Fernando Palma Rodriguez, *Meshigene*, 1997
Left Fernando Palma Rodriguez, *Come to Me My Eyes*, 1997

French and English. This programme provides a physical description of the child to be adopted, with his or her picture – anyone is able to access this information and see what kind of child is available.

These facts raise the following questions: Who has access to technology? How does one get access to it? Who controls it? What kind of discourse is built around it and what does this discourse say about the unconscious desires, aspirations and dreams of those who distribute it and of those who use it? What is interesting is to examine whether the discourse which insists that new technology is a fast and efficient tool which opens new roads into new ways of living, ultimately transforming and revolutionising the world, is the kind of discourse that existed in 1950s Western Europe. For instance, in France, just after the war, there was practically no electricity and no indoor plumbing in most houses – the modernisation of France was based on the American model. Advertisements depicting a woman with a Hoover, a refrigerator or a washing machine epitomised the American remodelling of domestic life. The machine was presented as a beautiful, fast and efficient piece of equipment that would provide new ways of living. Similar imagery, tropes to contemporary discourse about new technologies, were used to bring modernised ways of life to the 1950s. And effectively there was a change; whether one has indoor plumbing or not can change one's life – it is more than an image.

I want to point to the fact that during a period of incredible modernisation, when there was a new dimension to life, and a new possibility in France, there was, on the other side of the Mediterranean, a colonial war in Algeria. And suddenly, the application of electricity and indoor plumbing acquired another meaning because both were used in torture. When Henri Alleg, who was tortured by French paratroopers, talked about the house where he was taken he referred to a kitchen and its modern appliances: the same appliances which were advertised in a French women's magazine were thus used in torture. There was a cartoon by Bosc, a French cartoonist at that time, entitled '*Il faut que la torture soit propre*' ('Torture must be clean') where a paratrooper is depicted in a bathroom and is pushing an Arab in a bathtub, and beside the tub there is a box of soap whose brand name is *lave plus blanc* (wash whiter). On the one hand, new technologies brought to France an ideal of peaceful domesticity and, on the other, the new appliances acquired a new and horrific dimension. It was like a parody of modernised domestic life happening in Algeria, but this parody had a very concrete effect on the body of the Algerians; one witnesses a violent decolonisation abroad and a safe decolonisation at home. Situationists were calling this process 'the colonisation of everyday life'. Today, the Algerian army has taken back from the French army the methods used to torture people whom they arrested. Colonel Trinquier, a French officer in Algeria, said, on the subject of torture, technology and modernisation, that torture had to be organised, it could not be dirty and sloppy. The notions of organisation, cleanliness and pragmatism were used to describe the routine of everyday life and torture. At this moment in time, we should consider the colonisation of our everyday life and how new technologies may exercise a form of colonisation.

My last point concerns multi-lingualism. Derrida, in *Le Monolinguisme de l'Autre*, writes about growing up in Algeria as an Algerian Jew. Arabic was the tongue of the Algerian, French was the tongue of the colonisers and the *Pieds Noirs* (the European colonists), and Hebrew was spoken in certain parts of the Jewish community. Derrida first rejected French because it was associated with the colonising power, but then he had to work through this rejection because French became the language that gave him access to thought and philosophy. French was not only the language of the colonisers, but also the language of philosophers like Descartes, Pascal and Blanchot. To him it was important to understand that the Other is always monolingual while there is a plurality of languages within any one language. He argues that even the native tongue is a language of the Other because it is the language of the mother; there is already an Other in the maternal native tongue. Thus, as we learn language and as we learn to speak, so we have access to multi-lingualism.

The desire to communicate does not produce communication. Understanding a vocabulary does not produce communication. Even if I understand you, or you understand me, there will always be something which would remain misunderstood – though an impossibility of dialogue is not necessarily produced by misunderstanding. There is a fantasy of a universal language that will make everyone understand each other; a fantasy of transparency. Adopting a language which makes communication possible is fine. In everything there is a dimension of bondage and a dimension of emancipation. We are moving in a field that, while remaining stable, is simultaneously changing and liberating us.

01

Alia Syed

In early 2002, *Jigar* – an inIVA touring exhibition of the films of Alia Syed – opened at The New Art Gallery Walsall and TheSpace@inIVA, before touring to Turnpike Gallery, Leigh, Greater Manchester. The following year, in October 2003, inIVA premiered *Eating Grass*, a new film by Syed. Shot in London, Karachi and Lahore, the film simultaneously explores the overlap between different times, places and memories, expressed as in other of Syed's films through the overlap of evocative images and sounds.

01 Alia Syed, *Swan*, detail, 1989
02 Alia Syed, *Fatima's Letter*, detail, 1994
03 Alia Syed, *Watershed*, detail, 1995

Overleaf
Alia Syed, *Eating Grass*, film still, 2003, with a section of the voiceover manuscript, handwritten in Urdu and English by Alia Saleem. Image courtesy Talwar Gallery, New York

02

03

Alia Syed

aghrib

unseen dialogue between two

languages

"S of the sun.

A s yer before inky

black s my throat d I

breath

A sta

Soft

Wi

Even his moment

to

eath

And afte

آنکھوں سے اوجھل ایک
لوگوں اور دو زبانوں
شام سے ، ڈھلتا ہوا سو
اس سے پہلے کے راستے کی
ایک داغدار آ

میرے ہونٹوں کو بچھوتی ہو
نرم ہوائیں
کیا بھی کرن تمہارے ہو
کو بھی بچھوئے گی؟
بچھو انہیں ، گھونٹ ل
میرا دم گھونٹے ،
ایک خاموش دعا...
اور میری سانس لوٹ آ
"اور اس دوران
تھرتے سانس تھامے کھڑ
فلک شگاف سدائیں - مجس
"اور پھر؟
اس گھڑی تو چاشنی
کر سکتے ہے .

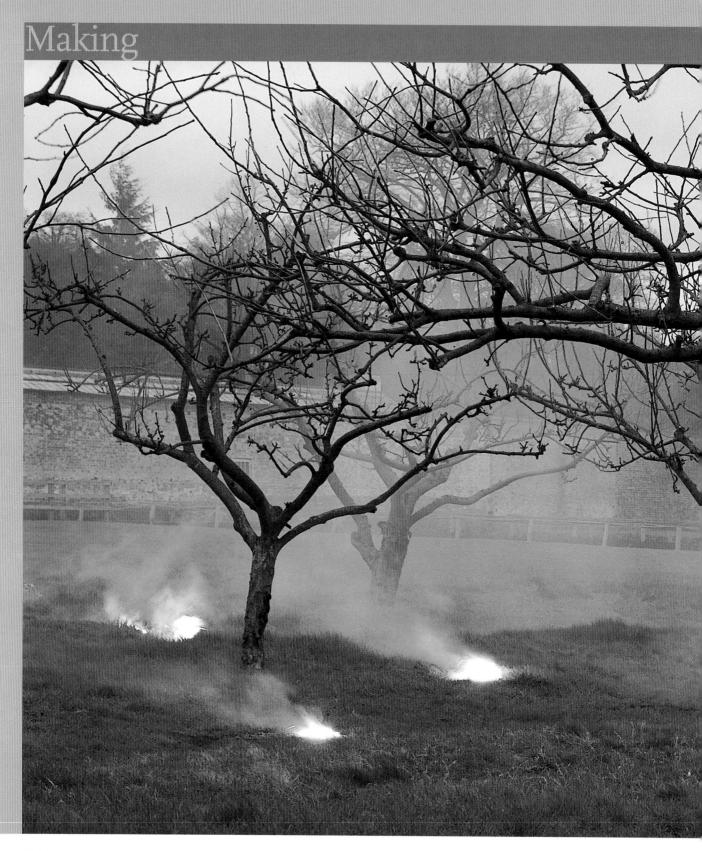

When faced with a finished artwork in an art gallery, it's sometimes difficult to imagine the process – the physical and conceptual journey – that an artist has travelled to make a piece of work. The process of making art, like many other areas of knowledge, requires time, patience, meticulous research and continuous questioning. The process of looking at art frequently makes the same demands of the viewer/participant. The potential rewards are great. For, in making artworks, artists take soundings from the world around them, ask difficult questions, probe deep beneath the superficial layers of social interaction. Listening carefully to an artist's work offers up the possibility of new insights, fresh perspectives, surprising revelations about the world, although never any easy answers.

Preceding pages
Sutapa Biswas, *Magnesium Bird*,
detail, 2004. Photograph: Jerry
Hardman-Jones

Sutapa Biswas: Flights of Memory/Rites of Passage/ Assertions of Culture[1]

Moira Roth

To accompany a touring exhibition and in collaboration with the Douglas F. Cooley Memorial Art Gallery at Reed College in Portland, Oregon, inIVA published the first critical appraisal of the work of Sutapa Biswas in 2004. Moira Roth's five-part study traces the development of the artist's film, *Magnesium Bird* (co-commissioned by inIVA and Film and Video Umbrella), and provides insight into the artist's working processes in realising the project.

1. The Evolutions of Magnesium Bird, *1997–2004*

A Description, January 2004
'*Magnesium Bird* will begin as a... performance in
Harewood's eighteenth-century walled garden when
one hundred small birds sculpted from magnesium,
connected to each other over a thirty square metre
space, will be ignited at dusk. As an ephemeral piece
of work, it will be intensely charged with themes of
loss, love and trepidation. Documentary film and
photographs of the event will be shown alongside a
selection of bird drawings by J. M. W. Turner.'[2]

A Schedule, March 2004
Email from Biswas, 31 January 2004:
SB_Magnesium Bird is scheduled to be filmed on
20 March. In theory the actual filming should ideally
be at the witching hour of dusk, which at that time of
year we suspect will be around 4pm. In practice we will
probably do several (three) takes before this time slot on
the day, as otherwise we may be cutting out our options
should things not go according to plan. We will arrive
the night before. I am hoping that six of my nieces and
nephews will act in the work, plus Enzo, my son.

A Birth and a Death, 1997–2000
Enzo, Biswas's young son – who appears in her two
recent films, *Birdsong* (2004) and *Untitled (Bit Part)*
(1999–2003), and will be one of the children in
Magnesium Bird – was born on 12 December 1997....
On 26 February 2000, Debidas Biswas – the artist's
much-beloved father, a distinguished Indian academic
and intellectual, for years based in London but still

deeply connected to India – died. She associates his
death with birds and, more generally, his life with
gardens: 'He loved gardens and, as a gardener, he grew
magnolias, camellias, foxgloves, roses, cherry trees.'
Magnesium Bird, whose imagery is that of the flight
and death of metallic birds in an orchard, accompanied
by the play of lively young children, clearly refers
symbolically to the death of Biswas's father and to the
ongoing presence of her young son in her life.

A Dream, January 2001
Email from Biswas, 20 January 2001:
*SB_*I've been having many thoughts around dreams,
some of which I had whilst in Oslo recently. One night
there I had a fantastic dream about a bird, whose
feathers were bright greenish-yellow. It was a small,
nervous bird, who kept jumping anxiously and shaking
its head left and right, before jumping to another
position. The strange thing was that every time it
jumped to a new point in my dream, it left an incredible
mantle behind made of traces of feathers, coloured
indigo blue. Eventually the small bird landed on my
left hand. I was anxious in my dream in anticipation
of this because the bird had very, very fine needlelike
claws which, as it landed, pierced my skin, yet without
blood or pain. I thought I had dreamt about my father,
and that he was the bird, but perhaps it means other
things too – I don't know, as I'm still unravelling it.

A Statement by Biswas, March 2002[3]
My new research has arisen out of my having
become a mother in the last four years.... It probes
the psychological and emotional realms of such

experience... and I also draw on the writings of
Marcel Proust and Frantz Fanon.... The new work
(some of which is in the very early stages of making) are
multimedia based, and include video pieces, drawings,
a performance and a film.... The works take the viewer
through a metaphorical journey which maps a set of
human relations. These relations are bound and
severed by the very essence of human life: birth; being
a daughter and becoming a mother; the transition
from childhood to maturity; and ultimately death
and the loss of a parent. *Magnesium Bird* is intensely
charged, dealing with loss, love and trepidation.

Birds occupy a particular place in my
consciousness, as they were the subject of the last
conversation I had with my father before he died, and
because the first sound which I heard after he died was
birdsong. Birds also occupy a great presence in life
more generally because of their migratory existence.
They are indicators of distance travelled, the seasons,
the time of day, the subject of nursery rhymes (such as
Edward Lear's 'The Owl and the Pussycat'). Indeed they
punctuate a sense of time and haunt us either in their
presence or in their absence wherever we travel....

2. Visit to Harewood House, Yorkshire, 6 January 2004

A Train Journey from London to Leeds
Biswas sits, absorbed, making a bird out of magnesium
strip – which she plans to ignite later in the day at
Harewood. She twists, turns, and cuts the tape, weaving
the narrow metal strips together until she slowly creates
the full body of a glittering silver metallic bird with a
long extended thin tail....

The Country House of Harewood and Its Gardens
It is one of those impossibly lavish English estates with
a formidable pedigree. Harewood is recorded in the
1086 Domesday Book,[4] and by 1738 had been bought
by the Lascelles family to whom it still belongs two
and a half centuries later; it is now set up as a trust and
has recently opened to the public....

It is a site that conjures up for me the art of
Constable and Turner[5] as well as the poetry of
Wordsworth and Crabbe. Arriving at the grand front
entrance of the house, we meet Sarah Brown, curator
at The Culture Company who programme Harewood
House, and stroll through the estate together, past the
West and Woodland Gardens, along the Lakeside Walk,
past the Rock Garden and Cascade, and through the
greenhouse area, finally arriving at our destination:
the Walled Garden. It is in this expanse of land,
surrounded by a vine-encrusted brick wall, next to
the Spiral Meadow, that we come across the orchard –
the site of the forthcoming film – with its barren
branches and stretches of well-tended ridged grass.

A Trial Run
We watch the test of what will be a complex spectacle in
March – all of us, surely, trying to imagine the scene of
many magnesium birds set on fire, interspersed with
children gambolling in the orchard, which by March
should be springlike with budding trees. It is cold and
windy, and we stand here, bundled in coats, scarves and
gloves, while Biswas lays down in the grass the fragile
silver-coloured bird she made during the train ride. It is
then ignited and filmed on a small video camera with a
monitor. The single bird, poignantly small and alone,

Left Sutapa Biswas, Sketch of the
Walled Garden, Harewood House,
2004
Right The Walled Garden, Harewood
House. Photograph: Moira Roth

burns brightly, sending off trails of grey smoke. Finally all that remains is a molten metal corpse smouldering in the grass. (Biswas describes her memories of a funeral bier she once saw in the Ganges and of the sunlight beating down on the blue water of that river.)

Afterwards, Biswas and Bevis Bowden (the production co-ordinator) talk about the production plans for March. What angles does Biswas want for the scene? Should the camera move or not in order to track the event? There are to be several children. Where should they be situated?

Sound? The ignition of the magnesium birds will be quiet, but the kids probably not. How to record this?...

3. Musings, Berkeley, California, 31 January 2004

For me, what makes Biswas's work so extraordinary is its range of references and tones. Like some perfectly tuned musical instrument or voice, she can move elegantly and unexpectedly from a single long pitched note to an almost orchestral richness of sounds, from the melodic to the harsh, and from a dominant to a minor key and back.

I think back, too, on our Harewood visit.

Of course, that house and its gardens conjure up delicious artistic and literary associations, but simultaneously more ominous ones, as it is the kind of site that inevitably evokes memories of the British Empire, colonialism and slavery.

In the 2003 Harewood House souvenir book, written by the Earl of Harewood, I read that 'by the late seventeenth century, the family's connection with Barbados and the sugar plantations they acquired

there was firmly established.... It was the Barbados connection and the increase in the family fortunes which made possible the building of Harewood (my family only relinquished its links with Barbados in the 1970s).'[16] I recall Edward Said's subtle analysis of the shadowy presence of Barbados sugar plantation income in Jane Austen's *Mansfield Park*. And I think of what I know of references to such British imperial history and associations that thread their way through Biswas's work, from her undergraduate days at the University of Leeds and postgraduate studies at the Slade School, until the present....

And the forthcoming *Magnesium Bird*? It is, on one level, a belated visual dirge about the departure, through death, of a beloved father; but the artist has chosen to stage the event, not in some anonymous forest, garden, or field, but in the walled garden of Harewood, a huge country estate in northern England with a rich and loaded history. One might, slightly fancifully, describe this as 'a walled garden of memories'.

All in all, it seems to me, that Biswas is continuing certain interests explored in her early 1992 *Synapse* series (those marvellous large photographs of the artist's nude body on to which were projected images of Indian temples, peoples and landscapes). In a statement to accompany her exhibition of these works, she explained that 'synapse' is a medical term for 'the anatomical relation of one nerve cell with another, the junction at which a nerve impulse is transferred, which is affected at various points by contact of their branching processes' and that the notion of synapse was 'a metaphor for the human

condition with particular reference to the experience of memory.'[7]

In *Magnesium Bird,*... these 'synapse' connections in the experience of memory take Biswas back and forth between the eighteenth and nineteenth centuries and the beginning of the twenty-first century, between colonial and postcolonial times....

4. An Email Exchange, London-Berkeley, 1 February 2004

*MR_*I have begun to think about the concept of an epiphany and how it often (always?) relates to the way you initially conceive your work – such a dramatic contrast to the later, often highly time-consuming, making of that work.

I looked up 'epiphany' in my dictionary yesterday, and among the definitions found: 'a sudden manifestation of the essence or meaning of something'and 'a comprehension or perception of reality by means of a sudden intuitive realisation'. It seems to me that this underlies the *Magnesium Bird* in several ways, in its origin(s) and its making. The imagery of the piece has that sense of an epiphany for me: the sudden light change of day to dusk, the sudden fire/light of the ignited birds, the sudden burst of children running. Then (suddenly?) over.

*SB_*I had almost forgotten until recently the extent to which *Magnesium Bird* was a homage to my father. I think that for the sake of my sanity, after we had filmed *Birdsong* in October 2003, I put this a little to the back of my mind. The last conversation I had with my father was about birds and about Proust and the millions of words he wrote. It is also true that there was a moment of epiphany at the time of my father's death, because after he had been pronounced dead, I arrived at the hospital and entered his room, and he came back to life and spoke to me and said in Bengali, 'Don't cry.' The first sounds I heard following my father's death were then birdsong.

I came up with the idea for *Magnesium Bird* after a dream I had in Oslo, in which I saw a bright fluorescent green bird hovering before my eyes. It was at a time when I was installing a work titled *To Kill Two Birds with One Stone*, a reworking of a piece I first presented in Winnipeg, Canada. The dream was so vivid, very lucid, and haunted me for a long, long time.

The idea of an epiphany makes a great deal of sense to me and, as you observe, does perhaps relate to the way in which I initially conceive a work. It is also true that this is mostly in stark contrast to the very time-consuming way that an idea is then realised.

To me, the threads bringing these ideas together seem to be very much part of a continuum, in terms of seemingly eclectic sources of influences – like all these bits of a puzzle, often from different puzzles, that fit together somehow....

There is a great epiphany to *Magnesium Bird*; like a lucid dream, it appears, and haunts.

5. Musings, Hakone Gardens, Saratoga, California, 8 February 2004

I wake up early, lying on a tatami mat in a wooden building assembled a number of years ago in Kyoto and reinstalled here in this huge garden-park of some

seven hectares, with its Japanese bridge; pond with carp, turtles, and ducks; and meticulously nurtured landscape, a blend of imported Japanese and indigenous Californian plants, flowers and trees. I look through the traditional screen windows and then walk outside. It is just after dawn and I can hear birds beginning to sing.

I wake up with the phrase 'a room and a garden' in my head, and realise I am thinking about (or perhaps had dreamt about?)... *Magnesium Bird*.

I remember... that *Magnesium Bird* is to take place in a garden whose walls are pierced with openings that reveal glimpses of fields on the other side.

Windows and walls? Inside and out?

In... *Magnesium Bird*'s walled garden Biswas summons up notions of flights of memory, rites of passage, and assertions of culture. In [this space], Biswas has intermingled, almost with a sleight of hand, postcolonial and autobiographical associations and references. That's intriguing enough, but she goes further and interweaves mythology into this mix, as surely her birds... bring to mind any number of magical creatures in both Indian and European legends.

What's more, *both* Proust and Fanon appear among the artist's favourite reading matter. After all, Proust's notion, which he writes about at the end of *Time Regained*, that time embodies 'past years, yet [is] not separated from us' and Fanon's commentary in *Black Skin/White Masks* that he must constantly remind himself that 'the real leap consists in introducing invention into existence' seem to haunt much of Biswas's work.

Biswas is an artist who, from the start, has brilliantly refused to stay put within a single theoretical, political, cultural, or psychoanalytic framework, or within a single historical time, or a single geographical place.

Standing in this Japanese garden in Northern California in the early spring of 2004, I wonder to myself: What surprising epiphany from Biswas will come next?

I imagine, in my mind's eye, that for a brief moment next month during the staging of *Magnesium Bird*, the orchard at Harewood House will be transformed into a supernatural world of magical birds and mythic children, a world of fire and smoke, then 'ashes to ashes, dust to dust...'.

Notes

1 This essay is the eleventh in my *Travelling Companions/Fractured Worlds* series of texts, which I began in 1998. For a list of their titles and publication sites, see http://www.collegeart.org/caa/publications/AJ/artjournal.html.
2 This description appears on the Harewood House web page (http://www.harewood.org/nav-shocked/index4.htm) and is based on publicity material supplied by inIVA.
3 Excerpt from a grant proposal by the artist.
4 Commissioned by William the Conqueror, the Domesday Book was a huge land survey, assessing the extent of the land and resources owned in England at the time and the extent of the taxes that could be raised.
5 One of Turner's earliest patrons was Edward Viscount Lascelles, the owner of Harewood in the early nineteenth century. When *Magnesium Bird* is shown at Harewood, there are plans to borrow Turner watercolours of birds from the nearby Leeds City Art Gallery to install in a temporary exhibition at the house.
6 *Harewood, Yorkshire: A Guide*, Leicester: Raitby Lawrence, 2003, p. 5.
7 From *Sutapa Biswas: Synapse*, limited edition artist's book, 1991, p. 13.

01

Sutapa Biswas

inIVA's touring exhibition of new films by Sutapa Biswas opened at Cafe Gallery Projects in Southwark Park, London, in May 2004, before touring to Angel Row Gallery, Nottingham; Leeds City Art Gallery; Harewood House, Leeds; and Douglas F. Cooley Art Gallery, Reed College, Portland, Oregon. Against the backdrop of her previous work, which engages with feminism and cultural identity, her recent films explore the passing of time, the mutability of memory and the rites of passage provoked by birth and death.

01 Sutapa Biswas, *Magnesium Bird*, 2004. Photograph: Jerry Hardman-Jones
02–05 Sutapa Biswas, *Magnesium Bird*, 2004

Overleaf
06–09 Sutapa Biswas, *Birdsong*, 2004
10 Sutapa Biswas, *Birdsong*, 2004. Photograph: Toby Glanville

02

03

04

05

Sutapa Biswas

06

07

08

09

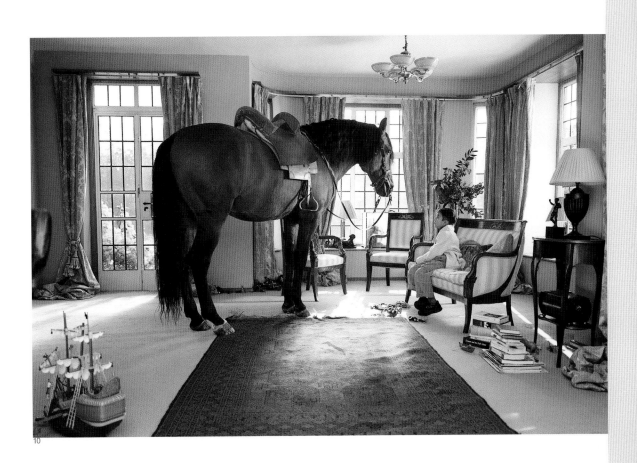

10

Sutapa Biswas

Dissolve

In March 2001, Flow Motion (comprising Eddie George, Trevor Mathison and Anna Piva) created a digital audiovisual installation entitled *Dissolve* that was shown at TheSpace@ inIVA in March 2001. This text, written in 2004, explains how Michelangelo Antonioni's epic film *Zabriskie Point* was the starting point for their own installation and provides insight into how their own artwork sought to draw on and develop aspects from the original film.

Flow Motion

In 1968 the Italian film director Michelangelo Antonioni was in California's Death Valley desert shooting *Zabriskie Point*, a film named after the desolate Death Valley region. 1968 was a year of protracted civil unrest, of a scale, diversity and ferocity unseen in American history. Nationwide rioting, the fiery ascent of the Black Panthers, and the growing protest against US involvement in Vietnam were all met with an increasingly militarised response from the American government.

These events, particularly the growth of political radicalism across college campuses and the subsequent clashes between police and students provided *Zabriskie Point* with its backdrop and story.

The plot is simple: Mark, a disaffected student planning an armed confrontation with the police, is mistaken for a student who shoots dead a policeman. On the run from the police he meets Daria, a hippy working for a wealthy tycoon who is developing a plush retreat in Death Valley.

Mark and Daria become lovers in a brief affair consummated in a hallucinatory love scene at Zabriskie Point. Mark attempts a flight to freedom during which he is shot and killed by the police. After receiving news of Mark's murder, Daria imagines the explosive annihilation of the opulent desert complex in the film's epic ten-minute finale of destruction and transformation.

Zabriskie Point was Antonioni's first American picture. He'd signed a prestigious three movie deal with MGM after scoring a huge box office hit with *Blow Up* (1966), hailed as a stunning portrayal of swinging London. MGM hoped Antonioni could do the same

with America's radical counter culture. And with a budget of over $7m *Zabriskie Point* was to have been Antonioni's Hollywood masterpiece, the most ambitious and expensive movie of his career.

Instead it was Antonioni's first major commercial failure. Released in 1970 the film was mauled by the critics and ignored by the general public. Worst of all, the counter culture regarded the film as something of an embarrassment. *Zabriskie Point* made less than $100,000 before being withdrawn from cinemas across America.

By 1975 the culture of radical dissent which the film dispassionately weighed against the broader severities of political injustice, had been infiltrated and crushed by the combined might of the US government, the police and the FBI, seemingly robbing the film of any possible future historical resonance.

By then the film had become known as one of the biggest disasters in cinema history. But seeing *Zabriskie Point* for the first time in Italy at the end of the 1970s, a strange time in Italian history, was to see a film which had quietly assumed an eerily precognitive power.

The 1970s in Italy were marked by the distancing of the parliamentary left from the progress made by the workers', women's, gay and student movements in the late 1960s, and a shift of alliance to the centrist Christian Democrats. Radical activism increasingly took on extra institutional forms, as the Italian government, with the help of the CIA and NATO, initiated a new wave of political repression, organised around the 'Strategy of Tension'.

This involved the infiltration of radical groups by fascist networks, a subsequent campaign of state

orchestrated bombings for which the radicals were blamed – like the Piazza Fontana bomb that killed seventeen and injured eighty-five in Milan in 1969, or the 1980 Bologna central station bomb attack which killed eighty-five and wounded two hundred. The bombings legitimised increasingly draconian laws, sentences of three to six years for distributing political literature and up to seven years in prison to 'prevent' dangerous acts, to name a few which are still law. It was an example of state orchestrated terror being used to stabilise right wing control of the country and create the conditions for military intervention.

Events reached critical mass in 1977 when a student, Francesco Lo Russo, was killed by the police in Bologna. Massive demonstrations followed in Milan, Turin, Naples and Bologna, during which armed groups began to appear. The stakes had been raised by the state, producing reactive, increasingly confrontational measures whose violence served only to legitimise further state repression.

By 1978 the radical movement was in a state of collapse. By 1980 there were an estimated 1,500 militants and intellectuals in Italian jails and in 1981 Amnesty International reported a growing incidence of torture in Italian prisons. Against this backdrop of events, the film had acquired a troubling resonance as a kind of chronicle of the gradual, if temporary, cessation of a global radical impulse.

Revisiting the film in 2000, thinking about its making and its undoing, its besieged cultural context, we found an ironic convergence of cinema and social history – a film which stands as a flawed testament to a moment in twentieth-century history when a wave of utopian political projects posed a very real threat to global capitalism, a story of the disintegration of a utopian politics, told by a film doomed and damned into invisibility by critical hostility and audience indifference.

One of the things that drew us back to the film was the wish of its protagonist to explode, to blow sky high (and higher) the suffocating dream environment of corporate culture. It was a wish which had a corresponding presence in the film's exploding into space the endless array of capitalism's consumer objects, and then transforming these floating objects into purely aesthetic phenomena – colour and form, weightless, useless, mutating, mutable.

It was a radical aesthete's revolutionary gesture, the dissolution of absolute force into purely optical phenomena, purely filmic space dissolving the space of high capitalism. For us, *Zabriskie Point*'s significance for digital art and movie-making practice lay in its still unexplored aesthetic formal possibilities, especially its final apocalyptic, explosive ten-minute scene. We were reminded of an observation made by Antonioni's filmographer Sam Rohdie fifteen years after the film's disappearance: '*Zabriskie Point* introduced a wholly new subject in narrative film, non-figurative, informal, unfixed, the subject of the subject dissolved, and that dissolution as the context for something utterly new and unseen.'[1] The dissolution of the subject and objects in the film's dramatic close suggested a transformative aesthetics as utopian as the transformative politics of US and Italian counter culture.

Zabriskie Point, like the international counter culture, suggested a necessarily unreasonable

departure from capitalism's self-interested sense of reason, realism and reality, a departure which formed the basis for our own point of departure, for a kind of elegy for the fallen counter culture and the fallen film which hailed and bid the culture farewell. It was a film which for us, in spite of its commercial and critical failure, still suggested radical, transformative possibilities.

We were interested in the implications of Antonioni's movie for digital art practice, while acknowledging Antonioni's own forays into this field. A number of ongoing preoccupations informed our return to the film.

Pictorial space, the foregrounding of the picture plane and the confounding of proximity and distance, counter cultural space and cosmic space, formed the basis of *Dissolve*. The theme of capitalism in space framed *Dissolve*'s opening section, in which digitally treated footage of the barren landscape of Mars, as forbidding as *Zabriskie Point*'s desert setting, provided a very real counterpoint to Antonioni's salute to the counter culture: Mars as capitalism's next port of call and possible territory of expansion.

We were concerned with landscape as a kind of living geological alien space in which digital treatment makes visible the layered past, signalling, for example, the ancient liquidity of *Zabriskie Point*'s parched desert landscape. We were also concerned with the pushing of figuration to its non-figurative limits, the transformation of figures into traces, of action and form into purely optical and sonic phenomena in which 'objects lose their object-ness to become part of a pattern; within the pattern volume disappears into line, line returns to volume, colour becomes line, density becomes surface… producing in that destruction and dissolution… something new; new patterns new forms.'[2]

Our starting point being no more than a few frames, a riff, if you like, on a few twenty-fifths of a second of Antonioni's film, we approached *Dissolve* as though it might be the location, or the result, of a meeting of two attempts at rethinking, remaking the world – an aesthetic project with political correspondences, in dialogue with a political project with aesthetic implications, held together by the transitory, transitional space between scenes, between events, of an elusive slip of a notion, the dissolve.

Notes
1 Sam Rohdie, *Antonioni*, London: BFI Publishing, 1990.
2 Ibid.

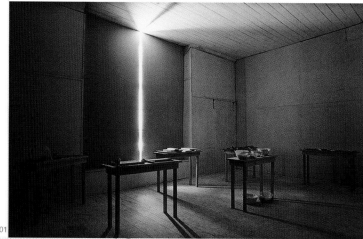

01

A Quality of Light

inIVA invited four artists – Carl Cheng, Victor Grippo, Mona Hatoum and David Medalla – to make new work for an exhibition entitled *A Quality of Light*, which took place at a number of sites across Cornwall in the summer of 1997. Organised in collaboration with Falmouth College of Arts, Newlyn Art Gallery, South West Arts and Tate Gallery St Ives, the project included a number of other artists and aimed to connect the strong artistic tradition of Cornwall (through the St Ives School) with contemporary art and practice, linking the regional to the international.

01–02 Victor Grippo, *La Intimidad de la Luz en St Ives* (The Intimacy of the Light in St Ives, 1997. Photographs: Steve Tanner. Courtesy Nidia Grippo
03–04 David Medalla, *A Stitch in Time*, St Ives, 1997. Photographs: Richard Okon

Overleaf
06–07 Mona Hatoum, *Current Disturbance*, Newlyn Art Gallery, 1997
08–09 Carl Cheng, *Ghost Ships*, Newlyn Art Gallery, 1997

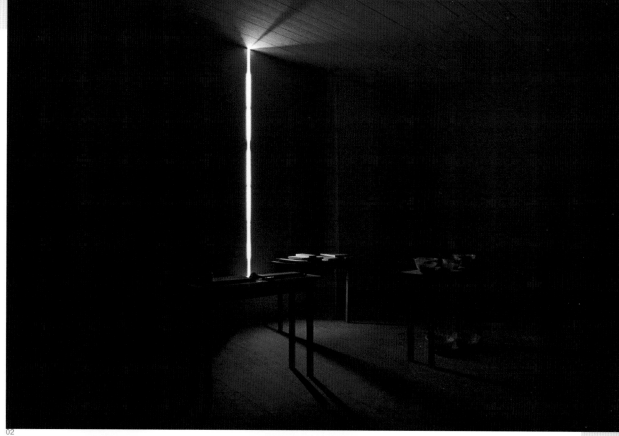

02

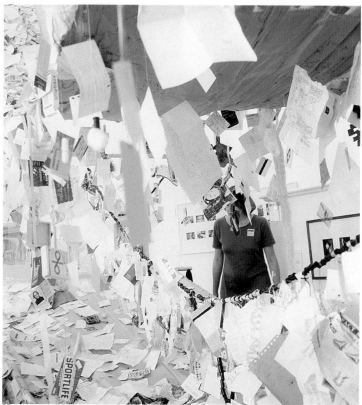

03

04

A Quality of Light

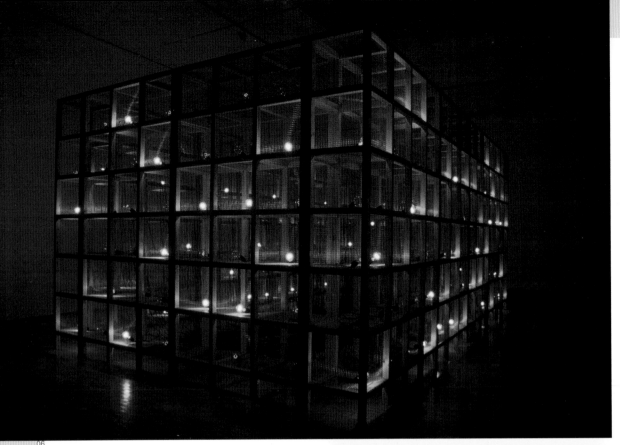

06

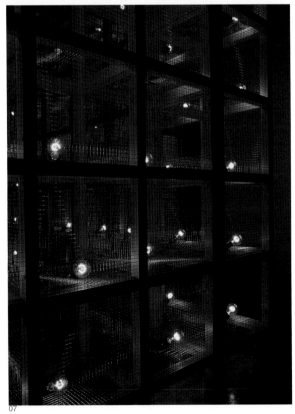

07

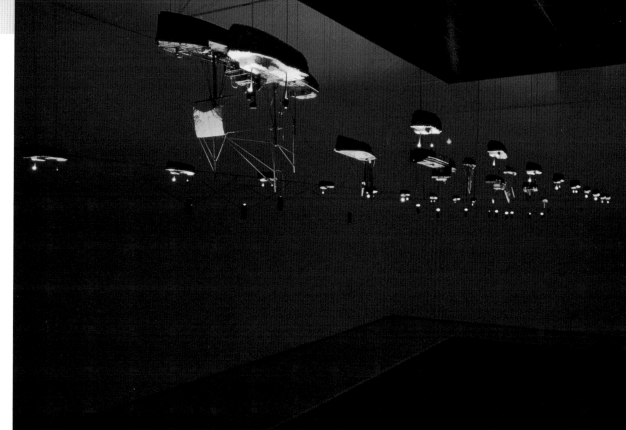

08

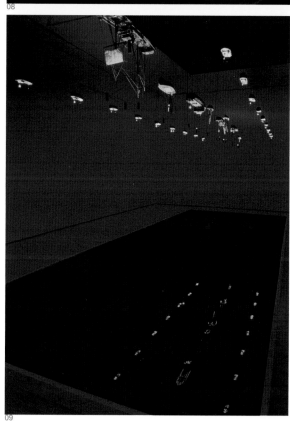

09

A Quality of Light

Li Yuan-chia

Guy Brett

In 2000, inIVA published the first fully illustrated monograph on Li Yuan-chia to coincide with a touring exhibition of his work. Alongside a selection of the artist's poems, introduced by Nick Sawyer, Guy Brett's essay provides an account of the artist's life and work. The extracts published here describe the artistic process involved in producing the body of hand-coloured photographs that the artist made shortly before his death.

During the LYC [Li Yuan-chia Museum and Art Gallery] years a photograph by Li would occasionally appear on the cover of a publication (such as the intriguing multiple-exposure, hermit-like self-portrait inside a derelict shelter). After LYC closed he turned to photography in earnest, experimenting with colour washes, hand-colouring, transparencies and the setting up of 'still-lifes', 'installations' and 'tableaux' for the camera. He worked with a large collection of cameras, new and old, cheap and expensive, and was constantly trying out different kinds of paper, chemicals and dyes. Li elaborated further the conjunction he had made in the 1960s between the abstract 'point' and the descriptive nature of the photograph. He made hundreds of magnetic photographic Points, each carrying an image, a fragment of reality, which could be distributed on a surface in any combination....

It is useful to give a typology of the formats of Li's late work. Being unsure at this stage of their chronological order (some are dated, some are not, and few are titled), it seems best to list them in groups, and non-hierarchically. There are the photographic Points just mentioned; hand-coloured black and white photographs; black and white photographs with an overall colour wash; colour slides; folded greetings cards (he had always liked this modest and personal form) containing a photograph on the cover and another on the inside right-hand page; reliefs incorporating photographs and movable panels incised with Chinese script; reliefs incorporating photographs and pieces of natural wood; impromptu installations in the house and garden (mostly recorded in photographs), and carved wood blocks and tablets with inscriptions in Chinese.

At Christmas 1993 I received a greetings card from Li with the invitation to come and see his new work. The card contained a hand-coloured photo of a figure holding a stave, robed in what looked like blankets, with the head invisible. I assumed the figure to be Li. The ritualistic gesture intrigued me greatly. It was so unlike his previous work, and the hidden head seemed to portend something disturbing. Later I found it was one of a whole series of self-images, one cannot call them performances since there was no spectator, but formal presentations of the self in a controlled setting and with attributes, photographed by Li by remote control. There is a chair set up in the garden, sometimes empty, sometimes containing Li looking away from the camera. Or the figure is enthroned in the chair holding a broom and a gardening implement with a book open on his knees and a large stone wrapped in a scarf at his feet. Or hands reach from inside a dark cloak to hold a flower. Or a chair is filled with a brick instead of a person. Or there is an interior sequence of a figure huddled in a corner covered in blankets. And so on. The face is almost always partially or wholly hidden. Among Li's papers after his death, a note was found which seemed to explain the meaning of the hidden face:

do not ask please why this man we could not see
his head or face, or we can only see his head not his
face
this man's face is very
this man has a very angry face,
do we want to see the face, no, certainly not
ugly
do not ask please, why we only see this man's back

because, they do not want to see his ugly face that's all
why not just imagine what his face is like
that's much more interesting,
do not ask please, I know you want to know why we only see part of the body,
a human head and face are not always nice to see.[1]

The very combination of a powerful pose with self-concealment seems to indicate the plight of this lonely figure. His anger was too vast to be expressed in polite society, so he had to hide it. Or express it with a subversive humour. In another long series of pictures Li arranged and rearranged a collection of upright wooden pieces – most likely off-cuts from a local timber mill – in groups indoors and out, like menhirs, or people, or witnesses (in one or two pictures a wooden post wears a balaclava mask). In other instances a gloved hand appears laying a sprouting onion like a fuse on a row of bricks which take on the appearance of explosives. When one remembers the role the flower takes in so much of Li's earlier work, as well as work contemporary with these images, it is shocking to see a sledge-hammer raised against a cluster of flowers, or a rose lying under an axe as if on an executioner's block.

Li wrote almost nothing about these images, and I have not yet found anyone with whom he discussed them in any detail. In some of his albums of negatives are hand-written phrases that may be titles: for example, 'to lay down one's arms', written next to an image of an axe, shears and a glove lying on the grass; 'the power struggles' on the back of a sheet of contacts of an axe resting in the crux of a pair of shears; and against the figure standing behind the chair: 'God Child's Wiseman'. In one image – beautifully hand-coloured – of an old newspaper lying in the mud, Li has rubbed out the word 'firms' in part of the headline and added his name so the line reads: 'Dark days for small Li'. Other 'titles' include: 'Under umbrella enjoy my glass', 'interested in news [?]', 'the old drunkard is not really', 'none share my glass', 'thinker or dreamer', 'do not cut my head down please'.[2]

However gloomy the message, the hand-colouring is exquisitely done. And this links the despairing images to the celebratory ones. In fact there is considerable overlap between them, and much that is enigmatic, or poetic, or impossible to verbalise about the discoveries Li made through photography. If we take Li's hand-colouring, we see a play of marvellous finesse between the 'automatic' black and white image and the added colour. Colour comes into its own again in Li's late work in a way that had not been seen since his early calligraphic watercolours, before he adopted his symbolic four colours. Sometimes, as in certain images using a single tinted wash, the application of colour works as another kind of light and shade, subtly altering the light/shade values of the original print. In other hand-painted photographs, Li completely changed the colouring, for example of a flower, from print to print, so the black and white image remains a constant and the hand-markings take on a freedom, as if inventing a new species each time. The black/white seems to represent the 'material world' and the colours a creative freedom. There is something about the

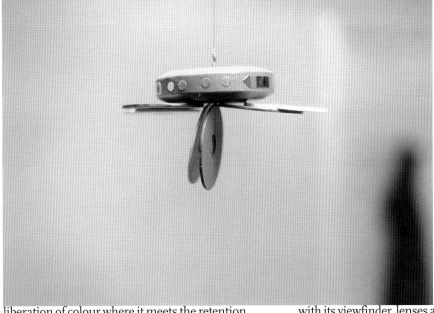

Li Yuan-chia, studio exhibition, Boothby, Cumbria, 1968. Courtesy Li Yuan-chia Foundation

liberation of colour where it meets the retention of material reality which denotes a universe in transformation.

As well as hand-painting on black and white prints, Li experimented extensively with superimposed images. His friend, the painter Donald Wilkinson, records that Li would expose a roll of negatives or slides, and then, as the camera was rewinding automatically, take the battery out at random points and re-expose the film (this is why the dividing bar between exposures appears as a formal element in many of the final images).[3] Here was another instrument of spatial/temporal freedom. He could combine the intimate with the distant (flowers in the sky), the inside with the outside (for example, warm-coloured cloths over snowy fields), or dry with wet (silk scarves over bubbling water). In a typical and witty touch, Li photographed his other and previous work through the multiple image of a superimposition.

What was taking place within the camera could be intimately linked with what was in front of it. Li produced special 'set-ups' for the camera, carefully choosing coloured cloths and liquids, flower petals, reflective materials, candle-flames and so on, to produce several layers. Or he would intervene to impose a subtle kind of symbolic order or symmetry on the natural flux. Indeed one could say that Li used the camera as a sort of mediator between the macrocosm and the microcosm, as one stage in an infinite series of layers, layers of materiality and transparency, veiling and 'seeing through'. This series would include the human eye, with its lens, its aqueous humour, retina, its light-sensitive cells, moving out through the camera with its viewfinder, lenses and light-sensitive emulsions, to the exterior world with its opaque and transparent bodies, light and dark – and back again. An endless optical chain. Nowhere is this more beautifully seen than in the slides Li took, looking down into the large tank of water he had installed in one of his outbuildings. The reflected light of the sky, the floating objects such as leaves, a half-soaked polythene sheet, or newspapers marked with calligraphic characters, a night-light, and the depths of the water with glimpses of goldfish, make up this ravishing pattern of what are essentially 'films'.[4]...

Notes

All unpublished statements by Li Yuan-chia quoted in this essay are taken from his personal papers, hereafter referred to as Li Yuan-chia Archive. These are now in the possession of the Estate of Li Yuan-chia.

1 Li Yuan-chia Archive.
2 Among Li's papers a note was found which read: '1993. My works based on power struggle love + heat [hate?]. death + peace, a human without head, & so on.' Li Yuan-chia Archive.
3 Donald Wilkinson, personal communication, 1998.
4 It was a poignant experience to revisit recently the water tank in the outbuilding at Banks. Five years after Li's death it lay in ruins. The fish had gone. After being faithfully fed for several years by Li's next-door neighbours, Mr and Mrs Clowes, they had eventually been gathered up and found a new home. The tank's extraordinary 'depths' as they appear in the slides were revealed to be shallow and mundane. This made all the more startling Li's work of transformation.

Li Yuan-chia

Curated by Guy Brett, inIVA's exhibition *Li Yuan-chia* opened at Camden Arts Centre in January 2001, before touring to Abbot Hall Art Gallery and Museum in the Lake District and the Palais des Beaux-Arts in Brussels. At once, an artist, curator, poet and archivist, Li Yuan-chia's inclusive approach to art and life anticipated the attitude and practice of many of today's contemporary artists.

01–07 Li Yuan-chia, hand-coloured
black and white prints, 1993. Courtesy
Li Yuan-chia Foundation

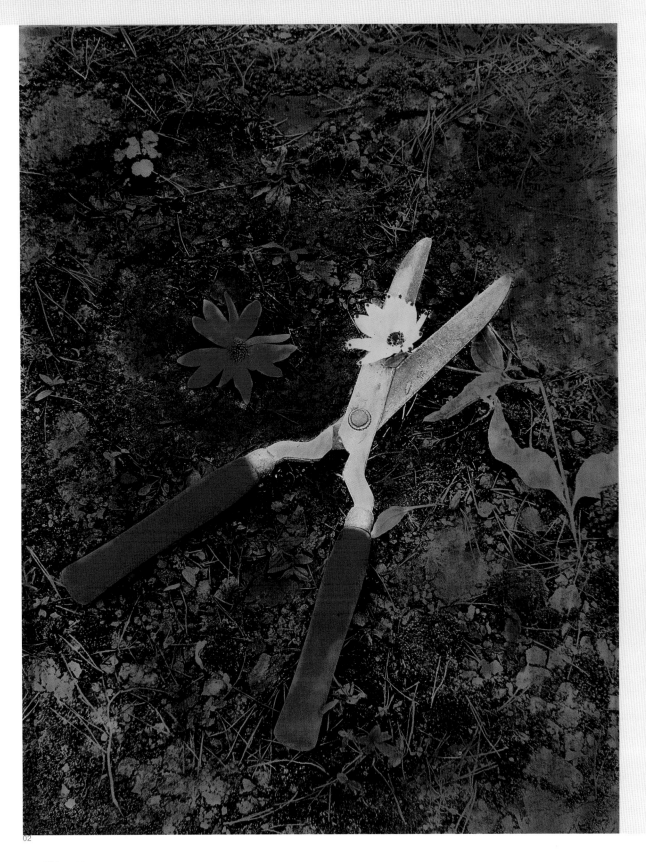

Li Yuan-chia

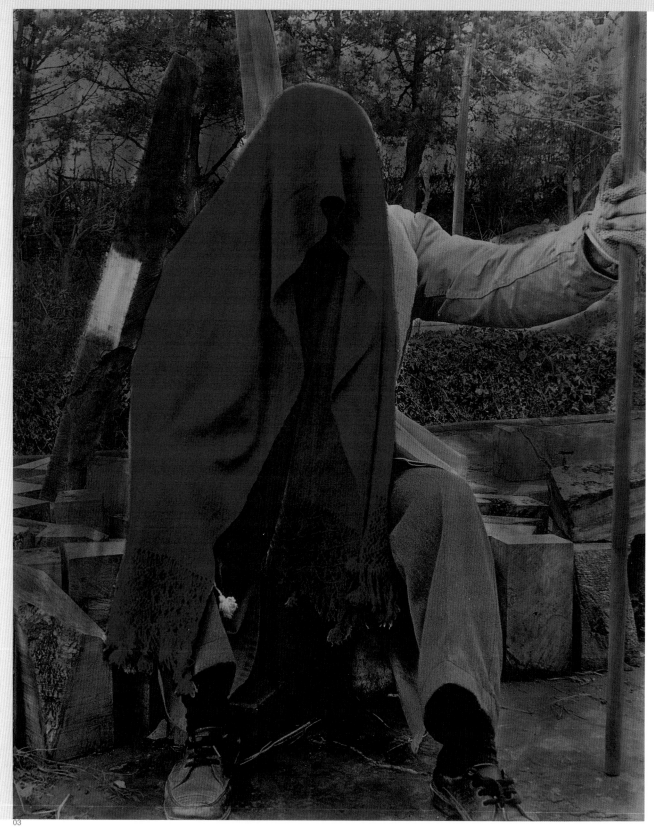

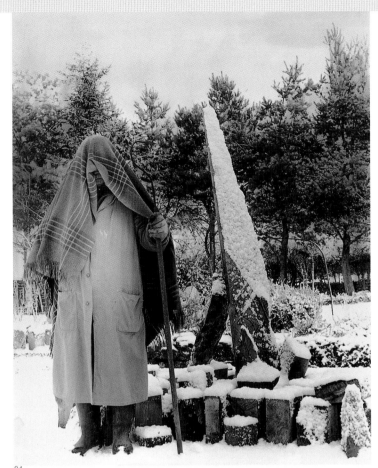

04

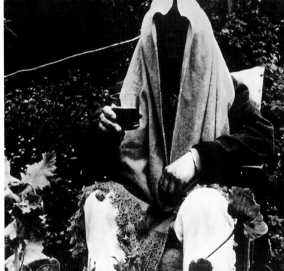

05

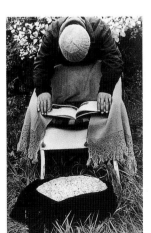

06

07

Li Yuan-chia

Introduction to *Vampire in the Text*

Jean Fisher

Vampire in the Text: Narratives of Contemporary Art, a selection of writings by Jean Fisher, was published by inIVA in 2003 to launch *Critics' Voices*, a new series of anthologies that draws together for the first time the writing of leading international art critics. The texts trace the author's journey through the political and intellectual turbulence of the late twentieth century and its impact on art practice and writing on art.

In cinematic and theoretical accounts of Bram Stoker's novel *Dracula,* the role of Mina, Jonathan Harker's wife, is usually glossed over or collapsed with that of her hapless friend Lucy; and yet, along with that of Count Dracula himself, her function in the narrative has persistently held my fascination. Mina and Dracula have long circulated in my imagination as possible metaphors of the relationship between artistic practice and its writing, connecting the enigmatic otherness of aesthetic language and what can be said about our experience of it.

Stoker was a journalist and something of an archivist, collecting together stories and legends about the vampire and melding them into his novel. It is, however, to Mina that he donates his role of receiver, collator and transmitter of perceptions and affects, which she performs using the new communications technologies then at Stoker's disposal: the typewriter, stenography, phonography, telegraphy, even telepathy. Mina's role is not one of interpretation but of making connections. Interpretation is the function of the cluster of bourgeois male figures – lawyer, psychiatrist, anthropologist, minor aristocrat and New World capitalist – whose collective aim is to observe, analyse, hunt down and destroy the vampiric threat to emergent bourgeois dominance, replicating the panoptical and disciplinary strategies of Victorian imperialism. Dracula personifies a dangerous otherness, a phantasmatic symptom of a repressed class and ethnic power that challenges the integrated identity of the western European bourgeois male subject, both in the vampire's 'intertextual' mixed-blood foreignness and in his antiquity, in so far as he is the repository of arcane knowledge and a malingering representative of Europe's ancient regime.

Periodically, the vampire has been resurrected as a popular villain for, amongst other 'delinquencies', an unbridled (usually 'feminised') libidinal energy, invasive viruses and, since Marx, the seductive, all-consuming drift of capitalism itself. I have at times used the figure in this sense, but it nevertheless carries a certain ambivalence that suggests other readings. If, for instance, one posits that western capitalism has turned us all into depoliticised, consumerist vampires, then among the strategies available to us for regaining a sense of subjective agency might be to use equally vampiric manoeuvres to infiltrate and recolonise its hegemonic discourses. I must confess therefore to some sympathy for Dracula, especially in considering contemporary intertextual practices, both in art and writing. Reading somewhat against the grain of attributes usually seen as malignant, one might say that the vampire destabilises the apparent coherence of any rationalist discourse; he (sometimes she) is the 'un-dead' element that, forgotten, annulled, or excluded from the discursive field, is nevertheless its invisible organising principle. The vampire haunts the circulatory systems of discourse.

Dracula has neither mirror reflection nor closure: without reflection it has no other (it is otherness itself) and cannot be readily interpreted either by an already given symbolic discourse, or by itself: it *acts* but does not reflect; and, since it cannot die, it can form no closure. It may therefore stand for a productive, creative act that does not yet possess a clear discursive boundary, a hybrid and polyphonic movement of insinuation into

the interstices of the already familiar, an evanescent, non-rationalisable and unaccountable remainder that 'contaminates' the text with an elusive and disturbing alterity. It is the opening of a space of turbulence in which the reader or viewer, momentarily unable to map itself in the field, may experience new perceptions of existence.

Hence, the title, 'Vampire in the Text' refers to the characterisation of experimental creative processes that in some way escape the determinations of orthodox interpretative languages, demanding in turn at least an attempt on the part of the writer to seek other forms of narration.

The paradox of language is that it is a displacement from, and a replacement of, its assigned object, whose significance, nonetheless, it can never grasp in its entirety. There is an inherent indeterminacy in language – at once an excess of signifiers and an impoverishment of meaning that perpetually oscillates in an interminable movement towards an ever-receding 'real'. Art is capable of exploiting this itineracy of language: as a language and structure in its own right it produces meaning-effects in excess of the words we have to describe them. Given that much of our understanding and interpretation of reality comes to us in mediated forms and that one cannot communicate one's sense of the world outside the terms of representation – visual and verbal – the question of shifting perceptions of reality rests upon expression and use: the syntactical and material organisation of language. Gilles Deleuze and Félix Guattari have characterised this shift as the 'deterritorialization' of language; typically, but not exclusively, it is 'that which a minority constructs within a major language' when compelled to 'live in a language that is not its own'.[1]

This revolutionary potential is central to my interest in the work of certain artists emerging from cultures historically disenfranchised by colonialism. Through an engagement with the work of various artists, I have had a particularly close involvement with the relations between England and Ireland, and the US and Native America, from which emerged questions regarding the role of artistic practice in the construction of political and subjective agency. (As regards US-Native American relations, I am heavily indebted to Jimmie Durham's patient guidance.) The historical and contemporary trajectories of these relations make particularly gruesome reading and, in writing about them, it is difficult to avoid falling into self-righteous outrage, whilst also acknowledging that colonialism and its legacy arose out of western thought and attitudes, and that these must be unravelled in order to see from different perspectives. I have attempted various approaches to writing about these issues, from polemics to irony. I have also tried to focus on what is possible for me, as an 'outsider', to address: namely, what is revealed of these relations through American mass culture, and how the artistic and the political are mutually articulated in the practices of certain contemporary Native American artists. Their work – like that of many other artists with a cultural history of colonial repression – is often deeply concerned with how language signifies, and the way representations

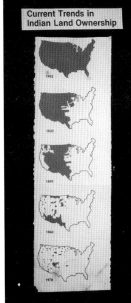

Jimmie Durham, *On Loan from the Museum of the American Indian*, 1985

disseminated through the media manipulate our interpretations of the world. However, this is by no means to suggest that their work proffers some more 'authentic' representation; rather, it poses questions regarding the inauthenticity of representational languages and the relations of power they support.

In the end, it is perhaps a striving towards understanding the *relations* among things that informs all these writings. This accounts for my interest in art as process, in what happens between the work and the viewer, in making connections between art and various critical discourses, and probably stems from my early training in the biological sciences where it is acknowledged that things in the visible world are connected and materialised through the flux of invisible forces or energies.

If how to write about the enigmatic nature of artistic language can be advanced as one underlying theme grappled with in these essays, its complement has been how to express spectatorship as artistic experience. The privileged moment here has been the dynamic encounter between the work and the viewer/writer. That is, what the work does, or how it functions as an affective machine or event capable of compelling a new trajectory of thought has been of more concern than an artist's putative intentions, biography or genealogy. My distrust about making the latter the focus of art writing, although I may often be guilty of it, lies in a conviction that visual art necessarily connects with a wider body of thought than that advanced by conventional art history

and criticism, and that, however seemingly formal its concerns, it is nonetheless an intrinsically social act. Deleuze states this more efficiently in his assertion that, contrary to the tendency of critics to treat artists and their work as 'patients' in need of treatment, in their ability to identify, group and evaluate new cultural 'symptoms' as yet unrealised by society, artists should be understood as 'diagnosticians' or 'clinicians' of civilisation. The symptomatology of artistic production is inseparable from style, the moment of a new use of language when it 'is no longer defined by what it says, but by what causes it to move, to flow... a process and not a goal... art as experimentation.'[2]

To experience the moment of a new use of language entails a degree of desubjectivation on the part of the viewer, a liberation from constraining patterns of thought. In effect, the work has to engage the viewer as a *participant* not an observer, to enable him or her to relinquish the ego-subject and open up to a space-time of otherness, to give one's self up to a kind of vampirish ecstasy! This threshold state is induced by an encounter with uncertainty, a prelude to the opening of a new horizon of meaning. For any artwork to produce this moment of affectivity depends on the way it understands and structures its relationship to the viewer as a participant in its production of meanings. It has to do with the way the self is inscribed into the field of possible meanings opened up by the work. If one can still speak of an ethical or political dimension to art, it is precisely this creative moment when it becomes capable of shifting existing perceptions of reality.

Thus, the experience of art referred to here is not based directly in any prior knowledge or reason since

Everlyn Nicodemus, *The Wedding no. 76*, 1993. Photograph: Felix Tirry

this would presume a fully conscious subject. It is on the contrary a suspension of knowledge and reason, an encounter with something that has no prior referent: a sensation of speechlessness, limitlessness or loss of boundaries between subject and object, between the corporeal and incorporeal that may even provoke a spontaneous laughter. It is perhaps what Freud described as the 'oceanic' feeling, although he admitted he had no experience of it. In any case, this rendering mute is not a return to some pre-subjective state, nor is it a function of the psychological subject, but an experience of the re-embodiment of language through sensation outside of discourse as its instrumental form.

If art as experimentation produces new configurations of visual language, it is the obligation of the writer to take up the challenge and seek new connections and forms of narration. Like other artists emerging towards the end of the 1970s, I felt frustrated with modernist art criticism and history – their hermetic context and attachment to description, artists' biography and western male genealogies – and wished to find a broader philosophical context for a writing that might reflect the tumultuous cultural and intellectual milieu of art at the end of the twentieth century.[3] Unencumbered by any strict academic affiliations, I have felt relatively free to play across the boundaries of different disciplines, seeking correspondences with the thought of contemporary art. Since this body of writings plots my peregrinations through alien territories, it doesn't claim to present 'truths' or

interpretations, but like Mina, tries to make connections that might form a plausible or possible narrative.

The essays selected here present possible points of articulation between the practices of art and critical thought, as an attempt to grapple with the intellectual and cultural concerns that shape our understanding of contemporary existence. They are divided simply into two sections: Art in Practice and Art in Context. The former section consists of essays that respond to an individual body of artwork; the latter section consists of essays concerned more with the sociopolitical context of artistic practices arising from a dual involvement in debates on cultural difference and questions about the efficacy of aesthetic experience itself.

My starting point has always been an encounter with the work itself, an encounter then elaborated through whatever philosophical debates seemed relevant to the work. Often I have followed one particular trajectory of thought, only to realise later that I was unconsciously tracking another, and so, throughout these essays, the same body of work may reappear from slightly different angles as I sought to come to grips with what I was trying to say about it. At the same time, as I have gravitated towards certain kinds of debates and art practices, so certain artists and I have gravitated towards each other, so there is in some sense the expression of shared or overlapping philosophical territory in these essays.

I have always been conscious of the form of the essay. My earliest efforts were written with a particular structure in mind (a Möbius strip, for instance, in the case of the Jack Goldstein essay), thinking of the text in

'sculptural' terms, although the strictures of time later disallowed this level of textual refinement. Generally speaking, however, although I might struggle to mimic an 'academic' style of exegesis, the predominant form, overtly or not, has been the 'story' or 'fable'. My main guide here has been Walter Benjamin's comments on storytelling: 'Actually it is half the art of storytelling to keep a story free from explanation as one reproduces it... it is left up to [the reader] to interpret things the way he understands them, and thus the narrative achieves an amplitude that information lacks.'[4] The event of art itself remains closer to the context of oral storytelling than to other forms of expressive culture. Like vampirism, art is concerned with orality, with a performance that is at the outer limits of speech. In the immediacy of its experience, in its demand for a participatory response, experimental art provides the 'amplitude that information lacks'. If as writer I fall short of the aim of keeping these stories free from explanation, rest assured that my explanations by no means exhaust the scriptural and contextual possibilities of the work under discussion.

Notes

1 Gilles Deleuze and Félix Guattari, *Kafka: Toward a Minor Literature*, trans. Dana Polan, Minneapolis: Minnesota University Press, 1986, pp. 16–27.
2 Daniel W. Smith, Introduction to Gilles Deleuze, *Essays Critical and Clinical*, trans. Daniel W. Smith and Michael A. Greco, London: Verso, 1998, p. li.
3 I was nevertheless inspired by Adrian Stokes, *Colour and Form*, London: Faber and Faber, 1937; and Leo Steinberg, *Other Criteria, Confrontations with Twentieth Century Art*, London and New York: Oxford University Press, 1972.
4 Walter Benjamin, 'The Storyteller', in *Illuminations*, trans. Harry Zohn, New York: Schocken Books, 1969, p. 89.

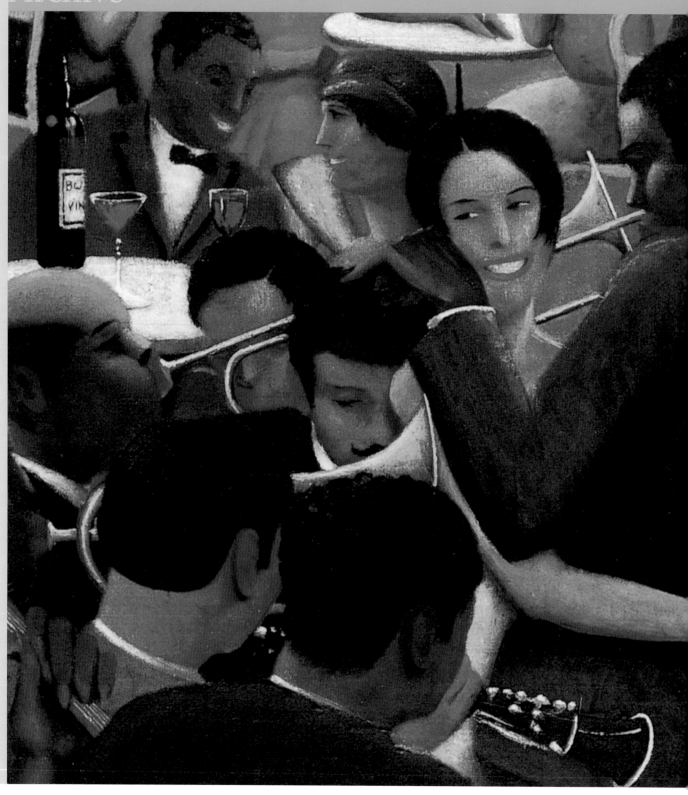

Most people have an archive of some description: photographs, letters, papers that record personal histories. Mining the archive and retrieving histories have increasingly become the mainstay of many museums and galleries. Contemporary art organisations, curators and critics are also delving deep into the archive of postwar contemporary culture to reclaim 'lost' artists and art histories. But reviving the past is full of pitfalls. It is easy to romanticise the past and gaze back through rose-tinted spectacles or to 'put a spin' on past episodes only to serve current political ends. Our view of the past is inevitably shaped by present concerns and perspectives but is it possible to reshape the present by re-examining our histories? Can a search through the archive be more than a nostalgic rummage through history?

Critical Difference:
Art Criticism and Art History

As part of inIVA's series of talks entitled 'Changing States', this debate examined the state of writing about contemporary art and asked how writing about art could bring about a different canon of art history. Chaired by art historian Niru Ratnam, the panel comprised writer and critic Richard Dyer, writer and critic Kobena Mercer, art historian Irit Rogoff and artist Alia Syed, who addressed an audience at London's Cubitt Gallery on 21 May 2002.

Niru Ratnam

The practice of writing art history, and indeed art criticism, if you can separate the two, has come under increasing scrutiny by feminist, postcolonial theorists and advocates of this new discipline called 'visual culture'. There are a number of key arguments, among them the idea that art history and art criticism are not neutral bodies of knowledge. The second, linked argument is that these accepted ways of writing about art perhaps implicitly exclude non-canonical art practices. So, on one hand, non-canonical art practices don't get written about and, on the other, the way art practices are written about exclude them even further.

To steal Griselda Pollock's phrase, another starting point might be to ask how we might go about writing art history and art criticism – although I'm not happy with that distinction – in a way that 'differences the canon'. I want to begin by asking why art history and art criticism are not neutral bodies of knowledge, or are they?

Irit Rogoff

First of all, I'm wondering about distinctions between art history and art criticism. One way to map things differently is to drop the expertise of things like art history and art criticism and think instead about the way in which intellectual work tallies with, learns from, corresponds to, is entangled with, practice. That's one sort of de-coupling. Another has to do with the way in which intellectual work relates to institutional practices. One can talk about differencing the canon of art history, but then there are also all the practices of the work itself that are institutional practices, hiring practices, teaching practices, what you pay attention to.

Difference isn't in the materials we teach, it's in thinking through the structures as well. I would therefore want to enter this conversation by thinking of undoing the categories in which we're naturally brought to speak about the subject: the categories of expertise, the divisions and the separations.

The ability to sustain disciplines and their discrete boundaries allows the promotion of these kinds of area studies. The other thing that happens when a body of thought remains imprisoned within a disciplinary framework is that it allows itself to fall within the status called identity politics. It then becomes a kind of additive model, so we work hard to add everybody that's been excluded and silenced and marginalised and is not obviously and manifestly present. This too has proven to be a real stalemate as huge issues about the core concepts of Western culture don't get addressed when we perpetuate the models of area studies, of identity politics, which continue to promote notions of division.

*NR*_How do we disentangle these areas of expertise?

Richard Dyer

Since the 1950s, certain artists, certain bodies of work, certain ways of thinking about practice have been excluded from the glossies and from the more solid canon of art history. The journal *Third Text* came into being in order to try and address that and fifteen years on is probably a good time to assess the situation.

The sort of writing I've done for *Third Text* would never appear in a magazine like *Contemporary* or *Frieze*, or certainly would not have done until the last two or three years. There has been what appears to be a sea

change, and I think it's only an apparent one, where some of the artists who were excluded from the mainstream arena have been seen to become very prominent. So black, Asian, African artists who were once marginalised, or taken care of by a notion which we refer to as 'multiculturalism', or which you could also call 'tokenism', are now taken care of. The fact that black artists have won the Turner Prize twice in a row is a very visible way of saying, 'That's been done. Now we can get on with constructing the main history of Western art once more, having taken care of that.' At some point will these artists and their achievements then disappear into the miasma of art history, the way that women artists were elided from art history from the fourteenth century until they started to reappear again in the seventeenth and eighteenth centuries?

Working at *Contemporary*, I don't feel like I'm trying to put a *Third Text* philosophical viewpoint into a mainstream magazine, but what I write is certainly informed by that. You can't write in the same way in one magazine as you do in another. Everything you think is not a five thousand word article with forty footnotes; there are other ways of talking about art. Coming back to the distinction between art history and art criticism, I think art criticism is a way of talking about what's going on in practice in the present and then, at some point, parts of that become art history. But why do certain things enter art history and others disappear?

Alia Syed
When thinking about how we start writing about art that differences the canon, my initial thoughts are about notions of radicalism. If art exists within the canon, then what is the canon? Is the canon the market? Certain people have a place within it and have an agenda within it. So if art that is radical can exist within that market, is it still radical?

I don't know what art is, I only know about what I do. The things that interest me are things that actually create ruptures within how we view or think about ourselves. So if you are going to write about a work, about something that has moved you, in a way that fixes it by saying that the artwork is about this or that, then you are automatically giving it a meaning through which people will then interpret it. And my idea of making is an idea of opening.

Kobena Mercer
There's a term that the art historian David Carrier came up with in the mid-1980s, called 'art writing'. It was his attempt to translate aspects of poststructuralism and Barthes, but it works as a term that covers both historical and contemporary writing, which I think also takes up some of Irit's points about the intellectual sea change that's happened, the fact that there are other ways of writing about art, both historically and in terms of the contemporary, that have challenged some of the assumptions of the discipline. I am an integrationist, in that I agree with the idea that you can't have an area studies model of separate but presumably equal differences. Having said that, the idea that interests me is taking up an interactive approach in revising twentieth-century art history, in the sense of looking at how different identities – whether those are defined as ethnic minorities, exiles, travellers, immigrants, diasporas, neo-colonial, postcolonial – have interacted

with different paradigms of modern art in the West. What's happened in the initial moments of a challenge to the closed nature of the canon is an over-emphasis on the politics rather than the aesthetics of the art object. It's the artist's identity that has to carry that politics and so we do end up in a potential dead-end in which we're not talking about the art, but about identities. Or, even worse, we end up talking about the institutions.

For me iconography is very important, in the sense that I think that it's one of the resources that exists in art history as a humanities discipline. If you look at the intellectual sea change over the last fifteen years or so, other disciplines have accepted that broad critique that uses the word 'exclusion', which is too simplistic. However, if you look at the history, at the archive, it's never as clear-cut as inclusion and exclusion; there's always a revolving door – now you see it, now you don't – and that is what makes it worth studying.

I think there's a risk of Griselda Pollock's idea of differencing the canon sounding like a programme or a policy, as if you could switch the button, difference the canon NOW! and make all the problems disappear. But I don't think Griselda Pollock means that at all; it's a much more nuanced approach that involves looking at the numerous points of ambiguity where stylistic choices that are available to artists both expand and contract, where artists make decisions that result in their disappearance or invisibility, but not necessarily because they're excluded.

IR_I understand very well why Griselda Pollock talked about differencing the canon in relation to sexual politics and feminist strategies. At heart I'm so against the notion of a canon altogether and I think that even an expanded, diverse kind of canon separates the objects of art from all of the complex, entangled fields in which they exist, and such spaces are for me as much part of something called art as the objects on display. For example, audiences are as important as objects, as important as artists, and reading strategies are everywhere, including in the production of art. The sea change that's happened throughout the humanities, across many different strata and registers of intellectual work, serves the notion of difference extremely well, so I don't want, in the name of difference, to go back to an expanded canon, because it seems to be a regression.

Both the cultural difference of diversity and the twentieth-century project of commemoration, which comes to compensate for an older history of racism and elision and exclusion, need revision. Precisely in the same way that I'm objecting to a notion of canon, I think that the model of creating a replacement for an absence is problematic. It may be best to try and say something in terms of projects that are trying to do something different.

One project I have in mind is Okwui Enwezor's *The Short Century: Independence and Liberation Movements in Africa 1945–1994* exhibition, which has had two stops in Germany and two in the United States over the past year. At one level it was an exhibition that actually built an archive, because Enwezor is a curator who is very concerned with notions of archive and alternative archives. They built an archive of African politics, of African writing, of African publishing, music, photography, artistic practice, and so on. At another level, they did an absolutely remarkable job at

challenging the radicality that the West embraces as the hallmark of the middle of the twentieth century. The West always perceives that students from colonised countries encountered Marxisms in centres like Moscow and Paris and London and then took them back to Africa and produced a revolution. With a very wide notion of Africa that includes North Africa and parts of the Middle East, the exhibition showed the degree to which radicality in the mid-century was actually a product of the wars of national liberation, of the anticolonial wars and of social reform movements and cultural reform movements taking place in Africa. Instead of having a debate about where did it start, the exhibition took the very concept of radicality and it wrote it in relation to cultural difference. After I'd seen the exhibition a couple of times, I went home and randomly pulled books off my shelf, biographies of famous thinkers from the 1960s, and all of these French and German intellectuals keep saying, 'The Algerian National Liberation Front was where I got radicalised. That is where I encountered radical politics. That's where it begins.' And then, a few years later, there is the students' movement in Europe and suddenly you are able to map the circulations of radicality. So it seems to me that to re-examine a lot of core concepts and core conceits in relation to cultural difference is something that I see far more mileage in than expanding canons.

RD_In terms of contemporary art practice, radicality has been expressed as almost a fethishisation of identity politics, where so-called 'other artists' can only be visible if they're dealing with issues of identity. In fact, some artists have changed their practice in order to be seen to be dealing with identity politics. For instance, Keith Piper, a black British artist, made work about the slave trade for a while; Chris Ofili makes work about a notion of black culture that's to do with black music, drug culture, the black dude, flamboyance, the dandy, etc. Yinka Shonibare is slightly a case to the left in that he appears to be critiquing this, but his work is still about the notion of identity. In his *Dorian Gray* series, everything else is the same as in the film, apart from the fact that the previously white protagonist is Yinka himself – a black disabled artist becomes white anti-hero. If these artists weren't making work about identity, about cultural difference, they might not have become so visible to the point of now being major art stars. Now what would have happened if their work was abstract, like that of Frank Bowling, whose degree of unrecognition was such that he had to move to New York in order to be recognised as a good painter? It's as if people were thinking, 'You're a good painter. Why don't you do some work about identity?'

NR_Is that partly because there are only certain modes of writing that are available to those writing about artists of colour? Is it to do with the writing around the actual work? Are certain themes more likely to catch that attention?

RD_Obviously it comes partly from the critics and partly from the artists, but, more importantly, it comes all around from the funding institutions and their policies. What's the criteria for throwing money at this or that?

NR_Has there been an institutionalisation of a certain type of theoretical writing around the hybrid, around the nomadic?

KM_Yes, there has. I think there has been a shift brought about by postcolonial theory and cultural studies that perhaps makes a wider range of writing about art possible, which is good. What isn't good is the idea that we've solved exclusion: we've done it, we're writing in a postcolonial paradigm, and we're appreciating the irony of Chris Ofili's canvases. The problem is that a lot of people doing that writing come from this very background. At worst, they approach the work of art instrumentally, using it as a means to an end to illustrate the conclusions that theory has already arrived at. I think there have been real problems with the consequences of using postcolonial theory to serve the politics of expediency.

I think that it's really important to slow down. I don't know what it is that's setting the pace, that it all has to happen so quickly. There's this idea that the artists that Richard just mentioned have to be success stories that get packaged so quickly after they leave college, go through representation with a gallery, get into retrospectives and surveys and get prizes. I think it's important ethically to slow down in order to be able to challenge the politics of expediency. The value of the work can't be appreciated because it's being made to serve a purpose. And it's great that institutions are responding to changes, but that's what they're supposed to do because they're in the public sphere. Institutions are supposed to be multicultural, and I don't think there should be a big song and dance because they've managed to include various artists. Intellectual ideas from Homi Bhabha and numerous other thinkers get used to serve a purpose and the way that artists go along with that is part of the problem, because they want the packaging.

AS_I think that the notion of packaging is very much to do with art as a leisure industry and how we fit into it. The idea that one is radical just because one belongs to an ethnic minority, or the idea that the work of black or Asian artists is radical just because it is by whoever it is by is also a dubious notion; it goes back to the idea of the noble native and natives are not noble.

IR_It seems to me that there is a constant tension between identity politics and what happens with the enormous body of cultural production – and by that I also mean writing and thinking and teaching and talking and drinking and everything that goes with it. What happens to that beyond the moment of identity politics? There's a need to break out of discrete and ghettoised positions – coalitions are built when one tackles those very concepts that have been keeping areas of culture separate.

01

Sonia Boyce

In 1995, Sonia Boyce's exhibition *peep* was held in the Cultures Gallery of Brighton Museum and Art Gallery and inIVA published an accompanying artist's book, also entitled *peep*. Working with the artefacts and objects in the gallery, Boyce's intervention involved swathing the transparent glass cases with tracing paper and cutting peepholes in the paper through which viewers were forced to peer at the objects on display.

01–04 Sonia Boyce, *peep*, 1995

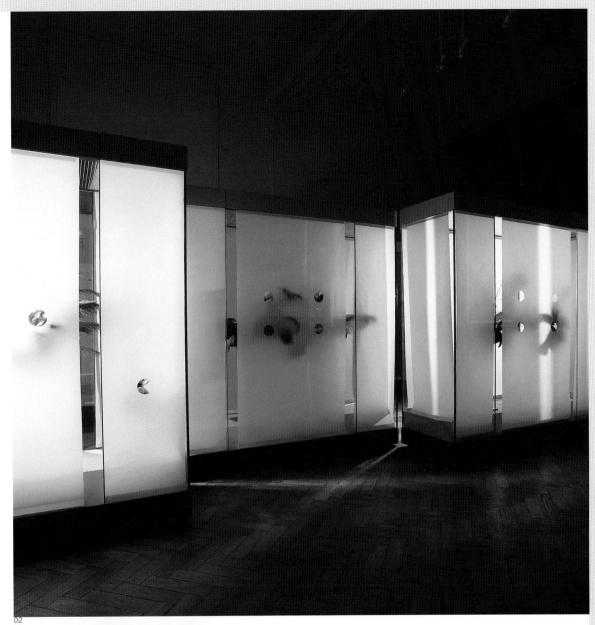

02

03

Sonia Boyce

Sonia Boyce

Introduction to *Shades of Black*

This text is part of the introduction to *Shades of Black: Assembling Black Arts in 1980s Britain* (Duke University Press in collaboration with inIVA and Aavaa, 2005). The book presents an archive of material (both visual and factual) and constitutes the first attempt to write a history of the British Black Arts Movement of the 1980s. Rather than seeking to define a closed history, the volume presents a living archive that we are invited to delve into and explore.

Ian Baucom, David A. Bailey and Sonia Boyce

In his concluding comments to 'The Living Archive' conference, sponsored by the London-based African and Asian Visual Artists' Archive (Aavaa) and held at the Tate Gallery in March of 1997, Stuart Hall issued a challenge to his audience. Responding to Rasheed Araeen's discussion of the importance of producing a history (or histories) of the contemporary black arts scene in Britain and the danger, in generating such histories, of 'ghettoising' a diverse body of artistic works within a 'minority enclave', Hall stated:

> I have to say that I think it's time that those issues were more directly and extensively faced and probed. I think that there's been a kind of slackness around notions of cultural diversity and ethnic arts, etc. We've been through a very intense period of reflection around that, and we're now in a period when a variety of different formulations stand in place of really serious and rigorous thinking and I hope therefore that today's debate which opened up some of those positions can really be followed through on some subsequent occasions.[1]

This book, and the set of transatlantic conversations and conferences that preceded it, represents one response to that challenge.

Beginnings, however, as Michel Foucault, Edward Said, and numerous other critics have reminded us, are notoriously unstable things. And so perhaps another point of departure was a heated conversation that took place in the fall of 1997 between Ian Baucom, Sutapa Biswas, Sonia Boyce and Keith Piper, several days before the opening of *The Unmapped Body: 3 Black British Artists*, co-curated by Baucom at the Yale University Art Gallery. 'What do you think of doing a book about the black British art movement of the 1980s?' Baucom asked, setting off a contentious discussion. Was there a movement as such? How might a volume on its history enable *and* limit the study and critical reception of individual artists and individual works? What, after all, did it mean for the Yale show to group Biswas, Boyce, and Piper together as '3 Black British Artists?' The conversation produced no definitive answers but it did generate one shared conviction: if you raised the question, you would be sure to start a debate about whether that 'movement' existed and what it might have consisted of. Baucom later repeated the question to Boyce, citing the importance of *Ten.8* magazine's final issue, *The Critical Decade: Black British Photography in the 1980s*, as the impetus for developing a discussion on the period. The decision to proceed by organising a set of conferences, one at Aavaa and another at Duke brought the project into conversation with an ongoing debate on transnationalism....

Behind all these arrangements, however, were those initial questions: What is, or was, this 'Black Arts Movement' in Britain? And why the 1980s? What was it about this moment and this convergence of artistic and political allegiances that had paved the way for a generation of 'raised in Britain' practitioners and analysts to meet and to name a black British art movement?

The title of both the conference and this book provides a preliminary set of answers, though perhaps only if appended with a question mark. For as much as

the aim of this project has been to produce a series of accounts of this 'critical decade' (as David A. Bailey and the other editors of *Ten.8*'s final issue have named it), it continues to ask whether it is in fact possible to speak of a semi-coherent 'arts movement' organised under the signs of 'blackness' and 'black Britishness.' It asks what it means for these terms to name the historical and conceptual site where a variegated array of artistic practices intersect. It asks what is gained, and lost, by gathering and organising both practices and a history of practices in this way and whether history is well served by such an impulse to collect and identify. The project thus implicitly constitutes an enquiry into the nature not only of a movement but of movements, particularly those sorts of 'Renaissance movements' (the Harlem Renaissance in the United States, the Celtic Revival in Ireland, the Sophiatown generation in South Africa, to name but a few), which have proven so central to the artistic, cultural, and political history of the twentieth century.

This endeavour proceeds from the conviction that such movements are made not found, that they are shaped and patterned, that they are historically produced and historically productive, that movements, identities, identifications and histories are concrete, if highly negotiable, assemblages. Like an archive, however, assemblages of this sort exist not merely to catalogue or contain the past but, as Jacques Derrida has recently reminded us,[2] as openings to the future. For they exist not only as repositories to be guarded but as something to be dis-assembled, re-assembled, and dis-assembled once more – at once shifting landmarks relating to what has been and intimations of what is to come. To 'assemble the black British 1980s' is thus in a very real sense to produce an array of contemporary histories in which both past and future are made present.

This work thus implies an investigation of what might be called the 'liveliness' of history by examining the temporal co-ordinates of knowledges, concepts, institutions and practices. To speak of a movement is also to speak of several interlocking moments: that of the movement itself; the moments from which it emerged; and the moment from which it becomes possible to look back in retrospect and forward in anticipation. Hence the title *'Shades' of Black* is chosen in part because, for many of the artists concerned, artistic practice has frequently been a sort of anamnestic labour. It is perhaps a conjuring art, an invoking and materialising of histories, subjects and images that have been repeatedly un-named, repressed, or assigned only a flickering, spectral visibility ('There are no stories in the riots', the narrator of John Akomfrah's film *Handsworth Songs* [1986] indicates, 'only the ghosts of other, earlier stories'). That title is also chosen because to look back at the Black Arts Movement is to revisit something that has a sort of 'untimely,' troubling, ghostly relation to the present, occasioning much debate for artists, curators and art historians unsure as to whether this particular disappearing/reappearing shade of 'black' or 'black British' art should be recalled or dispelled. It is to that uncertainty, to that ambivalence about what to do with the spectre of black art haunting contemporary art history and art practice that this book seeks to respond. As the obvious pun on 'shades' indicates, it further

seeks both to retain a primary focus on the visual and to insist that any apparent absolute has a multitude of incarnations. Any one history encompasses a multitude of stories and a history of a black British arts scene cannot be monochromatic; black is not black but all the shades of black.

This, obviously enough, constitutes an invitation to enormous labour, yet the outcome cannot be, in any sense, encyclopaedic. Nor should it be. For it has been a central notion of this project that to attempt a definitive or exhaustive history is to work counter to the spirit of the artistic enterprises that the project seeks to engage. If those enterprises share anything in common, then somewhat paradoxically it is a suspicion of fixed definitions, absolute histories, encyclopaedic knowledges. The difference around which a British Black Arts Movement might be organised, as Hall argued at the 'Living Archive' conference, is not the difference of a pre-existing essence but of a differentiated set of 'routes by which practising comes to modernity'. By attending to such a concept of difference, we have hoped to produce not a synthetic history of the black arts scene in Britain, but a collection of histories, a corporate and polyvocal genealogy, a lively and living archive of the present's ability to assemble both its pasts and its futures...

At least a few more words of explanation are due, on not only the matter of black British art but, also, the question of the 1980s, the moment we have chosen to posit as critical. Why select a frame that implies the priority of retrospection as much as it assumes the coherence of an (in many ways) artificial periodisation?... In his essay 'Assembling the 1980s:

The Deluge—and After,' Stuart Hall traces some of the key positions, circumstances and shifts that take place not simply in the 1980s but over a forty-year period, asking whether it is possible to assemble a definitive interpretation of the 1980s without taking into account earlier decades, international events and social movements. Paying particular attention to the 1950s and 1960s, he argues that events that took place in these periods had an important effect on the 1980s and 1990s, while also underscoring a crucial difference in attitude between the two consecutive postwar generations. Indeed, he suggests that what made the 1980s unique was its convergence of two generations of black artists, together with their contrasting relationship to modernism, and the opposing anti-colonial and postcolonial politics they articulated.

Notes
1 Stuart Hall, keynote address from the transcript (held at Aavaa) of 'The Living Archive' conference, Tate Gallery, London, 1997.
2 Jacques Derrida, *Archive Fever: A Freudian Impression*, trans. Eric Prenowitz, Chicago: University of Chicago Press, 1996.

Introduction to *Rhapsodies in Black*

David A. Bailey

This was the introduction to the *Rhapsodies in Black: Art of the Harlem Renaissance* exhibition catalogue, published by the Hayward Gallery, inIVA and the University of California Press in 1997. It explains how the exhibition set out to re-present the Harlem Renaissance, not as a phenomenon confined to a few square miles of Manhattan, but as a historical moment of global significance in the history of modern art.

Rhapsodies in Black is intended to challenge conventional representations of the Harlem Renaissance and to provoke new readings of the period from a contemporary perspective. For the first time, British and American writers and curators have joined together to explore this subject in a collaborative partnership, to discuss the relation between art and social history, to look at black and white relationships, and at ideas of nationhood and internationalism. One of our aims has been to focus on the important contribution made by people from the African diaspora to the art and culture of this century.

Rhapsodies in Black initially grew out of my interest in Jacob Lawrence's *Migration* series. Between 1940 and 1941, Lawrence produced a narrative cycle of sixty paintings in tempera, chronicling the great twentieth-century exodus of African-Americans from the rural South to the urban North. In 1993, the Museum of Modern Art, New York, and the Phillips Collection, Washington DC, who each own half of the *Migration* series, exhibited it in a number of cities in the United States. What attracted me to this work was Lawrence's conceptual use of a painted narrative, as if in a series of film stills, and the theme of migration inspired me to reflect upon the universal theme of black migration across the globe.

It was through discussions with Roger Malbert about Jacob Lawrence's work, and my reading of Henry Louis Gates's article in the October 1994 issue of *Time* magazine, about different African-American renaissance movements, that I realised that an opportunity existed for an exhibition that would introduce the British public not just to a single artist, but to a number of artists of the Harlem Renaissance period, such as Aaron Douglas, Archibald J. Motley Jr and William H. Johnson. Although the work of these artists has been published and exhibited widely in North America, it remains virtually unknown outside the United States. The idea of a major touring exhibition began to take shape, a show that would also help to establish an international dialogue between a range of artists and institutions on both sides of the Atlantic and provide a platform of debate within British visual arts and culture.

In thinking of black cultural movements outside America, it was clear to us that there were certain parallels between the ideas and issues that concerned the artists and writers of the Harlem Renaissance and those of black artists in Britain during the 1980s. There was in Britain at that time what could be described as a black renaissance movement, in which black artists, curators and cultural practitioners began developing work which prised open new perspectives on black experiences and identities. One cannot, for example, look at the work of independent film-makers such as Isaac Julien and Martina Attille without seeing parallels with the work of Oscar Micheaux; the writings of Rhodes scholar Stuart Hall with the philosophy of Rhodes scholar Alain Locke; the theatrical work of Double Edge Theatre with the work of Orson Welles's Mercury Theatre Group; the music of Courtney Pine, Sade and Soul To Soul with the sound of Fletcher Henderson and Bessie Smith; or the visual art of Keith Piper, Sonia Boyce, Zarina Bhimji, Sokari Douglas Camp and Rotimi Fani-Kayode with the work of Aaron Douglas, Loïs Mailou Jones and Richmond Barthé.

All of these artists from the diaspora have produced modernist autobiographical works that explore issues of representing the body, migration, memory and cultural hybridity.

During these early conceptualisation stages, we invited Richard J. Powell to participate in the project. He brought to our discussions an intimate knowledge of African-American art and the fruits of his research into artistic movements across the world. In our initial meetings, hosted by the Institute of International Visual Arts, Richard Powell developed the idea of an exhibition that went beyond earlier exhibitions on this subject in three fundamental respects: by treating the Harlem Renaissance as a phenomenon not confined to a single geographical location, but rather as an international movement linked to diasporan communities elsewhere in the world; by representing a range of media and other art forms, such as theatre, film, and book and magazine graphics; and by including the work of white artists such as Carl Van Vechten, Doris Ullman, Jacob Epstein, Edna Manley, Jean Renoir, Edward Burra and Man Ray.

Richard Powell's innovative vision stemmed from his interpretation of the complex international connections between the artists of the Harlem Renaissance era. In the late 1930s, for example, the Jamaican artist Ronald C. Moody, living in Europe, was exhibiting in the United States with artists such as Richmond Barthé, Archibald J. Motley Jr and Jacob Lawrence. Ronald C. Moody's work was put together with African-American artists not only because of the colour of his skin; it was also because the ideas, style and nature of his sculptures explored themes of modernity and Africanness which were the shared vision of the artists with whom he was exhibiting. Stylistic and iconographic references to an African heritage can be found in the work of many other artists of the early modern period. Not all of these artists were Harlem-based, nor were all of them African-American, and not all of them were black.

Examples of these interconnections can be found in all art forms. Orson Welles's *Macbeth* production of 1936 was influenced by the writings of Aimé Césaire and by international events in the Caribbean, which Welles masterfully integrated and visualised in a theatre in Harlem, in collaboration with a number of black artists and performers. In her studio in Paris, Loïs Mailou Jones painted *Les Fétiches* in 1938, with its African mask and Haitian symbolism. In the film *Songs of Freedom* of 1936 (shot in London and on location in Africa), Paul Robeson discovered his African royal ancestry. Jacob Lawrence's first major series of paintings, produced in Harlem, focused on the life of Toussaint L'Ouverture, the leader of the first Caribbean revolt in Haiti, in 1804. Josephine Baker, in a French feature film of 1934, *Zou Zou*, performed in a Paris night-club as a caged bird singing about her 'beloved Haiti'. Jean Renoir, after seeing Josephine Baker and Johnny Hudgins perform in Paris, was inspired to write and direct a short experimental science-fiction film called *Charleston*, about an encounter between a black space traveller and a white woman. The point is that these artists, black and white, were part of a movement working with new ideas of internationalism and cultural heritage. It is this broader view, rather than the definition of the Harlem Renaissance as a historical

Exhibition catalogue to *Rhapsodies in Black: Art of the Harlem Renaissance*, published by Hayward Gallery, inIVA and University of California Press, 1997

period narrowly circumscribed by the Red Summer of 1919 and the Great Crash of 1929, that has inspired this project.

The collaborative spirit of the Harlem Renaissance period is reflected in *Rhapsodies in Black,* in which film-makers, curators, performers, visual artists, art historians and cultural critics have been brought together to consider some of the key artists and issues of the time. Some writers, such as Martina Attille and Paul Gilroy, were invited to relate these ideas directly to contemporary artistic movements. Others have reflected upon a single figure, an icon of the time: Jeffrey C. Stewart on Paul Robeson, Andrea D. Barnwell on Josephine Baker, and Simon Callow on Orson Welles. Henry Louis Gates and Richard Powell have explored and mapped out a crucial moment in twentieth-century history and its impact on art and culture throughout the world.

Curated by Richard J. Powell and David A. Bailey, *Rhapsodies in Black: Art of the Harlem Renaissance* was an exhibition organised by the Hayward Gallery, London, in collaboration with inIVA and the Corcoran Gallery of Art, Washington, DC. Opening at the Hayward Gallery in June 1997, it toured in Britain to Arnolfini, Bristol, and Mead Gallery, University of Warwick, before moving to the M.H. de Young Memorial Museum, San Francisco, the Corcoran Gallery of Art, Washington, Los Angeles County Museum of Art and the Museum of Fine Arts, Houston, in the United States.

Rhapsodies in Black: Art of the Harlem Renaissance

01 Jacob Lawrence, *No. 23. General L'Ouverture Collected Forces at Marmelade, and on October 9, 1794, Left with 500 Men to Capture San Miguel, Toussaint L'Ouverture* series, 1937–38. Tempera on paper. Aaron Douglas Collection, Amistad Research Center at Tulane University
02 Jacob Lawrence, *No. 17. Toussaint Captured Marmelade, Held by Vernet, a Mulatto, 1795, Toussaint L'Ouverture* series, 1937–38. Tempera on paper. Aaron Douglas Collection, Amistad Research Center at Tulane University
03 Aaron Douglas, *Into Bondage*, 1936. Oil on canvas, 153 x 154cm. Corcoran Gallery of Art, Washington, DC. Museum purchase and partial gift from Thurlow Evans Tibbs, Jr. The Evans-Tibbs Collection 1996.9
04 Aaron Douglas, *Aspects of Negro Life: The Negro in an African Setting*, 1934. Shomburg Center for Research in Black Culture, Art and Artifacts Division, the New York Public Library, Astor, Lennox and Tilden Foundations. Photograph: Manu Sassoonian
05 Archibald Motley Jr, *Blues*, 1929. Oil on canvas, 80 x 100cm. Collection of Valerie Gerrard Browne. Reproduced courtesy of the Art Institute of Chicago

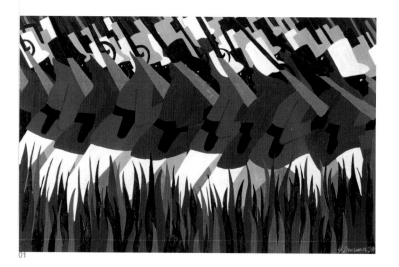
01

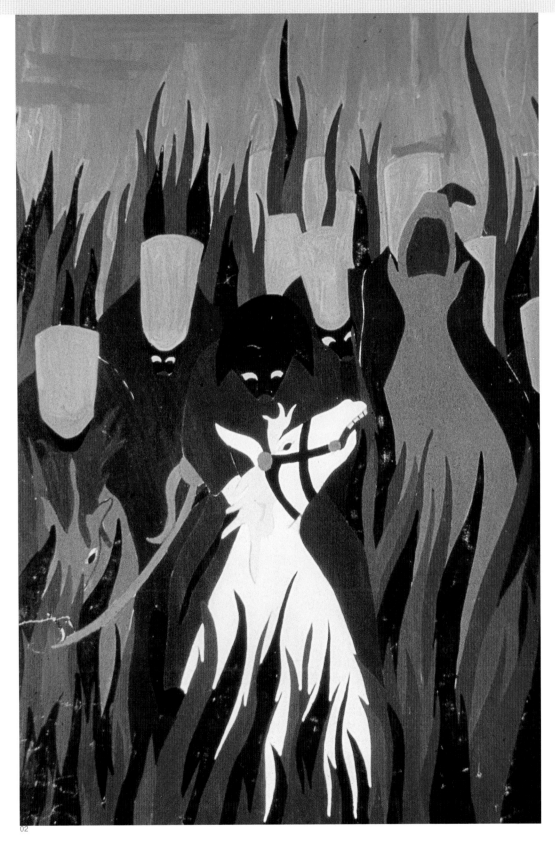

Rhapsodies in Black
Art of the Harlem Renaissance

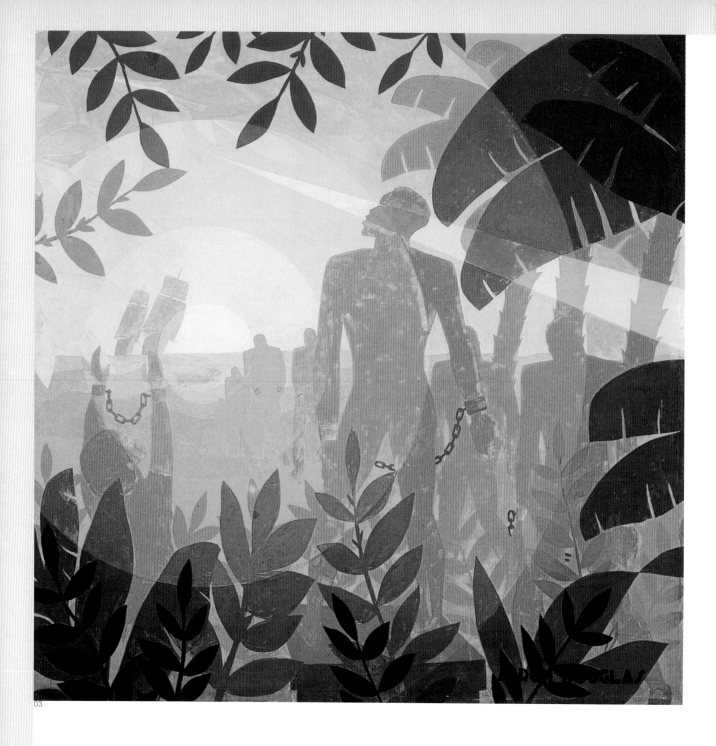

03

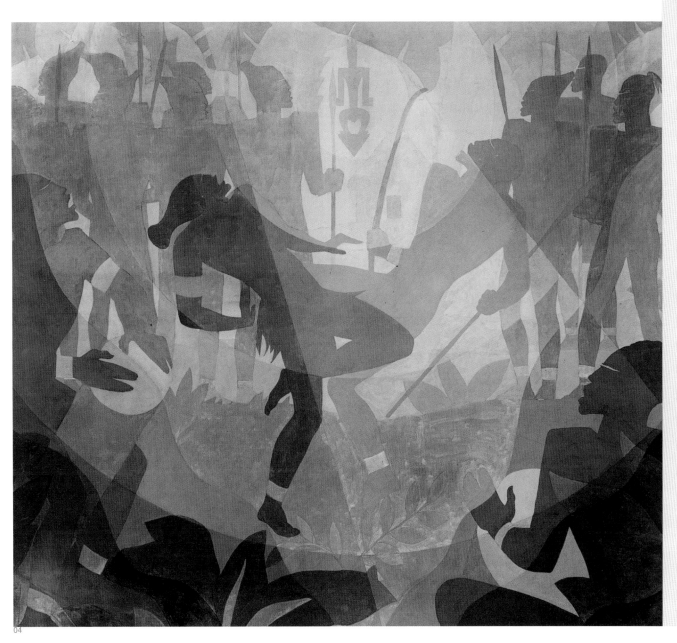

Rhapsodies in Black
Art of the Harlem Renaissance

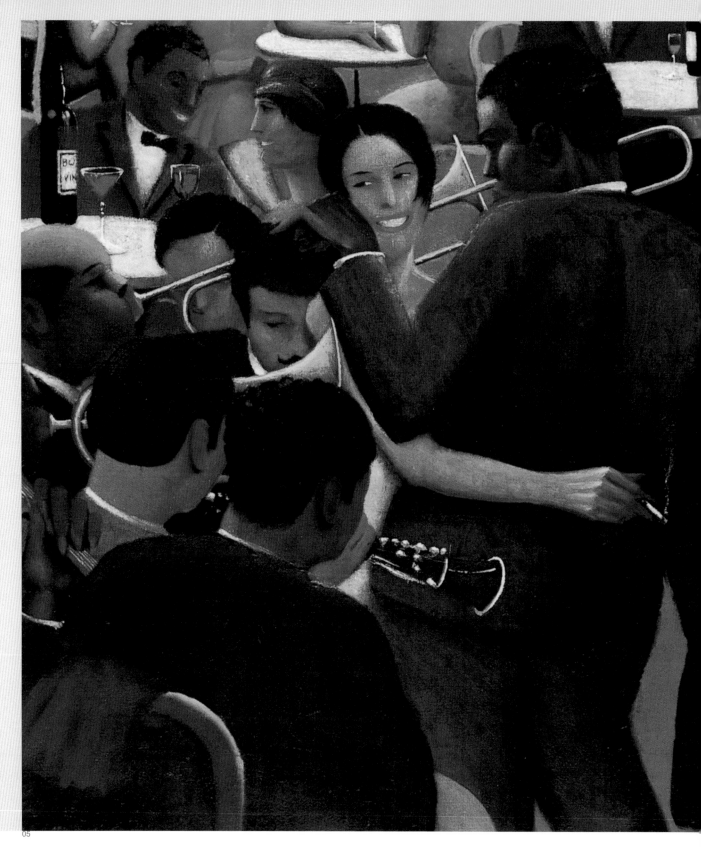

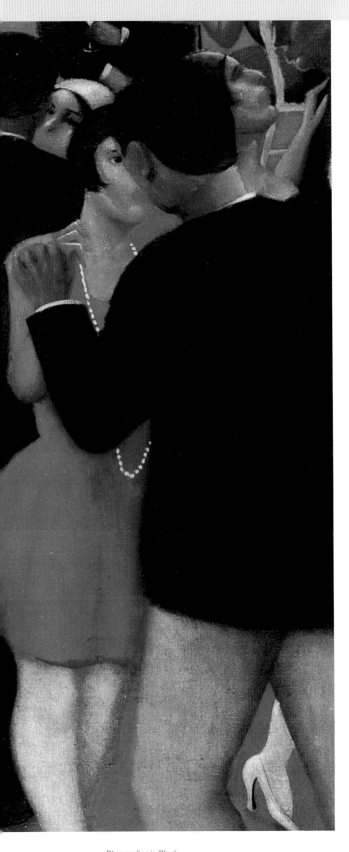

Rhapsodies in Black
Art of the Harlem Renaissance

Modernism from Afro-America: Wifredo Lam

Gerardo Mosquera

Published by inIVA in Gerardo Mosquera (ed.), *Beyond the Fantastic: Contemporary Art Criticism from Latin America*, London: inIVA, 1996, this text was first published in *Art Nexus*, no. 15, January–March 1995. Taking Wifredo Lam as a model of Latin American modernism, this text offers an alternative viewpoint on Lam's work, interpreting it less as a product of surrealism or 'primitive' art (as it tends to be read) and more as a result of Caribbean culture.

The history of art has, to a large extent, been a Eurocentric story. It is a construction 'made in the West' that excludes, diminishes, decontextualises and banishes to *bantustans* a good part of the aesthetic-symbolic production of the world. It is becoming increasingly urgent to deconstruct it in search of more decentralised, integrative, contextualised and multidisciplinary discourses, based on dialogue, hybridisation and transformation, open to an intercultural understanding of the functions, meanings and aesthetics of that production and its processes. Some time ago Etiemble invalidated 'any theory which is based exclusively on European phenomena', and his remark has a tinge of urgency in our field.[1]...

This article tries to interpret the work of Wifredo Lam from Africa in the Americas. Since Lam was a paradigmatic artist of Latin American modernism, such an analysis could be extended to a reading of modern art in Latin America *from* Latin America.

I want to look at the work of this Cuban painter less as a product of Surrealism or in terms of the presence of 'primitive', African or Afro-American elements in modern art, than as a result of Cuban and Caribbean culture and as a pioneering contribution to the role of the Third World in the contemporary world.[2] It is a change of viewpoint rather than a different reading. Lam's cultural sources have been fully recognised, although they have always been subordinated to Western avant-garde art; they have never been examined from the point of view of their own effect on that art, in terms of their own particular construction of contemporary 'high' culture. The displacement to which I am referring means, for example, that the emphasis would no longer be placed on the intervention of these cultural elements in Surrealism; rather, this movement would be seen as a space in which those elements are given expression outside their traditional sphere, transformed into agents of the avant-garde culture by themselves. This is what Lam must have meant when he said that he was a 'Trojan horse'.[3]

This change of perspective does not correspond to a binary displacement. On the contrary, it implies recognition of Western culture as characteristic of the world today, through the global expansion of industrial capitalism, which for the first time integrated the world into a global system centred in Europe.[4] Many elements of this culture have ceased to be 'ethnic' and have become internationalised as intrinsic components of a world shaped by the development of the West. Art itself, as a self-sufficient activity based on aesthetics, is also a project of Western culture exported to the rest of the world. Its complete definition, moreover, was given only at the end of the eighteenth century. The traditional art of other cultures, as well as that of the West from other epochs, was a different production, determined by functions of a religious, representational or commemorative nature. The current art of such cultures is not the result of an evolution in traditional art: the concept itself was inherited from the West through colonialism.

This new approach to Lam does not imply non-recognition of his academic training and the influence of Picasso and Surrealism, or mean that we no longer consider him as a participant in the modern movement. He himself once surprised me during an

interview when he showed me a picture of a work, which was clearly African in appearance, and commented: 'You need to have seen a lot of Poussin to do this.' Although the tension of 'Who eats whom?' is more or less implicit in any intercultural relationship, its processes, even in a relationship based on domination, are rather in fact those of give and take, as Fernando Ortiz has said. The active role of the receiver of foreign elements, who selects and adapts them to new ends, was stated a long time ago in anthropology by Franz Boas, Robert Lowie, Alfred Kroeber and Melville Herskovits, among others. Curiously enough, almost simultaneously, the Brazilian modernists had proposed as a programme the selective 'cannibalism of difference'.[5] It was a difficult enterprise – heralding postmodernism – since it was not carried out in a neutral context but in one of domination, with a praxis that tactically assumes the contradictions of dependency and postcolonial deformations....

The intercultural dialogue implicit in Lam's work is an example of the advantageous use of 'ontological' diversity in the ethnogenesis of the new Latin American nationalities, of which the Caribbean is paradigmatic.[6] Born as a result of Creole-oriented, hybridising processes, these nationalities are part of the Western trunk, although they are also modulated from within by very active non-Western ingredients. European culture lies at their origins and is not something foreign. Lam could paint in the academic, Cubist or Surrealistic style within a familiar tradition, even as 'second mark'. His contribution was to make a qualitative turn and base his art on those elements of African heritage that are alive in Cuban culture. To some extent his work reproduces

the plurality characteristic of the Caribbean, centring it on the African component, which determines the profile of the region. He constructs identity by assuming what is diverse from the non-Western angle, providing a rich response to the endemic problems of identity in Latin America, so often lost between Euro-North American mimesis, repudiation of the West, the utopia of a 'cosmic race', or the nihilism of finding itself in the midst of chaos.

This turn in interpretation of Lam is a response to a new orientation of the discourses that is taking place from the periphery towards the centre in which the former ceases to be a reservoir of tradition, leading to a multifocal, multiethnic, decentralisation of 'international' culture, along with the strengthening of local developments.[7] These processes encourage the dismantling of the history of art as a totalising and teleological paradigm of Western art, the need for which I noted earlier.

It is surprising that art critics and historians have not seen Wifredo Lam as the first artist to offer a vision from the African element in the Americas in the history of gallery art. This fact was an undeniable landmark and was the essential achievement of Lam, much more important than what may have been his 'Americanist' renovation of Surrealism, Cubism, Abstract Expressionism or modernism in general.[8]

Furthermore, what Lam did for modernism was to provide it with a new range of meanings, multiplying its scope and using it to turn its perspective within itself, without contradicting it but rather appropriating it, recycling, adapting, resemanticising. In this sense he was also the forerunner of the heterodox challenge to

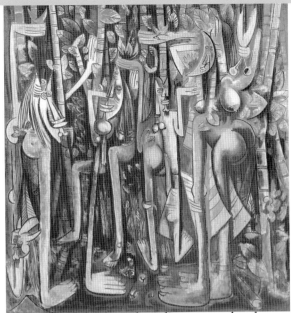

Western monism, through readjustment rather than rejection, which is now spontaneously developing along the peripheries....

In Paris, where Lam arrived in 1938 because of the Spanish Civil War, he consolidated himself as a late modernist, with the support of Picasso. His painting from 1938 to 1940, although based to a large extent on African masks and geometry, was reminiscent of the style of the artist from Malága and, in general, of the School of Paris: as a formal resource in the first place, within a 'brew' already developed by the latter, an epigonal language made up of a combination of ingredients (synthetic Cubism, Matisse, Klee, etc.).[9] At that time he also began to develop a passion for the traditional art of Africa and of other 'primitive' peoples.... It was such an important discovery for Lam that he became a permanent collector of such pieces.

In the discussions on the Picasso-Lam intertextuality, the emphasis is usually placed on the turn of the century 'black' Picasso.... It is symptomatic that the features that most attracted Lam to Picasso would subsequently become, after 'mixing', decisive in his own painting: the African element, and deformation as fable-making. Picasso was interested in African art in terms of geometry, as a constructive synthesis of the human image. His most Expressionist or fable-like works were based less directly on African geometry, which inspired colder and more abstract-oriented works. In Lam, there emerged a kind of line between both elements, a process that was to lead to his own personal kind of expression. It occurred in France, in works dating from 1940, such as *Portrait*, *Homme-Femme* and *Symbiosis* (the last two titles are significant

in terms of what the works intend to communicate – the unity of existence) and from 1941, such as his illustrative drawings for Breton's *Fata Morgana*. In these works the poetics that were to characterise him henceforth are already apparent. This evolution was undoubtedly connected to his relationship with the Surrealists and their fascination with tribal cultures, although Lam, a loner owing to his heterodox background, with its different worlds and poetics, never actually joined the movement. Nevertheless, he began to employ features valued by the Surrealistic visual imagery, such as double eyes, and adopted the pictorial figuration of Julio González, which was to become the basis of his own figuration. He tended to present mythological, fantastical and yet more carnal figures than his earlier schematised characters from Afro-Cuban geometry. He was interested in the African mask less as a lesson in synthesis – its morphological teaching – than as an inventive exploit for shaping the supernatural – its mytho-poetical and expressive teaching. Unlike other religious forms of representation, the mask does not simply embody the sacred: it must personify it, make it a moving presence, a physical entity that can be seen and felt. José Lezama Lima said that 'the mask is the permanence of the supernatural order in the transitory'.[10] It depicts the supernatural as something natural, it makes real what is wondrous.[11] Its design has required enormous amounts of imagination striving towards the personification of this acting fantastic.

At the time of his arrival in Cuba, Lam seems to have moved towards his final poetics in the midst of many and numerous displacements. The cultural

mood introduced by Surrealism had encouraged him to express his own world, the world of his culture, in an exercise of modernity. His arrival in Cuba marked his encounter with that world in reality, and its overflowing into painting. This arrival did not produce any sense of astonishment at the tropics, but a feeling of belonging. It was the confirmation of, and final encounter with, his own space. It was a 'retour au pays natal', in the sense of the moving poem by Aimé Césaire.

James Clifford has remarked: 'Perhaps there's no return for anyone to a native land – only field notes for its reinvention.'[12] The work of the Cuban artist henceforth is an achievement that can be seen in this perspective, related to *négritude* as a conscious and neological construction of a black paradigm. On the island, the painter rediscovered his cultural universe as a personal artistic universe.... It was a fruitful connection at the right time. Fascinated by African and 'primitive' elements thanks to modern art he had begun to give outward expression to 'African' and 'primitive' aspects of himself. This process was defined through his direct contact with Afro-Cuban traditions. In Cuba, as Ortiz writes, 'the Afroid world is in Lam and in all his environment': it is not some diffuse feeling, a dream, a sense of longing or something in a museum.[13] The Cuban folklore specialist Lydia Cabrera played a central role in this process, when she helped familiarise Lam with the myths, liturgies and representations of that world. Lam was also affected by the light and nature. He had come, as Alejo Carpentier said, from a 'fixed' world to another kind of world, 'one of symbiosis, metamorphosis, confusion, of vegetable and telluric transformations'.[14] But, once again, I should like to emphasise that the key to all these discoveries lies in the fact of his anagnorisis of himself as a 'Caribbean man'.

From 1942 – when he returned to Cuba – his works became the vehicle for his own, definitive kind of expression, the first vision ever of modern art from the standpoint of Africa within Latin America. There were formal changes in these works, with the prevalence of a figuration that, although indebted to Cubism, distanced itself from the analytical breaking down of forms, or their synthetic reduction, and moved towards invention, with the objective of communicating, rather than strictly representing, a mythology of the Caribbean. There is a baroque gathering of natural and fantastic elements in these works, woven into a visual and semiotic texture (which has been decodified by Desiderio Navarro) whose message is the unity of life, a vision characteristic of the Afro-Cuban traditions, where everything is interconnected because everything – gods, energies, human beings, animals, plants, minerals – is full of mystical force and depends and acts on everything else.[15] In this sense many of Lam's paintings could be compared to the *ngangas* of the Palo Monte religion, the recipients of power that structure sticks, leaves, earth, human and animal remains, iron, stones, signs, objects, spirits and deities into a kind of summary of the cosmos....

Lam's painting is a 'primitive' modern cosmogony, a recreation of the world centred in the Caribbean, although it uses the devices of Western art and the space opened up by it. It is a story of genesis, of the proliferation of life, of universal energy. Ortiz speaks of 'living natures': the term alludes to a genre established by the Western pictorial tradition (still life), which Lam

uses as a reference or artistic structure and at the same time transforms, because in the world view implicit in his art nothing is dead but only in metamorphosis, because everything is full of an energetic spiritual presence.[16]...

Picasso and many modern artists sought inspiration in African masks and statues, essentially to achieve a formal renovation of Western art, unaware of the context of these objects and their meaning and functions. Lam discovered African and 'primitive' art in Picasso and began to use it in the same way. However, under the drive of Surrealism, his own personal world became activated in a way that was to determine a more internal manipulation of those forms. As a modern artist Lam displaced the focus from forms to meanings, in a coherent, natural and spontaneous manner, something that has never been achieved before in modern art.

Notes

1 Etiemble, *Essais de Littérature (Vraiment) Générale*, Paris, 1974, p. 11.
2 See also Gerardo Mosquera, '"Primitivismo" y "contemporaneidad" en nuestros artistas jóvenes', *La revista del Sur*, Malmö, year 11, nos. 3–4, 1985, pp. 52–55; and John Yau, 'Please, Wait by the Coatroom: Wifredo Lam in the Museum of Modern Art', *Arts Magazine*, New York, no. 4, December 1988, pp. 56–59.
3 Quoted by Max-Pol Fouchet in *Wifredo Lam*, Barcelona, 1984, p. 31.
4 Mosquera, *El diseño se definió en Octubre*, Havana, 1989, pp. 27–37.
5 *Primitive Art* (Franz Boas) is dated 1927; *Revista de Antropofagia* was founded the following year, with the first number including Oswald de Andrade's *Manifiesto Antropófago*. For a critical examination of his programme, see Z. Nunes, *Os males do Brasil: Antropofagia e a questao da raça*, Rio de Janeiro, 1990.
6 The term 'Caribbean' is now used in ethnological theory to refer to a paradigm opposed to monocultural narrative; see James Clifford, *The Predicament of Culture: Twentieth Century Ethnography, Literature and Art*, Cambridge and London, 1988, pp. 14–15.
7 Mosquera, 'Tercer Mundo y cultural occidental', *Lápiz*, Madrid, year VI, no. 58, April 1989, pp. 24–25.
8 Through painters like Gorky and Pollock, less by means of Surrealist automatism than by its 'primitive' sensibility.
9 For the development of Lam's painting, see José Manuel Noceda and Roberto Cobas Amate, *Wifredo Lam desconocido*, catalogue of the Fourth Havana Biennial, 1991, pp. 155–60.
10 José Lezama Lima, 'Homenaje a René Portocarrero', in *La Cantidad Hechizada*, Havana, 1970, p. 380.
11 So might we say in an allusion to Alejo Carpentier, who uses Lam as a paradigm of his concept of the marvellous-real in his prologue to *El reino de este mundo* (1959), where the idea is expressed for the first time.
12 Clifford, op. cit., p. 173.
13 Fernando Ortiz, 'Las visiones del cubano Lam', *Revista Bimestre Cubana*, Havana, vol. LXXI, nos. 1, 2 and 3, July–December 1950, p. 269. This text is one of the fundamental interpretations of the painter's work and a fine example of the baroque in Cuban prose.
14 Alejo Carpentier, 'Un pintor de América: El cubano Wifredo Lam', *El Nacional*, Caracas, 1947, reproduced in the catalogue to the exhibition *Exposición antológica 'Homenaje a Wifredo Lam', 1902–1982*, Madrid: Museum of Contemporary Art, pp. 77–78.
15 Desiderio Navarro, 'Lam y Guillén: Mundos comunicantes', in *Sobre Wifredo Lam*, Havana, 1986; 'Leer a Lam', in Navarro's *Ejercicios del criterio*, Havana, 1988.
16 Ortiz, op. cit. p. 259.

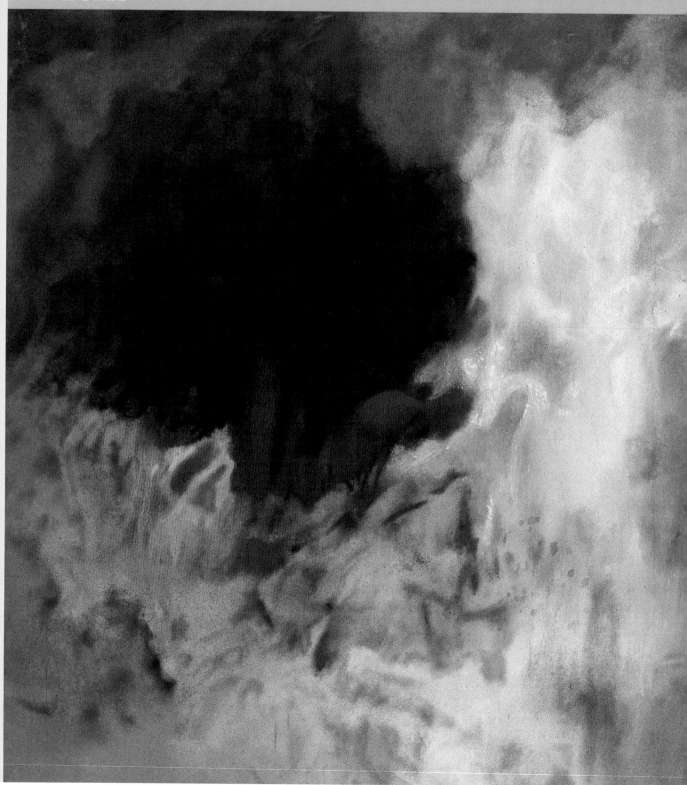

How do we define what it is to be 'modern'? Is modernity rooted in a particular time and location or is it a way of thinking, living and working? As Stuart Hall writes 'The world is absolutely littered by modernities... by artists who do not regard modernism as the secure possession of the West, never regarded it as such but always regarded it as a language which was both open to them but which they would have to transform.' Perhaps modernity is better understood as a set of experiences that encompass the movement of peoples across the globe and the exchange of cultures across geographical borders. In this context, the work of artists like Aubrey Williams and Nasreen Mohamedi can be located at the intersection of different cultures and experiences – as the work of quintessentially modern artists.

Museums of Modern Art
and the End of History

This text was published for the first time in Stuart Hall and Sarat Maharaj, *Annotations 6: Modernity and Difference*, London: inIVA, 2001. It was originally delivered as a keynote address that was given at the 'Museums of Modern Art and the End of History' conference at Tate Gallery, London, May 1999. In the text, Stuart Hall proposes the history of modernity and modernism as a set of cultural translations rather than as a movement firmly enshrined in the Western canon.

Stuart Hall

Rather than 'Museums of Modern Art and the End of History', I am tempted to suggest that the title of this conference should be 'The End of Museums of Modern Art and the Beginning of History'. We could learn a great deal simply by reversing all the terms. What I want to talk about is exactly the sort of 'ending' signalled by that kind of reversal. Of course, it would be too easy to think that simply turning all the terms of a dominant paradigm upside down will help us to understand what is going on. In that sense, I am not interested in endings; instead, I am going to talk about 'turns'. The idea of museums in general, but also the idea of museums of modern art in particular, is in trouble as a result of certain deep historical shifts or 'turns': transformations of theory and consciousness, but also shifts in the actual cultural landscape itself.

This 'crisis', if we may call it that, is the cumulative effects of a rather dispersed set of developments – what I refer to as a series of turns – which constitute the end of certain ideas of the museum, of the modernity of modern art and, indeed, of history. That notion of a turn is important for me. A turn is neither an ending nor a reversal; the process continues in the direction in which it was travelling before, but with a critical break, a deflection. After the turn, all of the terms of a paradigm are not destroyed; instead, the deflection shifts the paradigm in a direction which is different from that which one might have presupposed from the previous moment. It is not an ending, but a break, and the notion of breaks – of ruptures and of turns – begins to provide us with certain broad handles with which to grasp the current crisis of modernity, and thus of the museums of the modern.

This is clearly related to the much abused notion of the 'post', so I must spend a moment dogmatically reiterating what 'post' means to me. I do not use the term to mean 'after' in a sequential or chronological sense, as though one phase or epoch or set of practices has ended and an absolutely new one is beginning. Post, for me, always refers to the aftermath or the after-flow of a particular configuration. The impetus which constituted one particular historical or aesthetic moment disintegrates in the form in which we know it. Many of those impulses are resumed or reconvened in a new terrain or context, eroding some of the boundaries which made our occupation of an earlier moment seem relatively clear, well bounded and easy to inhabit, and opening in their place new gaps, new interstices.

Let us look at three examples. The postcolonial is not the ending of colonialism but is what happens after the end of the national independence movement. All those contradictions and problems which constituted the dependency of colonial societies are reconvened, partly now within the old colonised societies, but also inside the metropolis, which was previously regarded as standing outside of this process. Similarly, post-structuralism spends all its time and energies saying how it is an advance on structuralism, and yet the first thing to recognise is that, without structuralism, post-structuralism could not exist. It continues in its bloodstream, but in a disseminated or deconstructed form, which allows the original structuralist impulse, transformed, to take on new directions. I think the term 'postmodern' is exactly the same.

I do not want to evoke any of the enormous rubbish that has been talked about under the title of

'postmodernism', but instead want to focus on the kernel of significance in the term once it has been stripped of some of its many accretions. It seems to me that 'the modern' has ceased to be an ever-increasing present form or state of existence and is becoming a moment in history. When that happens, our understanding shifts from an awareness of the ground on which a practice stands to seeing where it came from, how it evolved and this enables us to ask the question: 'What might come after it, 'post' it?'

There has always been something contradictory about the relationship between modernity and history, which is bound to problematise the notion of art history itself.... Writing the history of a phenomenon or of a movement or of an epoch does, in a very complex way, suggest that one can trace its genealogy – what its evolution has been, define the principal forces which will drive it forward and ask the question of whether it has a conclusion. But this historicising tendency is seen as contradictory in the context of modernity, since modernity was precisely a fundamental rupture with 'the past' in that sense. It was a break into contingency and, by contingency, I do not mean complete absence of pattern, but a break from the established continuities and connections which made artistic practice intelligible in a historical review. It focused as much on the blankness of the spaces between things as on the things itself and on the excessive refusal of continuities. It was always caught between the attempt, on the one hand, to turn the sign back to a kind of direct engagement with material reality and, on the other, to set the sign free of history in a proliferating utopia of pure forms. Writing histories of modernity is not impossible, but I think they have always been extremely difficult to suture back into the more confident historical organisation of the history of Western art, which extends roughly from the Renaissance until the modern itself. I think we have reached the death of that idea of the modern, the logic of whose architecture, T.J.B. Clark (*Farewell to an Idea. Episodes from a History of Modernism*, 1999) argues, we no longer intuitively grasp.

I want to talk instead about the turn from modernism, but using 'turn' in the sense I have already established. Let me return to that version of postmodernism, which cites modernism as if the entire modern movement can be condensed forwards to the point of its elaboration under the aegis of American art and architecture – the 'American' moment. The notion of modernism which reads as if it came to its apotheosis only at its very end seems to me to misunderstand, misread and grossly oversimplify the radical, aesthetic, social and cultural impulses which made modernism the dynamic movement that it was. American cultural critics have a great deal to answer for by trying to subsume the many modernisms under the aegis of what we might call the art of the age of the American empire.

It seems that something significant has to be taken on board about the persistence of the impulse of modernity itself within postmodernism. I cite three examples. The first is what I would call modernism in the streets. I think postmodernism is best described as precisely that; it is the end of modernism *in the museum* and the penetration of the modernist ruptures into everyday life. This is closely related to my second

example, the aestheticisation of daily life. This might
puzzle people in this room who think of contemporary
life as the very antithesis of the aesthetic, but personally
I think the symbolic has never had such a wide
significance as it does in contemporary life. In earlier
theories, the symbolic was corralled into a narrow
terrain, but it has now entirely imploded in terms of
late-modern experience and we find the languages of
the aesthetic as appropriate within popular culture or
public television, as they are within the most *recherché*
rooms of the Museum of Modern Art. There are
aesthetic practices distributed by a massive cultural
industry on a global scale and the aesthetic is, indeed,
the bearer of some of the most powerful impulses in
modern culture as a whole, including what we used to
think of as its antithesis – the 'new economy' which is,
par excellence, a *cultural* economy. This notion of a
modernism that is to be found inscribed on the face
of everyday life, in everyday fashion, in popular culture
and in the popular media, in consumer culture and the
visual revolution, does obviously jeopardise the whole
concept of gathering together the best of all this in
one place and calling it 'a museum'.

Alongside all of this is my third example, the
proliferation of media or means of signification. I read
recently that it is completely ridiculous to define
modern contemporary visual art practices in terms of
the media in which they are executed; instead, we must
consider the proliferation of sites and places in which
the modern artistic impulse is taking place, in which it
is encountered and seen. This is not just a reservation
about the white cube gallery space. This is an explosion
of the boundaries – the symbolic as well as physical and

material limits – within which the notion of art and
aesthetic practices have been organised. Young
intellectuals – barely able to spell intellectual, let alone
call themselves that – who are working somewhere
within the cultural industries, with visual languages
and technologies, are as deeply and profoundly
implicated in the breaking point of modern artistic
practices as the most fully paid-up members of the
most academic, scholarly schools of art. That they came
in through the back door and went out into industry is
not important. What is relevant, however, is the
proliferation of these practices and the degree to which
this proliferation sits most uncomfortably with the
prestige attached to the process which attempts to sift,
on some universal criteria of historical value, the best
that is being produced and gets it displayed inside
some well-patrolled set of walls. Modernism in the
streets, the aestheticisation of everyday life and the
proliferation of sites and means of signification are
some ways of re-reading postmodernism, or the
postmodern 'turn', as the aftermath of modernism.

Postmodernism is not a new movement that kicked
modernism into touch, but, instead, by building on and
breaking from modernism, it transformed it by taking
it out into the world. Similarly, we might talk about the
post-museum – not in the sense of the necessary end
of all museums, but in terms of the radical
transformation of the museum as a concept. I would
call it the *relativisation* of the museum, which can
now be perceived as only one site among many in the
circulation of aesthetic practices. It is certainly true that
the museum remains a very privileged, well-funded
site, which is still closely tied to the accumulation of

cultural capital, of power and prestige, but in terms of the real understanding of how artistic practices proliferate in our society, it is only one site and no longer enjoys the privileged position that it had historically.

Now I want to look at what one might call 'post-history'. In exactly the same way that I have been talking about the postmodern, post-history is not the end of history. In fact, some of the most important critical and theoretical developments have arisen from the greater historicisation of aesthetic practices, which we have tended to talk of as if they were universal. The historicising function has not therefore gone away; but History, with a capital 'H', which is now increasingly understood as one grand narrative, has managed to situate itself, or substitute itself, in the place of the Universal.... There is an almost impossibly refined and elaborated exchange between history and value, which you might think are antithetical terms – after all, if something was important in a particular period, it is highly unlikely that it will be important in all other periods – and yet value reaches for a universal horizon from within a deeper and more profound sense of historical understanding.

In what sense then, do we have a post-history? Firstly we should be aware that histories *are* narratives and that accordingly we have histories rather than a singular history. These narratives are a discursive imposition of beginnings, middles and, indeed, endings on to histories which do not naturally produce themselves in this convenient form. Therefore, we are not talking about the history of art, but about how we have chosen to narrate the identity of the histories of

art to ourselves; the notion of narrative has interrupted and deflected the purity of the historical impulse....

The next 'post' that I wanted to talk about is what I want to call post-culture. You will say there is nothing post about culture; it is the ever-present, ever-evolving signifier of our times.... Culture is the ground on which everybody is somehow now said to be operating. But what is entailed in this conception of culture? We can no longer inhabit a notion of culture in the old anthropological sense, as something which is clearly bounded, internally self-sufficient and relatively homogenous across its members, which sustains and regulates individual conduct within the framework that it offers. Cultures, in that anthropological sense of specifically defined ways of life, have been broken into and interrupted by cosmopolitan dispersals, by migration and displacement. I think that the collapse of that anthropological definition – culture as a way of life – has to do with the point at which the West began to universalise itself. It is connected with the attempt to construct the world as a single place, with the world market, with globalisation and with that imperial moment when Western Europe tried to convert the rest of the world into a province of its own forms of life. From that moment onwards – the moment of modernity – we could no longer think in terms of cultures which are integral, organic, whole, which are well bounded spatially, which support us and which write the scripts of our lives from start to finish....

The movement from an anthropological to a signifying conception of culture does not mean that cultures become less important. Instead, we are now talking more than ever before about the domain, the

importance and the proliferation of meanings by which people live their lives, understand and contest where they are and develop aesthetic and artistic forms of expression. What has disappeared is the ability to carve those forms of expressions into strictly classificatory boxes, so that the primitive and the contemporary fit like two rooms inside the modern, with the modern itself boxed inside the ancient. The modern has been inside the primitive and the ancient since 1492 roughly speaking, so what is this 'new' discovery that all of a sudden there are more than one set of modernities? They have been proliferating ever since the world began, only ever tentatively, unevenly, contradictorily, to be convened under the rubric of Western time. This does not mean that we are merely moving everywhere towards a cloning of the West. Instead, those sharp distinctions which underpin our classification – that fixed notion of primordial cultural difference between tradition and modernity – simply do not explain any longer the way in which individuals and their practices are *both* embedded in certain cultural languages or repertoires and at the same time reach across any frontiers which they construct to those which lie beyond – the phenomenon of vernacular cosmopolitanism which is globalisation's shadow. This is nothing other than the shift from the notion of difference as an either/or concept to Derrida's notion of *différance*, in which you cannot make an absolute distinction between a here and a there, inside and outside.

The idea that we live in a well-bounded, well-policed, well-frontiered set of spaces, in which you can move from this room to that, tracing how that became

this and how the practices governed by a particular culture evolved to become something different, simply misses the degree to which cultures can no longer be clearly categorised. With the modern and even the postmodern condition, the process of *cultural translation* means that cultural languages are not closed; they are constantly transformed from both within and outside, continuously learning from other languages and traditions, drawing them in and producing something which is irreducible to either of the cultural elements which constituted them in the first place. The most dramatic example of how the notion of cultural translation is the only way in which the cultural process today can be properly grasped is found in the history of modernism itself. The latter has been written precisely as if modernism was a set of triumphal artistic practices, located in what you might think of as the West. However, a small number of deracinated artists out there were drawn to this pole of attraction and did relate to it, but of course, in the dominant way the history is read, they cannot be considered to have contributed in any central way to the history and evolution of modernist art practices. In reality, the world is absolutely littered by modernities and by practising artists, who never regarded modernism as the secure possession of the West, but perceived it as a language which was both open to them but which they would have to transform. The history therefore should now be rewritten as a set of cultural translations rather than as a universal movement which can be located securely within *a* culture, within *a* history, within *a* space, within *a* chronology and within *a* fixed set of political and cultural relations.

01

Aubrey Williams

inIVA collaborated with the Whitechapel Art Gallery in 1998 on the first major retrospective of Aubrey Williams's work in the UK. Moving between figuration and abstraction and with references ranging from Western classical music to pre-Columbian iconography, his paintings defy easy categorisation. In his essay for the accompanying exhibition catalogue, Guy Brett talks of 'Williams's own desire to be simply a modern, contemporary artist, equal of any other'. The series of paintings shown here are a visual expression of the symphonies and quartets of Dmitri Shostakovich.

01 Aubrey Williams, *Shostakovich series, Quartet No. 11, opus 122*, 1981. Photograph: Edward Woodman. Reproduced courtesy of Eve Williams
02 Aubrey Williams, *Shostakovich series, Quartet No. 5, opus 92*, 1981. Photograph: Edward Woodman. Private collection. Reproduced courtesy of Eve Williams
03 Aubrey Williams, *Shostakovich series, Symphony No. 10, opus 93*, 1981. Photograph: Edward Woodman. Reproduced courtesy of Eve Williams

Overleaf
Aubrey Williams, *Shostakovich series, Quartet No. 10, opus 118*, 1980. Photograph: Edward Woodman. Reproduced courtesy of Eve Williams

03

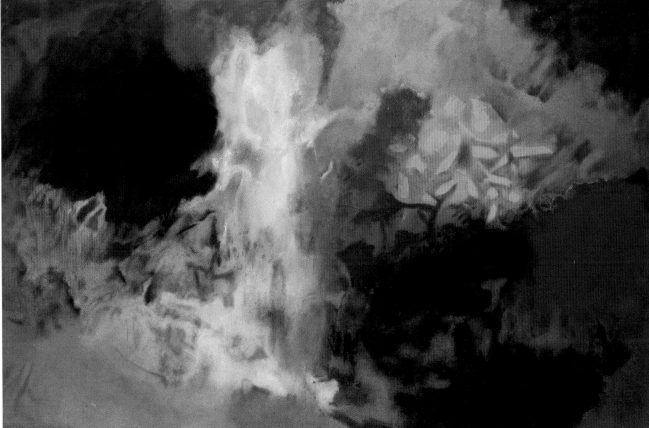

02

Aubrey Williams

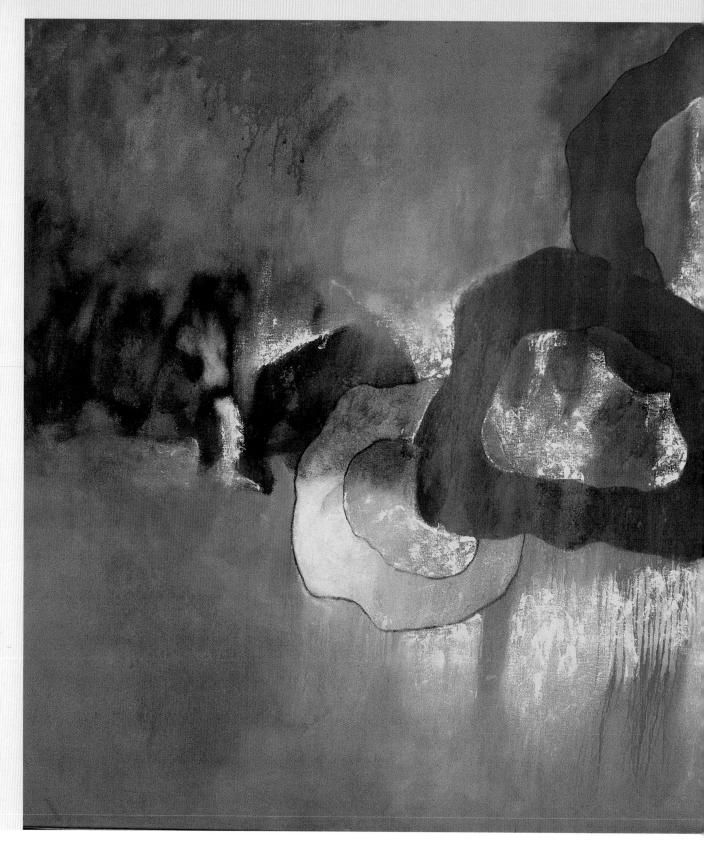

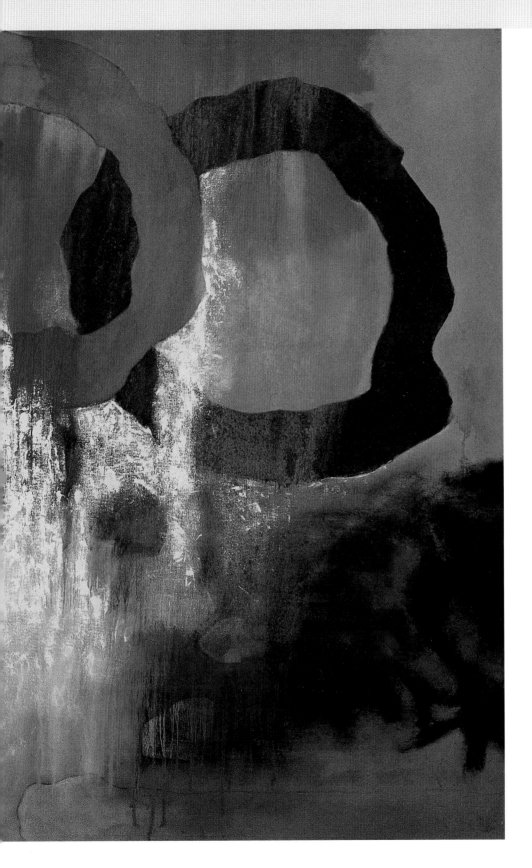

Aubrey Williams

Introduction to 'The Caribbean:
A Quintessentially Modern Zone'

Stuart Hall

This was Stuart Hall's introduction to a Chat Room event entitled 'The Caribbean: A Quintessentially Modern Zone' that took place at inIVA on 19 September 2000 with art historian Annie Paul and artist Steve Ouditt. Stuart Hall's introduction kicks off the discussion by defining the sense of dislocation and translation at the heart of Caribbean culture as an essentially modern experience.

I just wanted to start by reminding you that this session is called 'The Caribbean: A Quintessentially Modern Space', which is inevitably a provocative observation. Whatever you know about the Caribbean, it is not a modern space in the most obvious, banal sense of the term. It's not marked by technological wizardry, excessive lifestyles and high metropolitan living, etc. It's not modern in that simple and obvious sense. And the word 'modern' – and all its cognates: modernity, modernism, etc. – has a funny standing. Because if 'modern' means 'up to date', how come 'modernism' is now a hundred years old? There's a funny way in which 'modern' means both 'right bang up to now', but at the same time it designates a period of time in the past, so it establishes a strange relationship between past and present.

One of the senses in which the Caribbean can be considered modern is as a space of what I would call 'cultural translation'. Most of the people in the Caribbean were not originally from that area. The original inhabitants in the majority of the islands and even in most parts of the mainland, of the English-speaking Caribbean, were decimated within a hundred years. Everybody who has come to the Caribbean since then, comes from elsewhere; there's something peculiarly modern about that inability to find a long-standing origin in or continuity with the place from which you've come. The contrast between traditional societies and modern societies is a bit of a phoney one and even though we know that traditional societies are always rapidly changing and subject to migration, they are relatively slow-moving; people tend to stay where they were born for long periods of time and

connections between people and communities are very long-standing. This cannot be said of the Caribbean. If it's a place of any distinctiveness, it is because it is a place where nobody is, in the obvious sense, 'at home', where everybody is to some extent dislocated, and that sense of being 'not at home', or 'unhomeliness', is a very modern kind of experience. What comes out of the sense of dislocation – of having many origins, of coming together from very different roots and of nothing remaining fixed and stable over a long period of time – in terms of cultural practices, in terms of language, in terms of the arts, in terms indeed of political organisation, and in terms of the economics and so on, is all 'translation'. Translation is at the heart of what Caribbean culture is about.

The word Creolisation – or Creole – is also a slippery term. If you go to Martinique and ask who the Creoles are, you meet white people. If you go to the rest of the Caribbean and you ask who the Creoles are, you meet mostly brown people, except of course in Trinidad, where you meet people who are both African and Indian in their background. So even the terms Creole and Creolisation don't have an easily fixed historical trajectory. They suffer from everything else that happens in the Caribbean. They too get translated as you move from one place to another.

So the question of Creolisation, of cultural translation, of the refusal of its forms and its languages to stand still in any one place and to be able to trace their origins over a long continuity, the absence of those things and the sense of dislocation, all of those things make the Caribbean experience – although it's a very varied experience from one part of the

Caribbean to another – very modern. Some people have said the Caribbean is the first postmodern pre-modern society.

Another sense in which the Caribbean has a funny relationship to the modern relates to the historian C.L.R. James, one of our great historical and political figures and thinkers. His appendix to *The Black Jacobins* (1938), the book that he wrote about the Haitian Revolution, is wonderfully titled 'From Toussaint L'Ouverture to Fidel Castro'. You wonder what the Haitian Revolution which took place at the end of the eighteenth and beginning of the nineteenth century, coterminous with the French Revolution and one of the few, perhaps the only, really successful slave revolts of modern times, has to do with Fidel Castro. It's not just because these are two revolutionary leading figures, nor because there were revolutions in the two places, or the places look alike. It is because both these figures – and James really means Caribbean politics in general – have been obliged to address fundamentally modern questions. In relation to Toussaint L'Ouverture, the Haitian revolution is sparked, first of all, by the revolt against slavery and indenture, one of the most backward forms of human labour. And at the same time, it's triggered by the French Revolution, by the cries of 'Liberty, equality and fraternity', which is often taken to be the birth of modern politics. In Toussaint L'Ouverture's mind, these two things occupied exactly the same space: the ending of slavery and the call of the French Revolution to liberty, equality and fraternity. In very different circumstances, Castro also tried to break the 'backwardness' and underdevelopment of Cuba by invoking liberty, equality and fraternity.

Now, in that sense, the French Revolution is the toxin of what we would call 'political modernity'; since then politics have been about liberty, equality and fraternity – or resisting the demand for liberty, equality and fraternity. And when I say 'politics', I don't mean who's in power, I mean the play of power in society works in a fundamentally modern way. And what James means is that successive political, cultural figures in the Caribbean have been obliged to address themselves to a fundamentally modern set of conditions.

Now what is peculiar about that is, of course, that they addressed it from the deepest poverty and from a long period of slavery and indenture. Slavery, the most backward mode of production, is harnessed right into the most modern form of capitalism. Marx said capitalism doesn't even begin until you have free labour. It's outside the reach of the modern to have people whose labour still does not belong to them, whose bodies don't belong to them. And yet the system of slavery harnessed this backwardness of production to the capitalisation of the economy in Britain, to the mercantile trade of the new empire, and thus to the Industrial Revolution, which is the basis of modern modernity. The Caribbean brings together, therefore, backwardness and modernity in one single space. And that is, you might be surprised to hear me say, a fundamentally modern thing, too. Don't imagine that the modernity of the most modern thing that we can think of in the world – say Manhattan – is to be judged essentially from its skyline: it's also to be judged from the ravaged parts of New York which are an absolutely fundamental other

side of New York's metropolitan modernity. These two things belong with modernity.

And this coming together of backwardness and the modern makes the Caribbean a very peculiar kind of space. It's not a question of what is in people's consciousness so much as the constitutive space they are obliged to address, whether they want to or not. It's not that some politicians aspire to be modern, or some artists want to be modern, though they do. They have to engage, in the Caribbean, whether they like it or not, with an essentially modern space.

My friend David Scott who is working on a study of C.L.R. James calls the Caribbean people, using a phrase from an anthropologist, 'conscripts of modernity'. They are not the people who go forward and build the modern, but the people whose fate, whether they like it or not, has been to live the underside of modernity.

James once wrote in an essay on Africans and Afro-Caribbeans that it was essentially this double inscription, inside and outside Western modernity, that gave the Caribbean its very peculiar status. He said it's something that gives Caribbean people a peculiar insight, a shaft of insight, into life, this obligation that they have to stand with one foot in servitude and another foot in modernity, to be both part of the modern and yet not to have shared in the dreams of modernity's enlightenment and achievements, to come to modernity from the underside, but nevertheless to have to come to it.

You could look at this historically, but our job is to look at how this conscription to modernity – and the peculiar form that cultural translation takes in the Caribbean – affects culture and art today.

Nasreen Mohamedi's practice encompasses the visual forms of modernism from the West, filtered through an Indian sensibility. Her fine line drawing both adopts and subverts its point of reference, appropriating the grid and departing from it with the diagonal. Mohamedi's work was shown by inIVA in an exhibition entitled *Drawing Space: Contemporary Indian Drawing,* curated by Suman Gopinath and Grant Watson (Beaconsfield, London, 2000, touring to Angel Row Gallery, Nottingham, 2001).

Nasreen Mohamedi

01 Nasreen Mohamedi, *Untitled,*
mid-1980s
02–03 Nasreen Mohamedi, Untitled
photographs, *c.* 1975

Overleaf
04–05 Nasreen Mohamedi, *Untitled,*
mid-1980s
06 Nasreen Mohamedi, Untitled
photograph, late 1980s
All images courtesy Altaf Mohamedi

01

03

02

Nasreen Mohamedi

04

05

06

Nasreen Mohamedi

Extracts from Nasreen
Mohamedi's Diaries

These entries reveal Nasreen Mohamedi's struggle to find an equilibrium, both internal and external, which she believed could be found from amidst the conflict and chaos of the surrounding world. inIVA reprinted a selection of the diary entries in *Drawing Space: Contemporary Indian Drawing*, the catalogue to an exhibition of the same name. The entries were first published by the Ashraf Mohamedi Trust in *Nasreen in Retrospect*, 1995.

These entries that we have selected from Mohamedi's diaries provide a unique insight into her paintings, personality and inner conflicts. They reveal the fluctuating nature of her internal states of mind, from loneliness and despair to elation.... Creation, she claimed, must come from within this limitless despair and through this, a state of peace and calm. This desire for balance is also revealed in Mohamedi's fascination with the structural order of shapes that we detect in her frequent references to squares, circles and triangles.

Mohamedi rarely put a month or day to her detailed and intense observations of the world around and inside her that are at times lyrical, at times factual. The dates you see here are, therefore, only approximations. The fact that the events are not tied to a precise moment, combined with the incomplete nature of some of the entries, echoes the fluidity of her life.

3 November 1959
Life is becoming more and more difficult to understand – but one thing is sure – it is less complicated. Difficulties are akin to nature and through understanding of nature, things get solved themselves. Why has mankind always possessed that desire to live?...

Nothingness and again nothingness. Those patterns on the beach. Those little crabs which make those endless patterns. Something like those beautiful draperies and tapestries. To make an effort to do anything seems so futile. Everything in nature is so perfect. To copy is of course out of the question, but

even to create – is it creation? I feel empty and useless. That light on the beach. Those zig-zag designs that waves leave on the sand.

22 May 1960
It is a most important time in my life. The new image for pure rationalism. Pure intellect which has to be separated from emotion – which I just begin to see now. A state beyond pain and pleasure. Again a difficult task begins.

20 September 1964
War continues – I sit here and try and find a unity – not between religions but between people and people.

April 1966, Kihim
...I feel a madness within me. To know that there is no help from without – none whatsoever – is despair. But one must live with this and create from within this. Face each little particle.

18 July 1966, Deolali
Such a feeling of space
Open
Intense green –
Black, strong, gliding wires creating drama
As one moves along
Patterns of grey
Drops intersecting.

17 January 1967, Kihim
Lines, subtle, winding tremors
Orange shapes

Crystal sparks
An illuminated dark expanse
Notes on water
Charcoals
Limitless greys into purples
Weedlike patterns
Changing
Dark sounds.

18 January 1967
Study the texture of each object – the line and form of each.

March 1967
A conflict, an inner conflict which is not to be answered, but to be lived. Strange that this painting of Emile Nolde should correspond with my thoughts. I must learn again and again to discard certain thoughts which are stagnant with stench. Discard and renew a new depth of freshness.

April 1967
Out of these concentrated difficulties, frustrations and despair, one arrives at something very simple. It is also effort and repeated effort.

11 January 1968
Walking among vast spaces – space filled with intricate forms, lines arriving filled with various textures, footsteps inside feet – lines arriving and receding into lost space – the horizons keeping the limitless in limits – all forming a whole.

April 1968
I write with impatience at this stage – where I have slowly and yet today suddenly become aware of a certain strangeness – in my work, in my life. Let me pursue it with a single mindedness.

13 May 1968, Kihim
Lines, circles, dots, traces of texture, beatings on the beach, slow changes in rocks, weaving and polishing of pebbles, each wave a destiny which ends in one breath, a swaying of the palms and in one sway – all, everything. It all denotes change, change, change – nothing repetitive. Everything moving – grains of sands, all change is inevitable – only the grasping of it is as difficult as important. One has to grasp this entirely and wholly – then there is growth, progress – one walks with it whether it is slow or fast – it is then strong. All these lines, circles, dots on the beach are for a few hours – even then changing each moment with the wind and its own durability – to reach further designs and destinies.

5 September 1968
Everything is purified by suffering. To build out textures, the lines, □ squares and △ triangles. All this in a unity – a ○. Then despair through textures of △s □s reaching a dot, the centre of a circle. There is a straight line but one reaches it through the ○.

4 October 1968, Topkapi
...What a restrained quality
A leaf within the abstract – minute
All with their quiet powerful force

Each dot, each line, each curve a direction towards perfection
At times silently engraving upon the page
With a triangle or a rectangle

Tiny tiny letters
A restrained discipline
The Arabic with a squarish strength
Interlacing iron wrought structure
Sometimes a few bold lines to balance with a ○.

28 December 1968
A dark, inked circle within a cross
A line in weaving –
Orange, maroon, red, black.

1 February 1969, Kuwait
There is always chaos and confusion but it is the mind and the will that bring order.

Different levels of depth into paintings. That is what makes life injected with life – these variations, these unknown depths.

13 July 1969, London
When looking at painting
Sculpture or anything
– examine each contour
Each dot, surface.

21 July 1969, London
Examine and re-examine each contour, each dot where rhythm meets in space and continuous charges occur.

16 March 1970
What geometry one finds on the beach.

30 September 1970
Again I am reassured by Kandinsky – the need to take from an outer environment and bring it an inner necessity. I stress on the inner – almost a year ago when I read similar thoughts expressed by Klee (reading with Gita). The world is raging a war from the outside and mine is an inner one. Both are valid and necessary.

Despair after a long period but a kind of despair which is slowly reflected and understood. Not the former kind of total despair.

3 March 1971, Delhi
To grasp one's entire heritage with intuition, vision and wisdom – with a total understanding of the present.

2 July 1972, Kihim
Thought + geometry – geometry + thought
Layers + depths.

Vast space through complexity of thought.

15 August 1972, Baroda
Tones from black to white.
Coloured graphs.

3 October 1972
The comparison between the habitual eye and the scientific eye and the intuitive eye.

01

Drawing Space: Contemporary Indian Drawing

Drawing Space: Contemporary Indian Drawing, curated by Suman Gopinath and Grant Watson, opened in October 2000 in Beaconsfield, London, before touring to Angel Row Gallery, Nottingham in spring 2001. Weaving a thread between the work of three contemporary artists from inIVA – Sheela Gowda, N.S. Harsha and Nasreen Mohamedi – and nineteenth-century Company paintings from the V&A, the exhibition mapped the intimate historical connection between Britain and India.

01 N.S. Harsha, So Much Power in
Bird Shit! 1997–98. Photograph:
Sinisa Savic
02 N.S. Harsha, *Healing Space*,
detail, 2000
03 N.S. Harsha, sketchbook page,
1997–98

Overleaf
04–06 Sheela Gowda, *And Tell Him
of My Pain*, 1998–2000
07 Mausoleum of Humayun, Delhi.
Delhi or Agra, *c*. 1820–22.
V&A Picture Library
08 Mausoleum of Akbar, Sikandra.
Delhi or Agra, *c*. 1815.
V&A Picture Library
09 Nasreen Mohamedi, *Untitled*,
mid-1980s. Courtesy Altaf Mohamedi

02

03

Drawing Space
Contemporary Indian Drawing

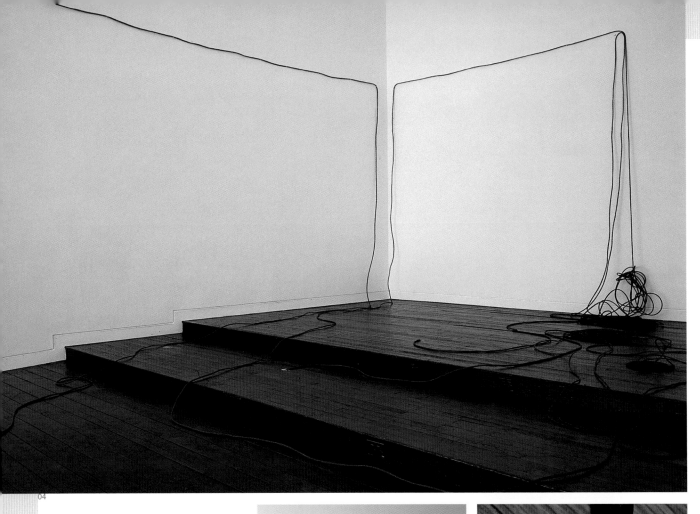

04

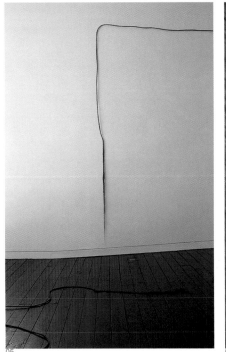

05

06

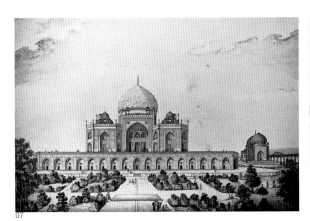

07

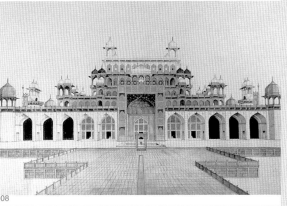

08

09

Strategies of Modernity in Latin America

Andrea Giunta

This text was published in Gerardo Mosquera (ed.), *Beyond the Fantastic: Contemporary Art Criticism from Latin America*, London: inIVA, 1995, an earlier version having first been published in *La Actualidad – Arte e Cultura*, no. 71, Buenos Aires, 1992. Giunta's contribution to the inIVA anthology analyses the tactics that Latin American artists developed to analyse modernism and rebuild it in relation to their experience.

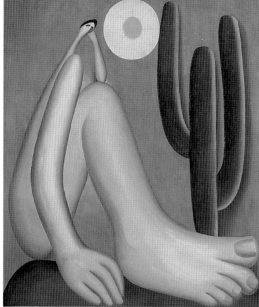

Tarsila do Amaral, *Abaporu*, 1928.
© Guilherme Augusto do Amaral.
Constantini Family Collection,
Museo de Arte Latinoamericano
de Buenos Aires

Tactics and Strategies

To speak of cultural strategies implies a conflict with something diverse and opposed. To develop a strategy it is essential to have previous knowledge of a situation in order to attack it through several tactics. It also implies finding weak spots that suggest ways to subvert an established order. Alternatively, it can be undermined through alliances, counter-discourses, value inversions, appropriations, mixtures, hybridisations, and even the practice of a certain clandestinity, creating a history of schemes and wit. One can borrow in order to develop one's own version, turn it upside down, deform, and selectively and intentionally assimilate.

Modernity in Latin America was a misappropriated and modified project. An educated and travelling intelligentsia built up alliances between a project born in the context of nascent capitalism in the nineteenth century and a discordant periphery. However, they soon realised the contradiction in singing the praises of technology and the machine age in countries where there were few cars (and those were imported) or roads on which to experience the heady excitement of speed.

Borges, Mariátegui and Vallejo all suggested an initial inversion of values. They coincided in criticising the ideology of novelty.[1] Peripheral strategies relativise the absolute truths of dominant discourse (be they of unlimited progress or 'the end of history'). By deconstructing this discourse they can find the relevant parts and rebuild it in relation to a diverse object. Latin American culture has worked in this way since it first gained independence. To formulate strategies and tactics requires an intelligent use of arms and tools, in this case cultural.

The Strategy of Swallowing

Few images are as successful as that of swallowing: eating the white man, devouring and digesting him. That which will nourish is selected and the negative parts are discarded. The swallowing metaphor was radically developed by the Brazilian avant-garde. Marked as an inaugural fact, it was also felt to be the start of a history that even required a new date-system, a chronological mark to vindicate the value of anthropophagy.[2]

The revolt against the past born of the ideology of the new – an uprising marked in Latin America by Futurist discourse and by its iconoclastic choice, which was simultaneously foundational – was mixed with other elements from the very outset. Inaugural utopia arose in Brazil with a local rhythm that sought to establish differences from the beginning....

It was a landscape ripe for Futurism that, in opposition to the substitutional break with the past beloved of the Italian movement, would propose a new image charged with localisms. It would vindicate invention and surprise from a culture that already existed 'in fact'; a complex reality, superimposed and impossible to abandon....

Markets, letters, industrial and telegraph towers, hillsides, fruits, cubes, are all filtered through an aesthetic that mixes Art Deco with Légeresque Cubism; Tarsila do Amaral's landscapes define the new in terms of the different. Nature is hot, rationalised, anthropomorphic and anthropophagite. In *Abaporu*, the whole painting is filled with a man, naked, whose giant size is greater than nature. The anamorphic body extracts its meaning from the land on which it rests.

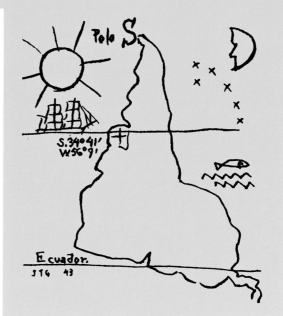

The man-eating man is, for Oswald de Andrade, the Brazilian devourer of cultures, the creator of an existent culture that refounds, through each appropriation, its own culture:

> Tupy, or not Tupy, that is the question.
> Down with all catechisms. And down with the mother of Gracchi.
> The only things that interest me are those that are not mine. The laws of men.
> The laws of the anthropophagite.... Justice became a code of vengeance and Science was transformed into magic.
> Anthropophagy. The permanent transformation of taboo into totem.[3]

The Inverted Map

With the foundation, with Michel Seuphor, of *Cercle et Carré* (1930), Joaquín Torres García had been a protagonist of the avant-garde in Europe. The development of his production connected successively to Mediterranean Classicism, Vibracionismo, Cubism, Fauvism; and the incorporation in his final Paris visit of the Golden Section and of a formal repertoire linked to pre-Columbian cultures had become by 1934 the form of a programme that Torres would redefine on arriving in Montevideo.[4]...

What Torres did not find in the artistic field that he entered on his return he searched for in houses, colours, the air, the great River Plate, the special and different appearance of people (a type based simultaneously on the European, the Indian *mestizo* or the negro).[5] It was a different city in which Torres denied precisely the distinguishing features of modernity visible in the new neighbourhoods, in as much as these traces of modernity were not his own ones. At this point Torres started to use his characteristic method of searching for a synthesis in opposed elements: dynamic syntheses that, in their contradictions, demonstrate the complex mixtures of a culture for which he wants to define a programme that is both sacrificial and integral. Torres's concern is not with written or spoken language but with forms. His gesture takes on a graphic and visual form. To invert the map is a decontextualising and resemanticising operation. It is the inaugural gesture of wanting to establish new parameters, which are now spatial:

> ...*Our North is the South*. There should be no North for us, except in opposition to our South.
> That is why we now turn the map upside down, and now we know what our true position is, and it is not the way the rest of the world would like to have it. From now on, the elongated tip of South America will point insistently at the South, our North. Our compass as well; it will incline irremediably and forever towards the South, towards our pole. When ships sail from here travelling North, they will be *travelling down, not up* as before. Because the North is now below. And as we face our South, the East is to our left.
> This is a necessary rectification; so that now we know where we are.[6]

The act of inversion implies a fundamentally ideological replacing; it marks a new stage, aiming

for independence, for Latin American art. Torres's aesthetic programme, formed in a European context and led on by the interest in the exotic that fed the avant-garde of the central countries, would acquire a new dimension from its confrontation with a diverse reality in which currents of Latin Americanist thought circulated intensely.[7]

Neither Mondrian nor all the theories on geometry and abstraction born in the European context can explain Torres's development in Montevideo. This development is not visible from a reading that interprets him as an epigonal figure. What is more, it was only in Montevideo that Torres could realise his original project. Thus these are the developments that follow a full understanding of his earlier itinerary in Europe and the USA.[8]

While it is true that Torres always expressed his rejection of aestheticism, it was in the country to which he returned that his proposals to integrate art with life from the perspective of a retroactive utopia were received and accepted. It was also in Montevideo that Torres developed the corpus of his theories; it was there that he would launch a monumental didactic programme; and there, finally, that he would give form to his aspirations to create an anonymous, popular, monumental, metaphysical and ritual art.

Torres's intention was foundational. Thus he added a strategy of vacuum to the significant gesture of inverting the map. Considering Uruguay to be lacking in a strong local tradition, he proposed to use the universal tradition of art as a starting point, a constructive tradition to which the 'continental Inca civilisation' also belonged:

...[for] we *rioplatenses*,[9] as regards *local tradition*, or one of our own, [it] is so short as not to warrant discussion. Habits and customs, folklore... should be forgotten before they are remembered....

This is true as regards our immediate tradition because, on the other hand, can we not rely on the *civilisation of our Continent*?

...if the ancient culture of this land can still be valid for us, it is because it is in line with the universal principles. For this reason, these cultures can incorporate themselves into the great tradition of knowledge of all ages.[10]

To not take a line or motif of Inca art, but instead to create with the ruler, with geometric order. The extreme austerity characteristic of Torres's work in the years following his return can be understood as the most radical expression of an art that, overcoming all temptation (pictorial, vanguard, realist), allows him to create an anonymous and monumental art. The abandoning of all sensual elements would become the pictorial expression of that stony and monumental art that was his ultimate aspiration.[11] Torres's utopia, simultaneously retrospective and foundational, synthesised the most extreme aspirations of European modernity. With his return to Montevideo his original ideas would be submitted to a series of inversions that would allow him to reformulate his project and make America the measure of the Universe....

Appropriation of Appropriation
Lam took the forms and structures of Cubism, which had itself appropriated the forms and structures of

primitive art, in a movement that he himself described as intentional:

> Since my stay in Paris I had a fixed idea: to take African art and to make it operate in its own world, in Cuba. I needed to express in a work combative energy, the protest of my ancestors.[12]

However, rather than repeating a form of operation, Lam wanted a rebellion based on a vindication of cultural mixture. This mix has much more to do with his own pictorial formation than with ethnicity. His development also allows one to reconstruct a double itinerary: the consolidation process of the Latin American artistic field and that of the European avant-gardes....

European modernity's appropriation of 'primitive' formal structures as food for a self-centred discourse was imitated and disarticulated as an operative system in Lam's work after his return to Cuba. He made the mechanisms of the centre evident, repeated them and charged them with a new meaning. He fed from their usurped forms. He expressed his 'otherness' in the central discourse so as to insert it, alive, into the universalising discourses of modernity. Thus it was discovered that what, in European discourse, was a horizon of desires or the object of a laboratory experiment, in the Caribbean was the latent everyday, hidden and suppressed since the Conquest and slavery.

Lam, in common with other Latin American intellectuals, managed to establish an undoubtedly privileged position through his cultural travels. This was owing to his coexistence from childhood with America's cultural mix and because he also shared and participated in the European cultural and social laboratory. Lam did not observe the West from outside, he rather recognised himself and learnt. It is all this heritage that allowed him to undertake new researches upon his return. A knowledge of the decontextualising operations of the European avant-gardes allowed him in turn to decontextualise the forms of the avant-garde to charge them with revolutionary and prophetic contents. And not only with the forms, but also with the utopian telos of modernity, allowing him to conceive his programme as the start of a different time....

Lam is a protagonist of the modern construction of Afro-American visuality. It is a construction in which, from the baroque aspects of Cubism, he discovered the sensual outlines of a nature that is simultaneously vegetable and religious. He wrote his own modern project taking advantage of the complex receptive constitution of European modernity and feeding it, in turn, with new components. Simultaneously, he interpreted his rereading as a cut: in America, culture is both summary and project; it gives new forms from difference....

To be Modern in America
The strategies used by Torres García, Lam, Tarsila do Amaral or the Andrades to meditate on the cultural map of America were born of a kaleidoscopic game. Europe and America were reconfigured from shattered images, the fragments of which declared a battle to impose a new order. Since the sixteenth century America had been an active element in the construction of European modernity: the 'encounter of two worlds'

also forced a change in the conceptualisation of the world.[13] American modernity in turn absorbed differential characteristics that are not fully described by notions of copy, addition or epigonal development.

In the early twentieth century cultural proposals were born of strategies that implied, above all, an ideological inversion of values. To devour, mix, appropriate and reappropriate, invert, fragment and join, take central discourse, penetrate and cut through it until it becomes a useful tool for the search for and creation (plagued with achievements and failures) of our own subversive discourse: these are the exploratory ways in which some enlightened artists created their visual constructions as part of the programme of a liberational culture.

Notes

1 Borges, influenced by Expressionism during his stay in Europe (1914–21), discovered his natal city of Buenos Aires when he returned. See his *Fervor de Buenos Aires* (1923), *Luna de enfrente* (1925), *Cuaderno de San Martín* (1929) and his collection of essays *Evaristo Carriego*. In the 1930s César Vallejo also launched his attack on the avant-garde: *El tungsteno* (1931) and *España, aparta de mí ese cáliz* (1939) are in a very different vein from his most famous book, *Trilce* (1922). As a compromise, Mariátegui also fought for an avant-garde that was not limited to formal issues. See Jorge Schwartz, *Las vanguardias latinoamericanas: Textos programáticos y críticos*, Madrid: Cátedra, 1991.

2 Oswald de Andrade's *Anthropophagite Manifesto* is dated at the end 'Piratininga, the year 374 after the swallowing of Bishop Sardinha'. The manifesto was published in 1928.

3 Oswald de Andrade, 'Anthropophagite Manifesto', in Dawn Ades, *Art in Latin America*, London: South Bank Centre, 1989, p. 312.

4 See Margit Rowell, 'Ordre i simbol: les fonts europées i americanes del constructivisme de Torres García', in *Torres García: estructura-dibuix-simbol*, exh. cat., Barcelona: Fundació Joan Miró, 1986, pp. 15–16. The incidence and the protagonism of this culture in Torres García's work has been evaluated in different ways. Juan Fló says: 'The influence of pre-Columbian art in Torres García is irrelevant. The Indoamerican art, as all primitive arts and that of the main archaist cultures, are of interest to him if they are part of the art paradigm with an aesthetic sense, but not linked with an imitative representation.' See Juan Fló, *Torres García en (y desde) Montevideo*, Montevideo: Arca, 1991, p. 48. I agree with this idea. However, I think Torres García had an American programme. See Torres García, *Metafísica de la prehistoria indoamericana*, Montevideo: Asociación Arte Constructivo, 1939, and many chapters of the *Universalismo Constructivo: Contribución a la unificación del arte y la cultura de América* (Buenos Aires: Poseidón, 1944).

5 An analysis of the different tendencies in this field can be found in an unpublished lecture by Gabriel Peluffo Linari, 'Regionalismo cultural y la vanguardia: el Taller Torres García', presented in Austin, Texas, 1991.

6 Torres García, *The School of the South*, 1935. Reproduced in Mari Carmen Ramírez (ed.), *El Taller Torres-García. The School of the South and its Legacy*, Austin: University of Texas Press, 1992, p. 53.

7 The studies of the American Constructivist tradition started by Torres García in 1938 were developed by the Asociación Arte Constructivo. This work was continued in the Taller Torres García.

8 Juan Fló has written: 'Torres's Montevideo period is not only significant in itself, but also because it provides us with some important keys with which to understand his whole trajectory.' See J. Fló, op. cit., p. 9.

9 *Rioplatense*: literally 'of the River Plate', adjective used to characterise the shared culture of Buenos Aires and Montevideo [translator's note].

10 Torres García, *Metafísica de la prehistoria indoamericana*, Montevideo: Asociación de Arte Constructivo, 1939. Original emphases.

11 Fló, op. cit., pp. 28–29.

12 In Antonio Núñez Jiménez, *Wilfredo Lam*, Havana: Editorial Letras Cubanas, 1982, p. 173.

13 See Aníbal Quijano, 'Modernidad, identidad y utopía en América Latina', in *AA.VV. Imágenes desconocidas*, Buenos Aires: CLACSO, 1988, pp. 17–24.

Timeline

inIVA's roots lie in Britain's first diaspora artists, who came to Britain before and after the Second World War to study and develop their artistic practice. Artists such as Ronald Moody, F.N. Souza, Uzo Egonu, Ivan Peiris, Aubrey Williams and Frank Bowling brought an international worldview to bear on the British art scene, making a significant impact upon it. They became an integral part of the modern movement, although subsequently they have largely been written out of that history. Some, like David Medalla and Rasheed Araeen, went on in the 1960s and 1970s, to establish new organisational ventures, galleries and publications, which had a profound impact on the local art scene.

In the 1970s and 1980s, an explosion of new work in the visual arts failed to win the visibility or attention it deserved in British mainstream arts organisations. This stimulated a vigorous campaign around questions of access and a number of local and community arts initiatives followed. Artists from the postcolonial world, such as Sunil Gupta, Lubaina Himid and Gavin Jantjes and a second generation of artists, born and brought up in the UK (among them David A. Bailey, Eddie Chambers, Donald Rodney, Keith Piper and Shaheen Merali to name only a few) were compelled to organise themselves both artistically and politically. These artists frequently took on the role of 'artist-entrepreneurs', organising exhibitions, setting up initiatives and launching ventures which challenged mainstream galleries and institutions to recognise artists from diverse cultural backgrounds. They pushed the envelope of established definitions of British and international art to include artists hitherto marginalised by the mainstream. These initiatives took place in an

environment shaped intellectually by critical ideas and debates that emerged uniquely within the context of the postcolonial experience in Britain, led by figures such as Homi Bhabha, Paul Gilroy, Stuart Hall, Sarat Maharaj and Kobena Mercer.

The Greater London Council (GLC) gave positive support and encouragement to these initiatives and, when it was abolished in 1986, devolved a sum of money to fund the visual arts component of a London-based national black arts centre. This project stalled for a variety of reasons and, against that background, the Arts Council of Great Britain (ACGB), who held the funds in trust, initiated discussions in the visual arts sector to see how the aspirations for a centre for black visual arts might best be taken forward. These discussions were led by Professor Christopher Frayling (Arts Council member and Visual Arts Panel Chair), Sandy Nairne (Director of Visual Arts), Sarah Wason (Senior Visual Arts Officer) with the advice of Gavin Jantjes (Arts Council member), David A. Bailey (Arts Projects Chair), Rita Keegan (Art Panel member) and members of Art Panel. In 1991, the Arts Council initiated a consultation with individuals, organisations in the visual arts and cultural diversity, museums, galleries, research and education sectors across the UK led by Gavin Jantjes, with the assistance of David Powell and Les Johnson. The most influential element of this consultation period was the focus group meetings, which looked at areas such as exhibitions and publication developments, organisational structures and the connection with international developments in the visual arts. The project team made a number of international visits and consulted a wide range of internationally based artists and others, connecting this new project with potential partners in Europe and elsewhere, and looking for good practice to emulate. It was during this process that a 'new internationalism' emerged as an important concept which needed to be explored in the new arts organisation.

A steering group determined that part of the action research programme to establish inIVA should be driven forward by black and Asian visual artists and curators already active in the field. This allowed the proposed new Institute time and space to define its terms of engagement with the visual arts world and wider communities. It ensured that the debate about new internationalism and the overall direction of the project would be informed by work already being made and presented alongside the development of the agency itself. It also gave the national and international visual art sectors a concrete sense of what this new visual arts project would be doing, especially in the arenas of exhibitions and publications. As a result, three franchises were established and funded. Two were to develop and curate an exhibitions programme, run by Sunil Gupta, working through his visual arts and photographic agency, the Organisation of Visual Arts (OVA), and Eddie Chambers, the initiator of the African and Asian Visual Artists' Archive (Aavaa), while the third – the publications franchise – was let to Rasheed Araeen under the aegis of Kala Press. A major international conference was proposed to explore questions of internationalism and globalisation, to articulate the creative and organisational basis for inIVA, and to launch the Institute into the public sphere.

As the direction of the project became more settled, a project steering group was set up, in effect to act as a shadow board. It included Chris Dercon, Raj Isar, Melissa Llewellyn Davies, David A. Bailey, Christopher Frayling, supported by ACGB and London Arts Board officers, including Majorie Allthorpe-Guyton, Jeremy Theophilus, John Kieffer and Amanda King. It was charged with overseeing the setting up of an independent company, looking for a Chair, the recruitment of board members, undertaking an international search for the first Director and previewing the preparations for the launch event.

By 1994, the board members were appointed, Professor Stuart Hall was appointed as Chair and Gilane Tawadros was appointed the Director. In April 1994, a two-day conference, conceived and developed by Gavin Jantjes and entitled 'A New Internationalism' was held at the Tate Gallery, London. Speakers at the conference included: Rasheed Araeen, Gordon Bennett, Jimmie Durham, Hou Hanru, Hal Foster, Raiji Kuroda, Sarat Maharaj, Gerardo Mosquera, Everlyn Nicodemus, Olu Oguibe, Guillermo Santamarina, Elisabeth Sussman, Gilane Tawadros, Fred Wilson and Judith Wilson. The conference provided the occasion for the formal launch of the organisation which subsequently became known as the Institute of International Visual Arts (inIVA).

Timeline 1994–2004
Compiled by Ariede Migliavacca

1994

inIVA (Institute of International Visual Arts) is established with support from the Arts Council of Great Britain and London Arts to promote the work of artists from culturally diverse backgrounds.

The exhibition *Wall and Case Works* celebrates the opening of inIVA's premises including key works by contemporary visual artists from different generations and cultural backgrounds. Curator: John Gill. Artists: Rasheed Araeen, Uzo Egonu, Balraj Khanna, Chris Ofili, Mitra Tabrizian, Aubrey Williams, Zarina Bhimji, Sonia Boyce, Hew Locke, Maria Mahr.

Michael Platt: Struggle to the One Bright Day, an inIVA franchise exhibition organised by Eddie Chambers in conjunction with City Gallery, Leicester. Tours Northern Centre for Contemporary Arts, Sunderland, and Oldham Art Gallery. Using press and media reports as source material, Platt's work focuses on the aspirations and anxieties of America's inner city children. Accompanied by a catalogue, with an essay by Allison Gamble.

Disrupted Borders: An Intervention in Definitions of Boundaries, an inIVA franchise exhibition in collaboration with Arnolfini, Bristol, and the Photographers' Gallery, London, is held at the Canadian Museum of Contemporary Photography, Ottawa. It explores the challenges offered by 'the others' of Western cultures: immigrants, women, the so-called underclass, the 'queer' and the disabled. Curator: Sunil Gupta. Accompanied by a book of the same title, edited by Sunil Gupta and published by Rivers Oram Press.

These Colours Run, Lesley Sanderson's first solo exhibition, organised by Eddie Chambers and Wrexham Library Arts Centre, as an inIVA franchise. Tours Sheffield's Mappin Art Gallery and Leeds City Art Gallery. Malaysian-born, Sanderson uses images associated with traditional ideas of the 'exotic' and 'oriental' to question the way different cultures are represented and stereotypes perpetuated. The accompanying catalogue includes essays by Jane Beckett and Gilane Tawadros, with introduction by Martin Barlow and Eddie Chambers.

Kala Press in association with inIVA publishes *Global Visions:*

Towards a New Internationalism in the Visual Arts, the collected papers of the inIVA symposium 'A New Internationalism', held at the Tate Gallery in April. Edited by Jean Fisher. Contributors: Rasheed Araeen, Gordon Bennett, Jimmie Durham, Hal Foster, Hou Hanru, Gavin Jantjes, Geeta Kapur, Raiji Kuroda, Sarat Maharaj, Gerardo Mosquera, Sandy Nairne, Everlyn Nicodemus, Olu Oguibe, Guillermo Santamarina, Elisabeth Sussman, Gilane Tawadros, Fred Wilson, Judith Wilson.

Over a period of five years, inIVA and the Royal College of Art present the 'International Curator Lectures' as part of the RCA's 'Visual Arts Administration: Curating Contemporary Visual Art' course. 'Curating from the South: Ante America and Other Exhibition Projects', by Gerardo Mosquera, is the first lecture in the series.

inIVA collaborates with the National Maritime Museum on the panel discussion 'Trade Winds' involving curators from the UK and the Netherlands.

The exhibition *Time Machine: Ancient Egypt and Contemporary Art*, organised by the British Museum in collaboration with inIVA, opens at the British Museum. Contesting the idea that the British Museum and its ancient Egyptian artefacts are stagnant remnants from the past, twelve artists create new pieces achieving a rare juxtaposition of ancient and contemporary art. Curator: James Putnam. Artists: Stephen Cox, Andy Goldsworthy, David Hiscock, Liliane Karnouk, Rita Keegan, Jiri Kolár, Alexander Mihaylovich, Igor Mitoraj, Marc Quinn, Peter Randall-Page, Martin Riches, Kate Whiteford. Catalogue edited by James Putnam and W. Vivian Davies, published by inIVA and the British Museum.

To complement *Tierra de Tempestades [Land of Tempests]*, a touring exhibition of contemporary art from Nicaragua, Guatemala and El Salvador organised by the Harris Museum, Preston, inIVA hosts 'Anglo-American Dialogues'. This is a two-part discussion featuring both the exhibiting artists and artists from the UK. Speakers include: Dawn Ades, Aparicio Arthola, Moisés Barrios, Antonio Bonilla, Alfredo Caballero, Erwin Guillermo, David Ocón, Luis Gonzalez Palma, Fernando Palma Rodriguez, Ana Placencia, Raúl Quintanilla, Isabel Ruiz.

1995

The Mondrian Fan Club, of which David Medalla is president, presents *The Secret History of the Mondrian Fan Club II, Mondrian in London* at Medalla's studio, in collaboration with Pulsynetic. The exhibition consists of a body of kinetic sculptures and installations alongside a series of events and performances by the artist, who is exploring the Dutch modernist's experiences in London between 1938 and 1940. Kala Press publishes *Exploding Galaxies: The Art of David Medalla*, by Guy Brett, with essays by Dore Ashton and Yve-Alain Bois (inIVA franchise).

Kala Press publishes the monograph *Chila Kumari Burman: Beyond Two Cultures*, by Lynda Nead (inIVA franchise). Born in Liverpool within a family who had settled in post-war Britain from India, Burman uses her own image in an ever-expanding repertoire of female identities and complements her artwork with polemical texts.

inIVA collaborates with the Whitechapel Art Gallery on a discussion of new Cuban art entitled 'Art and Post Utopia'.

'Hogarth', the first discussion in the 'Essential Guide to British Painting' series, is held at the Tate Gallery, London, with speakers Nick Dear, Partha Mitter, Roy Porter, and John Styles. The second discussion, 'Turner', also at the Tate Gallery, features Paul Gilroy, Gordon Parks, and Eric Rosenberg.

The first in the 'Collector's Eye' series of lectures (organised in collaboration with Autograph) looks at the work of Harlem Renaissance photographer, James VanDerZee through the eyes of public and private collectors.

Held in a vacant shop at 28 Fouberts Place, London, and touring to Oldham Art Gallery, the exhibition *Exotic Excursions* presents five young artists who explore the experience of travel through video, installation and photographic work. Curators: Clare Cumberlidge and Virginia Nimarkoh. Artists: Michael Curran, Clair Joy, Tatsuo Majima, Fernando Palma Rodriguez, Kate Smith. Catalogue edited by Clare Cumberlidge and Virginia Nimarkoh.

In collaboration with Artrage Intercultural Training Department, inIVA hosts the 'National Visual Artists Audit Consultative Seminar',

a major research project into the practices, needs and concerns of visual artists from different cultures throughout the UK. Participants: Faisal Abdu'Allah, Rita Keegan, Carole Morrison, invited artists, arts organisations and funding bodies.

Sonia Boyce, commissioned by inIVA to work with Brighton Museum's collection of non-Western art, produces the installation and book *Peep*, which explores themes of observation and identification with an 'ancestral' past. Contributors: Anthony Shelton, Gilane Tawadros.

The seminar 'Sweet Oblivion: Memory and the Museum' at the Institute of Contemporary Arts, London, discusses the exclusionary world of art and new models of curating. It also explores the radical and culturally diverse projects and policies effected by exhibition spaces in the late 1950s and 1960s and why these are being 'forgotten' or obscured in the 1990s. Speakers: David Crawforth, Clare Cumberlidge, Emma Dexter, Siraj Izhar, Virginia Nimarkoh, Nikos Papastergiadis, John Russell, Naomi Siderfin.

To complement the opening of the Oxford Museum of Modern Art's exhibition *Art from Argentina 1920–1994* at the Royal College of Art, the distinguished Argentine artist Gyula Kosice talks about his life and work to Gabriel Pérez Barreiro.

As part of the Institute of Contemporary Art's season *Mirage: Enigmas of Race, Difference and Desire*, inIVA and the ICA present multimedia work by eight artists in an exhibition that focuses on the work of Frantz Fanon. Tours to Bonnington Gallery, Nottingham. Curator: David A. Bailey. Artists: Lyle Ashton Harris, Black Audio Film Collective, Sonia Boyce, Renée Green, Isaac Julien, Glenn Ligon, Marc Latamie, Steve McQueen. A catalogue published by the ICA and inIVA includes essays by David A. Bailey, Kobena Mercer, and Catherine Ugwu.

Signals magazine, formerly the international forum for European and Latin American artists, is published by inIVA in a facsimile edition of volumes 1 and 2, 1964–1966. Edited by David Medalla, the boxed edition comes complete with a comprehensive index.

Thelma Golden presents 'Black Male: Before and After' as part of the 'International Curator Lectures' at the Royal College of Art.

inIVA establishes a specialist Library. Its unique collection of books and periodicals reflects the remit of the Institute and fills a significant gap in the international literature of the contemporary visual arts and cultural studies.

In collaboration with Digital Diaspora, inIVA hosts the conference 'Forty Acres and a Microchip' at the Institute of Contemporary Arts, London, debating issues of race, gender, cultural diversity and new technology. Participants: Mogniss Addallah, Ricky Adar, Carmen Ashurst, Sutapa Biswas, Marc Boothe, Octavia Butler, Janice Cheddie, Ben Caldwell, Julie Dash, Samuel R. Delany, Ekow Eshun, Conor Foley, Paul Gilroy, Stuart Hall, Roshini Kempadoo, Shaheen Merali, Paul Miller, Eddy C. Mupeso, Mudimo Okondo, Keith Piper, Derek Richards, Tricia Rose, Estella Rushaija, Mark Sealy, Nainan Shah, Gary Stewart, Greg Tate, Floyd Webb, Trix Worrell, Steve Wright, Lola Young.

The New Measurement Group's *Analysis Series* is the first of a series of exhibitions held at inIVA's library. Artists: Chen Shaoping, Gu Dexin, Wang Luyan. Curator: Hou Hanru.

inIVA organises 'Soap Box 1: Hair Today', a one-day seminar to explore and discuss issues surrounding the politics of hair. Speakers: Rita Keegan, Akure Wall and Roger Robinson.

The exhibition *Boxer* is produced in collaboration with Walsall Museum & Art Gallery. Artists use a variety of media to challenge the image and status of boxers in the context of race, masculinity and eroticism. Curator: John Gill. Artists: The Douglas Brothers, Andrew Heard, Glenn Ligon, Kurt Marcus, Jane Mulfinger and Graham Budgett, Keith Piper, Ingrid Pollard, Bruce Weber. Tour: Oldham Art Gallery; Aspex Gallery Portsmouth; Centre of Contemporary Art Glasgow.

inIVA produces two education packs for secondary schools. Focusing on British artists past and present, *Portraiture* and *Landscape* explore overlapping themes that introduce students and teachers to the work of contemporary British artists from a plurality of cultural backgrounds. *Portraiture* addresses issues of masking and constructions of 'self' and 'other' through the works of Hogarth and contemporary artists such as Faisal Abd'Allah and Chila Kumari Burman. *Landscape* is

discussed in terms of national identity and the ways in which it evokes memories of travel and conquest as well as fears and desires, through works by Constable, Mona Hatoum, Rasheed Araeen, Shaheen Merali, Vong Phaophanit and Ingrid Pollard, among others. Compiled and written by Rohini Malik.

Eddie Chambers is curator in residence at University of Sussex, Brighton. Students work with him on the development of exhibition ideas to be realised in the South East region.

Sources education pack is published on the occasion of the exhibition *Seven Stories about Modern Art in Africa* at the Whitechapel Art Gallery, London. It attempts to redress the lack of critical discourse relating to contemporary art made by African artists. Essay and slide notes by Rohini Malik. Bibliography by Debbie Smith.

inIVA publishes *Beyond the Fantastic: Contemporary Art Criticism from Latin America*, bringing together a selection of essays on the visual arts in Latin America. Edited by Gerardo Mosquera in association with Oriana Baddeley, the book provides an invaluable context for viewing contemporary Latin American art and includes contributions from leading critics and art historians: Mónica Amor, Pierre E. Bocquet, Gustavo Buntinx, Luis Camnitzer, Néstor Gárcia Canclini, Ticio Escobar, Andrea Giunta, Guillermo Gómez-Peña, Paulo Herkenhoff, Mirko Lauer, Gerardo Mosquera, Celeste Olalquiaga, Gabriel Peluffo Linari, Carolina Ponce de Léon, Mari-Carmen Ramírez, Nelly Richard, Tomás Ybarra-Frausto, George Yúdice.

In association with Norwich Gallery and Norwich School of Art and Design, inIVA presents *Uzo Egonu: Past and Present in the Diaspora*, an exhibition of paintings and works on paper by the acclaimed Nigerian-born artist. Tour: Maidstone Gallery Library, 1996, and Oldham Art Gallery, 1997. A monograph of the same title by Olu Oguibe is previously published by Kala Press as an inIVA franchise.

The Contemporary Chinese Artists Archive, curated and edited by Hou Hanru, and the Contemporary Nigerian and South African Artists Archive, curated by Everlyn Nicodemus and Kristian Romare, are made available for consultation in the library.

To coincide with the exhibition *Journeys West*, inIVA presents the 'Journeys West' conference in collaboration with the Chinese Art Centre, Manchester. It takes place at The Minories, Colchester and explores issues affecting contemporary artists of Chinese descent living and working in the UK and Europe.

inIVA launches the *Artist-in-Residence* programme, an experience to enable the artists to pursue their creative work and at the same time encourage dialogue and exchange between artists from different cultures. In collaboration with UNESCO's International Fund for the Promotion of Culture and Gasworks Artists' Studio, the first residency offers artists from Cuba and Africa an opportunity to work and exhibit in the UK. Esterio Segura Mora (Cuba) and Frederick Omega Ludenyi (Kenya) spend three months at Gasworks, their residency culminating in the exhibition *Bird and Fish: In the Freezer*.

'Wyndham Lewis', the third discussion in the 'Essential Guide to British Painting' series, is held at the Imperial War Museum, London. Speakers: Paul Edwards, Deyan Sudjic, Lisa Tickner.

The second lecture in the 'Collector's Eye' series includes the artists Renée Green and Steve McQueen.

1996

In collaboration with inIVA, the Museum of Modern Art, Oxford hosts a residency for Heri Dono, one of Indonesia's most established installation and performance artists. During the residency, Dono creates new work and performances and his catalogue *Heri Dono: Blooming in Arms* is published. It includes texts by the artist, David Elliott and Gilane Tawadros and an interview by Tim Martin.

Albert Chong presents a talk at inIVA, in parallel with the exhibition *New World Imagery: Jamaican Art* at the Hayward Gallery.

The 'Aubrey Williams Seminar' takes place at the October Gallery. Speakers: Rasheed Araeen, Wilson Harris, Stuart Hall, David Mellor, Anne Walmsley.

Peter Suchin is critic in residence at University of Northumbria at Newcastle. The residency provides a critical framework for assessing and

disseminating visual arts events and activities organised as part of the Year of Visual Arts in the northern region.

inIVA launches its *Artists-in-Research* programme, the first of its kind, enabling artists to undertake paid research to create artworks in industrial settings and forge informal links with employees.

Edwina Fitzpatrick is artist in research at Ellis Everard (UK) Ltd, Phillips Petroleum and Tioxide Europe, Cleveland. Her work *Trust* is the second of a series of exhibitions held at inIVA's library.

Indika Perera is artist in research at Ordnance Survey, Southampton. His work *Which Way Up?* is the third of a series of exhibitions held at inIVA's library.

The exhibition *Map* presents *Swallowing Geography*, a collaboration between visual artist Jo Stockham and performance artist Deborah Levy. Also sited at Beaconsfield, the exhibition *Maps Elsewhere* features works on the themes of maps and mapping by the above collaborators and the commissioned artists Chris Ofili, Alistair Raphael and Anne Tallentire. The book *Map* is published on the occasion of the exhibition, featuring 55 artists and writers, including: Gordon Bennett, Joseph Beuys, Zarina Bhimji, Andre Brink, Carlos Capelán, Bruce Chatwin, Carl Cheng, Elena del Rivero, Rita Donagh, Stefan Gec, Guillermo Gómez-Peña, Johnny Gordon Downs, Mona Hatoum, Wilson Harris, Susan Hiller, Gavin Jantjes, Guillermo Kuitca, Alistair Maclennan, Sarat Maharaj, László Moholy-Nagy, Piet Mondrian, Keith Piper, Edward W. Said, Bruno Schulz, Joaquín Torres García. A series of lectures by Steve Pile, Dunne + Raby, Keith Khan, Alexa Wright and Nikos Papastergiadis complements the exhibitions.

inIVA publishes *Familiars – Hamad Butt* in collaboration with the John Hansard Gallery, Southampton. This posthumous artist's book contains images and texts by the artist alongside essays by Sarat Maharaj and Stephen Foster. Edited by Stephen Foster and Gilane Tawadros.

Huang Yong Ping presents an illustrated talk at inIVA about his work, discussing the resistance to historical and contemporary totalitarian authority in China and the Chinese avant-garde movement's

struggle for freedom of expression over the last fifteen years. Translator: Hou Hanru.

The Fact of Blackness: Frantz Fanon and Visual Representation is published by the ICA, London, in association with inIVA and Bay Press, Seattle. This collection of texts and dialogues about Frantz Fanon's ideas originates from the symposium held during the season *Mirage: Enigmas of Race, Difference and Desire* (ICA, London, 1995). Edited by Alan Read. Contributors: Martina Attille, Homi K. Bhabha, Renée Green, Stuart Hall, Lyle Ashton Harris, bell hooks, Isaac Julien, Marc Latamie, Steve McQueen, Kobena Mercer, Mark Nash, Raoul Peck, Alan Read, Ntozake Shange, Gilane Tawadros, Françoise Vergès, Lola Young.

The 'Imagined Communities' conference takes place at John Hansard Gallery, Southampton. A collaboration between inIVA and John Hansard Gallery, the conference brings together distinguished speakers from a number of disciplines and countries to discuss issues relating to definitions of artist, community and nation. Speakers: Graham Crow, Simon Edge, Richard Hylton, Doreen Massey, Lynda Morris, Tim Rollins, Nikos Papastergiadis, Yinka Shonibare.

Comprising recent work by thirteen artists from Argentina, Britain, Colombia and Mexico, *Offside! Contemporary Artists and Football* is launched at Manchester City Art Galleries. Using photography, video, painting and installation, the artists reference the imagery and text of football to explore the cultural environment of the game. Curator: John Gill. Artists: Adam Beebee, Roderick Buchanan, Freddy Contreras, Rosana Fuertes, Lucy Gunning, Crispin Jones, Gabriel Kuri, Martin Vincent and David Mackintosh, Simon Patterson, Natalie Turner, Mark Wallinger, Nick Waplington. Tour: Northern Gallery for Contemporary Art, City Library and Arts Centre, Sunderland, and Firstsite, Colchester. Catalogue of the same title published by inIVA and Manchester City Art Galleries includes introduction by John Gill and contributions from Simon Kuper and Richard Williams.

Recordings: A Select Bibliography of Contemporary African, Afro-Caribbean and Asian British Art is co-published with Chelsea College of Art and Design. The bibliography

aims to reflect the diversity of black British visual practice ranging from painting to film to performance art. Compiled and written by Melanie Keen and Liz Ward.

Edited by David Chandler, John Gill, Tania Guha and Gilane Tawadros, *Boxer: An Anthology of Writings on Boxing and Visual Arts Practice* is published to develop issues raised by the exhibition. Contributors: Roger Lloyd Conover, Jean Fisher, Jennifer Hargreaves, Sarah Hyde, Nick James, Ian Jeffrey, David Alan Mellor, Joyce Carol Oates, Keith Piper, Marcia Pointon.

The large-scale exhibition *The Visible and the Invisible: Re-presenting the Body in Contemporary Art and Society* takes place in a number of sites in the Euston area of London and showcases work by fourteen international artists, not previously seen in the UK. Curators: Zoe Shearman and Tom Trevor. Artists: Sutapa Biswas, Louise Bourgeois, Tania Bruguera, Nancy Burson and David Kramlich, Maureen Connor, Brian Jenkins, Bruce Nauman, Virginia Nimarkoh, Yoko Ono, Jayne Parker, Donald Rodney, Doris Salcedo, Louise K.Wilson. *The Visible and the Invisible Walks* provide the opportunity for artists Sutapa Biswas, Edwina Fitzpatrick, Jefford Horrigan, Alistair Raphael, Jo Stockham and Alexa Wright to give personal interpretations of the works for the duration of the exhibition. In addition, seven young artists are on-site every day to discuss informally the site-specific works in the exhibition: Rebecca Geldard, Julia Rees, Laurraine Zialor, David Selden, Brett Dee, Liz Purchase, Michelle Lewis-King. A resource pack is made available to secondary school teachers (key stages 3 and 4) which explores different approaches to viewing the exhibition.

inIVA launches its website inIVA OnLine (www.iniva.org).

inIVA launches its X-Space Commissions, a series of commissions for artists to work with multimedia designers for the first time to create digital artworks for X-Space, inIVA's virtual gallery.

Simon Tegala creates the digital artwork *Fustigator* for X-Space. Production: Charmaine Watkiss and Stacey Zeecharan.

Indika Perera creates *Drawing Machine* for X-Space. Production: Charmaine Watkiss.

The three one-day seminars 'Frequencies: Investigations into Culture, History and Technology' are held at the School of Oriental and African Studies, University of London. The series seeks to expand the debate on issues of language, space and technology in relation to the internet. Seminar 1: 'Translating Technologies', chaired by Lola Young, November 1996. Participants: Takahiko Iimura, Olu Oguibe, Françoise Vergès. Seminar 2: 'Object Lessons', January 1997. Participants: Dunne + Raby, Marco Susani, Theodore Zeldin. Seminar 3: 'Bandwidths', March 1997. Participants: Susan Hiller, Gustav Metzger, Denise Robinson, Anne Mie Van Kerckhoven.

1997

inIVA launches its *Schools Programme* at Acland Burghley School in Camden. Over a period of five years, different artists work with children at the school across various subjects in the curriculum. The project involves children in the artistic process as a critical tool for learning about themselves and the world around them.

Fernando Palma Rodriguez forges links between the science and the art departments at Acland Burghley School. Collaborations with students from Years 7 and 8 produce *Four Nomadic Warriors of the Nomadic Engineer People*, which is staged as a performance at inIVA.

The artist Sonia Boyce is appointed to the position of Research Fellow at the University of Manchester. The 18-month residency, based in the Department of Art History, provides the opportunity for Boyce to develop her artistic practice within a cross-disciplinary context. An inIVA collaboration with North West Arts, University of Manchester and Cornerhouse. Her exhibition *Performance* is held at Cornerhouse. *Sonia Boyce: Speaking in Tongues*, by Gilane Tawadros, is published by Kala Press.

'Edward Burne-Jones', the fourth discussion in the 'Essential Guide to British Painting' series, is held at Southampton City Art Gallery. Speakers: Anne Anderson, Sonia Boyce, David Dibosa, Caroline Dakers.

Parisien(ne)s is held at Camden Arts Centre. The artists in the exhibition, who live and work in Paris but originate from different

countries, explore ideas of location and dislocation within and across the boundaries of the European metropolis. Curator: Hou Hanru. Artists: Absalon, Chohreh Feyzdjou, Thomas Hirschhorn, Tiina Ketara, Huang Yong Ping, Sarkis, Tsuneko Taniuchi, Shen Yuan, Chen Zhen. A catalogue co-published with Camden Arts Centre includes an essay by Hou Hanru.

Nicky Hirst spends one month as artist in research with the architectural practice Stillman-Field Partnership, London. Through access to the practice's library and staff, the artist becomes interested in instinctual and responsive architecture, 'architecture without architects'. *Perforated Observations*, a series of drawings, is produced at the end of the residency, which culminates in an exhibition at inIVA's library.

Louise K. Wilson is artist in research at The Science Museum, London, researching material from the Exploration of Space gallery and the Museum's library. She produces three pieces that explore cultural perceptions of space as an arena for evoking both nostalgia and dread. *Oneironaut ©*, *Enactment* and *Capsule* are exhibited in inIVA's library.

Within the UNESCO-Aschberg Bursaries for Artists programme, Subodh Gupta and I. Jayachandran are selected to undertake residencies at Gasworks Artists' Studio. The artists, who are both from India, develop new work culminating in an exhibition at Gasworks.

Ivo Mesquita presents 'Tourism, Multiculturalism and Art from Latin America' as part of the 'International Curator Lectures' at the Royal College of Art.

inIVA launches *Annotations*, a series of affordable and accessible publications that document and collate writings, artworks, debates and residencies that take place in a variety of sites. *Mixed Belongings and Unspecified Destinations*, the first in the series and published in association with John Hansard Gallery, Southampton, brings together the papers delivered during the 1996 conference 'Imagined Communities' held at John Hansard Gallery.

Geeta Kapur presents 'What's New in Indian Art: Canons, Commodification and Artists on the Edge' as part of the International

Curator Lectures' at the Royal College of Art.

inIVA invites four artists – Victor Grippo, Mona Hatoum, David Medalla and Carl Cheng – to make new work and participate in *A Quality of Light*, a major regional curatorial initiative presenting newly commissioned work by fourteen international artists in a range of gallery and public sites throughout the Penwith Peninsula, Cornwall. The title and theme of the project aims to connect the strong artistic tradition of Cornwall, through the St Ives School, with contemporary ideas and practices, linking the regional and the international.

New commissions by Avtarjeet Dhanjal and Zarina Bhimji are exhibited at Cartwright Hall, Bradford.

The first publication on the work of *Phillip Lai* is published to coincide with an exhibition of his work at The Showroom, London. It includes an introductory essay by Francis McKee and an interview between the artist and Karina Daskalov. Copublished by inIVA and The Showroom.

The seminar 'Soap Box 2: World 4' takes place at inIVA. This is a discussion and debate based on language and terminology and its influence on perceptions of self, European hegemony and future definitions of the world in relation to visual arts. Speakers: Javier Flores-Blanquet, Pascal Michel Dubois, Denzil Everett, Keiko Isutsumi and Michelle Lewis.

The illustrated broadsheet *inIVA Review* is published to promote the work of international artists and act as a discursive space of reflection on the Institute's programme of events to date. Contributors: Lea Andrews, Sonia Boyce, Hamad Butt, David Chandler, Caroline Collier, Avtarjeet Dhanjal, Wilson Harris, Richard Hylton, Geeta Kapur, Sarat Maharaj, Rohini Malik, Kobena Mercer, Virginia Nimarkoh, Steve Ouditt, Nikos Papastergiadis, Indika Perera, Keith Piper, Navin Rawanchaikul, Simon Tegala, Aubrey Williams, Huang Yong Ping.

The Trinidadian artist Steve Ouditt writes *Creole in-Site*, an online diary for inIVA's website. Combining both images and text, Ouditt's writings reflect the artist's concerns from the prosaic to the poetic. Production: Joanne Moore and Steve Ouditt.

Organised by the Hayward Gallery, London, in collaboration with the Corcoran Gallery of Art, Washington DC, and inIVA, *Rhapsodies in Black: Art of the Harlem Renaissance* opens at the Hayward Gallery, before touring to a number of venues in the UK and abroad. Curators: David A. Bailey and Richard J. Powell. Artists: Marc Allegret, Charles Alston, Richmond Barthe, Lutz Becker, Edward Burra, Miguel Covarrubias, Aaron Douglas, William Edmondson, Sir Jacob Epstein, Walker Evans, Meta Vaux Warrick Fuller, Palmer C. Hayden, Malvina Hoffman, Malvin Grey Johnson, Sargent Claude Johnson, William H. Johnson, Lois Mailou Jones, Isaac Julien, Jacob Lawrence, Man Ray, Edna Manley, Kenneth Macpherson, Richard Maurice, Oscar Micheaux, Ronald C. Moody, Archibald J. Motley Jr, Jean Renoir, Winold Reiss, Richard S. Roberts, Augusta Savage, Albert Alexander Smith, Doris Ulmann, James VanDerZee, Carl Van Vechten, James Lesesne Wells, J. Elder Wils. Tour: Arnolfini, Bristol, 1997; Mead Gallery, University of Warwick, Coventry, 1998; M.H. de Young Memorial Museum, San Francisco, 1998; The Corcoran Gallery of Art, Washington DC, 1998; Los Angeles County Museum of Art, 1998; Museum of Fine Arts, Houston, 1999. A fully illustrated catalogue, published by Hayward Gallery, inIVA and University of California Press, includes an essay by Henry Louis Gates and contributions from Martina Attille, Simon Callow and Paul Gilroy. To complement the exhibition, inIVA develops a website, which is produced by Maria Amidu and Charmaine Watkiss.

'Dialogues Across the Black Atlantic I & II' is a two-day series of discussions at inIVA reflecting those intellectual and artistic relationships forged across the black Atlantic diaspora, which provided the critical and curatorial framework for *Rhapsodies in Black: Art of the Harlem Renaissance*. Speakers: David A. Bailey, Gilane Tawadros, Richard Powell, Frank Bowling, Jacob Lawrence, Thelma Golden.

Trevor Mathison and Byju Sukamaran create *Rebirth*, a sound piece made in response to a recording of a discussion between Jacob Lawrence, Frank Bowling and Thelma Golden within the 'Dialogues Across the Black Atlantic' series. In the discussion, they reflect on what it means to be a black artist in New York in the 1930s and 1960s. Production: Sun Leegba Love, Trevor Mathison and Byju Sukamaran.

inIVA presents *Keith Piper: Relocating the Remains* at the Royal College of Art, London, a major solo exhibition of the artist's work from 1982 to 1996 in three interactive installations. A combined monograph and CD-ROM (including essay by Kobena Mercer and foreword by Gilane Tawadros and David Chandler) and a dedicated website complement the exhibition. It is the first such integrated multimedia exhibition of its kind in the contemporary visual arts. Tour: Ikon Gallery, Birmingham, 1998; New Museum of Contemporary Art, New York, 1999.

A series of 'Dialogues' on *Keith Piper: Relocating the Remains* is held at the Royal College of Art on the occasion of the exhibition. The discussions give writers, curators and artists the opportunity to present personal perspectives and insights into Piper's work to a gallery audience: 1. 'Depicting History: Mapping the Spaces of the Postcolonial Experience', speakers: Jon Bird, Jean Fisher, Gilane Tawadros. 2. 'Superfly, Heavyweight, Victim(iser): The Black Male as Hero and Thug in Contemporary Culture', speakers: Faisal Abdu'Allah, David Dibosa, Lee Pinkerton. 3. 'In the Cut-and-Mix: Possibilities in Collage, Multimedia and Digital Technologies', speakers: Kobena Mercer, Gary Stewart, Keith Piper. 4. 'Viewpoints: Keith Piper Relocating the Remains', speakers: Richard Hylton, Caroline Smith, Roshini Kempadoo, Sean Cubitt.

Mark Ingham works with the Mathematics Department of Acland Burghley School and Years 7 and 8 students to create a new insight into his working processes as well as revealing some visual implications of mathematics to the students. An installation is created in the Maths corridor that explores notions of numeracy in art.

inIVA presents the first major solo exhibition of the work of sculptor *Avtarjeet Dhanjal* at Pitshanger Manor and Gallery, London. Bringing together a range of works produced by the artist since his arrival in Britain from India in the early 1970s, the exhibition combines sculptures, drawings and two newly commissioned installations. A fully illustrated monograph with a critical essay by Brian McAvera accompanies the exhibition.

Filter is published by inIVA and the Royal Borough of Kensington and Chelsea to coincide with the conclusion of Mary Evans' six-month residency at Leighton House Museum, London. It contains an essay by Gilane Tawadros and a conversation between the artist and Julia Findlator. An online version of *Filter* is also produced in collaboration with John Lundberg for X-Space.

Viktor Misiano presents 'Art in an Age of Transition: the Moscow Art Scene Today' as part of the 'International Curator Lectures' at the Royal College of Art.

South African artists Clifford Charles and Premi Chakravarti, who work in community arts in Johannesburg, present 'Who's Fooling Who? Issues Affecting Contemporary Art in South Africa', a discussion at inIVA on issues of art and internationalism relating to the Johannesburg Biennale.

1998

inIVA presents Simon Tegala's *Anabiosis* at the Concord Sylvania Building in London. For a two-week period, Tegala's heart is monitored and the information transmitted digitally to an electronic sign in a public site in the city of London. Using state-of-the-art technology developed for the athletics industry, *Anabiosis* (the medical term for revival after apparent death) reflects on the ways in which modern information and communication systems affect our lives and understanding of what it means to be 'alive'. A website of the same name is launched simultaneously with specially commissioned writings by novelist Deborah Levy.

enTRANsit is launched on the internet in collaboration with Caribbean Contemporary Arts, Trinidad. This site is based on a discussion between Steve Ouditt and Gilane Tawadros which explores cultural translation using Sarat Maharaj's essay 'Perfidious Fidelity: the Untranslatability of the Other' as its starting point. It is the first in a series of sister sites which create new channels of communication and exchange between international artists, curators and critics. Production: Maria Amidu, Charlotte Elias, Nathan Idehen, Joanne Moore, Steve Ouditt, Gilane Tawadros and Carlene Weekes.

Sonia Boyce: Performance (*Annotations* series; no. 2) is published in collaboration with Cornerhouse. It records and interprets work produced by Sonia Boyce during her residency at the University of Manchester. Edited by Mark Crinson. Contributors: Mark Baldwin, Paul Bayley, Sonia Boyce, Vicky Charnock, Mark Crinson, Andrea MacKean, Nikos Papastergiadis, Marcus Verhagen.

Okwui Enwezor presents 'Johannesburg Biennale Revisited' as part of the 'International Curator Lectures' at the Royal College of Art.

Frequencies: Investigations into Culture, History and Technology (*Annotations* series; no. 3) brings together papers delivered during three one-day seminars held at SOAS, University of London between November 1996 and March 1997. Edited by Melanie Keen and Alistair Raphael. Introduction by Lola Young. Contributors: Olu Oguibe, Marco Susani, Dunne + Raby, Françoise Vergès, Denise Robinson, Susan Hiller, Gustav Metzger, Anne Mie Van Kerckhoven, Takahiko Iimura, Theodore Zeldin.

The UNESCO-Aschberg Bursaries for Artists offer Che Lovelace (Trinidad) and José Luis López-Reus (Venezuela) three-month residencies at the Gasworks Artists' Studio. They produce new work which is included in an exhibition at Gasworks.

A Fruitful Incoherence: Dialogues with Artists on Internationalism is published. This fully illustrated publication represents the culmination of a two-year *Artists-in-Europe* research project on internationalism in the visual arts. It presents a collection of dialogues between Gavin Jantjes and different artists living and working in Europe. Edited by Gavin Jantjes and Rohini Malik, with Steve Bury and Gilane Tawadros. Essay by Gavin Jantjes. Contributing artists and writers include: Carlos Capelán, Marlene Dumas, Susan Hiller, Huang Yong Ping, Svetlana Kopystiansky, Marie-Jo Lafontaine, David Medalla, Pennina Barnett, Leïli Echghi, Peter Foolen, Chohreh Feyzdjou.

The Digital Art Resource for Education (DARE) project is launched in collaboration with Middlesex University's School of Lifelong Learning and Education and the Lansdown Centre for Electronic Arts, with support from the Arts Council of England. Rebecca Sinker is appointed as Research Fellow to develop and research education in contemporary visual arts through digital media across primary, secondary and teacher education.

Within the *Schools Programme* – the ongoing collaboration with Acland Burghley School – Mary Evans takes up a three-month residency in the Science Department. Working with children from years 7 and 8, the artist is invited to explore the science curriculum in relation to her artistic practice.

Monica Dutta is artist in research at the Assisted Conception Unit, Kings College Hospital, London. Her work *Disposed ofs [sic]* is exhibited in inIVA's library.

Clare Charnley is artist in research at Lloyd Loom Factory, Spalding. An artist's book, *Nothing Like This*, on display in inIVA's library, incorporates extracts from the diary of her residency.

In collaboration with the Whitechapel Art Gallery, inIVA produces the first major retrospective of *Aubrey Williams's* work in the UK. Opening at the Whitechapel, the exhibition tours to National Gallery of Jamaica, 1998, and National Gallery of Barbados, 1999. Curator: Andrew Dempsey. The first monograph on the Guyanese-born painter is published to accompany the exhibition. Edited by Andrew Dempsey, Gilane Tawadros and Maridowa Williams with essays by Guy Brett, Andrew Dempsey and Denis Williams and chronology by Anne Walmsley.

The site-specific project *Diary of a Victorian Dandy* by Yinka Shonibare is extensively exhibited throughout October at poster sites in London Underground stations. Tour: Castle Museum and Art Gallery, Nottingham and Laing Art Gallery, Newcastle.

Joy Gregory creates *Blonde* for X-Space. Production: Emily Booth and Byju Sukumaran. In parallel to the launch of *Blonde* on inIVA's website, the exhibition *Joy Gregory: Blonde* is held at the Metro Cinema, London.

Steve Ouditt: Creole in-Site (*Annotations* series; no. 4) brings together the writings of Trinidadian artist Steve Ouditt in his first publication, alongside images of his work. Edited by Gilane Tawadros.

The 'Critical Writings' workshop held at Goldsmiths College explores the nature of critical writing on the visual arts. One of the aims of the seminar is to address the elitism and inaccessibility of much critical and theoretical writing and ways of

moving beyond a 'closed' language towards a suggestive, more evocative writing. Speakers: Irit Rogoff (Chair), Deborah Levy, William Nericcio, Steve Ouditt, Calvin Forbes and Sarah Jones.

Guillermo Santamarina presents 'Memoria y Melancolia: Some Thoughts' as part of the 'International Curator Lectures' at the Royal College of Art.

The Chat Room: a Series of Discussions on Contemporary Art and Culture is launched with 'Vindaloo and Chips'. It is an intimate evening where a selection of artists, invited guests and members of the public discuss the question of what precisely it means to be 'young, British and an artist'. Participants include: David Burrows, Simon Callery, Virginia Nimarkoh, Alistair Raphael, Yinka Shonibare, Simon Tegala.

'Performing Nations' (The Chat Room series) is a seminar that takes a look at the different ways in which 'ethnic performance' continues to feature in popular entertainment worldwide from Disneyworld to the Millennium Dome. Speakers: Pat Cooke, Coco Fusco, Joy Hendry, Sarat Maharaj, Kobena Mercer, Nick Stanley, Jane Wilkinson.

'Global Circuits' (The Chat Room series) looks at the relationship of the local and the global in the international art world and the role of digital technology in forging new connections between artists in different parts of the world. Participants: Jordan Crandall, Gerardo Mosquera, Steve Ouditt, Gilane Tawadros (Chair).

''What's in a Dome?' (The Chat Room series) takes the Millennium Dome as a starting point and reflects on what this project says about modern Britain in the year 2000 and beyond. Participants: Sonali Fernando, Eliza Fielding, Stuart Hall (Chair).

1999

inIVA organises New Player, a collaborative project with Weekend Arts College, where young people participate in a series of workshops that equip them with the critical, technical and creative tools to author their own computer games.

'Critic to Critic' (The Chat Room series) brings together a number of Britain's leading art critics to talk about the trials and tribulations of being an art critic in Britain in the 1990s. Speakers: Eddie Chambers, Richard Hylton, Tania Guha, Sarah Kent, David Burrows (Chair).

Run Through the Jungle: Selected Writings by Eddie Chambers (Annotations series; no. 5) includes a selection of Chambers's writings from the early 1980s to the present day, published here for the first time. Edited by Gilane Tawadros and Victoria Clarke with an introduction by Sarat Maharaj.

Apinan Poshyananda presents 'From Emerging Tigers to Tamed Cats: Perception and Presentation of Contemporary Asian Art' as part of the 'International Curator Lectures' at the Royal College of Art.

'Designer Breakfast' (The Chat Room series), a breakfast event at The Crowbar, is a chance to meet design magazine editors and artists to discuss the apparently converging relationship of art and design practices in the 1990s. Participants: Marcus Field, Caroline Roux, Stephen Todd.

New work by Keith Piper forms the basis of the first phase of Club Mix, a new digital multimedia presentation which tours clubs in London, Birmingham and Nottingham throughout March. Later tours to New York, Bradford, Reading. The transition of taking art from the gallery to the club is facilitated by inviting local artists, DJs and video jockeys to a series of workshops.

inIVA organises Criticise, a project involving A-level English students from Camden Girls School. They meet art critics including Adrian Searle, Sarah Kent and Eddie Chambers at a number of contemporary art exhibitions around London and are commissioned to write reviews. These are published on inIVA website.

Cities on the Move, a major exhibition touring Austria, France, USA, Denmark and Finland, opens at the Hayward Gallery. Curated by Hou Hanru and Hans Ulrich Obrist, the exhibition is the first joint presentation of art and architecture from Asian cities in Europe. Over 100 Asian artists present work that reflects the change that Asia's great cities face at the beginning of the 21st century. With participating artist Tsuyoshi Ozawa, inIVA co-curates one aspect of the show, commissioning work by nine artists: Phillip Lai, Indika Perera, susan pui san lok, Alistair Raphael, Erika Tan, Simon Tegala, Mayling To, Cai Yuan, Jian Jun Xi.

Throughout June, billboard sites in inner London host the first exhibition seen in Europe of Egyptian Cinema Posters. This site-specific project brings the iconography of one of the world's oldest and most dynamic cities in collision with one of Europe's largest and most culturally diverse metropolises. Co-curated and produced by inIVA and Rana Salam.

Georgina Evans completes her six-month residency with Union Dance Company and creates Ginga, an interactive work in progress that takes the form of movement-triggered animation and invites physical participation from the audience.

An international panel discussion explores the work of Brazilian artist 'Hélio Oiticica'. Following the discussion, inIVA hosts the launch of a CD-ROM of the artist's work, published by N-Imagen (Federal University of Rio de Janeiro). Speakers: Michael Asbury, Oriana Baddeley, Guy Brett, Milton Machado, Katia Maciel.

New York based poet Sarah Jones performs extracts from Surface Transit at Whiteleys Shopping Centre, London.

The anthology Reading the Contemporary: African Art from Theory to the Marketplace is published. Edited by Olu Oguibe and Okwui Enwezor, it brings together 22 essays by key critical thinkers, scholars and artists, including: Kwame Anthony Appiah, Manthia Diawara, Ima Ebong, Okwui Enwezor, Rotimi Fani-Kayode, Salah Hassan, Sidney Kasfir, David Koloane, Thomas McEvilley, Kobena Mercer, V.Y. Mudimbe, Laura Mulvey, Everlyn Nicodemus, Olu Oguibe, Chika Okeke, John Picton, Colin Richards, Margo Timm, N. Frank Ukadike, Octavio Zaya.

A digital educational resource for teachers is produced as an interactive CD-ROM of Mary Evans's online project Filter. With accompanying teachers' notes, the CD-ROM introduces the artist's work and ideas to pupils at key stage 2 of the National Curriculum.

'Postcolonial Cities' is held at the Lux Centre. The discussion explores the performative aspects of postcolonial experience and the complex dynamics of different urban experiences. Speakers: Okwui Enwezor, Isaac Julien, Sarat Maharaj, Olu Oguibe, Gilane Tawadros.

In collaboration with the Lux Centre, the international film programme Urban Exposure reflects the experiences of migration, isolation and belonging by the inhabitants of different, postcolonial cities. The films are shown at Lux Cinema, Hoxton Square.

Freddie Robins creates Bugbear for X-Space. Production: Joanne Moore.

'Performance Art in a Digital Age' (The Chat Room series) brings Coco Fusco in conversation with Ricardo Dominguez, with participation from Pervaiz Khan.

The book Artists in Research, 1996–1998 is published to document the three-year pilot programme through images and artists' statements. Introduction by Alistair Raphael. Artists: Clare Charnley, Monica Dutta, Edwina Fitzpatrick, Nicky Hirst, Indika Perera, Louise K. Wilson.

Tertia Longmire and Tanya Peixoto are in residence at Acland Burghley School and work with children from Year 8 in the Modern Languages Department. They explore themes of translation, mother tongue and vocabulary, and produce a collective 'artist's book' with the students.

Over a three-month period, Networks and Markets, an online discussion forum and website, explores issues of globalisation in relation to new technology and contemporary visual art. Hosts include Bruno Latour, Masao Miyoshi and Saskia Sassen. Moderator: Jordan Crandall. Editor: Barbara Asante.

2000

John Latham is artist in research at the Isaac Newton Institute for Mathematical Sciences, Cambridge. A screening of his experimental films and videos at the Lux Cinema is followed by a discussion with the artist (The Chat Room series).

Katrine Hjelde creates White for X-Space. Production: Russell Newell.

inIVA is selected for a Breakthrough Programme Award by the Arts Council of England to the value of £100,000. This one-off funding award is given to inIVA for 'its pioneering and inspiring work with

culturally diverse artists, writers and promoters/curators and critics in the UK and abroad'. inIVA is unanimously selected for its work in 'supporting and illuminating the work of those artists, writers and critics from diverse cultural backgrounds whose profiles have traditionally been overshadowed by the mainstream' and for creating a 'new kind of visual arts "production company" with a global reach and with a special interest in site-specific work, international collaboration, and new technologies'. The Breakthrough Programme highlights innovative arts practice and aims to bring recognition to organisations that are acting as successful role models for the future.

Within the UNESCO-Aschberg Bursaries for Artists programme, Song Dong is artist in residence at Gasworks Artists' Studio. The new work produced during his residency is exhibited at Gasworks' Open Studio and at Tablet at the Tabernacle.

Brazilian artist Eduardo Padilha is the first artist in residence at TheSpace@inIVA. His residency of seven weeks culminates in the exhibition *Dark Habits (Work in Progress)* at TheSpace@inIVA. The accompanying leaflet includes an interview with the artist by Melanie Keen.

'A Dirty Space?' (The Chat Room series) provides an opportunity for an informal discussion about the context for contemporary artistic practice. The 'white cube' as a highly controlled gallery environment is confronted with the notion of a 'dirty space' where risk and experimentation are demanded.

Una Walker is commissioned to create a digital artwork for X-Space. Production: Peter Richards.

The *Donald Rodney: Autoicon* website is launched, later published on CD-ROM. *Autoicon*, produced in collaboration with CaiiA/STAR at the University of Plymouth, is an internet artwork that simulates both the physical presence and elements of the creative personality of the late artist Donald Rodney. Realised by a group of friends and artists known as 'Donald Rodney plc' (Eddie Chambers, Geoff Cox, Richard Hylton, Virginia Nimarkoh, Mike Phillips, Keith Piper, Gary Stewart, Diane Symons), who redefine the role of the artist through this collaborative and creative process.

The screening of two films about James Baldwin – *Baldwin's Nigger* by Horace Ové, UK, 1969, and *James Baldwin: The Price of the Ticket* by Karen Thorsen, US, 1989 – takes place at the Lux Cinema.

The DARE (Digital Art Resource for Education) website is launched (www.dareonline.org). It explores culturally diverse contemporary visual arts and education through digital media, in the form of a playful, critical and interactive online resource aimed at teachers and pupils in the secondary education sector.

To coincide with the first ever London Biennale (1 May – 31 August 2000), which has been initiated and organised by artist David Medalla, inIVA hosts a one-off evening performance by the artist, an opportunity to engage with Medalla's unique practice and lived modernity.

Trinidadian artist Steve Ouditt is artist in residence at TheSpace@inIVA. His residency culminates in the *Creole Processing Zone* exhibition. A leaflet is published to accompany the exhibition including a conversation between the artist and Melanie Keen.

'The Caribbean: a Quintessentially Modern Zone' (The Chat Room series) coincides with Steve Ouditt's residency in inIVA's project space and focuses on creolisation, a process unique to the Caribbean, as an essentially modern articulation of language and culture. Participants: Steve Ouditt, Annie Paul, Stuart Hall.

The exhibition *Drawing Space: Contemporary Indian Drawing* opens at Beaconsfield, touring to Angel Row Gallery, Nottingham. Co-produced by inIVA and Beaconsfield in collaboration with Victoria & Albert Museum, it presents the work of Nasreen Mohamedi, Sheela Gowda and N.S. Harsha. Curators: Suman Gopinath and Grant Watson. Accompanied by a publication featuring specially commissioned essays, interviews and diary extracts providing the art-historical background to the work as well as personal insights into the creative processes of the three artists. Contributors: Dan Rycroft, Guy Mannes Abbott, Divia Patel and Graham Parlett, Grant Watson.

Zineb Sedira is artist in residence at Acland Burghley School. Working with two classes in Year 7 in the History Department, she explores

ideas around personal history and the different modes of documentation and representation.

'Modernity and Difference' (The Chat Room series) features Stuart Hall in conversation with Sarat Maharaj at the Lux Cinema to explore the relationship between modernity, difference and translation.

Taking the exhibition *Drawing Space: Contemporary Indian Drawing* as a case in hand, the panel discussion 'The Creative Circuit: The Experience of Cultural Translation' held at Victoria & Albert Museum focuses on how audiences respond to works from non-Western cultures. Speakers: Farrukh Dhondy (Chair), Grant Watson, Suman Gopinath, Nima Poovaya-Smith, Sadie Murdoch.

2001

inIVA is awarded £170,000 by the New Opportunities Fund to develop the inIVA Digital Archive.

An exhibition of drawings by British architect Cedric Price is held at TheSpace@inIVA. The show, selected by Hans Ulrich Obrist, includes a retrospective presentation of Price's *Magnet City* project. A leaflet including an interview between Cedric Price and Hans Ulrich Obrist, with introduction by Bruce Haines, accompanies the exhibition.

The first major exhibition of artist, curator, poet and archivist Li Yuan-chia opens at Camden Arts Centre. Born in China in 1929, Li Yuan-chia lived and worked in Cumbria until his death in 1994. Exhibition produced by inIVA in collaboration with Camden Arts Centre. Curator: Guy Brett. Tour: Abbot Hall Art Gallery and Museum, Kendal, and Palais des Beaux-Arts, Brussels. Accompanied by the monograph *Li Yuan-chia: tell me what is not yet said*, including texts by Guy Brett and Nick Sawyer.

Modernity and Difference (Annotations series; no. 6) is published. It includes the conversation between Stuart Hall and Sarat Maharaj on modernity, difference and translation, which took place at the Lux Cinema in October 2000. Edited by Sarah Campbell and Gilane Tawadros.

Following on from the Tate Modern's 'Local and Global' conference, inIVA hosted an international workshop 'Transforum' involving artists and

curators from different parts of the world and co-ordinated by Miria Swain. Participants: Ricardo Basbaum, Clifford Charles, Suman Gopinath, Hou Hanru, Michelle Marxuach, Steve Ouditt, Guillermo Santamarina, Gary Stewart and Gilane Tawadros.

Carlos Blanco is artist in residence at Gasworks Artists' Studio as part of Gasworks/inIVA's international programme. Blanco's work addresses issues of Colombian identity using large-scale iconic portraits. His residency culminates in the exhibition *La Cruda Realidad [Raw Reality]* at TheSpace@inIVA. A leaflet published to accompany the exhibition includes a conversation between the artist and Antonia Carver.

Michael Atavar is artist in residence at *The Guardian* newspaper. The residency is part of the Year of the Artist media residencies programme.

Working with multimedia designer Michael Uwemedimo, Maria Amidu creates *Joining the Dots*, an interactive web-based work that evaluates, archives and re-presents inIVA's five-year *Schools Programme*.

Flow Motion (Anna Piva, Trevor Mathison and Eddie George) presents the digital audio-visual installation *Dissolve* at TheSpace@inIVA.

Aaron Williamson is commissioned to make an artwork for X-Space. Informed by his experience of becoming profoundly deaf, the artist develops new ideas and reinterprets past works including *hearing things* (1998), a piece that explores the accidental creation and disintegration of language. Production: Pervaiz Khan and Estella Rushaija.

Waseem Khan creates *CodaOuija* for X-Space. Production: The Digital Guild.

Jamie Wagg creates *B52* for X-Space. Production: Adam Walker.

inIVA presents the web-based projects *Touring London*, on the role of the artist as tourist, and *Travellers' Tales*, in which nine international artists are invited to make a work inspired by a travel experience. Edited by Oliver Sumner, *Touring London*'s artists are: Zeigam Azizov, Tim Brennan, Isaac Julien, Emma Kay, Deborah Levy, Erika Tan, Cai Yuan and Jian Ju Xi. Participant

artists in *Travellers' Tales*: Suki Best, Gaye Chan, Eugenio Dittborn, Song Dong, Lina Dorado, Luis Cantillo, Keith Khan, Shimabuku, Anne Tallentire.

The first solo exhibition of *Shen Yuan's* work in the UK, including new installations and earlier works made over the past decade, takes place simultaneously at Arnolfini, Bristol, and Chisenhale, London, later touring to Bluecoat Gallery, Liverpool. A monograph, published by inIVA in collaboration with Arnolfini, accompanies the exhibition including texts by Caroline Collier, Shen Yuan, Hou Hanru, Evelyne Jouanno, Gilane Tawadros, Martina Köppel-Yang.

Farah Bajull is artist in residence at TheSpace@inIVA. The Iranian-born artist is commissioned by inIVA to make new work, which incorporates sculpture into performance pieces and addresses issues of female strength and identity. *Untying the Knot*, the outcome of her residency, is shown at TheSpace@inIVA. A leaflet including an interview with the artist by Melanie Keen is published to accompany the exhibition.

Magnet, the magazine, is launched to coincide with the Venice Biennale. *Magnet* is the name given to the group of artists and curators from around the world, dedicated to making critical interventions in contemporary art in a global context, who took part in the 'Transforum' workshop earlier in the year. Contributors: Ricardo Basbaum, Clifford Charles, Suman Gopinath, Veliswa Gwintsa, Michelle Marxuach, Janaki Nair, Oupa Ngwenya, Steve Ouditt, Ramidan Suliman, Gilane Tawadros.

The Arts Council of England's Capital Programme 2 announces that it has earmarked £5 million for inIVA and Autograph's joint building project. The new building will house offices, an expanded library/archive, an interactive education space and include new project spaces that will be used for exhibitions, talks, screenings and special events.

The Bodies that Were not Ours – and Other Writings, by Coco Fusco, is published by Routledge in association with inIVA. The book gathers together Coco Fusco's finest writings since 1995, with critical introductory essays by Jean Fisher and Caroline Vercoe.

To celebrate the launch of *The Bodies that Were Not Ours*, 'Coco Fusco in Conversation with John Akomfrah' takes place at Victoria Miro Gallery. Coco Fusco reads extracts from her book and discusses with Akomfrah the direction and future of debates around postcolonial cultural discourse.

Students at Aylward School are the curators of *Mail Art* at TheSpace@inIVA. This exhibition includes work by a group of A-level students along with the work of artists who contributed a 'postcard' on the theme of *Travellers' Tales* in response to inIVA's *Mail Art* commission.

Damien Robinson creates *Aerial* for X-Space. Production: inIVA.

Pat Naldi creates *East of Eden* for X-Space. Production: Estella Rushaija.

2002

With Niru Ratnam and Gilane Tawadros as curators, inIVA launches 'Changing States: Contemporary Art and Culture in the 21st Century' within The Chat Room series. This is a unique year-long programme of debates that considers the shifts in the cultural landscape in the light of globalisation. The debates take place at different venues throughout the UK and speakers include artists, cultural theorists, curators and social commentators. A *Question Time*-style discussion is the first in the season, chaired by Susan Hiller, with speakers: Matthew Collings, Adrian Searle, David A. Bailey and Gilane Tawadros. Held at Conway Hall, London.

'Branded: Art and the Economy' (The Chat Room series/Changing States) features presentations on the theme of branding in the context of museums, media, artistic practice, and the built environment. Speakers: Neil Cummings, Johnny Davis, Niru Ratnam, Sune Nordgren, Clive Sall. Held at Conway Hall, London.

In partnership with Proboscis and the London School of Economics, inIVA hosts *Liquid Geography*. It consists of two groundbreaking events investigating collaborations between the arts, academia and civil society organisations using new media and technology. These creative multimedia labs include academics, artists, funders, multimedia entrepreneurs, cultural strategists and policy advisors.

Jigar, the first solo touring exhibition of artist and film-maker Alia Syed, opens at the New Art Gallery, Walsall and TheSpace@inIVA, later touring to Turnpike Gallery, Manchester, and Gallery of Modern Art, Glasgow. Frequently depicting the Pakistani and Bangladeshi communities of East London, Syed looks at personal responses to physical and emotional relationships between individuals. *Jigar* includes a new film – *Spoken Diary* (2001) – plus *Watershed* (1995) and *Swan* (1989) as well as a single-screen version of *Spoken Diary* and *Fatima's Letter* (1994). A leaflet including a conversation between the artist and Bruce Haines is published to accompany the exhibition.

'Protest! Art and Anti-Globalisation' (The Chat Room series/Changing States) addresses the appropriation of public space by private interests and the challenge to corporate globalisation mounted by politicised artistic practice and guerrilla protest movements. Speakers: Julian Stallabrass, Nils Norman, Niru Ratnam (Chair). Held at Ikon Gallery, Birmingham.

Chinese Art at the Crossroads: Between Past and Future, Between East and West is published by New Art Media in collaboration with inIVA. This publication gathers together a wide-ranging selection of texts, interviews and debates published on the chinese-art.com website in 2001 to provide local and global perspectives on the contemporary art of China and its diaspora. Edited by Wu Hung. Contributors: Keith Andony, David Barrett, Francesca Dal Lago, Tang Di, Huang Du, Britta Erickson, Jonathan Goodman, Hou Hanru, Binghui Huangfu, Martina Köppel-Yang, Wang Lin, Bronwyn Mahoney, Wang Nangming, Regi Preiswerk, Zhu Qi, Kathlyn M. Ryor, Sue Rowley, Yin Shuangxi, Karen Smith, Harald Szeemann, Chen Tong, Val Wang, Li Xianting, Li Xu, Huang Zhuan.

Andrew Lewis's *Systems* opens at TheSpace@inIVA. Lewis's often large-scale sculptures project an internal view of domestic city life or propose playful solutions to domestic, travel and work problems. A leaflet, including an interview with the artist and Bruce Haines, is published to accompany the exhibition.

Janette Parris in *Mezzo Soprano?* at Hoxton Hall, becomes a singer for one night and performs a set of soul songs with a live band. She

uses music to break down cultural hierarchies and blur the boundaries between visual art practice and musical performance. A leaflet, including an interview with the artist and Melanie Keen, is published to accompany the exhibition.

'Critical Difference: Art Criticism and Art History' (The Chat Room series/Changing States) considers the discipline of art history in the light of its critique by feminist and postcolonial scholars. The panel, chaired by Niru Ratnam, includes: Richard Dyer, Kobena Mercer, Irit Rogoff, Alia Syed. Held at Cubitt Gallery, London.

Johannes Phokela opens at The Gallery, Café Gallery Projects, London. Phokela's paintings are as much about the history of the Dutch in Africa as they are about the history of painting. Produced in collaboration with Café Gallery Projects. A leaflet, including an interview with the artist and Bruce Haines, is published to accompany the exhibition.

Mayling To's *The Stranger*, a newly commissioned video work for inIVA, is presented at TheSpace@inIVA. To's character Panda is a metaphor for cultural displacement and identity issues. An interview with the artist by Melanie Keen is published in the accompanying leaflet.

'Cosmopolitism and Commerce' (The Chat Room series/Changing States) discusses the relationship between artists whose cultural origins are from outside the West and the burgeoning commercial art world. Speakers: Bea de Souza, Anne Tallentire, John Seth, J.J. Charlesworth, Shez Dawood, Niru Ratnam (Chair). Held at the Whitechapel Gallery, London.

The Danger Museum is housed at TheSpace@inIVA in September. An artists' collaboration between Miho Shimizu (Japan), Øyvind Renberg (Norway) and Tien Wei Woon (Singapore), the Danger Museum brings together projects from different cultural, geographical and social contexts by creating a meeting point for artists and promoting practices that are not widely documented.

Charlotte Cullinan + Jeanine Richards: artlab convert TheSpace@inIVA into their headquarters, presenting a fake archive of artists' materials and documentation to provide a supportive environment in which

the artists and their collaborators can show their work. Colombian collective Cambalache and four local artists – Simon Pendleton, Jo Soughan, Derek Ogbourne, Georgie Hopton – are commissioned to develop projects alongside the artlab open-air cinema events in the Shoreditch area. The open air cinema *Iglesia Universal* takes place at Boundary Estate Playground, Old Nichol Street and at the car park adjoining inIVA, Rivington Street, London.

msdm's *Outsourcing* is at TheSpace@inIVA. Initiated by Paula Roush in 1998, msdm (mobile strategies of display and mediation) is a collective laboratory which explores the mobility, distribution and presentation of artworks. The exhibition programme includes a film screening curated by Anthony Iles, a collection of audio-visual narratives on work presented by El Sueño Colectivo and Zeigam Azizov in conversation with Paula Roush on the 'domestication of visual pleasure' followed by a guided walk to the Geffrye Museum. Other participating artists: Sasha Costanza-Chok, Octavi Comeron.

'Art Circuits, Art Circuses' (The Chat Room series/Changing States) focuses on the proliferation of biennials. Speakers: Adam Nankervis, Will Bradley, Kellie Jones, Niru Ratnam (Chair). Held at Bluecoat Gallery, Liverpool.

Francesco Bonami (The Chat Room series/Changing States), the Director of the 2003 Venice Biennale, is in conversation with Gilane Tawadros at Centre for Contemporary Arts, Glasgow.

Diego Ferrari produces a series of images documenting the activities of the Danger Museum, artlab and msdm, which can be seen on inIVA's website.

In collaboration with 'A' Team Arts and Brady Arts and Community Centre, *watt UP!* is the launch project in Steve Ouditt's education and research programme entitled Open Plan/Public Geometries. It consists of a series of workshops and talks during which participants between the ages of sixteen and twenty investigate sound, music and street style in London. Ansuman Biswas – a visual and performance artist, a musician and composer – is the anchor tutor for the project.

'In the Shadow of Empire' (The Chat Room series/Changing States)

focuses on the publication *Empire* (Michael Hardt and Antonio Negri, Harvard, 2000) described as the 'first great theoretical synthesis of the new millennium'. Participants: Michael Hardt, Stuart Hall, Niru Ratnam (Chair). Held at Tate Britain, London.

2003

The DARE (Digital Art Resource for Education) CD-ROM for Primary Schools is launched. Developing from the DARE website, the CD-ROM is a multimedia art and education resource, created with and for children aged 5 to 10. Artists Maria Amidu and Barby Asante worked with children from Columbia School in East London to develop the CD-ROM. Interactive and accessible, the CD features a number of contemporary international artists, along with the children's video, voices and artwork. It offers a range of activities across the curriculum and includes a supporting booklet for parents and teachers.

The exhibition *Veil* is launched at The New Art Gallery Walsall, later touring to Bluecoat Gallery and Open Eye Gallery, Liverpool; Modern Art Oxford and Kulturhuset, Stockholm. This major exhibition brings together twenty international contemporary artists whose work explores the symbolic significance of the veil and veiling in contemporary art. Conceived by Zineb Sedira long before the events of 11 September, the project emerges directly from the practice of two artists – Sedira and Jananne Al-Ani – who are interested in the myriad, possible interpretations of the veil. Artists include: Faisal Abdu'Allah, Kourush Adim, AES art group, Jananne Al-Ani, Ghada Amer, Farah Bajull, Samta Benyahia, Shadafarin Ghadirian, Ghazel, Emily Jacir, Ramesh Kalkur, Majida Khattari, Shirin Neshat, Harold Offeh, Zineb Sedira, Elin Strand and Mitra Tabrizian. Curators: Jananne Al-Ani, Zineb Sedira, David A. Bailey, Gilane Tawadros. *Veil: Veiling, Representation and Contemporary Art* is published alongside the exhibition in association with Modern Art Oxford. Texts by Leila Ahmed, Jananne Al-Ani, David A. Bailey, Alison Donnell, Frantz Fanon, Reina Lewis, Hamid Naficy, Zineb Sedira, Ahdaf Soueif, Gilane Tawadros.

A selection of the compulsory identity photographs of Algerian women taken during the War of

Independence (1954–1962) by Marc Garanger during his military service are exhibited at TheSpace@inIVA. The show is part of a season of French photography and video, *Made in Paris: Photo/Video*, June 2003, at various galleries in London, co-ordinated by the French Embassy/Institut Français du Royaume-Uni.

Ghazel is commissioned by inIVA to make a trilogy of films as part of her *Me* series. Born in Tehran, Iran, Ghazel now lives and works in Paris, France. Her work highlights her position as an outsider both in the West and in Iran. The films are shown at TheSpace@inIVA as part of the *Made in Paris: Photo/Video* season.

Algerian-French artist Samta Benyahia uses Arab Andalusian geometrical patterns and rosaces to explore ideas of contrast such as light/shade, female/male, inside/outside. Her exhibition is at TheSpace@inIVA as part of the *Made in Paris: Photo/Video* season.

Majida Khattari's work links Western high fashion with Islamic codes of dress and behaviour. The artist presents a film of her fashion show *Défilé: Performance* and some preparatory drawings at TheSpace@inIVA. Part of the *Made in Paris: Photo/Video* season.

inIVA collaborates with *A Space*, an after-schools project for Year 4, 5 and 6 students from Shacklewell and Colvestone Primary Schools. Working with Faisal Abdu'Allah and Marc Garanger, students explore complex cultural issues of identity, transition, self-image, history, location, gender, role-play and self-discovery inspired by the *Veil* exhibition. The students form a collective, which makes shared decisions on the curating of the exhibition, using different media, holding equal parity with the artists to encourage ownership, critical thinking and making connections between themselves, their work and that of the artists.

In *Memex: A Cyborg Pilgrimage in the Age of Amnesia*, the artist Rokeby turns himself into a cyborg, equipped with a wearable computer, a digital camera, a portable brainwave monitor and a global positioning system tracking his precise geographical location. Online on inIVA website.

inIVA publishes *Vampire in the Text: Narratives of Contemporary Art*, by

Jean Fisher, a collection of writings on the political and intellectual turbulence of the past fifteen years and its impact on both artistic practice and art criticism. Essays explore the work of artists including: Susan Hiller, Judith Barry, Frank Stella, Anselm Kiefer, Jack Goldstein, David Dye, James Coleman, Lee Ufan, Willie Doherty, Jimmie Durham, Gabriel Orozco, Avis Newman, Everlyn Nicodemus, Santi Quesada, Adrian Piper. They precede a series of texts that reflect upon artistic practice in relation to subjectivity, postcoloniality and multiculturalism.

inIVA publishes *Fault Lines: Contemporary African Art and Shifting Landscapes* in collaboration with the Forum for African Arts and the Prince Claus Fund Library. *Fault Lines* brings together contemporary artists and writers from Africa and the African diaspora whose works trace the fault lines that are shaping contemporary experience locally and globally. Across a range of media, the works of fifteen artists span five decades, four continents and three generations. Edited by Gilane Tawadros and Sarah Campbell. Artists: Laylah Ali, Kader Attia, Samta Benyahia, Zarina Bhimji, Frank Bowling, Clifford Charles, Pitso Chinzima, Rotimi Fani-Kayode, Hassan Fathy, Veliswa Gwintsa, Moshekwa Langa, Salem Mekuria, Sabah Naim, Moataz Nasr and Wael Shawky. Contributors: Gamal Abdel-Nasser, Solomon Deressa, Deepali Dewan, Okwui Enwezor, Lisa Fischman, Elsabet Giorgis, Stuart Hall, Salah Hassan, Sarat Maharaj, Prince Massingham, Achille Mbembe, Prince Mbusi Dube, Kobena Mercer, Landry-Wilfrid Miampika, Adriano Mixinge, Simon Njami, Kwame Nkrumah, Bheki Peterson, Nasser Rabbat, Niru Ratnam, Jérôme Sans, Mark Sealy, Yasmeen Siddiqui, Gilane Tawadros, Ramon Tio Bellido, Hamza Walker and Kateb Yacine.

inIVA hosts the preview of Line Halvorsen's award-winning film *A Stone's Throw Away*. Made in collaboration with Media 19, the film is a visual account of children under siege that combines historical archive imagery with contemporary television documentary practice.

Writer-in-residence Kobena Mercer contributes to inIVA's programme by researching new approaches to international modernism in the visual arts. As a development of his six-month residency in 2002, Mercer invites leading international

scholars and writers to participate in 'Cosmopolitan Modernisms', the first in a series of symposia that explore cross-cultural aspects of the visual arts. Participants include: Michael Asbury, Monique Fowler-Paul, Ann Gibson, David Craven, Paul Overy and Michael Richardson.

Commissioned by Film London Artists' Film and Video Awards and inIVA, Alia Syed's new 16mm film *Eating Grass* is shown at TheSpace@inIVA. Shot in London, Karachi and Lahore and encompassing five stories relating to the times of day for Muslim prayer, the work explores overlaps between time, memory and location.

'Janine Antoni in Conversation with David A. Bailey' (The Chat Room series) reflects on the vast archive of her own work and the practices it draws upon. Hosted by the Whitechapel Art Gallery and organised by the Live Art Development Agency.

inIVA presents the UK premiere of Ové's new film on John La Rose, *The Dream to Change the World: John La Rose in Conversation with Horace Ové* preceded by a rare discussion between Ové and La Rose (The Chat Room series).

2004

'Lumumba' (The Chat Room series) presents the screening of Raoul Peck's political thriller *Lumumba* (2001) followed by a conversation between Ludo de Witte, Luc Tuymans, John Akomfrah and Raoul Peck.

Zarina Bhimji's exhibition is held at TheSpace@inIVA. It consists of three transparencies mounted on light boxes, the result of research carried out over the course of three trips to Uganda, where Bhimji was born.

inIVA Digital Archive is launched. Incorporating images, texts, audio and video materials, the Archive comprises documentation on artists, critics, curators and seminal inIVA projects. Supported by the New Opportunities Fund.

The monograph *Sutapa Biswas* is published. It is a critical appraisal of the artist's work and influences, her film work and her practice in various media. There is also an extensive interview. Contributors: Ian Baucom, Sutapa Biswas, Guy Brett, Laura Mulvey, Griselda Pollock, Moira

Roth, Stephanie Snyder. Published by inIVA in collaboration with the Douglas F. Cooley Memorial Art Gallery, Reed College, Portland, Oregon.

A collaboration between inIVA and A Space, *Touchstones* marks the impending closure of Kingsland School in Hackney and the opening of the new Mossbourne Community Academy. Exploring the resonance of architecture and space in the local community, children from local primary schools together with former Kingsland and Hackney Down students trace their social and spatial displacements and connections in celebration of their neighbourhood.

Sutapa Biswas's *Birdsong* is shown at Café Gallery Projects, London. An inIVA international touring exhibition produced in collaboration with Film and Video Umbrella, it presents two new films, *Birdsong* and *Magnesium Bird*, which explore the fluidity and mutability of memory within the context of rites of passage. The exhibition tours to Angel Row Gallery, Nottingham; Leeds City Art Gallery; Harewood House, Leeds; and Douglas F. Cooley Art Gallery, Reed College, Portland, Oregon.

Artist Walid Raad, of the Atlas Group, develops with inIVA a body of work on the history of the car bomb in Lebanon. During a residency/laboratory at TheSpace@inIVA, Raad, Bilal Khobeiz and Tony Chakar investigate the exact events of each bomb by tracking down witnesses and victims. Supported by Kunsten Festival of Arts (Belgium), La Caisse des Depôts (France), House of World Cultures (Germany) and Ashkal Alwan (Lebanon). The residency is followed by a discussion, within The Chat Room series, based on the group's new audio-visual and textual piece entitled *My Neck is Thinner than a Hair: a History of the Car Bomb in the 1975–1991 Lebanese Wars – Volume 1: 21 January 1986*. Hosted by inIVA at Bargehouse, Oxo Tower Wharf, London, in collaboration with LIFT.

In 'Architecture, Globalisation and Diversity' (The Chat Room series) a panel of speakers discusses the shape and role of architecture in relation to issues of diversity, access and politics. The discussion centres on the politics of place and the different ways in which space can be translated. Speakers: David Adjaye, Faisal Abdu'Allah, Lesley Naa Norle Lokko, Tom Dyckhoff.

In *Meet my Carer*, Kurdish artist Rebwar explores themes of home, identity and exile with students from Hanover Primary School. The project, managed by engage on behalf of the Clore Duffield Foundation is part of the Artworks Programme supporting art education in UK schools. The project ends with a workshop in which both students and their carers participate.

inIVA publishes *Carnival of Perception: Selected Writings on Art*, the first anthology of Guy Brett's writings, with a preface by Yve-Alain Bois. Included are key seminal essays of Latin American practitioners, as well as texts that reflect the cross-cultural and experimental nature of London's art scene. Artists featured: Rasheed Araeen, Derek Boshier, Lygia Clark, Juan Davila, Eugenio Dittborn, John Dugger, Rose Finn-Kelcey, Mona Hatoum, Susan Hiller, Tina Keane, David Medalla, Hélio Oiticica, Gabriel Orozco, Hannah O'Shea, Cornelia Parker, João Penalva, Carlyle Reedy and Takis.

inIVA presents *Length x Width x Height*, a site-specific installation by David Adjaye, the architect appointed to design inIVA's new home on Rivington Place, Shoreditch, London. The installation invites visitors on a journey through space and light that simulates the conditions, both physically and emotionally, of the Rivington Place site.

inIVA presents Janine Antoni's film *Ready of Not, Here I Come* at TheSpace@inIVA. For the duration of the exhibition, TheSpace@inIVA is converted into a domestic living room in which to view the film, which was made in collaboration with the artist's parents.

Note: Further information on individual entries can be found at www.iniva.org/archive

Glossary
Compiled by Melanie Keen

Abstraction
The act of withdrawing or removing something. The creation of artwork which references the surrounding environment through a radical simplification of colour and/or form. The act of abstraction can be a form of psychic self-expression and a mediation on light, colour, rhythm and space conveyed through music as well as visual art. See Aubrey Williams's and Nasreen Mohamedi's work in 'Modern'.

Apartheid
A social policy or racial segregation involving political and economic discrimination against non-whites; the former official policy in South Africa which was repealed in 1991. Literally meaning separateness, apartheid came to represent a moment of prolific creative production from the oppressed majority. See Prince Massingham's text 'We've All Been to Soweto' in 'Metropolis'.

Architecture
The discipline dealing with the principles of design, construction and ornamentation of buildings; the profession of designing buildings and environments with consideration for their aesthetic effect. The study of the utilisation of built environments, both real and imagined, and the interrelationship of space, site, geography, culture, history, society and community. See Hassan Fathy's 'Architecture for the Poor' in 'Site'.

Archive
A whole body of records or documents of continuing historical, social and cultural value to an organisation or individual. Often, a collection of ephemera, hard data and personal testimony – visual and written-word –, an archive is both repository and object that has been particularly important for the recuperation of forgotten or fragmented histories.

Art market
The total demand for a work of art; the process by which art buyers and sellers interact to determine prices and quantities. Created and used for the buying, selling and trading of artworks, several markets operate at once. They can artificially inflate and manipulate the value of works of arts based largely on monetary worth and trends. See Geeta Kapur's 'What's New in Indian Art' in 'Nation'.

Authorship
The act of initiating an idea or theory; the act of producing an (art)work which is usually attributed to an individual. An umbrella term to describe a collective way of producing works which negates the idea of a sole author.

Beauty
The quality that gives pleasure to the senses and/or the intellect; a non-universal quality that is sought subjectively through the absence of imperfection in relation to oneself.

Binary
A numbering system with only two values: 0 (zero) and 1 (one); characteristic of having only two states, such as true and false or male and female. A limited way of evaluating the particularities of a given social or cultural condition.

Border
A band or line around the edge of something; the dividing line between political or geographic regions; the boundary of a country or nation state. A metaphysical limitation of the psyche, i.e., a border mentality. See the exhibition *Fault Lines* in 'Global'.

Britishness
Characteristics pertaining to the people, objects or cultural forms of the United Kingdom. A cultural phenomenon, a political allegiance and social attitude increasingly defined less by nationality, place of birth or language than a cluster of tendencies and values that need to be periodically redefined in light of cultural shifts and emerging identities. A contested term, it is currently being embraced as a term which refers to community cohesion, integration and shared values of citizenship across the whole of British society. See Yinka Shonibare's work in 'Nation'.

Canon
A body of rules or principles generally established by the mainstream as valid and fundamental in a field or art. A list of authors or works considered to be classic or authentic, that is, central to the identity of a given literary tradition or culture. An accepted list of works perceived to represent a cultural, ideological, or historical grouping which defines taste and assigns value. See 'Critical Difference' in 'Archive'.

Capitalism
An socio-economic system predominant in the West based on a free market, open competition, a profit motive and private ownership of the means of production with

minimal government regulation. The function of regulating an economy is achieved largely through the operation of market forces and the market determines the type, quantity and price of goods. See Michael Hardt and Stuart Hall's 'In the Shadow of Empire' in 'Global'.

Collage
A technique of creating a pictorial composition in two dimensions or low relief by gluing paper, fabrics, or any natural or manufactured materials to a canvas or panel. A layering of sounds and images to create new ways of experiencing the world.

Colonialism
One country's domination of another country or people where the dominant country assumes political and economic control over the other – usually achieved through aggressive, often military, action. Practised by European states such as Britain, France, the Netherlands and Spain since before the 15th century throughout Africa, Asia and Australasia/Oceania. More commonly, an attribute of the late 19th century, where the control extended to the eradication of a people's cultural identity through assimilation and coercion. See Johannes Phokela's work in 'Identity'.

Colour
The perception of the human eye to the visible spectrum of light radiation; a visual attribute of things that results from the light they emit or transmit or reflect; a way of describing the timbre of a musical sound. See *A Quality of Light* exhibition in 'Making'.

Commodification
The tendency to turn goods and services, such as land and human resources, into products for sale in a market; a process whereby certain human physical attributes are seen as commodities to be sold; used critically to describe loss of human qualities in capitalist production and exchange.

Community
A group of people living in a particular local area, occasionally drawn together by social and political circumstance in spite of ethnic, cultural or religious differences; a group of people having ethnic, cultural or religious characteristics in common; an online or virtual gathering place for people with similar interests to establish discussion forums.

Conceptual art
An international movement which emerged in the 1960s to become a predominantly global phenomenon. It is art that is intended to convey an idea or a concept to the viewer – which can be a written, published, performed, fabricated, or cerebral act – rejecting the creation or appreciation of a traditional art object; an artistic practice that is dependent upon the text or discourse surrounding it rather than the presence of the art object.

Conflict
A broad term regarding an interaction between people or groups with differing interests that are perceived as incompatible which may or may not be acknowledged by the parties themselves. A divergence of goals, objectives or expectations between individuals or groups, occasionally on grounds of ethnicity and nationality.

Consumerism
Prior to the 1970s, consumerism was seen as the emphasis of advertising and marketing efforts toward creating consumers. More recently, it is the theory and/or belief that an increasing consumption of goods is economically beneficial to the consumer as well as advocating the rights of consumers, as against the efforts of advertisers.

Content
The subject matter held in a field of study; a part, element, or complex of parts. The meaning of an image, beyond its overt subject matter, including the emotional, intellectual, symbolic, thematic and narrative connotations. All forms of information: the typography, composition, content links of a website; what the user interfaces with on their monitor; the look and feel of a website; the sum of all elements of a website. See 'Entries from Nasreen Mohamedi's Diaries' in 'Modern'.

Cosmopolitanism
Attitude of concern for the world as a whole and an interest in universal principles of solidarity that transcend the borders of states. An appreciation of the subtle influences which define cross-cultural interaction. See John Styles's presentation 'Hogarth' in 'Nation'.

Cosmos
The world or universe as a complex, ordered and unified system, usually referring to the world of human experience. A reflection of the cosmos goes against a binary view

of reality by unifying subject and object, humanity and nature, mind and matter. See Li Yuan-chia's work in 'Making'.

Creolity
Pertaining to the unique cultural make-up of people, language and customs from the Caribbean whose ancestry ranges from African and Indian to European. Rooted in a linguistic tradition, creolity has become the foundation of a cultural, political and national identity and self-image that has evolved and been adapted into something unique which is evident in cultural forms such as Trinidad's Carnival. See Stuart Hall's introduction to 'The Caribbean: A Quintessentially Modern Zone' in 'Modern'.

Cyborg
A human being whose body has been taken over in whole or in part by electronic or bio-mechanical devices. A creature of social reality as well as of fiction, it signals the end of traditional concepts of human identity. There are many actual cyborgs existing in society; anyone with an artificial organ, limb or reprogrammed to resist disease is a living composite of evolving technological, neurological, emotional, physical and virtual identities. See Keith Piper's 'Caught Like a Nigger in Cyberspace' in 'Metropolis'.

Democracy
Literally meaning 'power of the people' (combining the Greek words *demos*, meaning 'the people', and *kratien*, meaning 'to rule'). A political system where the legitimacy of exercising power stems from the consent of the people to elect a government, with recognition of freedom of speech, press and assembly; freedom to form opposition political parties and to run for office; commitment to individual dignity and to equal opportunities for people to develop their full potential. Can also mean a process of choice which is fair but not always equal. See Michael Hardt and Stuart Hall's 'In the Shadow of Empire' in 'Global'.

Desire
The strong feeling of wanting to have something or wishing for something to happen, also in terms of sexual longing and appetite. Relates to illusion, fantasy, dream and imagination, which contribute to the contemporary understanding of the dynamics of race and sexuality. See *Mirage* exhibition in 'Identity'.

Diaspora
The historical movement, migration or scattering of people, their language and culture from their original homelands. Body of people living outside of their homelands or place of origin. A lateral dispersion with many sources connected through some sense of common cultural origins, shared ideas and beliefs. See the *Parisien(ne)s* exhibition in 'Metropolis'.

Difference
The quality or state of being unlike or dissimilar; a variation that deviates from the standard or norm. Perceived or real, difference is about identifying qualities of race, gender and sexuality within socio-cultural contexts that separate but also unify individuals. See Stuart Hall and Sarat Maharaj's 'Modernity and Difference' in 'Translation'.

Dislocation
The act of disrupting an established order so it fails to continue. A displacement of a person or ideology from its normal position. A condition of being disconnected or separated from a location, identity or time from which emerges a different interpretation of the world. See Gilane Tawadros's 'The Leftovers of Translation' in 'Translation'.

Empire
An extensive group of territories, usually formed by colonisation, ruled by a single authority. Closely associated to imperialism, it is a monolithic, and notably oppressive, entity which did not allow for the expression of multiple identities – racial or cultural – or a declaration of individual nationhood. See Michael Hardt and Stuart Hall's 'In the Shadow of Empire' in 'Global'.

Ethics
A system of moral principles, rules or standards that govern the conduct of members of a group. A branch of philosophy that deals with the moral consequences of human actions, stressing objectively defined, but sometimes idealistic, standards (or laws) of right/wrong, good/evil and virtue/vice. See Jean Fisher's introduction to *Vampire in the Text* in 'Making'.

Ethnographic
Of, or relating to ethnography which is the study of people in their natural settings and/or a descriptive account of social life and culture, in a defined social system – usually a sub-culture or non-Western culture – based on qualitative methods such as detailed observations,

unstructured interviews and analysis of documents. A typological method of categorisation which narrows the possible readings of certain cultural artefacts and products. See 'Vindaloo and Chips' in 'Nation'.

Eurocentric
Centred or focused on Europe and the Europeans. A European mindset; an unquestioned assumption of European values and culture, to the exclusion of other ways of seeing. See Sonia Boyce's work in 'Archive'.

Excavation
The systematic removal and recording of prehistoric or historic artefacts, features and associated materials. The recovery of materials and information from the space of history and personal experience which usually includes a period of intense upheaval and negotiation with the self and others.

Exclusion
The state of being excluded; to be forcibly separated from a space, place or institution to which one has emotional and physical ties to the detriment of that individual; the act of forcing out someone or something by creating cultural and social barriers. See Eddie Chambers's 'Mainstream Capers' in 'Identity'.

Exile
To be voluntarily absent from home or country; or expelled from there by the ruling authority. A conceptual break with one's original culture which may stimulate new perceptions of the self but which could lead to feelings of isolation or displacement. See Alia Syed's work in 'Translation'.

Exoticism
The way in which all that existed /exists outside of Europe was/is portrayed as mysterious. The process by which the exotic – that which is different and foreign in an imperial context – was domesticated while continuing to render foreign people, objects and places strange. See Okwui Enwezor's 'Reframing the Black Subject' in 'Nation'.

Exploitation
The use of a resource for expected profits or benefits; to make unethical use of someone or something for personal gain or profit usually at the cost of someone else's welfare.

Freedom
The condition or state of being free; the power to act or speak or think without externally imposed restraints, obligation or duty.

An emotional experience of being unrestricted, unlimited, uncontrolled and unrestricted by thought processes which would otherwise create internal or external constrictions in thinking or acting.

Geography
The study of the physical world, its inhabitants, the interaction between the two and of the patterns and processes of built and natural landscapes, where landscapes comprise real and perceived space. A process through which psychological and physical experiences and encounters are mapped across a series of delineated spaces. See the *Fault Lines* exhibition in 'Global'.

Global
Of or applying to the whole earth; of or applying to the whole of something in the world; not limited or provincial in scope. Can refer to a perspective or strategy which can be located within a specific geographical context though it is not dependent on geographical markets and administrative borders and has an impact or repercussions worldwide.

Globalisation
To put something into effect worldwide. An increase in the pace of human interconnectedness – precipitated by technological changes – where information and goods flow more quickly making it easier for transportation and communication creating the possibility of being in several places at once; the process whereby the barriers to trade are increasingly dismantled enabling foreign trade and investment to grow dramatically across ever-widening geographical boundaries; the gradual eradication of regional contrasts at the world scale, resulting from increasing international cultural, economic and political changes. See Stuart Hall and Michael Hardt's 'In the Shadow of Empire' in 'Global'.

Hegemony
Domination of one state, country or class within a group of others. The domination of culture by one particular cultural or privileged social group, resulting in the sanctioning of certain cultural beliefs, values and practices over others.

Hierarchy
A system of ordering people or things which places them in higher and lower ranks. A system where a patriarchal-style relationship is assumed giving power to a minority over the masses.

Hiphop
An American popular culture movement originating in the 1980s. A cultural form that is translated across (graffiti) art, (rap) music and (break) dance which attempts to negotiate the experiences of marginalisation and oppression within African American and Caribbean history, identity and community.

History
The sequence of events occurring in succession leading from the past to the present and even into the future; a record or narrative description of past events. Previously thought of as being linear in manifestation, the recovery of forgotten histories has revealed history as multi-layered, circular/cyclical and concurrent. See the introduction to *Shades of Black* in 'Archive'.

Home
The place or dwelling where one lives or a person's country of birth; a region or place where one finds rest, refuge or satisfaction. The place where one understands oneself in relation to the rest of the world and from which one learns the concepts of inside and outside, order and disorder, belonging and exclusion. See Hou Hanru's 'Parisien(ne)s' in 'Metropolis'.

Humour
The quality of being funny; a message whose ingenuity or verbal skill or incongruity has the power to evoke laughter; the trait of appreciating and being able to express the humorous.

Hybridity
The state of being a mixture of two different things combined to create something new or unique. The creation of new transcultural forms and states of being which have been produced by the effects of colonisation, exile and migrancy.

Identity
The individual characteristics by which a thing or person is recognised or known. Collective identity, social identity and personal identity are ways in which to describe how one negotiates past experiences to constantly recreate the self. An ongoing process towards self-recognition away from fixed or known representations.

Industrialisation
The development of industry on an extensive scale; a process of social and economic change wrought by technological innovation whereby a

human society is transformed from a pre-industrial to an industrial state precipitated by a different attitude towards the perception of nature. See Avtarjeet Dhanjal's work in 'Site'.

Interactive
Promoting action between or among; mutually or reciprocally active. Communication between two or more entities that invites contribution which affects all parties and enables both questions and answers. Reciprocal actions taking place with and/or through a computer that allow the user to influence and react to any type of media. See Keith Piper's 'Caught Like a Nigger in Cyberspace' in 'Metropolis'.

Internationalism
The quality of being international – of more than one nation – in scope; the belief that nations should cooperate because their common interests are more important than their differences. A project of cultural interaction which gives equal acknowledgment to the achievements of all peoples within, and in the making of, existing and emerging parallel histories. See the *Offside!* exhibition in 'Nation' and David Medalla's work in 'Performance'.

Landscape
An expanse of scenery that can be seen in a single view; an image depicting an expanse of natural scenery; a genre of art dealing with the depiction of natural scenery; an extensive mental viewpoint which is defined or shaped by the impact of historical and socio-political movements. See Hassan Fathy's 'An Architecture for the Poor' in 'Site'.

Language
A system for communicating which is innate. A designated system of verbal signs which includes both spoken (or auditory) and written signs; the cognitive processes involved in producing and understanding linguistic communication. An inherently open-ended structure not bound to its individual enactment which can be the subject and form of artistic practice. See Jean Fisher's introduction to *Vampire in the Text* in 'Making'.

Liberation
The act of freeing someone or something; the attempt to achieve equal rights or status; the state of complete personal freedom from suffering and its causes.

Local

An inhabitant of a particular district; within easy reach, not remote; of or belonging to or characteristic of a particular locality or neighbourhood. A space defined less by proximity to things than by its inclusion of different elements such as race, culture, class, gender and sexuality.

Map

A diagrammatic representation of the earth's surface (or part of it); to plan out; to divide a country or place into districts; to explore or survey for the purpose of making a map; a creation that is a visual or tangible rendering of someone or something. To chart territory in a multi-layered way which acknowledges shifting border lines, new or emergent economic zones and decentralised political power. See Chris Ofili's work in 'Site'.

Margin

An edge or rim and the area immediately adjacent; the amount by which one thing differs; allowing some freedom to move within limits. Originally perceived as a pejorative space in which the oppressed or minorities were/are located in the realm of culture, race, class, etc. Now understood and utilised as a conceptual space where the present is critically articulated as a form of radical expression to reverse the polarisation of out/in. See Andrea Giunta's 'Strategies of Modernity in Latin America' in 'Modern'.

Materials

The matter from which things or concepts are constructed; anything that imparts a surface appearance on a 3D object. A disparate and multiple means by which art can capture life through painting and sculpture, the artist's body and its organic traces, or cultural remnants, the seen and the unseen, the permanent and the ephemeral. See Guy Brett's 'Li Yuan-chia' in 'Making'.

Memory

Capacity for storing information in a computer; something that is remembered; the power of retaining and recalling past experience; the cognitive processes whereby past experience is remembered. See Sutapa Biswas's work and Moira Roth's 'Sutapa Biswas' essay in 'Making'.

Metropolis

One or more large, densely populated urban areas, such as a capital of a country, and their surrounding suburbs that dominate the economic and cultural life of a region. An area in which the collision of economic, occupational and social life sets up a deep contrast with small town and/or rural life. A place where the diffusion of populations and cultural interfacing through the emergence of diasporas comes to characterise the collective life of cities.

Migration

The movement of persons from one country or abode to settle in another. The act of moving oneself and one's ideas away from fixed geographical and cultural locations, to new positions determined through a creative negotiating and assembling of cultural identities. See Shen Yuan's work in 'Translation'.

Misrepresentation

A misleading falsehood or untrue representation; an incorrect statement made about a material fact; something which conveys the idea of intentional untruth.

Multicultural

Of or relating to or including several cultures of many races or cultural and ethnic backgrounds. Emerged as a specific term in the mid-1970s to describe ethnicity, in general, without a critical engagement with the specifics of cultural difference. Now commonly understood as a sampling of different cultures operating within a distinct historical and political context which binds those cultures together through a continuous process of mutual engagement and acceptance.

Multimedia

The use of computers to present text, graphics, video, animation and sound in an integrated way. A collection of different forms of communication, such as television, computer, printer, modem and video disk recorder, connected to allow information to be presented in any combination of media, such as textual, audio, video, or electronically. See Flow Motion's 'Dissolve' in 'Making'.

Multinational

Involving or operating in several nations or nationalities. Commonly used to describe corporations which developed in response to market forces and a reaction to rising barriers to international trade. Criticised for undermining national cultures through intensive advertising of standardised non-local goods, the rise of the multinational can be seen as the first wave of globalisation.

Multiplicity

The quality or state of being multiple or various; of many identities; that which goes against the binary, linear and fixed. See Zineb Sedira's 'Mapping the Illusive' in 'Identity'.

Museum

A building, place or institution devoted to the acquisition, conservation, study, exhibition and educational interpretation of objects having scientific, historical or artistic value. An institution which can be historically and culturally biased, preferring to uphold the canon in order to validate its own existence. The idea of a museum has been subverted by imagining it as nomadic, without walls, a playground and a shopping mall. See 'Interview between Cedric Price and Hans Ulrich Obrist' in 'Site' and Stuart Hall's 'Museums of Modern Art and the End of History' in 'Modern'.

Mythology

A system of traditional stories embodying ancient religious ideas; a collection of myths belonging to people and addressing their origin, history, deities, ancestors and heroes; a body of stories associated with a culture or institution or person which have become lodged in popular consciousness through storytelling. See Gerardo Mosquera's 'Modernism from Afro-America: Wifredo Lam' in 'Archive'.

Narrative

An element of storytelling, often subjective, or a retelling of events that identifies the people involved, describes the setting and sequences the important events. Sometimes folkloric, sometimes rooted in lived experience, these can be stories people tell as a way of knowing, understanding and explaining their lives. Can also describe the way that the dominant discourse has shrouded other histories, i.e., the grand narrative. See Deborah Levy's 'Simon Tegala Downloads his Heart' in 'Global'.

Negritude

Coined by Martiniquan poet and statesman Aimé Césaire in Paris in the 1930s, it is an ideological position that holds black culture to be independent and valid on its own terms; an affirmation of the African cultural heritage by rejecting imperialism. The artistic expression of black intellectuals who affirm black personality and redefine the collective experience of black people. See the *Rhapsodies in Black* exhibition in 'Archive'.

Net art

Artwork made for and residing on the world wide web aka the internet. A term coined in the 1990s for art which was made specifically for the internet which bypassed institutional control and choice. Initially seen as an opportunity to have work displayed as in a shop front, or to work collaboratively regardless of geographical constraints, more recent manifestations of net art have harnessed the unique qualities of the web as a medium which is fluid, transient and unhindered by time and space.

Network

An interconnected system of things or people; a communication system consisting of a group of broadcasting stations; a group of connected computers that can communicate with one another. To communicate with and within a group. See Coco Fusco and Ricardo Dominguez's 'Electronic Disturbance' in 'Global'.

Other

A different one (or ones) from that or those already specified or understood. To be different or distinct in appearance, character, etc. from that which is dominant or subordinate and, conversely, a desire to be the same. See Stuart Hall and Sarat Maharaj's 'Modernity and Difference' in 'Translation'.

Pan-africanism

A movement established in the late 19th century by individuals of Caribbean and African descent living in the West which asserted their rights and equality. A political movement aiming to remove arbitrary colonial state boundaries to create a single African state. Embraced by emerging politicised black artists in Britain in the 1980s, pan-africanism came to represent a way of understanding their practice in relation to a broader (international) context of black intellectual radicalism. See *Fault Lines* exhibition in 'Global'.

Performance

The action of performing a ceremony, play or piece of music. Sometimes participatory or solitary, random, unobserved and uninvited, it can be an action, act, gesture or deed which involves the use of props or the human body as a prop to interrogate function above form, subject above object, live above recorded moments.

Physicality
Concerned with the deployment of substances or having a material existence; a characterisation of an energetic bodily or gestural activity which dominates a space. See 'Janine Antoni: Artist's Talk' in 'Performance'.

Place
The particular portion of space occupied by a physical object; an appropriate position or location; the combination of factors that makes the location of natural and human-made phenomena unique; the location of a psychological and spiritual nexus which defines something in relation to other matter, non-living and living.

Plurality
The state of being plural or more than one; a large indefinite number; a situation in which many different world views coexist such as a plurality of cultures.

Poetry
A form of speech or writing; a variable literary genre characterised by rhythmical patterns of language. It may break the conventions of normal communicative speech in the attempt to embody an original idea or convey a linguistic experience in order to create/achieve an emotional response.

Politics
Methods by which individuals and groups try to influence operations of government; the profession devoted to governing and to political affairs. Social relations involving authority or power within the realm of identity such as race or gender.

Poverty
The state of having little or no money and few or no material possessions; the relative condition of being poor. The state of being deprived, vulnerable and/or excluded from society as well as being materially destitute. See Françoise Vergès's 'Economics, Postcolonialism and New Technologies' in 'Translation'.

Power
Political, financial, social force or authority; a position or possession of controlling influence; a person or a group having the ability to get what they want either through force, cooperation or integration in which people are held together in groups.

Primitivism
A wild or unrefined state; a philosophy advocating a return to a pre-industrial and usually pre-agricultural society. A European art movement of the late 19th century that was more of a sensibility or cultural attitude than an aesthetic movement. A description of that which is a naive, less-developed culture and a 'non-Western art' form outside of the European tradition which has been critiqued on the grounds of being degrading and misrepresentative. See Gerardo Mosquera's 'Modernism from Afro-America: Wifredo Lam' in 'Archive'.

Progress
A gradual improvement or growth or development; a linear movement forward. To advance or develop – a key drive behind Western industrial culture – to provide material benefit at the expense or loss of other ways of living. See Suman Gopinath's 'Bangalore' in 'Site'.

Race
A group of persons or nation of people connected by common descent or origin. A way to describe difference which classifies individuals according to the colour of their skin and does not allow for cultural or social particularity. See Kobena Mercer's 'Busy in the Ruins of Phantasia' in 'Identity'.

Racism
Discriminatory or abusive behaviour towards members of another race; prejudice or discrimination based on the belief that race is the primary factor determining human traits and abilities and that racial differences produce an inherent superiority of a particular race. Institutional racism is racial prejudice supported by institutional power and authority used to the advantage of one race over others. See Eddie Chambers's 'Whitewash' in 'Identity'.

Religion
A belief in a deity or personal God or gods; a system of faith, practice of worship, action, and/or thought related to that deity. Loosely, any specific system of ethics, values and belief through which an individual or group of people struggle with the ultimate problems of human life.

Renaissance
A revival in culture, art and literature. Also used to describe social and economic regeneration through changes to the built environment. A moment of creative liberation in which artists and writers are able to revolutionise the cultural landscape through an opportunity created by a patronage of the arts and culture. See David A. Bailey's introduction to *Rhapsodies in Black* in 'Archive'.

Representation
A creation that is a visual or tangible rendering of someone or something though not necessarily based in reality; the act of representing; standing in for someone or some group and speaking with authority on their behalf. A situation where the one may involuntarily stand in for the many, which is viewed ultimately as an attempt to redress a perceived social or political imbalance. See *Veil* exhibition in 'Identity'.

Resistance
The act of opposing something that you disapprove or disagree with; a secret group organised to overthrow a government or occupation force; group action in opposition to those in power. An act that engenders a period of socio-political turmoil which can give rise to new political tendencies and cultural expression. See Michael Hardt and Stuart Hall's 'In the Shadow of Empire' and Coco Fusco and Ricardo Dominguez's 'Electronic Disturbance' in 'Global'.

Risk
The probability of an undesirable outcome; the exposure to the chance of loss; an action undertaken in the hope of a favourable outcome. The creation of an opportunity to develop something challenging which would otherwise be missed or avoided.

Rupture
State of being torn or burst open; a personal or social separation between opposing factions; separate or cause to separate abruptly. The emergence of a discordant space where there are greater possibilities for new intersecting discourses and forms to compete against and eclipse existing or stagnant ways of being and seeing.

Rural
In or of the countryside; a description of people who live in the countryside; characteristic of farming or country life. A mindset which is determined by certain cultural and social conditions specific to the countryside.

Signs
The words, gestures, pictures, products and logos used to communicate information from one person to another. Things that have a subjective and immediate meaning in the social construction of reality. See *Egyptian Cinema Posters* in 'Site'.

Slavery
The state of being under the control of another person; the treatment of human beings as a commodity to be bought and sold; the practice of owning slaves. A system of enforced servitude in which people are owned by others and in which enslaved status has historically transferred from parents to children.

Solidarity
A unanimity of attitude or purpose between members of a group or class; a union of interests or purposes or sympathies among members of a group that can be specifically related to labour unions and protest movements.

Space
The unlimited expanse in which everything is located; that in which material bodies have an extension; an empty area usually bounded in some way between things. Something that can be virtual and concrete (physical), public and private, space is always territorialised, policed/surveilled and partisan, and very rarely democratic in spite of many (historical) attempts to challenge the status quo. See *Drawing Space* exhibition in 'Modern'.

Spirituality
Relating to spiritual/sacred matters; being connected to the essence of self, others and life; a desire to transcend material things which brings about a deeper understanding of the relationship between nature and the spirit. The manifestation of this experience in artworks is typically in a non-objective form.

Subject
Some situation or event that is thought about; a branch of knowledge; make subservient; force to submit or subdue; something – a person or thing – which is represented or is central to an investigation.

Superpower
A country with very great military and economic power. A state with the ability to influence events or project power on a wide scale, probably an entity with a strong economy, a large population and strong armed forces, including air power and satellite capabilities, and a huge arsenal of weapons of mass destruction.

Surveillance
The covert monitoring of activities of persons or groups; all forms of observation and monitoring occasionally overt. A method of remote observation by means of